CINEMA'S BODILY ILLUSIONS

CINEMA'S BODILY ILLUSIONS

Flying, Floating, and Hallucinating

SCOTT C. RICHMOND

 University of Minnesota Press

Minneapolis

London

The University of Minnesota Press gratefully acknowledges financial assistance provided for the publication of this book from Wayne State University.

Published by the University of Minnesota Press

111 Third Avenue South, Suite 290
Minneapolis, MN 55401-2520
http://www.upress.umn.edu

Printed in the United States of America on acid-free paper

The University of Minnesota is an equal-opportunity educator and employer.

23 22 21 20 19 18 17 16 10 9 8 7 6 5 4 3 2 1

Library of Congress Cataloging-in-Publication Data
Richmond, Scott C.
Cinema's bodily illusions : flying, floating, and hallucinating / Scott C. Richmond.
Minneapolis : University of Minnesota Press, 2016. | Includes bibliographical references and index.
Identifiers: LCCN 2015039888| ISBN 978-0-8166-9096-1 (hc) | ISBN 978-0-8166-9099-2 (pb)
Subjects: LCSH: Motion pictures—Aesthetics. | Illusion in motion pictures. | Cinematography—Special effects. | Motion pictures—Psychological aspects. | Perception (Philosophy)
Classification: LCC PN1995 .R53 2016 | DDC 791.4301—dc23
LC record available at http://lccn.loc.gov/2015039888

TO MY PARENTS

The cinema isn't I see, it's I fly.

NAM JUNE PAIK (VIA PAUL VIRILIO VIA MICHAEL TAUSSIG)

CONTENTS

INTRODUCTION

Proprioceptive Aesthetics, or the Cinema

On Finding Yourself Lost in Space

The opening shot of Alfonso Cuarón's 2013 *Gravity* is already famous, and rightly so. It is nearly thirteen minutes long, a virtuosic exercise in acrobatic camera movement and sensational perceptual impact. In the exorbitant display of IMAX 3D, the scale feels enormous, overwhelming. In Cuarón's expert deployment of 3D, the inky black of space recedes into astonishing, terrifying depth. As Cuarón's camera continually moves through space, as I sit in the theater I find myself saturated by a sensation of my own body moving through onscreen space, at once weightless and frictionless, terrifying and illusory. *Cinema's Bodily Illusions* is about this kind of feeling in the cinema.

As Kristin Thompson has noted, *Gravity*'s camera movement at moments takes the form of relentlessly disorienting rotational figures, redolent of Michael Snow's vertiginous experimental film *La région centrale*.[1] In the closing moments of *Gravity*'s opening shot, the camera's movement careers out of control, rotating along multiple shifting axes and shuttling between different frames of reference. As fast-flying debris crashes into the space shuttle, the Hubble Space Telescope, and the astronauts, the movements of objects, of people, and of the camera itself are wild and wildly complex. We might begin to describe the camera movement by referring to its multiple frames of reference. At first Dr. Ryan Stone (Sandra Bullock) spins and whirls against the relatively stable backdrop of Earth, even as the camera itself tilts, pans, displaces, and rotates to keep her in frame along her trajectory (Plate 8). Then, as she draws nearer to the camera, it fixes her face in frame, aligning its movements with hers—not only her trajectory but her rotation (Figure 1). As this happens, Earth and the stars and the sun and their reflections on the glass of her helmet all begin to rotate around us, frenzied, dizzying. Finally, as Stone

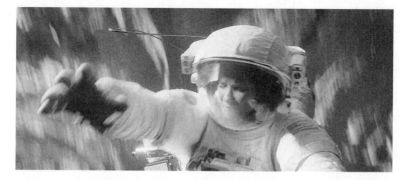

Figure 1. In the second stage of movement at the end of *Gravity's* first shot, the camera approaches Dr. Ryan Stone (Sandra Bullock) and starts rotating with her.

detaches from the wrecked arm of a crane, the camera appears to stop moving altogether—neither displacement nor rotation—showing her recede at terrifying speed into the equally terrifying depth of space (Figure 2). These moments are accompanied not only by the sounds of Stone's breathless panic but by my own panicky, breathless, even nauseated affects.

While such camera movement is particularly intense in the final moments of *Gravity's* first shot, throughout the shot—and indeed, throughout the film—the camera moves in nearly continuous sweeping, arcing, panning, and canting movements, in all directions and around all axes. *Gravity* strives to give its viewers a sense of the weightlessness of space, and this vocation determines its form. In the microgravity of low Earth orbit, there is no longer up or down. In place of a Cartesian (linear or planar) worldly space, *Gravity* gives us polar coordinates. Space is organized by angle and rotation and distance-from-here. The dissolution of the vertical axis entails the dissolution of the horizontal—and with it, the stability and consistency of screen direction. At a formal and cinematographic level, Cuarón's use of long takes, along with his reliance on camera movement rather than editing to orient our attention, is also conditioned by this predicament. Continuity (or intensified continuity or, even, postcontinuity) editing relies heavily on consistent screen direction for its spatial cues, and *Gravity* must do without it. Instead, the camera remains in nearly constant movement, orienting our attention by fixing objects, events, and people in an unerringly mobile frame. More to the point, Cuarón discovered that to really engender an experience of weightlessness in space and not merely document the weightlessness of onscreen bodies, he needed to engender in his audience the illusion of movement through that space.

As the considerable formal problems—and solutions—of *Gravity* turn on

Figure 2. In the final moments of the shot, Stone flies off into the inky depth of space.

the absence of diegetic gravity, their effect on viewers is a voluptuous, anxious, or thrilling sensation of illusory movement through onscreen space. In my own viewing of the film, especially (but not only) the first time I saw it and especially (but not only) in IMAX 3D, I found my heart rising in my throat, my arms tensed, my hands clutching armrests. I found myself pressing my whole body back into my seat and my feet into the floor in an attempt to anchor myself. My response was intense, but it was not intentional. In the opening moments of the film, as Cuarón's camera begins to move around and through astronauts in a spacewalk, it engenders the illusion of bodily movement through onscreen space, an onscreen space radically other from what I have experienced, bound as I have been to the earth, as well as from what I am *currently* experiencing, bound as I am to my seat in the movie theater. As this illusion of movement through onscreen space is not only slightly queasy but also anxious and since it persists no matter how hard I grip my armrests, I find the only way I can bear it is to relax into it or, if I cannot relax, then to submit: to this movement that is not my own, to the cinema's disordering and reordering of my perception, and indeed, as we will learn to say, to its ongoing modulation of my *proprioception*.

In *Gravity*'s generally positive critical reception, critics not only routinely remarked upon this perceptual effect and its intensification in IMAX 3D but also set these effects in relation to what was, it seems, an unavoidable point of reference: Stanley Kubrick's *2001: A Space Odyssey* (1968). Although the fate of every "serious" science fiction film may be to suffer comparison to *2001*, considering *Gravity* in relation to *2001* is instructive—in large part, because they have little in common.[2] Kubrick's *2001* is nearly three hours long, whereas *Gravity* is barely half that. Narratively, *2001* is somehow both sprawling and

abbreviated, eschewing consistent storytelling and trafficking instead in grandiose ideas expressed in vaguely (elliptically, associatively) connected narrative vignettes, whereas *Gravity*'s unusually tight, nearly monomaniacal narrative structure supports an ostentatious verisimilitude. Finally, *2001* is psychedelic and speculative, whereas *Gravity* is literal and presentist. Which is to say, despite critical consensus *Gravity* is in some sense a reprise of *2001* or, at least, the first truly successful space movie since *2001* (it's not really science fiction), according to a familiar film criticism that proceeds by considering form, theme, and narrative perhaps the only matter the two really have in common is that both take place (largely) in outer space.

My interest in *Cinema's Bodily Illusions* lies not in the superficial similarity of their shared setting but rather in the aesthetic ends to which this setting is put: *Gravity* and *2001* are both centrally concerned with the perception of space as an embodied phenomenon and the modulation of this embodied perception of space as a fundamental aesthetic affordance of the cinema. Consider a related sequence in *2001*. Immediately after perhaps the most famous graphic match in the history of cinema, from flying bone to floating satellite, we see Earth from orbit, glowing bright white–blue against the black of space—nearly identical to the view of Earth that opens *Gravity* (Figure 3). Then, a few shots into this segment of *2001*, we see a needle-nosed midcentury-futurist Pan Am space shuttle begin a docking procedure with the wheel of a rotating space station (Figure 4). In a brief series of shots, *2001* shows these docking maneuvers and rotational movements across multiple frames of reference—in order, that of Earth, of the ship, and then of the station—engendering in each case a dizzy disorientation similar to but distinctly less anxious than *Gravity*'s. *2001*'s rotational figures are slower, operating at the much larger scale of future-tense commercial shuttles and enormous rotating space stations. *Gravity*'s concern lies with the tiny, fragile human body stranded in space, where, according to its opening titles, "life is impossible."[3] The journey to the moon in *2001* instead demonstrates the grandeur of the inevitable human mastery of (outer) space, set to Johann Strauss's *The Blue Danube*.

Although *2001* and *Gravity* are remarkably different in thematic development, mise-en-scène, and narrative concern, they share an intense interest in space: its perception, its embodiment, and its manifestation in the cinema. In this, both are emphatically, crucially *cinematic* films. They are invested in the *cinema* screen as well as the cinema as a space of exhibition. *Gravity* is really itself only in IMAX 3D, and *2001* attains its full, literally awesome effects only in 70 mm cinematic exhibition.[4] Across their historical distance, these films

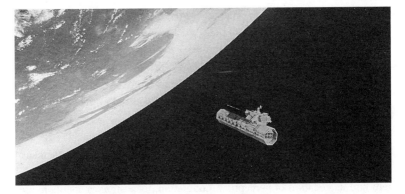

Figure 3. After the famous graphic match in *2001: A Space Odyssey* (dir. Stanley Kubrick, 1968), a satellite floats high above Earth.

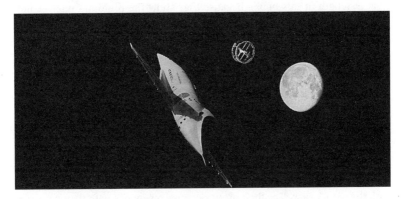

Figure 4. A Pan Am space shuttle approaches a rotating space station in *2001*'s glorious retro futurism, showing three frames of reference for movement: shuttle, station, and moon.

show how the sensational, perceptual, and proprioceptive effects they elicit and elaborate are emphatically (if not specifically) cinematic.

This investment in the cinema seems particularly clear and urgent in the case of *Gravity*, given its elaborate employment of 3D in the context of the rapidly increasing sophistication of home theaters and the proliferation of different kinds of screens in heretofore unimaginable corners of our lives. But if it and *2001* may be unusual in the degree of their investment in the cinema as a technological system, this investment as such is not unusual. The intimate relation between sensational perceptual intensification and the cinema as a site of exhibition and a technological system has a long history—from the phantom rides of the 1890s to *2001*'s native exhibition format: multiprojection Cinerama,

first developed in the 1950s. *This Is Cinerama,* the eponymous commercial film demonstrating its powers of perceptual modulation, opens with a roller coaster ride.[5] This may seem an intuitive, even banal, fact, as we still go see certain sorts of films "on the big screen." However narratively juvenile, aesthetically degraded, or frankly stupid such films may often be[6]—most often blockbusters destined for international distribution and keyed to the real or imagined demands of that market—the films we still seek out on cinema screens are especially invested in a cinema that is still "more perceptual," in Christian Metz's felicitous phrase, than the other arts and, indeed, other sorts of screens.[7]

Cinema's Bodily Illusions is about the cinema as such a technological system and its vocation of perceptual modulation: its aesthetics, its phenomenology, and its decisive importance for a contemporary theory of the cinema. I open with this brief comparative discussion of *Gravity* and *2001*—films I treat at length in this book—because they show the profound interrelation between the modulation of embodied perception and the cinema's existence as a technological system. Put another way, *Cinema's Bodily Illusions* is about the cinema as a technology for the modulation of perception, which proceeds by discussing films that offer aesthetic elaborations of this technological fact, in various ways: in turn, Marcel Duchamp's *Anémic Cinéma,* Kubrick's *2001,* Godfrey Reggio's *Koyaanisqatsi: Life Out of Balance,* Cuarón's *Gravity,* and Tony Conrad's *The Flicker.* But this book is not really about these films. Rather, it is about what they share: a particular investment in the cinema as a technological system and the deployment of this technology to the same end—the exacerbation, disordering, and modulation of viewers' perceptual resonance with the world, as well as their proprioceptive resonance with themselves.

On Proprioceptive Aesthetics

In different terms, what *Gravity, 2001,* and these other films share is an intense and extended investigation and elaboration of what I call *proprioceptive aesthetics.* My central thesis in this book is that proprioceptive aesthetics lies at the heart of the cinema as an aesthetic medium and as a technical system—in both its historical continuity and its contemporary uses. *Proprioception* is the name for the set of perceptual processes whereby we orient ourselves in and coordinate ourselves with the world. *2001, Gravity,* and the other films I discuss thematize or roughen our perceptual and, thus, embodied involvement with the world unfolding before us onscreen.[8] In these films—and, as I argue, in the cinema since its inception—the cinema's vocation of manifesting a world unfolding before us onscreen is fundamentally proprioceptive.

According to a well-known scheme in perceptual psychology and related fields, perception functions in three registers.[9] *Exteroception* names perception of the world beyond our bodies, typically by the canonical five senses we learn in grade school (and have inherited from Aristotle): hearing, sight, touch, smell, and taste.[10] *Interoception* names the perception of the interior of the body, indexed by visceral sensations—that is, sensations of the internal organs, such as the stomach, intestines, bladder, and so on. *Proprioception* names the perceptual processes that mediate between these two, that coordinate the interior of the body with the external world. As with interoception and exteroception, in this scheme, proprioception takes place within a specific set of perceptual modalities that provide information about the location and position of the body in space: stretch receptors in muscles and articular receptors in joints specify the posture of the body, and most important, the vestibular sense in the inner ear specifies the relation of this posture to gravity and acceleration. In short, in this traditional theory of perception, *proprioception* is a mediating term, coming between and coordinating the inside of the body and what lies outside it.

Perceptual psychologist James J. Gibson, by contrast, offers a radically different account of proprioception. Along with Maurice Merleau-Ponty's phenomenology of perception, Gibson's theory of perception, what he calls the *ecological approach to perception,* orients my work in this book, and I turn to his unusual (even radical) concept of proprioception in my account of proprioceptive aesthetics.[11] For Gibson proprioception remains the perceptual register in which a perceiver (in his terms, an organism) arrives at a sense of its posture and orientation in the world. Gibson denies, however, that this takes place through a specific set of discrete sense modalities. Rather, he argues that proprioception as a process of self-perception is distributed across *all* sense modalities—it suffuses perceptual life. Walking down the sidewalk, I see not only other people walking near me, the ice I must avoid, the buildings and cars that constrain my path but also the bridge of my nose, my arms and hands moving in time with my gait or carrying a package. If it is quiet enough, I hear my footfalls, or if I am talking to a partner, I hear myself speak. For Gibson proprioception simply is self-perception. It does not belong to or inhere in specific sense modalities. Rather, in each sense we may have (and as we shall see, Gibson denies that there are discrete sense modalities at all), we not only perceive the world but also always perceive ourselves. For Gibson *all* perception includes an aspect of self-perception. Furthermore, in his scheme any sense we have of being a capable self in the world, of being a bounded perceptual subject that occupies a *here* and is capable of action and

being acted upon, this sense of self arises only as a result of proprioceptive self-perception.

Proprioceptive aesthetics is thus an aesthetics of self-perception modulated by the cinema. The proprioceptive aesthetics at work in *Gravity* and *2001*—and as I argue at length, at work in the heart of the cinema—is manifest in the films' ongoing modulation of my perception of space, specifically my sense of my own position, orientation, and attitude in onscreen space. This modulation gives rise to the sensational and voluptuously illusory feeling of moving through onscreen space accompanied by a series of bodily responses: a lump in my throat, a tightening in my chest, the involuntary engagement of the musculature of my core, pushing into the back of my seat, my hands gripping my armrests. I want to underline the fact that such modulation of my sense of space gives rise to an intense manifold of affects, the vertiginous or dizzy or nauseating heightening not only of the space around me but also of my position in it. The films modulate both my perception and my self-perception: my proprioception. In doing one, they cannot help but do the other. *Gravity* and *2001* thus serve as an initial diagram, even demonstration, of the fact that proprioception and perception of the exterior world are not different in kind.

Both in the ecological sense of reflexive self-perception and in its broader meaning of perceptual processes of orientation in the world, proprioception has an intimate connection with aesthetics. As Steven Shaviro shows, aesthetics names not only the philosophy of art or regimes of artistic practice but also the study of our modes of receptivity to the world.[12] Proprioceptive aesthetics thus relates to aesthetics in two senses. To be sure, it includes the more obvious case in which the cinema's aesthetic work lies in modulating my sense of space and my processes of orienting myself in space. But it also includes a more subtle sense, modulating and elaborating my modes of relation to the world and, in the same move, to myself. After all, the sensation of moving through space in both films is not manifest, really, in a sense of space as such but rather in sensations of self: I feel *myself* moving through space; my body, at rest in my seat in the theater, becomes an object of sensorial involvement, even as I am simultaneously and intensively enmeshed in onscreen space. And so one of the most important topics of investigation in this book is the ways in which the cinematic modulation of perception is, at a profound level, also the modulation of proprioceptive self-perception. The cinema modulates my relations with the world unfolding before me onscreen, and in so doing it inexorably modulates my relation with my self—as well as the perceptual processes by which I arrive at a sense of myself as a self in the first place.

I mean to indicate by proprioceptive aesthetics three things at once: (1) a set of possibilities in and vocations of the cinema understood as an arrangement of technologies or a technical system; (2) a set of films that take up a particularly productive relation to these possibilities and vocations; and (3) a broader field of aesthetic practices and aesthetic media, not at all limited to the cinema, wherein the paradoxically double presence of the body—its illusory presence in a world unfolding onscreen and its ordinary presence in the world—is the focus of aesthetic elaboration. These categories overlap, to be sure, but my target throughout this book is the theoretical level implied in the first and made manifest in the second. Which is to say, although *Cinema's Bodily Illusions* holds lessons for scholars of other screen media, especially of video games, and draws together a canon of especially proprioceptive films, my sustained focus is neither on other screens nor even on the films themselves. *Cinema's Bodily Illusions* is not about films but about *the cinema*. It offers a theory of the cinema in which the modulation of perception is its primary aesthetic vocation, phenomenological import, and technological work.

On Modernism and Representation

In his review of *Gravity*, J. Hoberman not only compares *Gravity* to *2001* but does so under the aegis of "blockbuster modernism":

> A survival drama set almost entirely in the unfathomable abyss of outer space, *Gravity* is something now quite rare—a truly popular big-budget Hollywood movie with a rich aesthetic pay-off. Genuinely experimental, blatantly predicated on the formal possibilities of film, *Gravity* is a movie in a tradition that includes D. W. Griffith's *Intolerance*, Abel Gance's *Napoleon*, Leni Riefenstahl's *Olympia*, and Alfred Hitchcock's *The Birds*, as well as its most obvious precursor, Stanley Kubrick's *2001*. Call it blockbuster modernism.[13]

This locution is meant to index a tension in *Gravity's* aesthetic that it shares with *2001* (and, of course, other films): it is aesthetically rich and genuinely experimental and yet somehow does not require feats of intellection or critical labor to elucidate or catalyze its aesthetic work. Already, I want to point out the way in which Hoberman's intentionally contradictory formula gets its rhetorical force by setting a stupid (or at least unthinking or unreflective) populist blockbusterism against a presumably experimental, critically valuable, and intellectually verbose modernism.

Meanwhile, in a remarkable 1969 essay on *2001* in *Artforum*, Annette Michelson holds up *2001* as an exemplary, even emphatically, modernist work. For

her, *2001*'s interest in space and the movement through it lies at the heart of its modernist aesthetic agenda. In its perceptual intensity and through its illusion of bodily movement through onscreen space, *2001* engenders a sensory alienation that is the hallmark of modernist aesthetics, in which the cinema plays a decisive role:

> If this distance, the alienation of the spectator with respect to his experience, reflecting the elevation of doubt to an esthetic principle, may be said to characterize modernist sensibility as a whole, determining, in fact, the intensity of its very longing for immediacy, then film's conversion of that principle to the uses of a formal dynamics gives it a privileged place as a medium centrally involved with the cognitive aspiration of modern art.[14]

For Michelson *2001*'s modernism consists in the way it folds vision against itself, heightening perception to the point of alienation, transforming it into *apperception*. In this model modernist film engenders a reflexive turn for (or in) its subject, turning perceptual intensity into the object of intellectual elaboration. Modernism of this kind is thus not only an aesthetic of doubt but an aesthetic of reflection. Michelson calls this aesthetic structure phenomenological, although unlike phenomenology in its strictest sense, modernist aesthetic reflection does not achieve its reflexive awareness of perception by suspending or bracketing perception.[15] Rather, *2001* and other modernist cinema immerses us in our senses. It does so, however, to perform an exemplary phenomenological move: it "develops from the concern with 'things seen to that of seeing itself'" (61). Being modernist, it cannot give up reflection or alienation. For Michelson *2001* immerses us in our senses only to alienate us from them, offering a doubling of our consciousness that leads to phenomenological reflection, an intellectual elucidation demanding—in Michelson's words, "critical athleticism" (69).

By contrast, I contend that to the extent *2001* and *Gravity* and other films engage in proprioceptive aesthetics, they are precisely *not* modernist. Proprioceptive aesthetics takes as its central object of aesthetic elaboration its viewers' reflexive processes of perception—that is, their self-perception—but it does so in a way that neither requires nor particularly benefits from modernism's intellectual elucidation or critical athleticism. When I encounter *Gravity* or *2001* or other especially proprioceptive films, the forms of reflexivity that arise are not intellectual. They are sensational, visceral, perceptual, affective. Which is once again to say, when I feel myself moving through onscreen space, I feel *myself* doing so: I register it in my body. Feeling myself moving through onscreen space, I feel none of the doubt that is modernism's

animating aesthetic principle. In fact, I find that I cannot muster this doubt, that my powers of intellection falter in the overwhelming presence of this world unfolding before me and my insuperable movement through it. I can only submit: however much I may tell myself while I watch *Gravity* that I am not *really* moving through a debris field in orbit, I cannot dispel my perceptual disorientation and reorientation, my profound proprioceptive unraveling. But then, I don't need to tell myself that. *Gravity*'s proprioceptive effects may be intense and indubitable, but they do *not* resemble the feelings I might have if I were really flying through space. The intensity of such proprioceptive effects instead lies in an exacerbated *divergence* between cinematic and ordinary perception.

This may seem innocuous enough a disagreement, a matter of aesthetic description: the sort of reflexivity that *2001* and *Gravity* engage isn't intellectual but directly perceptual, proprioceptive. Nevertheless, the stakes of this disagreement run deep and organize much of the theoretical project of *Cinema's Bodily Illusions*. My disagreement comes not at a critical but rather at a more properly philosophical or theoretical level. Michelson casts modernist doubt as central to *2001*'s "phenomenological esthetic" and in so doing reflects what we might shorthand a bit bluntly as the late midcentury *Artforum* and *October* consensus. She inherits the intellectual legacy of Clement Greenberg, which we might abbreviate schematically by referring to thinkers such as Michael Fried and Rosalind Krauss, and to which Stanley Cavell gave philosophical voice.[16] This legacy also organizes much recent film-theoretical discourse on medium specificity in the wake of what, in a false monolith, scholars often refer to as "digital cinema."[17] This modernism not only relies on the "elevation of doubt to an esthetic principle" but is, as Cavell shows in precise terms (as I elaborate in chapter 1), the aesthetic conjugation of philosophical skepticism.

Proprioceptive aesthetics, as I understand it and as I argue in the opening chapters of this book, forms a crucial antiskeptical alternative to modernist aesthetics. The importance of proprioceptive aesthetics lies in its very different form of reflexivity. If you are oriented by skepticism, the reflexivity of the intellect, of criticism, and of philosophy will seem decisive not only to aesthetic experience but to things like the ontology of cinema and the phenomenology of perception. Effectively, both modernist aesthetic experience and skeptical philosophical positions follow from a determination that perception is somehow inadequate, that it misses its object, that it misses the world as it is, that it misses *something*. For the skeptic perception is wanting because it is finite and perspectival. More pointedly, the skeptic's mistrust of perception

is not only abstract or philosophical but arises concretely because perception sometimes gives rise to *illusion.*

My contention is perceptual illusions are not occasions for skepticism. Instead, illusions are particularly important encounters in which the processes of proprioception come to be the objects of pleasurable sensation and aesthetic intensity, rather than operating as they usually do below my conscious attention or intentional awareness. This is why the illusion of bodily movement through onscreen space in *2001* and *Gravity* is so important for me. It not only makes proprioception palpable—in phenomenological jargon, it makes proprioception *thematic,* or it thematizes proprioception—but does so as an illusory sensation, either voluptuously pleasurable or palpably anxious, of moving through a world unfolding before me onscreen. It heightens, roughens, draws out the reflexivity that suffuses perceptual life as perceptual intensity. And yet in this heightened proprioceptive reflexivity, I need neither my intellectual nor my critical faculties to tell me I am not *really* flying through outer space: the illusion of bodily movement is palpable not only as movement but also as *illusion.* Illusions of this kind index not the insufficiency of perception but rather its exorbitance. Rather than leading to skepticism, I argue such illusion leads to something like its opposite: to an encounter with what Merleau-Ponty calls "perceptual faith." This faith is the ground of our continual inherence in the world and our orientation toward and in it. As Merleau-Ponty puts it, this is the faith, simply, that when I open my eyes "the world is what I see."[18]

Perceptual illusion of this kind in the cinema—a durational feeling of vision fooled, modulated by technics and attended by voluptuous and uneasy affects—operates in a register that comes before representation. It is phenomenologically prior to representation and aesthetically distinct from it. To take another example from *2001,* the film's famous Stargate sequence offers a sustained illusion of traveling through an abstract space specified by nothing more than colored streaks radiating outward from a vanishing point at the center of the screen. As these colored lights streak past, I feel myself hurtling through onscreen space into a depth that forms on the screen, accompanied by an astonishing proprioceptive intensification. This space is neither represented nor representational but forms in the coupling of my body with the technics of the cinema. Scott Bukatman suggests we might more correctly describe it as *presentational* not representational, addressed as it is directly at the body of the viewer.[19] This space is furthermore not representational in the plain sense that there is no profilmic object nor scene nor world that has been recorded and projected, nor even animated or rendered. Instead, in the

mode of proprioceptive illusion, this space and my palpably illusory movement through it arise not because of a correspondence to a profilmic object nor the movement of the camera through the world but only as a result of the coupling of my perceiving and indeed proprioceptive body with the cinema as a technical system.

Illusion can thus take on a positive meaning not often found in film theory. Illusion as I mean it here is neither "not real" nor "not *really* there." Because of this, illusion needs neither critical nor intellectual work to unmask it. Rather, illusion in this sense is a divergence or distance, registered within perception as palpable sensation, between cinematic and ordinary perception. An illusion indexes that *this* perception is counterfactual and thus arises as a reflexive turn in perception: in proprioception. Cinematic illusions such as movement through onscreen space—whether in the Stargate's minimalistic rendering of space or *Gravity*'s maximal one—bring with them a continual intensification and thematization of the perceiving body, literally present in a cinema and undergoing its ongoing work. Because of this, illusion is one of the primary terms—both as aesthetic effect and as aesthetic problem—of the cinema's proprioceptive aesthetics.

On Ecological Phenomenology and the Technicity of the Cinema

Because this illusory space is itself nonrepresentational and proprioceptive aesthetics plays out below (or at least to the side of) representation, a method adequate to describe and theorize proprioceptive aesthetics must dispatch with representation as an organizing term. As representation has been one of film theory's central, nearly indispensable, conceptual and aesthetic categories, this is a more difficult and more thoroughgoing departure than it may at first seem.

To put it programmatically, *Cinema's Bodily Illusions* is a sustained attempt to articulate a resolutely nonrepresentational theory of the cinema, to develop the conceptual tools adequate to that theory, and to make an argument that such a theory is both necessary and salutary. And, proprioceptive aesthetics is the aesthetic field of the cinema once representation—as well as skepticism and modernism—ceases to be the star that orients our journey.

As I have hinted, Gibson and Merleau-Ponty will serve as our guides as we strike out. Taken together, Gibson's ecological approach and Merleau-Ponty's phenomenological philosophy of perception form my major method: *ecological phenomenology*. Ecological phenomenology operates at the surprisingly large overlap between Merleau-Ponty's philosophical, existential, and

phenomenological approach and Gibson's scientific, psychophysical, and ecological perspective. Despite their largely independent development—in different disciplines, on different continents, in independent milieux—in a kind of convergent evolution, they share decisive high-level traits: a conceptual style and descriptive method oriented toward a holistic understanding of perception as it operates at a phenomenal level; a thoroughgoing and sustained critique of the dualistic and skeptical foundations of "traditional" theories of perception, to wit, empiricist, behaviorist, and cognitivist models; and a sustained emphasis on the spatial, reflexive, and indeed proprioceptive aspects of perceptual life, in which a subject (Merleau-Ponty) or organism (Gibson) takes up its position in a world toward which it is insuperably bound. At base they share a foundational characterization of perception as a durational, relational term between a perceiver and the world.

In particular, this shared ecological–phenomenological doctrine of perception allows me to elaborate my basic description of the cinema as a technology for the modulation of perception. In the ecological–phenomenological terms I develop at length in *Cinema's Bodily Illusions,* the cinematic encounter, like perception itself, is both durational and relational, comprising overlapping and complementary acts of perceptual modulation on the part of the cinema and perceptual attunement on the part of viewers. Drawing these acts together, the name for this encounter taken as a whole is *perceptual resonance.* Beyond a certain phenomenological inflection—especially in the term *attunement,* redolent as it is of Heidegger's *Stimmung*[20]—the ecological meaning of these three terms is literal rather than metaphorical: perception is a literal resonance; the cinema is literally modulating this resonance; and viewers literally attune themselves to the impetus of this modulation.

Methodologically speaking, then, ecological phenomenology differs substantially from much recent phenomenological work in film theory and cinema studies. To be sure, there are significant areas of overlap—especially in the emphasis on embodiment and affect, the impulse to precise and sustained description, and a shared set of intellectual resources in the phenomenological tradition of philosophy. However, the major approach to phenomenological theories of the cinema, following the work of Vivian Sobchack, has been to argue that the cinematic encounter is literally intersubjective: the film is an embodied subject in its own right, by virtue of its capacity to "perceive" (that is, to record images of the world) and "express" (that is, to represent those images onscreen).[21] Perceptive and expressive, the cinema's capacity to represent in the way that it does gives it a literal body, if a body that is not recognizably human. In particular, Sobchack places camera movement at the

center of her analysis, arguing it exposes an intentionality substantially different from my own, the manifestation of a subject that is not-me.[22]

As Jordan Schonig has recently argued, such phenomenological theories of cinema stress camera movement precisely because it seems to exacerbate the correspondence between ordinary spatial perception and the cinematic image.[23] According to this logic, the phenomenological claim that the cinema gives us a world onscreen is underwritten, at an embodied level, by this correspondence between perception and image. We find a particularly strong articulation of such correspondence in Sobchack's claim, elaborated by Jennifer Barker, not only that the film has and lives a body but that we move and breathe and feel with films.[24] This claim has a weak form, too, which is weak not because it is wrong but because it is less strictly phenomenological, and also because it is less explicitly theorized. This weak form focuses on the embodied effect of film images in the cinema. In Sobchack's later work, as well as in the work of thinkers like Laura U. Marks, Elena del Rio, and others, the impact of cinematic images stems from a correspondence between cinematic representation and embodied perception so strong it can give rise to a confusion between bodies in the audience and bodies onscreen.[25] By the same token, in this complex of theories, this correspondence is almost always underwritten by an assumption that the cinematic image is photographic and that it represents objects and people and scenes in the world—that the cinema is fundamentally representational.

Gibson offers one model for departing from this assumption: the cinema is not a medium for representation but rather a technology that literally modulates our perceptual resonance. By virtue of such modulation, cinematic perception does not correspond to ordinary perception but rather is marked by its decisive difference from it. But we can find another guide to such a departure in the form of French phenomenologist Renaud Barbaras and his "return to Husserl," under the influence of Merleau-Ponty's own late work on Husserl.[26] Barbaras argues for a phenomenology that relies neither on representation nor even lived experience but instead investigates *appearance*. Barbaras's sustained target of critique is Husserl's doctrine of intentionality, which can be found in the *of* that connects consciousness and the world in his slogan "All consciousness is consciousness *of* something." *Intentionality* is Husserl's term for the connection between an object and a subject's consciousness or perception of that object. In Barbaras's phenomenology of perception, by contrast, it is that very intentionality that must be suspended. Barbaras shows us how to attend not to the intentional object (of perception, of consciousness) but instead to the partial, provisional, and porous manner in which it

appears. Barbaras's critique of intentionally has far-reaching consequences for a phenomenology of the cinema in the wake of Sobchack's pathbreaking work, organized as it has been not only by a presumption of representation and a concomitant correspondence between image and object but by an account of cinematic intentionality. Following Barbaras, my approach to a phenomenology of the cinema seeks to suspend the representational vocation of the cinema, instead attempting to *explain* how this representational vocation, and even the sense of world unfolding before us onscreen, might come about.

In the ecological-phenomenological account I present, the cinema is able to manifest a sense of a world unfolding before me onscreen in which objects might appear only by virtue of its proprioceptive modulation of viewers. In *2001* and *Gravity,* I have a sense of space that opens before me and through which I move only as a result of the films' perceptual and proprioceptive modulation, in the coupling of my body with the cinema screen. To be sure, these films, in their exacerbation of spatial orientation, are of necessity attuned to our perception so that we may attune ourselves to them and so that they may take our perception as an object of aesthetic elaboration. But they do not *correspond* to it. In fact, these films attain their appeal and their sensational impact through a specific *noncorrespondence* of the cinematic image and ordinary perception, a noncorrespondence of the world unfolding before me onscreen and the ordinary world, a heightening of the divergence between cinematic and ordinary. They attain their appeal in *illusion.*

These films also, finally, attain their appeal not by means of a represented, intentional object of the cinema that appears onscreen, as it would be for Sobchack and Barker. If the cinema has an intentional object, it is not to be found onscreen but in the auditorium: my body in the cinema. My body and its proprioceptive capacities are the objects of aesthetic elaboration. My interest in *Cinema's Bodily Illusions* lies not in a film's capacity for its own form of embodiment but rather in the cinema's existence as a technical system that takes up viewers' perceptual resonance as its aesthetic material. To disclose and to describe the proprioceptive work of the cinema and its aesthetic elaboration in these films, I work to suspend the cinema's representational vocation. This means turning away from any object onscreen and turning instead toward the twinned problems of the cinema image as its appears and its manifestation of a world unfolding before me onscreen. Or in what amounts to the same thing, it means understanding the cinema image in a technical and a formal sense in its ongoing modulation of its viewers' perception and proprioception. Proprioceptive aesthetics operates, then, as a manifold in which three terms are constantly referred to each other: body, world, technics. It is

an aesthetics of the body in its materiality and intensities, an aesthetics of worlding in its indeterminacy and incompletion, and an aesthetics of technics in which the cinema's operation as a technical system is made palpable. *Cinema's Bodily Illusions* argues for an approach to the cinema as a technical system, but it does not argue for a return to a theory of the cinema as determining its spectator or constructing its viewing subjects. My encounter with the cinema is indeed an encounter with a technical system—and in proprioceptive aesthetics, the technical dimension of this encounter is emphasized. It does not follow, however, that the cinema is an *apparatus* (or, as it has been more recently known, a *dispositif*). Borrowing from media theory, I use the term *technics* in the sense Bernard Stiegler gives it, "the pursuit of life by means other than life."[27] For Stiegler, in a figure redolent of Marshall McLuhan's midcentury media theory, technics is a literal exteriorization or extension of living activity. Technics is not a domain over against life but rather life's manifestation in "organized inorganic beings."[28] The cinema's proprioceptive aesthetics intervenes in my very perceptual self-relation, and it does so technically.

Drawing on Stiegler as well as Mark Hansen's recent phenomenological media theory, I show that proprioceptive aesthetics does more than exacerbate my perceptual resonance with the world—it also thematizes and aestheticizes my constitutive susceptibility to technics. Indeed, it shows that my perceptual life, including my proprioceptive self-relation, is subtended by technics, by what Hansen calls an "essential technicity."[29] Technics are the infrastructure for my ability to get on the world: perceptually, aesthetically, affectively (even metabolically).[30] I am neither self-possessed nor self-sufficient. I am open to the world not only perceptually but also technically. Aspects of my existence as fundamental as my perceptual resonance with the world and my proprioceptive sense of self are susceptible to and always depend on technical manipulation. During the heyday of 1970s theory, the cinema's vocation of technical modulation and, indeed, manipulation of its viewers was cause for a great deal of anxiety and counterdiscourse.[31]

The reason for this anxiety was, of course, that the cinema's powerful technology was—and still very much is—set to work in the service of politically regressive ideologies, reproducing as it does capitalist, misogynistic, homophobic, racist, ableist, and other toxic structures of power and exploitation. Coupled with the cinema's capacities to affect its viewers, to organize their perceptions, and even to modulate their very subjectivity, such ideological work is worrying, indeed. But it is not the only work the cinema does, and it is not the only way in which the cinema is political. For a long time, we have

inherited a political modernist scheme that parses the cinema's political and ideological force in terms of its representational practices. The phenomenological remit of this book is to bracket its representational dimension—and thus also to suspend most of our ways of attending to the social, political, cultural, and ideological work of the cinema. This means foregoing politics—but only for a time. Following Walter Benjamin, we will eventually specify the infrastructural, rather than ideological, sense in which the cinema can be political.

At the same time and for reasons I elaborate in the first chapter, I do not share the modernist idea that we need more reflexivity, more alienation, more anxiety about technology's capacity to influence its viewers. From the position I take, the cinema's capacity to modulate our perception need not be a cause for anxiety, in part because to the extent it engages our proprioception, some degree of reflexivity is endemic to the cinematic encounter. I wish instead to affirm our constitutive incompleteness and the fundamental technicity of our presentness to the world and our presentness to ourselves. By giving us a world onscreen, by insisting on its divergence from the ordinary world, and by doing so only by means of technics, the cinema can teach us, at least for a time, to be at home in such technicity.

On Chapters and Illusions

Cinema's Bodily Illusions includes six chapters, most of which are organized around an extended phenomenological description of individual films, focused on the *illusions* these films give rise to in their viewers. I have selected my cases with an eye toward how these films embody the aesthetic, theoretical, and phenomenological problems that attend the cinematic modulation of proprioception. My central case in the book is the illusion of bodily movement through onscreen space, or cinematic kinesthesis. We have seen this already in *Gravity* and *2001,* and it is perhaps the most important aesthetic effect in *Koyaanisqatsi.* It is my central case not only because it is perhaps the most obviously proprioceptive effect in the cinema but also because it is certainly the most common: so many recent Hollywood films open with a flyover shot over some landscape it is not worth accumulating examples (but if you really want one: *Avatar*). I close the book with *The Flicker's* hallucinatory stroboscopic phenomena, in which the cinema's proprioceptive effects move off the screen, disordering my very inherence in the world.

I open the book, however, with a discussion of Duchamp's only surviving film, *Anémic Cinéma,* and its stereokinetic effect, in which the rotation of a two-

dimensional figure induces an illusion of depth. Presenting a series of discs that anticipate Duchamp's later *Rotoreliefs,* the film thematizes the illusoriness and weirdness of a depth that somehow forms on a surface—the depth, that is, of the screen. More to the point, *Anémic Cinéma* creates this illusory depth in the coupling between the cinema and its viewers' bodies: it configures the cinema as an optical device, or a machine for the modulation of its viewers' perception. In place of representation, it engenders voluptuous illusion. And yet as Rosalind Krauss argues, *Anémic Cinéma* is an emphatically modernist object, but to do so she reads it not as a film but as a painting. Departing from Krauss and using Rey Chow, Sianne Ngai, and Stanley Cavell as my guides to modernist aesthetics, I argue, even in the historical heart of modernist aesthetics, that *Anémic Cinéma* opens up a position from which skepticism is not so much wrongheaded as somehow extravagant. In this first chapter, "The Unfinished Business of Modernism," I show how *Anémic Cinéma* becomes a schematic diagram for an alternative to modernism, for proprioceptive aesthetics.

The second chapter, "Beyond the Infinite, at Home in Finitude," turns to the question of illusion in a sustained way. In this chapter I attend closely to the illusion of bodily movement on offer in Kubrick's *2001.* I argue it demands a response different from the skepticism that usually attends discussions of illusion—not only in film theory. This chapter introduces my antirepresentational phenomenology of the cinema in an extended discussion of not only Barbaras but also Jean-Louis Baudry's apparatus theory and his engagement with Husserl. I argue that a properly antiskeptical phenomenology of the cinema must, as its method (in its *epochē*), suspend the representational character of the cinematic image. It must cease to appeal to lived experience, turning instead to a phenomenology of *appearance.* Not only does this phenomenology embrace the indeterminacy of our perception, the partiality of our openness to the world, and the inexhaustibility of the world, it also embraces our finitude, and along with a sense of technics borrowed from the media-theoretical work of Bernard Stiegler and Mark Hansen, it embraces the fundamental technicity of this finitude.

The third chapter, "Ecological Phenomenology," is explicitly methodological. In it I introduce Gibson's ecological approach to perception and develop it in relation to the cinematic illusion of bodily movement and the cinema more generally. I go on to describe the cinema's perceptual work in ecological terms, developing one of my most important terms at length, *perceptual resonance.* Finally, I show how Gibson's doctrine of perceptual resonance is profoundly complemented by Merleau-Ponty's investigation of perceptual faith.

The fourth chapter, "Proprioception, the *Écart*," turns to the experimental documentary *Koyaanisqatsi* to describe how the cinema modulates not only its viewers' perceptual resonance with the world but also their proprioceptive self-perception. In this chapter I continue the project of bringing Gibson and Merleau-Ponty together, showing how Gibson's theories of proprioception intersect with Merleau-Ponty's late doctrine of the *écart*, or my paradoxical separation from but continuity with the world. Exacerbating both my involvement in the world onscreen and my embodied presence in a cinema, proprioceptive cinema heightens the *écart*'s paradox.

The fifth chapter, "The Body, Unbounded," offers a summary and schematic presentation of proprioceptive aesthetics, emphasizing in particular how such aesthetics addresses its viewers. Taking *Gravity* as my exemplar and developing proprioceptive aesthetics in terms of its fundamental aesthetic problems, I argue, in the locution *proprioceptive aesthetics,* the term *proprioceptive* is not merely some qualification of a previously understood aesthetics, a modular adjective specifying a region of aesthetics. Rather, proprioceptive aesthetics entails the sense of aesthetics in which it names how we resonate with the world and attune ourselves to it.

The final chapter, "Aesthetics beyond the Phenomenal," takes up Conrad's *The Flicker* as a kind of twin to *Anémic Cinéma,* showing how the cinema's proprioceptive aesthetics continues to operate in contexts where there is no world and, even, no image onscreen. *The Flicker* transforms the conditions of my inherence in *the* world. It shows the fundamental technicity of such inherence, how our presence in and presentness to the world are at once technically enabled and also technically transformed. In *The Flicker* aesthetics is not the experience or property of a spectator but rather distributed across both the organic body of the viewer and the inorganic technics of the cinema. It belongs to the coupling between them. Finally, building on this chapter and on the work of the book as a whole, I conclude with "The Technicity of the Cinema," showing how we can finally dispense with the film-theoretical concept of the cinematic apparatus and replace it with the media-theoretical understanding of the *cinema as technics.*

I have selected the films in *Cinema's Bodily Illusions* with an eye toward the centrality, intensity, and exemplarity of the illusions they engender. Even so, my selection of films may seem idiosyncratic. They come from two categories: experimental(ish) film and science fiction(ish) film. (*Koyaanisqatsi* is only experimentalish, and *Gravity* is only science fictionish.) Experimental film has been, well, more experimental concerning cinema's possibilities

for perceptual modulation and more willing to eschew representation than mainstream varieties of cinema have been. Meanwhile, my predilection for sci-fi is not the only reason behind my reliance on it in *Cinema's Bodily Illusions*. Sci-fi has often used its futuristic and fantasy elements as cover for a more experimental film practice than is typically allowed in mainstream films. Furthermore, sci-fi of all kinds engages in earnest in world building; in cinematic terms this often means manifesting a fabulously counterfactual world onscreen and eliciting its viewers' faith in it. These two aspects have, I take it, led to a particularly strong affinity for proprioceptive aesthetics among sci-fi films, which at least excuses this generic overrepresentation in this book. And yet part of my claim is that the cinema's perceptual vocation and its proprioceptive aesthetics have a long history. Proprioceptive aesthetics may be particularly salient in the contemporary blockbuster, but it has been with cinema since its inception.

On the Contemporaneity of the Cinema

But then, why the cinema, and why now?

It may seem quaint to write a book about *the cinema* long past the era of moviegoing and the dominance of feature film. Gabriele Pedullà has written a history of "spectators after the cinema," as though the cinema were over and done with.[32] The cinema just isn't as important as it used to be, a casualty of television and home video and cable long before digital technologies delivered their blows. When we do watch films, it is on screens—many screens—that are not cinema screens. It might be enough to point out that in much the same way Hollywood turned to widescreen formats and 3D technologies in the 1950s to rescue cinema-going (read: their economic model) from the threat of television, recent cinematic aesthetics have emphasized the proprioceptive aspects that really work only in cinemas.[33] Since at least 2002, with *Spider-Man* (Sam Raimi) and *The Bourne Identity* (Doug Liman), big-budget action films have brought proprioception spectacularly into their logic of heightened attractions. Proprioceptive aesthetics, from this perspective, may seem merely an especially *cinematic* yet largely neglected species of the cinema of attractions.[34] Clearly, it is that. But it is not only that. The cinema's proprioceptive work is not only attractional. *Any* instance in which the cinema manifests a world onscreen to which I attune myself (and some moments when it does not) and to which I bear faith is proprioceptive.

The cinema, in other words, stages the problem of my presence to the world

and its fundamental technicity. Arguing that "the 'digital' in digital cinema is not the 'digital' in digital technics," Mark Hansen has recently written:

> What we call "cinema" encompasses all time-based media that operate within the temporal thresholds of human perception, including deployments of digital technology to transpose analogue media like film into installation environments. And what we call "digital," on the other hand, specifically designates media that operate outside of any synchronization with human time-consciousness and at a scale finer than that of image perception.[35]

For Hansen, here as elsewhere, cinema is a model, perhaps even the fundamental model, for the correlation of human perception to technical operation, especially on the correlational model of the cinematic image. Film's body is one emblem of this correlation; in Sobchack's and Barker's accounts, film's technical body perceives and expresses at a scale commensurate to my fleshly one. Digital technics, however, happen too small and too fast. Important for Hansen, the newly inhuman time scales of digital technologies do not lead to a decoupling of the body and technics but rather only sunder the perceptual and cognitive correlation between them.[36]

I largely agree with Hansen here, although I want to put some pressure on what it means for the cinema to act as a site for the correlation of technics to the human body's perceptual capacities. Cinema has more to teach media theory as perceptual technics than as a medium for recording or representation.[37] As James J. Hodge has shown, in response to this situation, media studies has often turned to technicist explications of the operation of digital technologies, in a sort of quasi-Enlightenment discourse.[38] Hodge furthermore argues that this overlooks what Stiegler calls "the deep opacity of contemporary technics," which no amount of information about the operation of such technology will serve to remediate.[39] By the same token, I am suggesting that understanding the technical operation of digital media beyond the thresholds of perception might not be the only, or the best, way to come to grips with our presence to our contemporary world and its fundamental technicity. In the cinema we encounter the technicity of our presence to the world and of its presence to us. More to the point, I take my account of the cinema's proprioceptive aesthetics to be a theory of the cinema for the "digital" era, *precisely at the moment in which the correlation between bodies and technics comes into question—even into crisis.* In a moment characterized by a crisis in our perceptual grasp on the world precipitated by the withdrawal of technology from our phenomenal field, the cinema has redoubled its dedication to an

aesthetics that invests, modulates, elaborates, and even fabulates our modes of resonating with the world.

If the cinema still matters—and I believe it does—it does not still matter only by virtue of the continued production of films adhering to an aesthetic norm of feature-length fictional movies, now likely shot on digital video and in any event viewable on whatever screen you choose—even if what we see in cinemas mostly continues to take that form. Nor does the cinema still matter only in virtue of, once upon a time, having been the dominant mass medium of the twentieth century—even if such a legacy continues to condition the aesthetic projects of what we see on cinema screens as well as our intellectual resources for addressing and acknowledging moving images. Rather, it matters because of its fundamental proprioceptive vocation, because of its proprioceptive aesthetics. In a moment marked by the rapid proliferation of screens and the profound transformation of what those screens can do, the cinema matters now as an architecture and a particular kind of screen. In the cinema as nowhere else, we bear faith to a world that unfolds before us onscreen. In the cinema, as nowhere else, we encounter in an aesthetic mode our fundamental and unaccountable resonance with ourselves and with the world.

What I am offering with proprioceptive aesthetics and ecological phenomenology is a way of describing—and thus understanding, conceptualizing, and even experiencing and inhabiting—the cinema in which its technology no longer feels threatening, in which our perceptual modulation by the cinema does not give on to skeptical doubt and in which we learn, at least partly and for a time, to be at home in the indeterminacy and finiteness and porousness of our perception. But this porousness is not merely a problem for the cinema. It is a condition of our presence in the world; it is a condition of the world. And so the cinema's manifestation of a world onscreen is in fact a restaging of the problems of our very presence in and to the world—its opacity, its inevitability, its fragility, its richness and stupidity and partiality, and its inevitable technicity.

1 THE UNFINISHED BUSINESS OF MODERNISM

Anémic Cinéma

In July 1921 three visitors to Marcel Duchamp's studio reported being quite taken with a bicycle wheel—not Duchamp's famous *Bicycle Wheel* Ready-made of eight years previous but, rather, one in the service of the cinema. Duchamp used the wheel to fix "his drawings of spirals in order to film them in rotation."[1] As early as 1920 and with the help of Man Ray, Duchamp was working on attempts "to make a three-dimensional movie employing two cameras to produce what Man Ray has described as 'a double, stereoscopic film of a globe with a spiral painted on it.'" Sadly, however, much of this work was lost. "Due to a mishap in the developing process only two short strips of the film were saved, which when viewed through an old stereoscope produced the desired illusionistic effect of relief."[2] In fact, their experiments were later met with some greater degree of success using an anaglyphic process (similar to that used in the 1950s with those nostalgic blue/red 3D glasses). Duchamp managed to successfully film "a specially prepared revolving sphere, so that when it was projected and looked at through glasses of one red lens and one green lens, an adequate effect of a spiral going into depth could be seen."[3] This film was apparently lost, though, sometime in the 1930s.

The only film that survives from Duchamp's largely experimental cinema practice is his 1926 *Anémic Cinéma*. It is, not at all surprisingly, a small, very peculiar, and frankly delightful film. Over the course of its six minutes, it alternates between two sorts of rotating discs. One set has word games in French written on the discs in spirals (Figures 5 and 6). The games—mostly puns, more or less nonsensical, sometimes playfully obscene—unfold into phrases as the discs rotate. This set has received the bulk of critical and scholarly attention to the film.[4] The other set, which starts off the film's alternation, anticipates Duchamp's later *Rotoreliefs* (1935). These discs have eccentric circles and spirals painted on them, which when rotated induce an illusion known

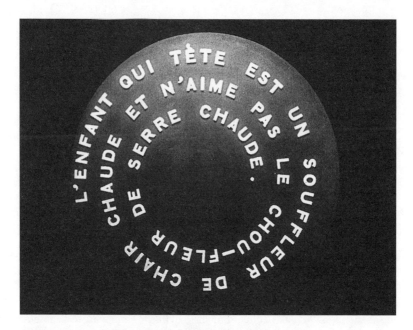

Figure 5. A word spiral from Marcel Duchamp's *Anémic Cinéma*, 1926.

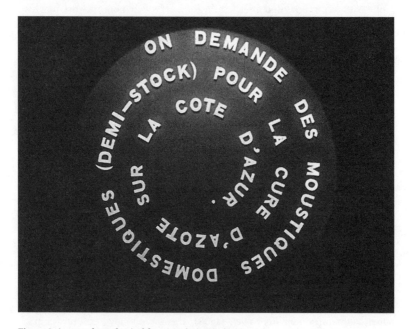

Figure 6. A second word spiral from *Anémic Cinéma*.

to perceptual psychologists as the stereokinetic effect, in which the rotation of a two-dimensional figure produces an illusion of depth (Figures 7, 8, and 9).[5]

The effects of these circles are equivocal. While I quickly and easily grasp what I am seeing onscreen—a pattern on a rotating disc—even that "true" visual sensation is unstable, slippery. At first I see a slithering motion that, while operating in the register of ordinary vision, still feels wrong somehow, almost ticklish. Then, under further attention, this ticklish vision gives way to a voluptuously illusory perception of depth—relief, arising from rotation. In different discs this depth appears differently. In some a cone or another circular shape projects out from or recedes into the surface of the discs (i.e., the screen). In others I have the vertiginous sensation of traveling into a tunnel or descending into a hole. These discs not only produce the illusion of depth but also induce the illusion of moving through that depth. Throughout, this depth and my movement through it are both unmistakably illusory and unmistakably present. The illusion of depth and of my movement through it never quite become real, never assume the solidity of what perceptual psychology calls *veridical* perception. Or more precisely, I never feel at risk of confusing such illusion with reality—it remains solidly illusory. Illusion abides, even if only incipiently, as a ticklish, slithering, slippery feeling. Stranger still, I find that

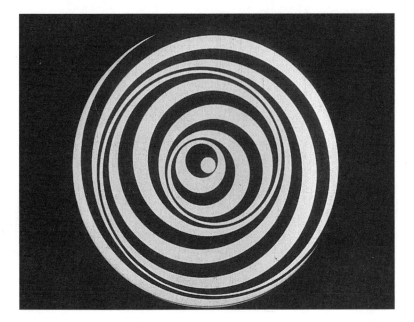

Figure 7. A stereokinetic disc from *Anémic Cinéma.*

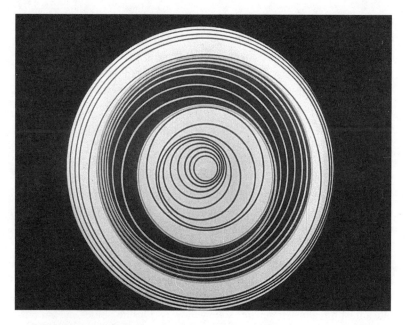

Figure 8. A second of *Anémic Cinéma*'s stereokinetic discs.

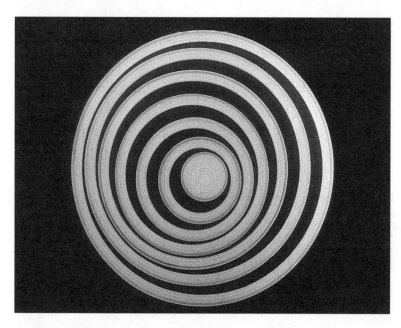

Figure 9. A third stereokinetic disc from *Anémic Cinéma*.

while engrossed in these rotating figures I can, with shifts of my attention and nothing more, snap consciously between creepy-crawly spirals and a wobbling cone. These discs deal in the pleasurable sensation of vision fooled.

The two sorts of discs both engender and require the viewer's attunement to the image onscreen. If, strictly speaking, I can read ahead along the word spirals, I nevertheless find it easier to submit, to read at the pace the discs dictate as they rotate. Likewise, the stereokinetic illusion of depth becomes fully manifest only if I assume a relaxed, receptive posture, not unlike how I might unfocus my eyes to make out the illusion of depth in Magic Eye dot stereograms. Both halves of the film bring out the materiality of the cinematic encounter, in multiple registers. The puns play on the sonic material of language beyond or below meaning, and the illusions make palpable the fallible materiality of the viewer's embodied perception. In both cases this materiality is not the materiality of film but rather that of the coupling between my perceiving body and the cinema's perceptual technics. My main interest in this chapter lies in the stereokinetic discs, their pleasurable and palpable illusion, and the materiality of the perceiving body they make manifest.

Anémic Cinéma is delightful, small, even *cute*. It goes down easy despite the way it frustrates some very fundamental expectations we might have about the cinema. It belongs to a class of films that violates, as an outlier, much of what we often take to be the defining characteristics of films. In Noël Carroll's words, *Anémic Cinéma* and its cousins "*present* visual stimulation to audiences with the intention of eliciting certain perceptual states—like afterimages—from spectators."[6] Like Carroll's example of flicker films—and we will turn to *The Flicker* in due course—*Anémic Cinéma* withholds or rejects the characteristics of the typical or normative case of cinema: it is neither pictorial nor representational.[7] Rosalind Krauss can even doubt (if only rhetorically) that *Anémic Cinéma* counts as cinema: "If *Anémic Cinéma* is a film, the target it seems to have in mind is nonetheless painting."[8] *If* it is a film? I will return to Krauss's treatment of the film (or whatever it is), as well as her concern with painting. For now I just want to draw out the friction between, on the one hand, how *Anémic Cinéma* is or can be challenging to our ways of speaking and being articulate about the cinema and, on the other, just how easy it is to encounter as a viewer.

Because, really, *Anémic Cinéma* is a kind of cinematic trifle. It is not much discussed, despite Duchamp's stature. How has his only extant film provoked so little criticism or theory? Let me restate this perplexity more philosophically. On the one hand, the film seems to pose questions of what we have come to know as *cinematic ontology* by withholding representation and figuration

and replacing them with direct perceptual illusion and the modulation of its viewers' bodies. Presented with *Anémic Cinéma*, I no longer know quite how to say what the cinema *is*. And yet, on the other hand, the very ease of the film suggests I find something familiar (or familiar enough) in *Anémic Cinéma*. I watch it delighted, laughing. If I find myself asking questions, they won't be about the cinema or its ontology. Rather, I might wonder, How did Duchamp do *that*?[9] Or if not Duchamp, How on earth could *a rotating disc* do that to me?

In the terms I develop in this chapter, terms borrowed from Rey Chow, Sianne Ngai, and especially Stanley Cavell, *Anémic Cinéma* avoids what Cavell calls the predicament of modernism and the concomitant problem of ontology. But this avoidance isn't itself why *Anémic Cinéma* is significant. Duchamp's film serves, in a direct way, as a schematic diagram for the cinema's proprioceptive aesthetics: its aesthetic force comes from the direct perceptual and proprioceptive modulation of its viewers; it thematizes its viewers' acts of perceptual attunement; it gives rise to voluptuous illusion; it does so in duration; it does not offer anything that might be construed as representation; it does not give rise to an urge to communicate our experience of it; and it invests in the relation between viewer and film, modeling it as a coupling between a body and a technical device. And most important for this chapter, it offers a form of perceptual reflexivity, a palpable awareness of perceptual activity—proprioception—that is neither intellectual nor critical. *Anémic Cinéma*'s proprioceptive reflexivity allows its avoidance of the modernist predicament, and this avoidance holds important lessons for how we can speak about proprioceptive aesthetics.

As I argue, some of our most common and most important ways of theorizing about the cinema remain oriented by modernism, invested in a concept of medium specificity, and oriented by canons of aesthetic significance organized by philosophical skepticism. The goal of this chapter is, then, at once to elaborate *Anémic Cinéma* as an initial diagram for proprioceptive aesthetics and to argue that such aesthetics requires, at a critical and theoretical level, a departure from modernist discourses about the cinema and the skepticism that animates them. This formulation may seem a bit broad, so let me return to *Anémic Cinéma*'s smaller scale. *Anémic Cinéma* offers a mode of reflexivity, of aesthetic self-relation, that is unspeaking, inarticulate, voluptuous, delightful. It does not give rise to a compulsion to speak about, to share, our aesthetic experience. Rather, it calls out for laughter, delight, wonder. And it does not demand—indeed, it frustrates—the philosophical and critical sophistication that is the hallmark of modernist aesthetic significance and the discourses of cinematic ontology. Turning through *Anémic Cinéma*

and its departure several times and addressing it in different registers, this chapter offers an initial, differential description of proprioceptive reflexivity and its insignificant aesthetics.

Anémic Cinéma and the Precision Optics

To elaborate this proprioceptive reflexivity, a consideration of its historical context is instructive. *Anémic Cinéma* is the only surviving piece of Duchamp's cinema practice, but it is also part of a larger set of works known as the Precision Optics, Duchamp's series of optical experiments and machines throughout the 1920s and 1930s.[10] Both Duchamp's cinema practice and his Precision Optics machines use the rotation of prepared surfaces to produce a variety of optical illusions (most often, the stereokinetic effect found in *Anémic Cinéma*). The Precision Optics catalog typically includes four major pieces: *Rotary Glass Plates* (1920), *Rotary Demisphere* (1924), *Anémic Cinéma*, and the *Rotoreliefs*. The formal similarity of rotating surfaces with circular figures on them is not the only aspect that draws these devices together. They all solicit, address, capture, even seduce their viewers' bodies, engendering voluptuous illusion. In so doing, they thematize overlapping processes of the devices' perceptual modulation and their viewers' perceptual attunement.

The existing Precision Optics pieces were, however, part of a much larger series of experiments, many of which were never completed or exhibited—in part because their significance for Duchamp lay elsewhere than in their aesthetics. He saw their significance, instead, as experimental or scientific. He wrote that he would "regret it if anyone saw in [the *Rotary Demisphere*] anything other than 'optics.'"[11] And in 1935 he took the *Rotoreliefs* to the Concours Lépine, the annual inventors' fair, and sold them as a kind of appliance next to innovations in washing machine technology.[12] Before going to the Concours, Duchamp wrote Katherine Dreier that the *Rotoreliefs* "had interested 'scientists (optical people) and they say it is a new form, unknown before, of producing the illusion of volume or relief.' He planned to show them to a professor of optics and 'maybe have a scientific account written by him for the Academy of Sciences.'"[13] Indeed, Duchamp may well have been the first to discover the stereokinetic illusion at work in *Rotary Demisphere*, *Anémic Cinéma*, and the *Rotoreliefs*.[14] From this perspective we can begin to ask how *Anémic Cinéma* might configure the cinema such that it becomes a Precision Optics machine, a device for the manipulation of embodied perception rather than the sort of art object for which Duchamp is best known.[15] To put it bluntly, *Anémic Cinéma* is not in fact significant—at least, not when

modernism furnishes our model for what counts as significant. How might we describe what takes place in an aesthetic encounter once modernist significance ceases to be our model?

Describing the stakes and force of a proprioceptive encounter will be easier if I begin with the noncinematic works of the Precision Optics. Take *Rotary Glass Plates* (Figure 10). The piece includes five pairs of glass plates arranged into planes receding from the viewer. Each plate has several arcs of concentric circles on it. When they are moving and I see them from the correct angle, the ten plates in five different planes seem to become a single disc with several unbroken concentric circles painted on it. Several conditions must obtain for me to experience this perceptual effect, some of which are quite obvious. The machine must be in motion. I must be positioned directly in front of the machine, at the right level, so that one of my eyes is on the line formed by the axis of the rotation of the plates. I must use only that one eye to view the device. Finally, I must be the correct distance from the machine, about a meter away. If I stray from any one of these conditions, I attenuate or destroy the effect.

Rotary Glass Plates is the most stringent piece of the Precision Optics in its bodily restrictions and requirements, but the *Rotary Demisphere* and the *Rotoreliefs* both impose similar restrictions and requirements on my body in terms of position and distance. These restrictions do not, however, impose passivity. Rather, these pieces rely on my positive, embodied capacities as a viewer in at least two ways. At a basic level, for as long as I am engaged with their illusions I must actively orient myself—my attention and my body—to the machine. Perhaps I do not know quite how to engage with a device, and so I move around, change angles, get closer or farther away, close one eye. To attune myself to the device, I maintain a receptive, even exploratory, posture and disposition.

At the same time, the Precision Optics devices involve or solicit their viewers' perceptual capacities in a more significant way. Their illusions arise not only from the way I orient my body to a device but also from the way I continually attune my ongoing attention and perception to the device and its *illusion*. For as long as I am enmeshed in illusion, I am resonating perceptually with these devices. To produce their effects, these devices rely at once on the possibility—and indeed delight—of perceptual illusion, on my receptivity to their technical modulation, and on my embodied capacity to let myself be carried along by such perceptual modulation. That is, when a Precision Optics device is functioning—for the duration of my ongoing resonance with the device in motion and not merely the fact of its motion—this device modu-

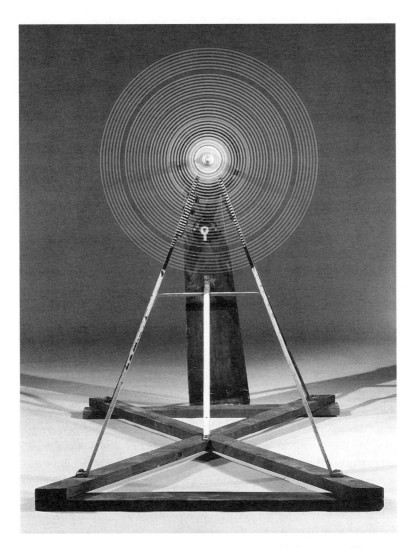

Figure 10. Marcel Duchamp, *Rotary Glass Plates*, 1920. Photograph courtesy of the Yale University Art Gallery.

lates my embodied perception, and I attune myself to the device in both physical carriage and perceptual involvement.

So, too, *Anémic Cinéma* modulates its viewers' embodied perception. It brings viewers into a dark room, projector in back, screen in front, bodies oriented toward the screen—the still familiar scene of the cinema. Similarly, it involves an invocation or recruitment of viewers' perceptual capacities as

a component in the creation of illusory percepts. In short, *Anémic Cinéma*, like the Precision Optics in general, is a device or machine for the modulation of viewers' bodies, the production of illusion and viewers' delight in that illusion. But the device also coincides exactly with the cinema, and *Anémic Cinéma* is not a discrete machine. It is yoked to the cinema as an architectural arrangement of seats, surfaces, and machinery. Unlike the other Precision Optics devices, *Anémic Cinéma* is not a particular machine aiming at a specific illusion. It is instead an arrangement of possibilities within the more flexible machinery of the cinema: it configures the cinema as an optical device.

It is, of course, still a film. *Anémic Cinéma* is an unusual sort of optical device. Two aspects of the film are particularly salient here. First, *Anémic Cinéma* is a discrete event or series of events. As a film it is bounded in time and has a linear trajectory. The other Precision Optics machines have the open-ended time of sculpture or painting. Second, for the time it plays in a cinema, *Anémic Cinéma* generates an audience and does not imply the spatial exactitude of a single body on which the other machines rely. These facts are pertinent because they are aspects of the cinematic nature of *Anémic Cinéma*. To put it another way, they are utterly unremarkable aspects of *Anémic Cinéma*'s existence as a film.

In this context I want to recall just how easy a film *Anémic Cinéma* is. Its ease dramatizes the familiarity of the cinema as a technology and a site or scene of the modulation of our perception. Watching *Anémic Cinéma* in the cinema, I do not need to explore its conditions (of comportment, disposition, attention, etc.) for it to function. Rather, I discover it is enough to attune myself to the cinema in familiar ways, with an inarticulate and embodied competence. The word spirals also dramatize the familiarity of the cinema as I easily attune the speed of my reading to the rotation of the spirals. Although this may be largely lost to us today, in 1926 these word spirals would have been immediately legible as references to intertitles of silent film.[16] In this way *Anémic Cinéma* dramatizes its viewers' familiarity with multiple registers or modalities of visual attunement to the cinema. The film discloses that such attunement and such familiarity are in fact integral to the cinema, even as they do not give rise to questions about what the cinema *is*. Rather, if we find ourselves entertaining philosophical perplexities while watching Duchamp's film, they are much more likely to lead us to the problems of perceptual modulation and attunement, of our carnal competence, and of its inarticulateness: to proprioception. These are the problems of cinema reduced to optics, of a relentlessly minimal cinema—of an *anemic* cinema, as it were.

Anémic Cinéma makes the cinema available not as art *but as optics*. This

should recall Krauss's doubt about whether *Anémic Cinéma* is a film. This doubt arises in the context of an argument that the Precision Optics and *Anémic Cinéma*, in particular, are parts of a succession of moves in Duchamp's career away from, but always in relation to, painting: "Duchamp moved from oil on canvas, to pigment and lead on glass, to the work he collectively called '*oculisme de précision*,' and signed 'Rrose Sélavy.' Each move in this sequence is a critique of the one before it, all of them having as their target the certainties and theories of a developing modernist art."[17] She ties *Anémic Cinéma* to a modernism she sees as Duchamp's target and thus to the fate of painting. Whatever Duchamp's protestations, for Krauss the Precision Optics consist in a critique of, rather than a departure from, painting. To do so, however, she must call into question whether the film really is a film, writing, "If *Anémic Cinéma* is a film, the target it seems to have in mind is nonetheless painting—or rather, modernist, abstract painting."[18] In a similar manner, Annette Michelson proposes that *Anémic Cinéma* is "much more than singular"; rather, it is "emblematic of the entire range of painting, sculpture, games, and language games, of speculative and poetic ventures which compose that elaborate semiotic system we know as Duchamp's lifework."[19] Indeed, Michelson places the film at the very center of Duchamp's oeuvre, with its enigmatic, seductive, and impossibly productive semiosis. She writes, "Embarking, then, upon the description and account of a filmic object one is rapidly led beyond the limits of description."[20] For Krauss as for Michelson, the Precision Optics stands as a series of grand gestures in the noisy history of modernist painting and sculpture, recruited into the agonism of avant-garde aesthetics. In other words, *Anémic Cinéma* is an emphatically modernist work, addressing itself to questions of various media in their specificity. More to the point, for both critics the film poses the questions that lie at the heart of modernist aesthetics: the impossibility of sufficient interpretation, of objective criticism, of total description.

Which is to say, for both critics it is difficult to say what *Anémic Cinéma* really is. And here I must confess I do not know how to take seriously Krauss's idea that *Anémic Cinéma* might not be a film. Surely it is, if it is anything. (On my reading, even as it configures the cinema as an optical device, it is *also* a film.) This doubt lies at the very heart of modernism: as Cavell makes clear, modernist aesthetic significance turns on the question of whether *this* object will count as art. Krauss's inclination to read the film in relation to painting maintains continuity with Duchamp's playful modernism. But my point here is exactly that *Anémic Cinéma* seems *not* to be making the sorts of challenges characteristic of modernism. In contrast to Duchamp's better-known, earlier Readymades, in *Anémic Cinéma* doubt about the object, its status, the kinds

of responses we ought to have, and the forms our acknowledgment of it ought to take are remarkably attenuated. Or rather, to reach a modernist intensity we would, like Krauss, have to work to achieve doubt that *Anémic Cinéma* is a film at all by hearing its claim as a claim to painting. Put otherwise, *Anémic Cinéma* may well be modernist if we think of it as a painting, but it is not modernist if we encounter it as a film.

To be sure, wondering whether *Anémic Cinéma* is a painting or a film opens onto art-historical questions about modernism, cinema, and the other arts, and might explain the fact that many avant-garde artists turned to cinema in turning away from painting and sculpture. Either way, at stake in this turn is the questioning of forms and traditions of art, *but not of cinema*.[21] What drew the attention of avant-gardists—Duchamp, certainly, but also Francis Picabia, Man Ray, and Fernand Léger—was the ease with which cinema could express or accomplish something otherwise impossible in other artistic media.[22]

All this said, however, if we wish to take seriously both Duchamp's claim that the Precision Optics is not art and *Anémic Cinéma*'s titular claim to be cinema, we find ourselves very little in doubt. The claim that a urinal is a sculpture—its flagrantly challenging insistence that *this is art*—is radically different from *Anémic Cinéma*'s claim to the cinema. In place of doubt, there is an ease, an agreement that feels never to have been in question and so never to have needed to be *achieved* in the first place. This inarticulate know-how does not need to be elaborated in criticism, does not demand an intellectual accounting, becoming the object of conscious effort. The aesthetic stakes of *Anémic Cinéma*'s are small, indeed, and the way that we must take the film seriously is *not* to inflate its stakes to those commensurate with modernism. And yet, as I indicated in my opening, in the encounter between most theoretical approaches to film and *Anémic Cinéma,* the theories founder.

Anémic Cinéma thus bears a different relation to modernism and its problems of criticism and ontology—a departure from rather than a critique of— from that of the works for which Duchamp is best known, for example, the Readymades or *Nude Descending a Staircase* (1912). These are exorbitantly challenging works of art that radically put into question the status of sculpture, painting, and art in general. These works display a characteristically modernist concern with a reflexive explication of the encounter with as well as an exploration of the limits of the medium: of what will count as art and thus the question of *ontology.* This is at the core of their project. In contrast, by making its claim elsewhere—neither to painting nor to art more generally but rather to the cinema and to optics—*Anémic Cinéma* manages to avoid what, with Cavell, we will learn to call the modernist predicament.

Reflexivity and Cuteness

Staging the problem this way, we can see both a conflict and a contradiction. For the first, I've stated *Anémic Cinéma*'s importance in dramatic conflictual terms: the structure and scale of its aesthetic—its proprioceptive aesthetics—marks an important departure from modernist forms of aesthetic experience, attended as it is by the problems of skepticism and doubt, demanding elucidation by a criticism that draws its force from those problems, placing its faith in an intellectual reflexivity. As for the second, describing *Anémic Cinéma*'s aesthetic significance as a matter of conflict between two terms (a knowing or articulate criticism and an inarticulate attunement to the cinema) precisely reinscribes the structure of modernist aesthetic experience—from which I am claiming the film departs. The solution to this contradiction is that the film is not, in important ways, *significant.*

An example from the film will get us started in seeing why. The third rotating disc in *Anémic Cinéma* offers one of its more compelling illusions: a spiraling thick, white line describes the interior of a cone that recedes precipitously into the screen. This depth isn't static but keeps receding in an uneasy and unending way. I have the sensation of traveling backward, away from its vertex. The stereokinetic effect this disc engenders, the relief that arises from its rotation, does not merely produce the prototypical, paradoxical recessions or protrusions as modulations of the flatness of the screen. I not only see a third dimension form on a screen but also feel myself moving in relation to that depth, receding precipitously away from it. The quasi depth that forms does not remain bound to the surface of the screen, as it does in many other discs. Rather, the rotating disc engages my sense of space and my orientation in it. In this, the work of this disc is straightforwardly proprioceptive: I feel myself moving through onscreen space.

The work of this disc is also reflexive in the proprioceptive sense: I feel myself moving through this manifestly, palpably illusory space. As with all proprioceptive aesthetics, this self-sensation and this illusory space are bound together. *Anémic Cinéma* demonstrates a profound cobelonging of terms typically figured as opposed or in conflict. It does so graphically in what appears onscreen in this third rotating disc. The space through which I feel myself moving moves off the screen, enveloping my body. However, and strangely, it does not fill the whole screen; it arises only in the region of the screen that bears the rotation of the disc. Its strangeness does not arise from a feeling of moving through space nor, really, from the fact that the movement of a two-dimensional image should give rise to an illusory depth. These are, of

course, ordinary enough features of films. The strangeness lies, rather, in the way only part of the screen gives rise to depth. At once, the screen is plainly both a flatness and a depth. I see both aspects of it simultaneously.

We might notate this by saying the flatness marks the presence of the literal screen—and the depth marks the illusion. Or by describing one as indexing my literal presence in a cinema and the other, my involvement in an illusory onscreen space. Or, even, by asserting that the first marks the literal, physical support of their media—the painted disc, the screen—whereas the second marks the operation of a technology in motion, engaged in an ongoing process of modulating my perception. In *Anémic Cinéma,* as with proprioceptive aesthetics in general, these two aspects are not only present but belong to one another.

Modernist aesthetics, meanwhile, has generally seen these aspects as being in conflict, parsing one as a naïve and unreflective involvement with the object, the other as a critically reflexive awareness of the encounter. Politicized versions of modernism in particular construe them as terms in a contradiction whose resolution can only be ideological; critical reflexivity does not resolve but rather exacerbates and elaborates the conflict. In favor of a presumably unreflective and therefore unintelligent immersion in a world onscreen, modernism of all stripes—including its less politicized, more properly aesthetic versions—has preferred instead an intellectual reflexivity that aims at an explicit awareness of the conditions and context of the encounter. In film studies the most famous example is of course Laura Mulvey's "Visual Pleasure and Narrative Cinema," in which she brings psychoanalysis to bear on Hollywood film to destroy pleasure and immersion in favor of "passionate detachment."[23] To be sure, this politicized form of modernism is broader and deeper than that, and not only in film theory. Rey Chow and Sianne Ngai have recently offered complementary analyses of our contemporary aesthetic situation, drawing out, respectively, two problems that lie at the heart of aesthetic criticism: critical reflexivity and compulsive sharing.

As Chow observes, Mulvey's essay took place as "part of a collective theoretical effort, enabled by Brechtian alienation" dedicated to "dislocating classical film narrative."[24] For Chow the avatar of this reflexivity is of course Bertolt Brecht. For her the sort of reflexivity at issue, what modernist aesthetics aims at, is "thought's critical self-consciousness" (18). She argues that "the Brechtian imprint, which eventually found its way into studies of literature and art as well as theater, film, and performance in a broad sense, has to do with turning reflexivity itself into a perceptible object" (18). For both Brecht and Walter Benjamin, as Chow points out, epic theater alienates spectators

from various scenes of the ordinary in order to destroy both identification (with characters) and immersion (in a diegetic world), with the specifically political aim of showing how the situation in the fiction (on stage, onscreen) is anything but inevitable. As Chow argues, this preference for reflexivity runs deep and wide—she finds it not only in Brecht and Benjamin but also in Shklovsky, Bazin, Althusser, and Derrida (20, 27–28). More to the point, it is not only present in our thinking and writing about aesthetics but organizes modernist art objects themselves. In Pamela Lee's words, the modernist art object is marked by its "self-criticality."[25]

Chow's ultimate interest lies in articulating the exhaustion of reflexivity in a political sense; as she indicates in her title, we have found ourselves in a moment "when reflexivity becomes porn." It has become porn in the precise sense that the spectatorial dynamics that once marked the specific political force of Brechtian theater have become diffused into late-capitalist culture. This is, to be sure, not a new complaint. Mass culture has become structured by political and aesthetic techniques that destroy identification and bring about an attendant heightened, self-conscious awareness of our position as spectators. Chow illustrates this claim by turning to the films of Michael Haneke and to the sadistic dynamics she takes to be endemic of pornographic spectatorship (28–30). For her, reflexivity has become politically exhausted by virtue of having become the dominant logic of capitalist aesthetics: it has therefore lost its special relationship to the ordinary; it is no longer capable of alienating from the ordinary, as it simply *is* our ordinary.[26]

As a response to this exhaustion of political modernism, in one of the most important contemporary works of aesthetic theory, *Our Aesthetic Categories,* Sianne Ngai has shown how we must turn our attention to "our" aesthetic categories, the aesthetic categories of contemporary capitalism, which is to say, the aesthetic categories that articulate our ordinary—zany, interesting, and, of course, *cute.* Of particular concern to me here is how *Anémic Cinéma* is cute and what it means for me to say that it is cute. I do not mean the term in quite the same way as Ngai. I mean it in a fuzzier and frankly much more naïve sense, one that will not bear much pressure but will nevertheless be useful in distinguishing from Ngai's.[27] As Ngai points out, asking about cuteness (and zaniness and interestingness) involves questions that "cut straight to the heart of philosophical aesthetics."[28] At issue are the deeply related questions of the scale and the stakes of aesthetics.

The cute is Ngai's primary figure for aesthetic encounters that are small, seem to have no stake or impact, or are nonthreatening: "the diminutive, the weak, and the subordinate" (53). In particular, her analysis of the cute shows

how apparently smaller and more retiring aesthetic encounters might attain a significance we typically or traditionally reserve for only the bigger, louder aesthetic categories that so often organize our accounts of the aesthetic: the beautiful and the sublime.[29] To be sure, this isn't obviously the case: "Cuteness contains none of beauty's oft-noted references to novelty, singularity, or what Adorno calls 'a sphere of untouchability'" (54).[30] That said, the familiarity and reassurance of cuteness as an aesthetic judgment serve to highlight the continuity between our ordinary encounters and the heightened or literally extra-ordinary states that attend aesthetics. She writes, "What these aesthetic categories based on milder or equivocal feelings make explicit, in a way in which categories based on the powerful feelings evoked by rare experiences of art or nature cannot, is the continuousness and everydayness of our aesthetic relation to the often artfully designed, packaged, and advertised merchandise that surrounds us in our homes, in our workplaces, and on the street" (58). To put this a different way, small and familiar aesthetic encounters are of course small and familiar, but for all that, they remain aesthetic encounters.

Being aesthetic encounters, they share important structural elements with experiences and judgments of the beautiful and the sublime. As Ngai argues at length, *cute, interesting,* and *zany* are aesthetic judgments just as much as their more rarefied cousins. In fact, they are in some sense better aesthetic judgments in that they are more specific than *beautiful* or *sublime* (41). She elaborates this claim at a philosophical level by turning to Cavell's philosophical writing about aesthetics. In particular, she stresses the performative aspect of aesthetic judgments: "As Stanley Cavell shows, aesthetic judgments belong to the especially troublesome class of performative utterances J. L. Austin classified as perlocutionary: actions such as praising, criticizing, complimenting, soothing, or insulting" (38). Because she is particularly concerned to show that our (or her) aesthetic categories entail and embody aesthetic judgments (and not merely experiences), Ngai attends primarily to their existence as speech acts.

For example, as a way of restating Kant's observation that aesthetic judgments (as opposed to judgments of "mere" taste) carry a universal appeal, she argues that, on the model of Austin's perlocutionary utterances, aesthetic judgments "look constative but are actually performative" (40). They take the form "x is cute"—or beautiful, zany, whatever. More to the point, "aesthetic judgment is less like a propositional statement than an intersubjective demand—which is to say, less like a constative than a performative that performs best when disguised as a constative" (40). Drawing out this performa-

tive dimension of aesthetic judgments, Ngai follows Cavell's indication that aesthetic judgments are in some sense incomplete if they are not also *shared.* She stresses this by quoting Cavell, whose target is "the feature of the aesthetic claim, as suggested by Kant's description, as a kind of compulsion to share a pleasure, hence as tinged with an anxiety that the claim stands to be rebuked."[31] Aesthetic judgments (and not only for Kant and Cavell) cannot be made in isolation but must be shared according to a vocabulary we must also share among ourselves.

Ngai both describes and theorizes an aesthetic vocabulary we already share—they are, after all, "our" categories—and shows how they structure not only the extraordinary of heightened encounters with art but also our late-capitalist ordinary. As Cavell has it, we can see the ordinary "not as what is perceptually missable but what is intellectually dismissible."[32] Ngai's book belongs to the important project, shared among a number of recent scholars, of ensuring the ordinary can no longer be intellectually dismissed.[33] She shows that our ways of talking about and sharing our aesthetic encounters and experiences are continuous, in profound ways, with how we speak about the heightened aesthetic encounters that have largely absorbed the philosophical attention paid to aesthetics.

But what if an aesthetic encounter takes place in a mode that somehow does not come with the need to be shared? Whose reflexivity is other than critical or intellectual? This is not quite a question of scale, since the cute, both as Ngai means it and in a more colloquial sense, is prone to sharing, even solicits it—as the most recent adorable animal video on my Facebook feed will surely attest. But if *Anémic Cinéma* is cute, it is not cute in Ngai's sense or, even, in the colloquial sense of adorable animals. Rather, it is cute in that it is in some sense ineffectual: it does not do the work we might expect from a piece by Marcel Duchamp. Its illusions do not rise to the level of comment. I do not need to say anything at all about them. To be sure, these illusions are not ineffectual *as optics*: they do indeed work, giving rise to a more or less saturating attunement to the cinematic illusion unfolding before me. To put it another way, *Anémic Cinéma* does *precisely* the work we expect from a film. I may have a feeling of astonishment; I may even show the film to you, laughing as I do. But I find I do not feel a compulsion to speak about the film, to describe my experience of it, to offer a reflexively critical account of it. If *Anémic Cinéma* calls for some kind of acknowledgment, this acknowledgment will not be articulate. It will not take the form of an utterance, performative or otherwise. It may demand laughter, but that is all.

Proprioceptive aesthetics, as we shall see repeatedly over the course of this

book, departs from both Chow's and Ngai's tokens of modernist aesthetics—critical reflexivity, and a compulsion to share according to the canons of aesthetic judgment. Proprioception is a form of self-relation that is neither critical nor intellectual but is instead perceptual, operating below or to the side of "thought's critical self-consciousness." Most important, it does not oppose cinematic illusion or immersion to our awareness of the cinema as a technology of perceptual modulation or a scene of aesthetic encounter. It grasps both at once. Likewise and relatedly, proprioceptive aesthetics leads to voluptuous delight or anxiety or nausea, but it does not lead us to critical elaboration, to share our aesthetic judgments. Because of this, proprioceptive aesthetics has often seemed insignificant, since our habitual forms of aesthetic significance pass through various forms of criticism—more often than not, a specifically modernist criticism. Perhaps more to the point, a method of describing and theorizing proprioceptive aesthetics will have a force and a texture substantially different from the modernist criticism common in film and media theory. I am aiming not at defamiliarization or estrangement but rather at something more like *re*familiarization. If proprioceptive aesthetics itself departs from modernist aesthetics, so too must we learn to speak about aesthetics in a way that is itself not modernist.

Cavell's Modernism

Broadly speaking, in this book my use of *modernism* as a name for an aesthetic regime follows Cavell's sustained philosophical articulation of the term over the course of several works from the 1970s, especially *Must We Mean What We Say?* and *The World Viewed.* For her part, Ngai cites Cavell on aesthetic experience, invoking the anxiety that attends our compulsion to share pleasure, the anxiety that we might find our judgment rebuked in some way. She does not, however, pursue the question of why we might feel a compulsion—rather than, say, an urge or a desire—to share aesthetic pleasure, or why our aesthetic judgments should be attended by anxiety.

Cavell explains in the sentence that follows Ngai's quotation, "It is a condition of, or threat to, that relation to things called aesthetic, that something I know and cannot make intelligible stands to be lost to me."[34] For Cavell aesthetic judgments are not merely performative and therefore incomplete without being shared. They are animated by a peculiar anxiety: perhaps I might not be able to share something I nevertheless know (or feel I know, with the force or conviction of knowledge) with another, to make it intelligible, to describe it sufficiently. Because I find I do not know how to communicate

it, this knowledge might be lost, might not count as knowledge.[35] In other words, for Cavell aesthetic experience is haunted by skepticism. To be sure, in his account skepticism haunts all aesthetic experience, but the threat of and anxiety about skepticism are decisive in modernist aesthetics: "Modernism only makes explicit and bare what has always been true of art. (That is almost a definition of modernism, not to say its purpose)" (189). "You often do not know which is on trial: the object or the viewer: modern art did not invent this dilemma, it merely insists upon it" (190).

Following these passages and over the course of several pages, Cavell offers a rich description of modernist aesthetic experience. He begins by noting how aesthetic experience feels like knowledge or, rather, that aesthetic experience gives rise to knowledge that takes the form of feeling: "Works of art are objects of the sort that can only be *known in sensing*" (191). "Such objects are only *known by feeling*, or *in* feeling" (192). The proximity, even the identity, of knowing and feeling in aesthetic experience cuts at least two ways. On the one hand, it is a different way of parsing Kant's claim for the "universal subjective validity" of aesthetic judgments: feeling somehow attains the universality and incorrigibility of knowledge.[36] On the other, it underwrites, even validates, the skeptical suspicion that what we call knowledge is really no more reliable than feeling.[37] Either way, this complex of knowing-as-feeling leads to the compulsion to share aesthetic experience and to the anxiety that attends it:

> This seems to me to suggest why one is anxious to communicate the experience of such objects. It is not merely that I want to tell you how it is with me, how I feel, in order to find sympathy or to be left alone, or for any other of the reasons for which one reveals one's feelings. It's rather that I want to tell you something I've seen, or heard, or realized, or come to understand, for the reasons for which *such* things are communicated (because it is news about a world we share, or could). Only I find I can't tell you; and that makes it all the more urgent to tell you. I want to tell you because the knowledge, unshared, is a burden . . . like the way not being believed is a burden, or not being trusted. . . . It matters, there is a burden, because unless I can tell what I know, there is a suggestion (and to myself as well) that I do *not* know. But I *do*—what I see is *that* (pointing to the object). But for that to communicate, you have to see it too. (192–93)

For Cavell the compulsion to share and the conviction of knowledge are the primary constituents of aesthetic experience. It cannot be made fully explicit; it cannot be *merely* communicated in the same way ordinary knowledge might be; its conviction might be uncovered as spurious. It can be argued about, and reasons can be given for a particular judgment according to shared rules,

categories, and vocabularies. And yet we must be "powerless to prove" any of these sorts of judgments (96). "At some point, the critic will have to say: This is what I see. Reasons—at definite points, for definite reasons, in different circumstances—come to an end" (93).

Rather, aesthetic judgment and aesthetic experience must be articulated in a feat of aesthetic criticism that is tantamount to phenomenology (93). There is something fundamentally unaccountable in aesthetic experience, and this unaccountability is *precisely* what makes it important as such. It is not precisely incommunicable—it is occasioned by art and expressed by criticism. But the success of any communication is always in doubt. (And at least sometimes, what is unaccountable is the obscure fact of my embodiment, the lonely and impersonal fact of being *this* body.) Here, if a bit obliquely, he calls modernist aesthetic experience a burden; elsewhere, he calls it a predicament.[38]

Burden or predicament, either way this unaccountability is, for Cavell, in the nature of aesthetics; it is not new. It is, in fact, a way of rephrasing another of Kant's formulae—that aesthetic judgments are made without a concept.[39] What *is* new, however, is the emphasis, even the nakedness, of this fact. Modernism radicalizes this unaccountability. This is what Michelson means to evoke in her description of modern art as "an elevation of doubt to an esthetic principle," with the attendant "cognitive aspiration of modern art."[40] Modernism draws its significance from what it cannot say out loud. The significance of modern art lies in that, despite the withering doubt of skepticism, it really does transmit experience and give rise to its shared acknowledgment. Modernism is art's acknowledgment of skepticism, and it draws its significance in that every successful attempt at art is at once an overcoming of its standing threat and is thus also always a reinvocation of it.[41]

The compulsion to share and thus to describe aesthetic significance—which will never in itself be sufficient to convince another of this significance—starts from the anxiety that perhaps I do not know how to give an account of my sensation, of what I have come to know, even to myself. A successful description—which is necessarily also to say, a successful act of criticism—entails the sense that skepticism has been overcome, or can be, at least temporarily. But what counts as success? Compelled to share, what I end up sharing with you (if I succeed) is only "*that* (pointing to the object)"—which is also news from "a world we share, or could." For Cavell and for modernism, aesthetic experience is marked not only by a compulsion to share and an anxiety that attends it but also, as Ngai points out, by ways of speaking about such experience: our aesthetic categories. But to this we can now

add our profound sense of the inadequacy of these ways of speaking and the uneasiness that attends any deployment of these categories.

Anémic Cinéma avoids the predicament of modernism in part by avoiding the seriousness or significance that modernist aesthetic encounters usually entail: the film is *cute*. Partly, that is because what it makes palpable is our competence—a mute embodied know-how, an unelaborated reflexive awareness of our situation—rather than what we *don't* know how to do, to say, or to account for. *Anémic Cinéma* does not merely belong to Carroll's category of films that flagrantly withhold the expected representation or figuration. In this cinema stripped bare, we find ourselves at home in the cinema's direct perceptual modulation and our own perceptual attunement to the cinema. Even though I may not be able to say, quite, what it is I experience in my encounter with *Anémic Cinéma,* I do not find that inability to be particularly significant. Rather than acknowledging (and possibly overcoming) the standing threat of skepticism, Duchamp's film operates in an aesthetic mode in which the skeptical demand appears misplaced, nonsensical, alien, or exorbitant. This mode is proprioceptive, marked at once by a reflexivity neither intellectual nor critical, organized by the copresence of opposed terms that are nevertheless not in conflict. In *Anémic Cinéma,* as in proprioceptive aesthetics in general, I find myself at home in an encounter with the obscurity of my body and my attunement with the machinery of the cinema.

Against Ontology

A familiar textbook definition of modernism equates it not with a practice of criticism nor a structure of aesthetic experience nor the philosophical skepticism that orients such practice and gives weight to such experience, but rather with a particular emphasis on medium specificity. This suggests that if *Anémic Cinéma* has avoided what Cavell calls "the fate of modernism"[42] and instead operates in the mode of proprioceptive aesthetics, it has also managed to avoid a concern with the cinema's version of modernist medium specificity, which we might usefully shorthand as "cinematic ontology." Indeed, it has.

For a long moment, one that appears to be passing, D. N. Rodowick's *The Virtual Life of Film* magnetized much argument and counterargument around cinematic ontology. For Rodowick the problem of the ontology of cinema had become newly visible and important because our old stories about what the cinema was—that is, essentially photographic—were no longer adequate. With the rise of digital technologies of the moving image, we no longer quite

know how to say what the cinema *is*. In Rodowick's words, digital technology has posed the question of cinema's ontology—*what is cinema?*—with new force and urgency "because for the first time in the history of film theory the photographic process is challenged as the basis of cinematic representation."[43] If this moment is indeed passing, and it does appear to be, it suggests we have made our peace with digital technology; cinematic representation remains pretty much what it has always been. Possibly photography never quite was what it was cracked up to be, or possibly "digital cinema" wasn't.[44]

Neither were, really. *Anémic Cinéma* and its proprioceptive aesthetics can help us see that what matters is not a rupture in technologies of representation but rather the continuity of technologies of perceptual modulation. As a viewer of *Anémic Cinéma,* I remain indifferent to its technologies of representation or its ontology. I am far more likely to ask, How is the film doing that to me? than I am, What is cinema? The illusory space to which its stereokinetic effect gives rise is simply not *represented*: technologies of representation (e.g., photographic versus animated) are beside the point. The investment, the site of questioning—if there is one—is not about representation and its technologies but rather about the familiar, obscure process of coupling between my body and the cinema.

This is, to be sure, yet another way of stating that *Anémic Cinéma* avoids the predicament of modernism—but it is an especially significant way of stating it. Skepticism animates modernism, orienting its practice of criticism, its mistrust of unreflected experience, and its faith in reflexivity. It also drives its concern with the more familiar modernist problem of medium specificity. In Cavell's account of modernism, as well as in much film theoretical discourse, this goes under the name *ontology*. Cavell's philosophical account of modernism is especially clarifying in the way he shows how "properly" philosophical concerns—here, skepticism and ontology—are at work in domains we typically consider to be aesthetic.

For Cavell this is because modernist art "now exists in the condition of philosophy."[45] Modernist art now feels the burden of questions that belong more properly to philosophy: What is painting? What is cinema? What is art? Skepticism determines the structure of not only modernist aesthetic experience but also modernist aesthetic practice. Very schematically, Cavell's artist is as much at a loss to express what she feels as I am to report what I come to know in an aesthetic encounter. Skepticism, however, haunts the artist in a specific way: she has lost faith that the material facts of a medium, aesthetic tradition, or artistic convention will assure the meaningfulness of the work of art. She no longer knows, quite, what art is—or painting or sculpture or film. To be sure, as

a viewer I also no longer know what any of these are, and that is no small part of the anxiety I feel in the aesthetic encounter. But as Cavell shows, this anxiety attaches to a yet more specific object. Every attempt at artistic production, just as much as aesthetic criticism, is both haunted and driven by the skeptical doubt that neither I nor the artist really know what art is. Modernist art draws its significance from the continual re-posing of the ontological question—What is art? What is painting? What is music? If it works, if there is significance, when I encounter the object I have the feeling I have indeed discovered what art (painting, sculpture, music, film) *really* is: "*that* (pointing to the object)."[46]

Every piece of modernist criticism is thus not only news about a world we might share but also, more pointedly, news about what art (or an art) *really* is. Modernist art *and* criticism both find themselves in the position of philosophy, constantly returning to the ontology of their media. Aesthetic significance appears in the form of an ontological claim. And yet with the Precision Optics and *Anémic Cinéma,* we do not (or, at least, need not) feel the skeptical doubt that would set the well-oiled machine of modernist aesthetics in motion. To do so, we would, like Rosalind Krauss, have to doubt the film is a film, parsing it instead as painting. To be sure, once this doubt arises, it leads Krauss to a series of important reflections on Duchamp and his relationship to painting and to the history of twentieth-century modernist aesthetics. But what if *Anémic Cinéma* appears as only cinema?

If, as I am claiming, *Anémic Cinéma* specifically and proprioceptive aesthetics more generally do not bear the burdens of modernism, I must also acknowledge that, in Cavell's accounting, the whole of cinema has "avoided the fate of modernism" or, as he also figures it, "the burden of seriousness."[47] Now, as a matter of historical fact, the cinema has indeed had its modernism— and had already had it at the time of *The World Viewed.* But if *Anémic Cinéma* manages to avoid the burden of modernism, it does not do so in the same way Cavell's cinema had: escaping skepticism by means of its photographic basis. Photography and cinema present the world seemingly untainted by human subjectivity: it makes a world present to me from which I am absent. Because of this, photography satisfies "the human wish, intensifying in the West since the Reformation, to escape subjectivity and metaphysical isolation—a wish for the power to reach this world, having so long tried, at last hopelessly, to manifest fidelity to another" (21). This is why the cinema is for Cavell the "moving image of skepticism": in the cinema I can bear faith to a world onscreen because it is untainted by my subjectivity. It solves, in an aesthetic modality, the skeptical problem of my presence of the world.

Both modernist and photographic ontologies are responses to skepticism,

but there are two decisive differences between them. First, whereas modernism relies on the prowess of the critic to communicate significance, in photography it is, in Bazin's words, "the impassivity of the lens," the absence of a tainting subjectivity, that defends against the skeptical threat.[48] Second and relatedly, what we do *not* know differs decisively. In modernism significance is by its nature deep and ineffable; it arises when I manage to communicate something to you in the face of the impossibility or difficulty of sharing it. Meanwhile, photography is, or at least should be, easily explicable. As Cavell writes, "A photograph does not present us with 'likenesses' of things; it presents us, we want to say, with the things themselves. But wanting to say that may well make us ontologically restless. 'Photographs present us with the things themselves' sounds, and ought to sound, false and paradoxical" (17). And yet the alternative sounds just as false and paradoxical: "Obviously a photograph of an earthquake, or of Garbo, is not an earthquake happening (fortunately), or Garbo in the flesh (unfortunately). But this is not very informative. And, moreover, it is no less paradoxical or false to hold up a photograph of Garbo and say, 'This is not Garbo,' if all you mean is that the object you are holding up is not a human creature" (17). We do not know what a photograph is, quite, or how it makes its objects present. We also do not know what it is we experience in an aesthetic encounter. These forms of not-knowing are similar in that they both lead to ontology—which comes to matter, in effect, only after the fact. And yet they pose the problem in complementary, if largely opposing, ways. One places its faith in critical reflexivity and intellectual elucidation, and the other, in a technological, indeed mechanical, dissolution of the human.

The isomorphism between photographic and modernist ontology might help explain why ontology as a film-theoretical problem arose with as much force and anxiety as it did at the moment photographic technologies were eclipsed by digital ones.[49] Rodowick proposes that the most pressing task of film theory is "to understand how a photographic ontology, in Cavell's sense of the term, is being displaced by a digital ontology."[50] In Pavle Levi's words, however, "We live in an age in which it is easy to overlook the fact that [the] severance of cinema from its traditional, historical base—the film apparatus—did not emerge as a possibility only with the advent of digital technologies."[51] With Levi, we might object to Rodowick that the cinema's ontology has always included more than a specific technological basis, the photochemical film strip—and that therefore its disappearance may well not lead to a change in the cinema's ontology. Levi's response is to show that the cinema as an apparatus (or *dispositif*) encompasses far more and is far stranger than an ontology

organized by its technologies of representation: the cinema has been embodied in any number of materializations in a variety of media.[52]

It could just as well be that what counts as cinema now (or ever) was not really about photography in the first place. *Anémic Cinéma*'s cute, unserious, insignificant cinema of perceptual modulation is part of a tradition, as old as the cinema at least, of films for which photographic representation just isn't an issue (neither photography nor representation). My point here isn't quite that ontology is a false problem, though. How could it be? Ontology has mattered a great deal under the regime of modernist aesthetics. And yet I may appear to be making an ontological claim about the cinema, even a modernist one. I am arguing that the cinema is usefully understood as a technology for the modulation of human perception, even before it is a technology for representation. This sure looks like a claim that (1) we do not know what the cinema *really* is and (2) the cinema really *is* a technology for the modulation of embodied human perception. Ontology, indeed! But that really isn't my claim. Rather, I am attempting to describe a different response to skepticism, a way of avoiding ontology as a problem, and a model of reflexivity not governed by skeptical doubt. If *Anémic Cinéma* avoids the modernist complex of problems, it leads us to a very different set of problems: the obscurity of my body, its competence in attuning to the machinery of the cinema, the pleasure I take in this ongoing resonance of body and machine.

In Stephen Mulhall's words, Cavell's skeptical impulse "exemplifies one way in which human beings attempt to deny their conditionedness (their condition)."[53] In the context of *Anémic Cinéma* and the cinema's proprioceptive aesthetics, this impulse appears as denial or a deprecation of the embodiedness and finiteness of perception. Skepticism imagines an impossible ideal perception that would know the world wholly, transparently, in itself, from which the perspectival or local or finite nature of—that is, the very enabling conditions for—human perception appear as flaws to be remediated by intellection. Embodiment becomes an impediment to, rather than the very ground of, my perception.[54] In stark contrast, my pleasure in the voluptuous illusion of *Anémic Cinéma* is, or at least can be, a way of being at home in my embodiment, in my finiteness, in the nontransparency and nonideality of perception, in the only way I have of being open to the world that is open to me.[55]

Anémic Cinéma's illusions are nevertheless ambivalent—and this, we shall see, is another hallmark of proprioceptive aesthetics. Like an experiment in a perceptual psychologist's lab, they may well seem to demonstrate the very fallibility of my perception. Or they are an occasion for delight and wonder in my

embodied perception. If I take pleasure in *Anémic Cinéma*'s voluptuous illusion, this illusion is precisely not the inert illusion in a psychologist's laboratory, evacuated of subjective meaning. As such, *Anémic Cinéma* is not (or not simply) a demonstration of perceptual skepticism. Its illusion does not inaugurate a mistrust in the veracity of perception. Rather, it stages an encounter with the finiteness of my perception and the obscurity of my body.

This obscurity has both objective and subjective dimensions; it is at once personal and impersonal. Elsewhere, Krauss has written that in front of the *Rotoreliefs* the physiological body of the perceptual psychologist and the libidinous body of the psychoanalyst meet, or coincide.[56] The *Rotoreliefs* thus set the stage for the encounter between two different modes of accounting for my obscurity. Both perceptual psychology and psychoanalysis are ways of articulating what we do not know about ourselves. But their articulateness comes at the cost of making statements about domains inaccessible to experience—the Unconscious on the one hand, and neural substrate or cognitive processing on the other. Both capitulate to the skeptical demand that I give an account of my obscurity, even as I cannot ever reach total transparency. (Significantly, if suggestively, they also mirror the positions and methods of psychoanalytic and cognitivist film theory.) However present these dimensions may be, with the *Rotoreliefs* as with *Anémic Cinéma*, they need not lead to skepticism. Instead, they offer a way of being at home in the palpable finitude of my perception. The film does more than invoke these bodies or makes them coincide. Rather, it opens up my experience to its own limits or, better, to its own limitedness—an inarticulate, embodied reflexivity.

As a viewer of *Anémic Cinéma*, I encounter my nontransparency to myself. I discover the mute know-how of my body. I come upon my limitations, my finiteness, and my unknowingness in the form of a voluptuous illusion. These effects, then, are not (or not only) curiosities, aberrant mistakes of the human visual perceptual apparatus whose causes must be isolated, explained, and formalized—as perceptual psychology's stereokinetic effect and false induction, or as psychoanalytic scopophilia and libidinal investment, or even as critique of retinal modernist painting. Rather, the ways we must come to terms with such an encounter—even if it does not, quite, seem so very significant—lie in a sustained, precise description of my modulation by the machinery of the cinema and my attunement to that machinery. This perceptual resonance must be grasped from the inside, in its conditionedness and finiteness and obscurity and possibly its insignificance. I take delight in vision itself as the materially embodied process of seeing. The word I know for this attempt to grasp such phenomena from the inside is *phenomenology*.

2 BEYOND THE INFINITE, AT HOME IN FINITUDE

2001

Stanley Kubrick's 1968 masterpiece, *2001: A Space Odyssey,* is a singular film. There has been nothing like it before or since in the history of cinema: we could find any number of reasons to be interested in the film.[1] For us here, however, *2001* is exemplary for its continual interest in space and movement through it, not only in the journey to the moon we saw in the introduction but also in jogging through the rotating habitat ring of *Discovery One* and, especially, as we hurtle "beyond the infinite" through the Stargate. As Annette Michelson has written, *2001* is "a film which takes for its very subject, theme and dynamics—both narrative and formal—movement itself."[2] For her this interest in movement lies at the heart of what makes *2001* an emphatically, even paradigmatically, modernist film. In its perceptual intensity and through its illusion of bodily movement, *2001* gives rise to the alienation that lies at the heart of modernist aesthetics—but in a specifically sensory mode. Michelson's perceptual modernism is strikingly coincident with phenomenology's famous *epochē.*[3] Unlike the *epochē,* however, this modernist aesthetic reflection does not suspend perception in order to come to consciousness of it. Rather, *2001*'s "phenomenological esthetic" immerses us in our senses. It does so, however, to perform an exemplary phenomenological move: it "develops from the concern with 'things seen to that of seeing itself'" (61). Being modernist, it cannot give up reflexivity or alienation. Immersing us in our senses, *2001* offers a doubling of our consciousness, which in turn leads to phenomenological reflection.

2001's voluptuous alienation arises from its defamiliarization of space. As we saw in the introduction, this defamiliarization occurs primarily in the ways in which the film moves us *through* space. In its journey to the moon, this movement through space takes place particularly in rotational figures, with perspectives in multiple frames of reference. The spaceship cannot merely

approach the rotating space station; it must also match its rotation, shifting from one frame of reference to another (see Figure 4). Much like *Gravity*, the film takes us through these frames of reference, demonstrating the disorienting process of shifting from one to another. In one shot we see the spaceship in the foreground and the rotating space station in the background. In the next we are in the cockpit of the spaceship, cutting closer in to a computer monitor showing the station's rotational frame of reference. Then, the reverse perspective shows a rotating field of stars from the docking bay and, against that, the spaceship slowly starting its rotation. Finally, again we look in long shot in a static frame of reference, spaceship and station rotating together. The effect is dizzying, especially on the big screen (and more so in *2001*'s native widescreen 70 mm format), particularly in the moment we find ourselves in the rotating space station, as the tiny dot of the spaceship slowly begins to match our own unearthly rotation.

Which is to say, *2001* offers an unusually sophisticated and robust elaboration of the illusion of bodily movement through onscreen space. In the journey to the moon, the illusion is manifest both in our movement through space and in various rotational figures. Near the end of the film, in the Stargate sequence, we hurtle into the depth of the screen for nearly fifteen minutes. It is perhaps not surprising that Michelson poses this modernist (and skeptical) doubt and its concomitant longing for immediacy at the heart of a film so invested in illusion. And yet illusion need not give rise to doubt. Which is also to say, *2001*, in all its disorienting intensity, need not be seen as modernist: it may just immerse us in our senses. Its aesthetic value need not flow from Michelson's "phenomenological esthetic," in which sensation gives onto reflection. We might not need what Michelson calls "critical athleticism" to render its aesthetic importance (59). What might it mean to value such perceptual, visceral, voluptuous and specifically *illusory* intensity on its own? How might we do so?

In this chapter I pursue two deeply related questions whose relation might not at first be clear. For the first, I propose we take *2001*'s illusion of bodily movement as seriously and as much on its own terms as possible, asking what it means to call it the *illusion* of bodily movement and how the sense of illusion in the offing differs from how we have typically understood the term in film theory. For the second, which develops from the first, I pursue a phenomenological approach to the cinema that does not assume its representational vocation. Following French phenomenologist Renaud Barbaras, I argue for a phenomenology of *appearance* as such a nonrepresentational method. Both of these agendas entail a further questioning of, as well as

an argument against, the skeptical impulse that has organized much of our thinking about the cinema. In this chapter this means denying an essential difference between an object in the world and its illusory presence in a cinema, not because these are not essentially different—they are, if those are our terms—but rather because cinematic images are not in the first instance representational.

These agendas converge at the rather difficult point where something other than critical reflexivity is the posture we must take in thinking about the cinema. Thinking about the cinema might not take as its vocation the elucidation or elaboration of something otherwise lost to us—to wit, the difference between cinematic objects and ordinary ones, which has often gone under the name *illusion*. This is for two reasons: the cinema is not in the first instance a technology for representing objects but rather for modulating perceptual resonance, and the difference between cinematic and ordinary perception is always manifest proprioceptively in this resonance with the cinema.

Beyond the Infinite

Let us begin, however, by collecting some data. Like a symphony, *2001* is divided into four movements. In the last of these, almost exactly two hours into the film and after the narrative portion of the film comes to a close, a title reads: "Jupiter / And Beyond the Infinite." What follows is a remarkable and remarkably opaque half hour of cinema. The first half offers the nearly continuous illusion of moving into the depth of the screen. It opens with an extended sequence of shots of space: Jupiter, its moons, the sun, a spaceship, a space pod, and a floating black obelisk (Figure 11). The obelisk somehow opens the Stargate, and we fly through a multicolored, abstract landscape. This headlong rush into the depth of the screen continues and then disperses in a series of slowly moving patterns of increasing abstraction. Finally, before coming to a close, our flight continues over actual landscapes, whose manipulated colors maintain the weirdly abstract, alien, and frankly psychedelic character of the journey. The entire affair takes almost fifteen minutes.

The opening sequence of Jupiter and its moons in conventionally recognizable space is elliptical in its editing and prepares us for the visual intensification to come. The ellipsis at once develops and disrupts the film's previous orchestration of movement. Up to this point, its elaboration of movement has been purposive, toward a goal, in a particular direction, as in the journey to the moon with its fluid, disorienting circular figures of movement. Now, individual shots are only loosely connected. In these shots movement begins to

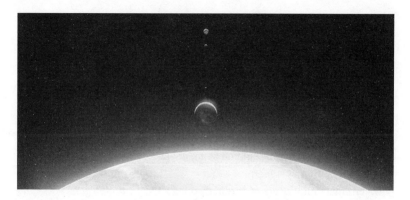

Figure 11. The planets (and pod and obelisk) align in *2001*, just preceding the Stargate sequence.

acquire an autonomy, losing its connection with purpose, direction, or destination. We experience a dilation of movement and space, preparing us for the direct, intense, and autonomous movement that follows.

Jupiter, its moons, and the obelisk align. Thus we are catapulted "beyond the infinite," hurtling headlong into the depth of the screen, into an indefinite, abstracted space. If the fragmented, floating movement of an autonomous camera in "normal" (planetary) space before became abstracted from goal-oriented, purposive movement, drawing our attention to movement as such, then here we have a hyperbole of absolute movement. This movement is movement *through,* but not through any definite space. While there is direction, there is no goal, no *toward,* to explain or anchor such movement. It becomes pure movement into the depth of the screen. The "special" effect here is produced by Douglas Trumbull's slit-scan machine (Plates 1 and 2).[4] Kubrick reportedly told Trumbull, his effects supervisor, that it should feel like the camera was moving through something.[5] Colored lights move out from the center of the screen, giving the impression of movement through a landscape made up of nothing more definite than abstract patterns of brightly colored light. More specifically, the movement here is toward a featureless *horizon* rather than through a tunnel. At first, this horizon is vertical. Later, it becomes horizontal.

Particularly on the big screen, the perceptual effect of this movement is immersive, visually and viscerally overwhelming. The colors are stunning, and György Ligeti's *Lux Aeterna* is haunting. And movement abides: a strangely light-headed, vertiginous feeling of almost-movement that I feel at the bottom of my throat, in my chest, underneath my sternum, or in the pit of my stomach.

I do not feel *disorientation,* quite, but rather a sort of heightening of oriented-ness, a drawing out, roughening, and thematizing of an embodied feeling of not quite flying through space. Thus I find myself caught up in one of the purest examples of the illusion of bodily movement in the history of cinema.

The Stargate sequence continues with several other sorts of shots before ending with the famously opaque "future selves" segment of the film.[6] Continuing and elaborating the illusionistic work of this first segment is first a series of shots of abstract, psychedelic patterns (Plate 3). Many (although not all) of these continue the quasi movement of the slit-scan shots. In fact, the movement they present is even stranger, more weirdly illusory. Space itself seems to stretch. The transmutations of space I experience are palpably impossible while also palpably manifest. The movement in them has the ghostly, vaguely nauseating quality of the movement in Aristotle's famous waterfall illusion.[7] Then, this movement into the depth of the screen continues into a series of moving aerial shots of "real" landscapes, recolorized and defamiliarized (Plate 4). The illusion of bodily movement and the near purity of movement-as-such continues in these shots, but the quality of this movement is again subtly different. While continuing the giddy quasi movement of the previous segments, this movement is distinctly more concrete. It feels less abstracted, more oriented, somehow closer to earth. This is not entirely a function of the increased verisimilitude of these landscapes—it is not only because we recognize helicopter shots of the desert in the American Southwest that these feel different. Importantly, while the illusion of bodily movement persists, its quality shifts.

Throughout these sequences, we occasionally see reaction shots, in increasing close-up, of the protagonist astronaut, Dave (Keir Dullea). Eventually, these become colorized ultraclose shots of a single eye. As Scott Bukatman writes, "The passage into kinetic lights and the amorphous shapes of the Stargate sequence in *2001* . . . is explicitly directed *right at* the viewer. Close-ups of David Poole [*sic*], the astronaut, do not reintegrate us into a fictional (*re*-presentational) space; neither do they situate Dave as a psychologized subject meant to focus audience identification."[8] Rather than interfering with the visceral illusion of our own quasi movement through space, they laminate it to an intimate but impersonal bodily identification with Dave (as the sound of his breathing did throughout much of the previous movement of the film). Both the sorts of shots of Dave (blurry, freeze-framed, or so close they're anatomically depersonalized) and the intensity and duration of movement itself make the illusion of movement not only the most important but the nearly exclusive interest of this segment of film (Figures 12 and 13).[9]

Figure 12. In the Stargate sequence, we cease to recognize Dave (Keir Dullea) as he shakes violently.

Figure 13. Dave's eye in an anatomically impersonal extreme close-up.

And so *2001* offers something like the "autonomous" illusion of bodily movement, independent as it is from any vocation of representation, a pure proprioceptive attunement. Because of this, Bukatman argues that the Stargate sequence "participates in the presentational mode through the prevalence of optical effects that in fact *re*-integrate the virtual space of the spectacle with the physical space of the theater."[10] Indeed, this presentational mode, as well as a corresponding address to the body, seem apt descriptions for what *2001* is doing. With Bukatman we can say that instead of enjoining me to lose myself in a world onscreen, the Stargate offers a different constellation of spaces. Enmeshed in the illusion of bodily movement through onscreen space, I am nevertheless aware of my body in the cinema as I am subject to perceptual modulation by the film. In short, while I am immersed

in onscreen space, my body is voluptuously or viscerally present as a tightness in the throat and a thickness in the chest.

Bukatman continues, however, "Special effects redirect the spectator to the visual (and auditory and even kinesthetic) conditions of the cinema and thus bring the principles of perception to the foreground of consciousness."[11] He goes on to cite Michelson, who herself writes that in *2001* "the dissociative economy of film viewing heightens our perception of being physical to the point of apperception: one becomes conscious of the modes of consciousness."[12] For Bukatman as for Michelson, the importance of *2001*'s address to the body, the force of the intensity and grace of its modulation of embodied perception, lies in how these give rise to a process of cognition or intellection or reflection. Once again, we find the skeptical mistrust of perception, the latent or tacit conviction that such perceptual intensity is somehow not sufficient—to get us to the world, to organize a decisively modernist aesthetic experience. And yet Michelson and Bukatman offer a way to move beyond this mistrust. The film's address to the body, its engagement with my perception, its illusion of bodily movement—these are not a function of representation.

If I am right, *2001* and its cinematic illusion of bodily movement do not bring the principles of perception to consciousness. They do not even bring perception to consciousness, as though consciousness were capable of grasping perception, bestowing upon it a value that perception itself lacks. They do, however, *thematize* perception, making it palpable as affective impact, available to experience, manifest in proprioceptive reflexivity. They make perception available to the acts of intellection that critics and phenomenologists alike perform after the fact. They do not, however, require or even call out for these acts. Perception itself is not inadequate. It needn't be tamed, grasped, or elaborated by something else called consciousness (or criticism). In short, Michelson and Bukatman show us, even from inside a modernism oriented by skepticism, the decisive importance of the cinema's proprioceptive vocation, distinct from its representational vocation. *2001* makes this vocation unavoidable as I sit in a theater, still in my seat, saturated by the obviously illusory feeling that my body is moving—rotating, hurtling, stretching, floating—through the space onscreen.

Cinema, Illusion, Apparatus

What sort of illusion is this illusion of bodily movement? Or to ask the question another way, What does it mean to call the illusion of bodily movement illusory? At the level of phenomenal experience, it is clearly an illusion. During the

journey to the moon, I might feel light-headed, dizzy, slightly nauseated. During the Stargate sequence, I might feel thrilled or taken aback by the intensity of the giddy almost-movement. Emphatically, I do not feel as though I were actually moving. I do not confuse the illusion of bodily movement with actually moving, and this is not because I consciously reckon I must not be moving (because, say, I remember walking into the theater). I feel a quasi movement whose distance from real movement is measured by responses in my body: in my throat, my sternum, or my stomach. Proprioceptively aware of my situation in the cinema, when I feel *as though* I am moving, I feel it as illusion, *merely as though*. Which is to say, I *also* feel my stillness in the cinema.

In short, the cinematic illusion of bodily movement, like the other illusions I discuss in this book, is palpably illusory. What I mean by illusion here is something different from its most common uses. Illusion, at least in this manifestation, is a quality or qualification of experience. This quality isn't superadded to the experience, a form of reflection after the fact. Rather, it inheres in the perceptual effects generated by sequences like the Stargate. In this, it is related to but quite distinct from what perceptual psychologists call *cognitively penetrable* illusions, in which the illusion may be dissolved or dispelled by shifts of attention or acts of cognition—for example, as in Magic Eye dot stereograms.[13] In fact, the stereokinetic effect is often cognitively penetrable in this sense. But whether an illusion is corrigible is not the same thing as whether it feels like an illusion.

Illusions that feel like illusions are not deceptive. This puts them at some distance from how illusion has often been understood. In film theory we most often find an appeal to illusion at one of two points. Either it attaches to what scholars have sometimes called the "illusion of reality," or it shows up as part of an explanation of the way the cinema generates its moving images. Let us take these in turn. Under the first sort of illusion, as Richard Allen describes it, "the spectator involuntarily takes the cinematic image to be real."[14] On this account the cinema's representations are incorrigible and deceptive illusions. As Noël Carroll points out, this entails a rather poor opinion of cinematic realism.[15] (And as Tom Gunning points out, this also entails a rather poor opinion of film viewers.)[16] As Carroll puts it, "Contemporary film theorists have been prone to call mimetic pictorial representations 'illusions.' . . . Calling mimetic representations 'illusions' already castigates them, for even nowadays, visual illusions *proper* involve the *deception* of the percipient."[17] Carroll makes this point in the course of arguing that at least according to this concept of illusion, we ought not call the cinema's realistic—or mimetic or verisimilar or representational—capacities illusory. This is because cinematic representa-

tions are generally not deceptive. We are not fooled into thinking we are really traveling to the moon, nor do we find ourselves astonished to learn that Pan Am has sent an almost-empty flight to a rotating space station.

Carroll wants us to stop calling the cinema illusory. Allen, however, wants to change what we mean when we say the cinema's representations are illusions. To do this, Allen distinguishes between "reproductive illusion" and "projective illusion." Reproductive illusion is his name for the sort of effects trompe l'oeil painting elicits. Under the sway of a reproductive illusion, I believe the thing depicted is actually present as an ordinary object in the same space I am in: a piece of furniture or a door open to a beautiful landscape. A cinematic example would be if I were to mistake the projection of a ladder onscreen for an actual ladder leaning against the screen. This sort of illusion happens very rarely indeed in the cinema. I do not ordinarily take what is onscreen to actually be before me in the theater.

Meanwhile, for Allen the cinema typically deals in what he calls *projective* illusion. Using George Romero's *Night of the Living Dead* (1968) as an example, he suggests that what spectators are likely to perceive (although are not *forced* to perceive) is not an actual zombie in the theater nor documentary footage of zombie hordes nor a stage set populated by actors dressed up as zombies, but rather "a world inhabited by zombies." "When you see a world inhabited by zombies you do not mistake a staged event for actuality in the manner of a reproductive illusion, rather you lose awareness of the fact that you are seeing a film. . . . You perceive a fully realized, though fictional, world that has all the perceptual presentness or immediacy of our own."[18] Allen's account has the benefit of giving us a concept of illusion that works well enough for a typically representational, fictional film. It has the added benefit of emphasizing the relationship between illusion and a world unfolding before us onscreen. (Projective illusion is, in this sense, a close relative of the diegetic effect.)[19] That said, even if Allen's projective illusion isn't deceptive, quite, it does seem to require that the viewer lose awareness that the world onscreen is an illusion. He hangs a lot on the word "fictional" to name the divergence between cinematic perception and the ordinary world, but it's not at all clear that the only illusory worlds manifest onscreen are fictional.

Christiane Voss suggests a better term: "aesthetic."[20] In an important theory of cinematic illusion and in terms very similar to those I am developing here, she writes, "The film spectator constitutes, as a resonating body in need of further determination, the illusion-forming medium of the cinema" (139). In this, "the spectator is neither object nor viewing subject of a technique of illusion that could be described independently of him or her" (139). Rather,

"reflection on the formation of illusion by means of and in the cinema thus leads to a new concept of cinema itself that includes the spectator's body" (139). In place of Allen's projective illusion, Voss argues that cinematic illusion indexes a difference between cinematic and ordinary perception, and we can only assign this difference the name "aesthetic." Arguing against a theory of illusion grounded in deception, Voss writes, "The fine distinction between illusionary perception and hallucination"—that is, outright deception—"consists in the fact that only illusion includes an aisthetic dimension in which perception and projection inseparably interact" (141). In other words, illusion carries with it a perceptual index that it is illusory; by virtue of this "aisthetic" dimension, we do not mistake illusion for reality—and we are not at risk of such a mistake.

Drawing on Vivian Sobchack, Voss argues that we are able to enliven the otherwise flat, merely represented, obviously absent events and objects onscreen only by means of a contribution of our body as a surrogate for the film, which she calls "projection." In Allen's and Voss's closely related concepts of illusion, then, the cinema is illusory in the precise sense that it represents objects, events, and others in a way that is deficient vis-à-vis reality—less vital, less convincing, less important. This deficiency is then made up for by an act of projection on the part of the viewer. Perceptually deficient, the cinema nevertheless represents objects, characters, and events in a way that may be affectively intensified; the illusion lies precisely in this coupling of perceptual deficiency and projective intensification. In Voss's words, "The difference between the mode of presence of the events on-screen and that of (empirical) reality may remain latently perceptible, but it is forced from the spectator's consciousness to the benefit of a perception of the events on-screen that includes projective additions" (143). Despite their efforts to overcome the deception theory of illusion, both Voss and Allen sneak it in through the back door: illusion is formed or occasioned precisely by the only-representationally-present, actually-absent real object.

Following Robert Musil, Voss wants to affirm the reality of illusion, in the sense of an operative aesthetic effect. To do so in a strong sense, however, we must pursue a different sense of illusion, grounded not in representation but rather in *movement*. Watching the Stargate sequence, immersed in its illusion, not only do I know I'm not really flying through space when I feel it, I cannot help but feel its illusoriness. Visceral, light-headed, giddy, it *feels* illusory—which is to say, it does not feel *like* real movement. There's nothing ersatz here: there is no object that might be absent. Instead, movement abides.

Motion and Illusion

In the remarkable first "phenomenological" chapter of *Film Language,* Christian Metz claims that cinematic motion is, in fact, real. He writes, "The objects and the characters we see in a film are apparently only effigies, but their motion is not the effigy of motion—it seems real."[21] He continues, "Because movement is never material but it is *always* visual, to reproduce its appearance is to duplicate its reality. . . . In the cinema the impression of reality is also the reality of the impression, the real presence of motion."[22] I must admit I do not know what he means when he says movement is visual instead of material. And yet it is clear that for Metz the motion of the screen image is not the ersatz motion of a real object but the real motion of an effigy of an object. For Metz, however, we do not confuse this effigy with the real object. The movement is manifestly real, and the attendant cinematic impression of reality is neither a deception on the part of the cinema nor a misrecognition on the part of the spectator.[23] It is an *impression,* not an illusion.

While compelling, it is hard to know, quite, what is at stake in this shift from impression to illusion. Like Metz, I want to affirm that the cinematic impression of reality is not a deceptive illusion and that it does not require a mistake on the part of the viewer. (And in any event, I am agnostic as to whether cinematic motion is usefully considered an illusion.) Nevertheless, between an object and its representation, we once again find a term that insists on an ontological distance between an object and its effigy. And Metz, interested as he is in signification and narration in *Film Language,* passes quickly beyond questions of movement and illusion, leaving us without adequate tools to conceive of that distance as anything other than the actual absence of a real object. Strangely enough, it is Metz's contemporary, Jean-Louis Baudry, who shows a way forward, although this is largely despite himself. This is strange not only because Baudry's account is so different from Metz's and because Baudry's apparatus theory has come to be seen as an excessive and perhaps embarrassing moment in the history of film theory, but also because it does not lead directly to a straightforwardly better account of illusion. Rather, he leads us to the phenomenology of perception—ordinary perception as well as cinematic. I may well seem to be taking the long way round here, but it is the only way I know, and the views are better.

Baudry's apparatus theory is better known for the way he likens the cinema to Plato's cave and Lacan's mirror stage, but his treatment of the "cinematographic illusion" of motion is unusual and suggestive. He likens the synthesis

of individual frames into continuous motion to Husserl's account of the intentionality of perception in the *Cartesian Meditations.*[24] He writes:

> The meaning effect produced [by the cinema] does not depend only on the content of the images but also on the material procedures by which an illusion of continuity, dependent on persistence of vision, is restored from discontinuous elements. These separate frames have between them differences that are indispensable for the creation of an illusion of continuity, of a continuous passage (movement, time). But only on one condition can these differences create this illusion: they must be effaced as differences.[25]

Baudry moves from cinematic motion derived from a succession of still images to an intentional act of perceiving an object through individual incomplete, perspectival views. In phenomenological jargon, these are adumbrations, individual moments of appearing (I shall have much more to say about adumbrations later). He writes, "The multiplicity of aspects of the object in view refers to a synthesizing operation" (292). To arrive at the unity of the intended object—that is, its very constitution *as* an object, for it is given to us only by adumbrations—the differences between individual adumbrations must be elided by a synthesizing activity on the part of the perceiving subject. Of the cinematic illusion, he writes, "Difference is necessary for it to live, but it lives on its negation" (290).

Schematically, in Baudry's account illusion, perception, embodiment, and technology come together in such a way as to underwrite not only the perceptual illusion of onscreen motion but also and more important the *ideological* illusion of a unified, transcendental subject. In Baudry's cinema the synthesizing activity of perception is absolutized, freed from the constraints of a body, detached from the constitutive partiality and finitude of human perception. He writes, "If the eye that moves is no longer fettered by a body, by the laws of matter and time, if there are no more assignable limits to its displacement—conditions fulfilled by the possibilities of shooting and of film—the world will be constituted not only by this eye but for it" (292).[26] In place of the thickness of embodied finitude, the camera's seemingly limitless movement and its ability to move *without* a body open the world in a radically new way. Baudry writes, "The mobility of the camera seems to fulfill the most favorable conditions for the manifestation of the 'transcendental subject.' There is a phantasmatization of objective reality (images, sounds, colors)—but of objective reality which, limiting its powers of constraint, seems equally to augment the possibilities or the power of the subject" (292). The world we

encounter in the cinema, then, is our world, but encountered without the constraints of our carnal body.

Our finitude seemingly attenuated, the character of the world is transformed: "The world is no longer only an 'open and indeterminate horizon.' Limited by the framing, lined up, put at the proper distance, the world offers up an object endowed with meaning, an intentional object, implied by and implying the action of the 'subject' which sights it" (292). Of course, what is effaced is precisely that this transformation is an illusion—it does not *really* occur. The objects we encounter onscreen seem somehow technologically, even ontologically, amplified, our access to them no longer located in the encumbrance of a fleshly body. But precisely *because* our encounter with the cinema really does depend on the encumbrance of the flesh, this seemingly more transparent access to the object is, for Baudry, not only deceptive but complicit, even corrupt.

Both Metz and Baudry connect a foundational condition of the cinema— the motion of its moving images—to a more thoroughgoing account of the impression of its reality.[27] Although Metz would move on from this phenomenological account, articulating positions very similar to Baudry's in *The Imaginary Signifier,* here they differ on the question of whether this motion is an illusion, and this difference is instructive. Baudry models the cinematographic illusion directly on our ordinary perceptual access to the world: each frame is like an adumbration. Schematically, this suggests either that all perception is illusory in a way similar to the cinema, or that the cinematographic illusion is not illusory in the deceptive or corrupt sense but has a different status. Metz's solution is to replace *illusion* with *impression,* indicating that although the motion is real, it nevertheless belongs to a different category from ordinary motion. In either case—and parallel to the problems in both Allen and Voss—the question of illusion is inextricably bound up with how we understand the relation between cinematic and ordinary perception.

A Phenomenology of Appearance

To elucidate this problem, I want to draw out Baudry's analogy between cinematographic illusion and perception. This analogy turns on what is perhaps most famous in Husserl's phenomenology: its *intentional* structure. Husserl's slogan is as follows: "All consciousness is consciousness *of* something."[28] According to this doctrine, consciousness—and by extension all perception—is relational. That italicized preposition is doing an awful lot of work.

As Renaud Barbaras argues, the fundamental question of Husserl's phenomenology is the nature of this *of*: the "ostensive function" of perception. What do we mean by *of* here? How are object and perception connected? What is the nature of the relation between consciousness and the world? This question, really, has oriented the entirety of the phenomenological program since its inception in the 1890s. But I do not want to get ahead of myself, nor bite off more than I can chew.

Rather than cut straight to the big, messy questions right away, we might start by constraining our question to that of intentionality in the cinema. Vivian Sobchack offers such an investigation in her groundbreaking phenomenology of the cinema, *The Address of the Eye* (and elsewhere). Her most famous concept, film's body, offers an important clarification of how we understand cinematic intentionality, starting crucially from the question of the camera's movement through space. She points out that the movement of the camera through diegetic space is not the transparent, unencumbered movement through the world Baudry presumes. Rather, as the camera moves I encounter such movement as an intentionality substantially different from my own. Thus I encounter the film as an embodied subject in its own right, with its own body different from my own. She writes, "The film emerges as an autonomous presence in its intrasubjective perceptive and expressive activity. That intrasubjective activity, however, is also intersubjectively visible in our presence. The film shares the theater with us as we share the existential structure of perception and a world with it."[29] Crucially, Sobchack shifts the question of intentionality in the cinema away from the analogy between my perception and the camera's, or between the technical conditions of the cinema and my embodied inherence in the world. Instead of asking about the brute technological apparatus of the cinema, she asks how these images appear to viewers in a cinema. In so doing, Sobchack shifts our emphasis away from the objects we intend in the cinema to their conditions of appearance. That is, she begins the work of a true phenomenology of the cinema.

Nevertheless, for Sobchack what we intend in the cinema—even as it is mediated through a machine, one that "can genuinely be said to have and live a body"—is an object in the world: "This embodiment relation between perceiver and machine genuinely extends the intentionality of both filmmaker and spectator into the respective worlds that provide each with objects of perception." She continues, "It is this extension of the incarnate intentionality of the person that results in a sense of *realism* in the cinema. However, this sense of realism is not—as theorists like Baudry would contend—an illusion" (181). Instead, this is a realism of perceptive experience of the world. In place of the

analogy between the cinematographic illusion and perception by adumbrations, Sobchack posits a similarity of intention between the fleshly embodiment of the spectator and the machinically embodied film. Such similarity is itself similar to that which we have with any other subject: we do not coincide with others but share a similar structure of intention. It is not, however, identical to an ordinary embodied, intersubjective relation. Rather, this relation is technically mediated: "Although the spectator is always partially aware *of* a mediating instrumentality, s/he is always also given partial perceptual access to a visible world *through* that mediating instrumentality" (199).

Sobchack's fundamental argument in *The Address of the Eye* is that the cinematic encounter is best understood as a complexly intersubjective one, in place of the deterministic accounts of the semiotic and psychoanalytic film theory that were dominant when she wrote the book. This argument requires her to emphasize a centering of intention: film, filmmaker, and viewer all intend objects in the world. Indeed, Sobchack's argument for film's body depends on its situation as mediating—even as what we mean by *mediating* shifts radically—the intention of a viewer intending an object in the world. This is a richly suggestive account, offering a way of approaching the "typical" case of cinema that is genuinely illuminating. That said, Sobchack organizes her account around the cinema's representational function, positing this function as formally similar to perception in the world. To put this another way, Sobchack emphasizes the fact that camera movement specifies intentionality different from my own. My emphasis is, by contrast, on the way camera movement engenders a voluptuously embodied perceptual effect. In the illusion of bodily movement, the cinema modulates my perception. We might see this as inverting Sobchack's account: if we can say the cinema has an intentional object, then it is not an object in the world but my body in the cinema. Instead of an inversion, however, let us not presume the cinema and its viewers have intentional objects. Instead, let us pursue an account of cinematic perception not organized by an account of intentionality.

Let us turn this question back toward *2001*, to the Stargate sequence and to the illusion of bodily movement. The second, most psychedelic segment of the sequence continues the forward movement that abides in the slit-scan shots (Plate 3). In the first of these, I feel again as though I am moving into the depth of the screen. My movement is specified here neither by colored lights nor by flight over landscapes but rather closely resembles our go-to image for spaceflight: stars radiating out from a vanishing point. Perhaps now we are flying into a nebula, tinted slightly blue? But this movement is aberrant, weird, thick. The center of the screen continues to give me the feeling of hurtling into

depth, but unlike the shots that open and close the sequence, this movement slows, shifts, and eventually dissipates at the edges of the screen. Rather more like *Anémic Cinéma*'s rotating discs, the depth that forms and my movement through it obtain only at the center of the screen, bounded by a rough circle: the cinema screen is once more, paradoxically, both a depth and a flatness. And also like the depth and movement that arise in Duchamp's film, the quality of the illusion here is more palpably illusory, is definitively not ordinary depth and movement—a depth and movement that do not belong to my ordinary, nor the cinema's. It is incorrigible, and it is also plainly impossible.

And yet in this encounter, I experience these not as opposing or conflictual terms. Rather, they belong to each other. I am bound to it; it unfolds before me; and I feel myself moving through it. Not only is my proprioception thematized, as it is in the other portions of the Stargate, but it becomes problematic. As space goes weird, so too does my ability to attune myself to it. In both proprioceptive reflexivity and palpable illusion, we find the cobelonging of terms that seem opposed. More to the point, however, we find ourselves in an encounter, resonating perceptually with the cinema, in which neither the feeling that abides—a visceral sensation of movement, a lump in my throat, my hands clutching the armrests, and so on—nor the space we fly through are represented or representational. More to the point, if consciousness seems to matter here, it matters not as consciousness *of* something: there is no object.

In *2001,* as in *Anémic Cinéma,* the cinema organizes a perceptual encounter attuned neither to consciousness nor to objects, but to the screen and that which appears on it. We attune ourselves to a world unfolding before us onscreen that is neither representational nor populated by objects. A phenomenology concerned with intentionality and with consciousness, much like an aesthetic criticism organized by modernism, will overshoot perceptual resonance of this kind, attending instead to the relations between subjects and objects, working to overcome the skeptical suspicion that we do not really know our objects. In Sobchack and Michelson, as in Husserl, phenomenology moves from "the things seen to seeing itself."

The alternative attends not to the things seen but only to their appearance. In place of a phenomenology of intentionality and consciousness—dominant in philosophy as well as film and media theory—in his remarkable study of Husserl, *Desire and Distance,* Renaud Barbaras outlines a phenomenology of *appearance.*[30] Because Husserl's doctrine of intentionality is so fundamental to the practice of phenomenology, displacing its centrality is no easy task. I will leave to Barbaras the extended critique of Husserl, offering instead a schematic overview of his project. The most schematic way of putting it is to

say that philosophy since Plato has concerned itself with a division between appearance and essence: philosophy deals with essences, whereas naïve perception dwells only in appearances. Even Kant postulated the essential noumenon behind the merely apparent phenomenon. As post-Kantian philosophy, Husserl's phenomenology, although it begins as a study of appearances, approaches appearance in an explicit project of finally really getting at essences. For Barbaras, however, phenomenology must renounce its concern with essences in favor of a focus on appearance. This has far-reaching consequences for phenomenology in general—and for a phenomenology of the cinema.

Primary among them is an approach to the cinema that suspends or brackets (in the famous *epochē*) the representational character of the cinematic image, studying instead its "mere" appearance. Understanding the cinematic image only as appearance has several benefits. First, it disrupts the norm of photographic, representational cinema, allowing abstract films—like *Anémic Cinéma,* the Stargate sequence, *The Flicker*—to count fully as films, no longer needing to be special-cased as somehow not fully quite counting as cinema.[31] Second, it demotes the importance of technologies of representation, such that a presumed ontological—or, for that matter, phenomenological—difference between digital and photochemical cinema, or live-action and animated cinema, will no longer occupy pride of place. Perhaps more important, it lays out a task for a phenomenology of cinema very different from the one that has been typical in recent film theory. In the work of "properly" phenomenological theorists like Sobchack and Jennifer Barker and in the more broadly "phenomenological" work of thinkers like Laura U. Marks, the critical emphasis has been on an analogy between the cinematic representation of objects and our ordinary perceptual access to them. In Sobchack's "What My Fingers Knew," for example, the correspondence between cinematic perception and ordinary perception is so great it somehow bypasses vision altogether, affecting Sobchack's fingers before her conscious awareness.[32] In no small part, this has led phenomenology in film theory to a project of articulating how films mediate objects in the world and, in turn, how the objects in the film affect us at a perceptual and embodied level.

(Here, I want to flag that what I am arguing runs parallel to Eugenie Brinkema's recent critique of how affect has been used in film theory.[33] I share both her complaints with the recent "turn to affect" and her desire for a (re)turn to a more formalist project. But I do not think, as she apparently does, that this entails dispensing with phenomenology as a practice. In fact, by turning to Barbaras—and later to Gibson—I am trying to articulate a phenomenological

practice that is on the side of formal description rather than the evocation of an inchoate shudder. This is why perception, not affect, is my primary category in this book.)

At a philosophical level and crucially for my argument here, Barbaras's rationale for a phenomenology of appearance is that Husserl's doctrine of intentionality is in fact a sort of skepticism hangover, despite Husserl's career-long goal of putting subject and object, experience and world, back together after they were sundered by skeptical (Cartesian) doubt. Barbaras discerns two opposing tendencies in Husserl's account of perception: "The first, which is supported by phenomenality itself, grasps the object directly through perception and recognizes within it a constitutive indeterminacy. The second conceives of the presence only as adequate givenness and therefore interprets the indeterminacy of perception as a deficiency or fault."[34] This latter tendency in Husserl's thought determines his doctrine that adumbrations are merely adequate, implying a more complete perception. It stems from Husserl's lingering attachment to the impossible skeptical ideal of a God's-eye view: totally determined, completely clarified, perspectiveless, absolute. Against this ideal, our finite, indeterminate, embodied, merely human perception will always fall short. And adumbrations, individual moments of perceptual appearance, will then seem to be "that which compromises access to the thing itself rather than giving it presence" (16). Skepticism longs for but can never find absolute determination; indeterminacy and finitude always appear as flaws. Thus, for Barbaras, even as he offers the tools to liquidate skepticism—most especially, the very concept of adumbrations—Husserl remains trapped by a latent skepticism.

One of the ways Barbaras puts this is that Husserl confuses the adumbration "with a sign or an image" (16). The adumbration is the mere image of, only a sign that points to, the real object. Meanwhile, most theories of the cinema make a complementary confusion, one that stems from presuming a correspondence (however mediated) between cinematic and ordinary perception: as theorists of the image, we reflexively presume images share the structure of an adumbration. Baudry makes this explicit with his moralizing judgment of illusion—but so too does Sobchack, just without the ideological (or ideology critique) baggage. And so we make a similar mistake, assuming the cinematic image is somehow an altered—ontologically deficient, epistemically deceptive, or subjectively mediated—re-presentation of the world. Paradoxically, this mistake entails both too radical a separation of the thing from its cinematic image and one not radical enough. It is too radical because it affirms what Husserl calls "an unbridgeable essential difference" or, in Bar-

baras's words, "an eidetic abyss" between image and object, as it really is, in all its plenitude.[35] It is not radical enough because it nevertheless affirms an ineluctable connection between the image and what the cinematic image is *of*. In this thought image and object are insuperably connected across a nevertheless unbridgeable difference.

Barbaras's methodological contribution is that, following Merleau-Ponty, especially his reworking of Husserl in *The Visible and the Invisible,* he shows us that phenomenology must thwart perception's "ostensive function," the *of*-ness of the adumbration, the structure by which it points to the thing *of* which it is an adumbration. We must avoid proceeding from the appearance of the thing to what Merleau-Ponty calls its "natural continuation," objective perception.[36] The reason we must do so is that by pointing emphatically and transparently at the thing, the adumbration itself tends to disappear in favor of the object. Barbaras writes, "In disappearing behind the object, in making it present, the adumbration is dissimulated as [a] specific moment and as such causes itself to be forgotten" (19). (Here we might hear an echo of how we must "forget" the ordinary world in Allen's projective illusion.) For Barbaras phenomenology must, in its *epochē,* arrest the movement from appearance to object. In other words, phenomenology must hold on to the adumbration as a moment, giving in neither to the naïve ontology of the natural attitude nor to the sophisticated naïveté of skepticism, which proffer the pure positivity of the ostentatious object as the measure of being. A true phenomenology of perception must dilate the provisional, partial, and porous nature of perception.

As for a phenomenology of the cinema, this will mean suspending its representational or ostensive vocation. This will entail also dispensing with any assumption of a photographic cinema. Roland Barthes writes that in photography "the referent adheres"; it speaks "a pure deictic language."[37] Ostentation, deixis, indexicality—it hardly matters which. Each is a pointing, an emphatic indication of an object that absorbs its image, its moment of appearance. The cinematic image is like an adumbration in this precise sense and only in this sense: it tends to disappear behind its objects. A phenomenology of appearance, when brought to the cinema, will not discover yet again a correspondence with ordinary perception, sustained by an object behind which both adumbration and image tend to disappear.

At a phenomenological or methodological level, this will mean describing the appearance of the cinematic image in a way that will explain rather than presume its capacity to represent objects. But let us turn back, once again, to how illusions—the stereokinetic effect, the illusion of bodily movement—

manifest themselves in the cinema, to the encounters we have with *Anémic Cinéma* and *2001*. Not only do these films give rise to a space that is not representational, they also dramatize how my proprioceptive attunement to that space and to the technical operation of the cinema is proprioceptively reflexive: I feel *myself* in an ongoing resonance with the cinema. The proprioceptive reflexivity in these encounters is the aesthetic and perceptual correlate of Barbaras's *epochē*, indexing not any objects we might see but rather the fact of my presence in and ongoing modulation by the cinema as a technological system. In other words, it indexes not the correspondence but the always palpable divergence between ordinary perception and its technical modulation by the cinema.

A Note on Technicity

If the cinema is a perceptual technology, then it is one that works not on objects, intentions, and representations but on appearances and resonances. By way of conclusion, I would like to briefly reprise the work of this chapter in terms of the technical operation of the cinema. The shift from a phenomenology of intentionality to one of appearance can be stated as a shift in how we understand the technology of the cinema: from Baudry's apparatus theory to a notion of technics borrowed from media theory.

If for Baudry the cinema is an apparatus (or, as is now common to say in English, a *dispositif*), this is because it is at once a perceptual and an ideological technology.[38] Baudry's sense of an apparatus is not coincidentally but fundamentally both. As we have seen, on his account, the technology of the cinema not only offers perceptual release from the bonds of human finitude but does so in favor of the illusion of a unified subject position, even a God-like ubiquity. Metz's presentation of the same concept, citing Baudry, is clearer and more concise. In Metz's terms the operation of the apparatus goes under the name "primary cinematic identification" and takes place at the level of the bare technical functioning of the cinema.[39] Metz argues that the cinema's perceptual work of manifesting a world onscreen and demanding proprioceptive attunement to it is then recaptured by an ideologically freighted and psychically anodyne subject position in one or several secondary cinematic identifications that play out at the level of representation. It is not difficult to see how even Sobchack's revision of this, offering a "centering of intention" in place of identification, repeats the central feature of the apparatus theory of the cinema: the cinema's representational function captures, organizes, or determines its spectators' experience.

Apparatus theory gave an important theoretical basis for a broader project in film theory, an ideology critique that took its cues not only from Metz and Baudry but also from Laura Mulvey and Louis Althusser—thinkers who, as Rey Chow shows, placed their faith in a modernist critical reflexivity inherited from Brecht. This model and this project prioritizes representation over perception, often eliding the perceptual and properly technical work of the cinema, preferring instead to speak of the ideological work of individual films. Barbaras offers a phenomenological perspective that revalues and demotes this priority, suspending as it does at once the cinema's representational (and therefore ideological) vocation in order to describe the cinema's perceptual and, indeed, proprioceptive work.

To describe the technological operation of this work, in place of apparatus theory we ought instead borrow from media theory. Media theory, or at least a certain strain of it that includes Marshall McLuhan, Bernard Stiegler, and Mark B. N. Hansen, allows us to attend to the operation of the cinema at a level neither organized by representation nor freighted by ideology. Importantly, this does not mean a media-theoretical understanding of the cinema's operation will not be political; it will mean instead a displacement of its politics away from being, in the first instance, representational. In particular, I want to borrow Stiegler's phenomenological theory of *technics,* which is an important tool in this regard. His laconic definition of technics is as follows: "As a 'process of exteriorization,' technics is the pursuit of life by means other than life."[40] Stiegler's definition in some sense reprises McLuhan's foundational theory of media; you might simply read McLuhan's "extension" for Stiegler's "exteriorization."[41] In both authors' work and in this media-theoretical thought more generally, technics are "organized inorganic beings" that take on living functions of human beings, functioning only in a coupling between the human and the technical.[42] McLuhan's figures for this include his depiction of humans as the sex organs of the machine world and the extremely problematic image of the Indian being a servomechanism of his canoe.[43] Nevertheless, McLuhan and Stiegler allow us to understand a technical operation as an ongoing, durational coupling. A theory of the cinema as apparatus will emphasize the work of the apparatus on its human spectators; a theory of the cinema as technics will instead construe the cinematic encounter as an ongoing coupling of humans and technics.

That said, even Stiegler's theory of the cinema emphasizes its essentially representational character, casting it as a form of memory (in the jargon, "tertiary retention"), emphasizing how its vocation of photographic representation has reorganized industrial and postindustrial temporality.[44] His basic

thesis is that "organized inorganic beings [read: technics] are originarily . . . *constitutive* (in the strict phenomenological sense) of temporality as well as spatiality" (17). In fact, for Stiegler, in an evolutionary sense, technics are constitutive of the human. As both Hansen and Amy Villarejo point out in their respective considerations of Stiegler, the human's coupling with the cinema will not only take on a decisively temporal character but do so by a reconfiguration of our capacity to remember.[45]

Glossing Stiegler's account of our coupling with cinema and television, Villarejo stresses the way the "flux of the temporal object (both its visual and aural elements) coincides with the flux of the spectator's consciousness of which it is, in turn, the phenomenal object."[46] Understood representationally, in Stiegler's terms this means the cinema becomes "an artificial memory of what was never perceived," the flux of the film substituting for the flux of lived experience.[47] If we recast this in nonrepresentational terms, however, we can begin to see a way to conceptualize the cinema as a technology for the ongoing modulation of perceptual resonance. The cinema's flux as a temporal object might not determine its viewers' phenomenal object but rather index its ongoing work of modulation. Furthermore, we will want to hold fast to the insight that this perceptual modulation never achieves total transparency, remaining as we do always aware of our situation in a cinema, even in our most intense moments of self-loss. Cinematic perception always carries with it a margin of palpable illusion present in perception as proprioceptive reflexivity, which we have seen Voss describe as its aesthetic dimension. How then are we to describe, in concrete terms and without recourse to a concept of representation, the technological and indeed aesthetic work of the cinema in its temporal flux as it modulates its viewers' perceptual resonance?

3 ECOLOGICAL PHENOMENOLOGY

Merleau-Ponty and Gibson

Unlike the other chapters, this one is explicitly methodological, developing a formal, descriptive vocabulary for cinematic perceptual and proprioceptive resonance. While I continue working with *2001*'s Stargate sequence as my primary example, my concern here is less the film and its aesthetic problems than it is developing an ecological phenomenology as an antiskeptical and nonrepresentational approach to theorizing about the cinema. Ecological phenomenology combines insights and methods from American perceptual psychologist James J. Gibson's ecological approach to perception and Merleau-Ponty's phenomenology of perception. While certainly not identical, these approaches share several important commitments: their antiskeptical and antidualist orientations, their revision or rejection of "traditional" accounts of perception, their dedication to forms of description that are operative at the level of phenomenal experience, and their theoretical program that construes *perception* as a durational, relational, and indeed, resonant term—between a subject and the world for Merleau-Ponty and between an organism and an environment for Gibson. Both the ecological and the phenomenological approaches to perception allow for a rich, philosophically precise and aesthetically evocative description of the overlapping acts of the cinema's perceptual modulation and its viewers' perceptual attunement that are the basis of the cinematic encounter.

I use the term *ecological phenomenology* with some hesitation. While *ecological phenomenology* is definitely the right term for my approach in this book, it might also feel like a bit of a misnomer. We have seen a recent and increasing interest in what might go under the heading of *ecological humanities* (especially since I first began working on this project in 2007), whether this be ecocriticism or a concern with the "ecology of things."[1] And indeed, while I have affinities with both older and more recent work that goes under

the moniker *ecological* (e.g., Gregory Bateson and Timothy Morton), my use of the term here comes entirely from Gibson. His use is idiosyncratic in that it designates the baseline position that perception is a capacity organisms evolve for attuning to relevant features of their environment.[2] Gibson has more in common with Jakob von Uexküll than with Jane Bennett.[3] Which is just to say, although my position here may well have affinities with other ecological work in the humanities, such affinity is neither obvious nor especially intentional.

Rather, my aim with this formulation of ecological phenomenology is an approach to the cinema and its perceptual vocation that can describe how it gives rise to a world unfolding before us onscreen, without making recourse to an assumption of representation or photographic ontology. In this chapter I work out a way of bringing Gibson and Merleau-Ponty together that allows me to offer an account of cinematic illusion in which illusion engenders not skepticism but faith in a world unfolding before us onscreen.

To do this, I first introduce Gibson and his basic positions, paying particular attention to his criticisms of "traditional" accounts of perception, which mirror Barbaras's criticisms of Husserl's doctrine of perception as adequate givenness, as I discuss in chapter 2. Then, I outline the ecological approach to perception in greater detail, emphasizing those aspects of Gibson's account of perception that resonate with Merleau-Ponty's phenomenological approach to perception, in particular Gibson's doctrine of perceptual resonance. Next, I offer a description of the cinematic illusion of bodily movement—cinematic kinesthesis—in ecological terms, once again using the Stargate sequence as my example. In particular, I argue that the cinema's modulation of vision entails a suspension of the embodied and postural constituents of vision. Finally, developing a positive concept of illusion, I set Gibson's ecological approach in direct relation to Merleau-Ponty's phenomenological account of *perceptual faith*. Throughout, my aim is to present an account of the ecological approach and ecological phenomenology that is correct in the details but does not get bogged down in them. Even while this chapter moves away from a cinematic or aesthetic object, my fidelity to the particulars of each theory of perception is in the service of my overarching goal of an account of the cinema as an aesthetic technology of perceptual modulation.

The Development of Ecological Optics

Gibson's ecological approach was formulated most significantly in his last book, *The Ecological Approach to Visual Perception*.[4] It came at the end of a

long and productive career of theorizing about human perception, with an emphasis on perceptual competence and action. When I first encountered the ecological approach, I was struck, even stunned, by the frankly surprising consonance between Gibson's ecological approach and Merleau-Ponty's phenomenology, particularly given their almost completely independent development on different continents, in different languages, in different disciplines, and with different goals. I am, of course, not the first to have noticed this.[5]

As a matter of intellectual history, we do know that Gibson read Merleau-Ponty's first book, *The Structure of Behavior*, and some of the *Phenomenology* but was not particularly influenced by them.[6] Meanwhile, Gibson and Merleau-Ponty share a common ancestor, as it were, in William James. On the one hand, James had substantial influence on Husserl, whose influence on Merleau-Ponty hardly needs to be stated.[7] On the other, Gibson's doctoral advisor at Princeton was Edwin B. Holt, who received his doctorate from William James's psychology department at Harvard.[8] For the full intellectual-historical picture in all its weird intersections with the history of film theory, we must add that Holt's adviser in James's psychology department was none other than Hugo Münsterberg, often considered the earliest theorist of film (along with Vachel Lindsay).[9] (Although, Münsterberg and James were apparently often at loggerheads.) To be sure, this anecdotal history doesn't really explain very much. Rather, the consonance between Gibson and Merleau-Ponty is to be sought in their shared conceptual problems.

I would, however, like to pause here to acknowledge some difficulties in my attempt to make what is, after all, a quantitative approach to scientific problems available to humanistic thinking. My strategy has been to outline particularly important aspects of the ecological approach without aspiring to completeness. My goal is not a total unification of these two approaches but rather their productive collaboration in the task of describing the cinematic modulation of perception. I give a highly synthetic and syncretic account, often summarizing rather than quoting, drawing from common arguments across multiple sources, and relying heavily on footnotes for both references and commentary. In part, this strategy ensures I can offer an account of the ecological approach that is accessible to an audience of humanities-oriented film scholars.[10] As I am neither a philosopher nor a perceptual psychologist, I can afford to bring these two approaches together in a way bound not to disciplinary integrity but rather to the phenomena at hand.

The most obvious point of agreement between the phenomenological account of perception and the ecological approach is their nearly identical break with what Gibson calls "traditional"—that is, metaphysical and

skeptical—accounts of perception. The ecological approach usually starts by differentiating itself from these traditional approaches to perceptual psychology. In an exemplary if hyperbolic essay, Michael Turvey and Robert Shaw claim the ecological approach is a radical break from the past *five hundred years* of theorizing about perception.[11] Gibson himself spends much of his *Ecological Approach* criticizing traditional theories of perception. Although not identical, these traditional positions generally agree, in the broad strokes at least, with Husserl's doctrine of adumbration as "adequate givenness" that is the object of Barbaras's critique. These are, most famously, sensationalism, empiricism, behaviorism, and cognitive psychology, among others.[12] When Husserl and others use the word *adequate* to describe perception, we must also always hear its modification by a silent *merely*; adequate perception is adequate by virtue of its distance from a presumably total or perfect perception and is thus always, at the same time, somehow inadequate. Traditional approaches to perception are effectively all skeptical, affirming as they do perception's deficiency with respect to its objects and the world.

There are two customary and related ways of arriving at the conclusion that perception is merely adequate. The first, called the argument from illusion, consists simply in noticing that there are sometimes illusions. From this, it supposedly follows that perception does not grasp the world transparently, as it is in itself. The second, sometimes called the argument from insufficient specification, is closely related to Husserl's doctrines and complements the argument from illusion. It begins by observing that retinal images are ambiguous with respect to the world. In principle, a given retinal image—at least when it is taken instantaneously, severed from the flux of ongoing perception—could correspond to an arbitrarily large number of arrangements of objects in the world. (Illusions such as forced-perspective rooms are supposed to illustrate this point or something similar.) On this account, because perceptual information is insufficient to give us the object or the world itself, we must perform some variety of interpretation on the impoverished information our senses receive. Because our perception thus relies on interpretation, it is sometimes wrong. When such an interpretation is wrong, we call this a mistake; when such interpretations are systematically wrong, we call this an illusion or a "systematically nonveridical percept."[13] Traditional approaches to perceptual psychology can be characterized as the study of how we (our bodies, our minds, our perceptual or nervous systems) perform such interpretation. In both cases illusion indexes the deficiency, the unbridgeable abyss, between our perception and the world as it is.

The ecological approach to perception rejects all of this. Even before he formulated the ecological approach, Gibson was concerned with the failures of traditional theories of perception to account for the natural facts of perception, most especially perceptual performance. Happily for my purposes here, Gibson's early research was on the cinema: he conducted research for the U.S. Army as part of the effort for World War II, investigating how best to teach American farm boys to fly planes using motion pictures. His first published monograph is entitled, rather unglamorously, *Motion Picture Testing and Research.*[14] In large part, his criticisms of traditional theories of perception began because these theories simply couldn't account for the manifest human ability to land planes. As he notes in an autobiographical piece:

> The classical cues for depth referred to paintings or parlor stereoscopes, whereas the practical problems of military aviation had to do with takeoff and landing, with navigation and the recognition of landmarks, with pursuit or evasion, and with the aiming of bullets or bombs at targets. What was thought to be known about the retinal image and the physiology of retinal sensations simply had no application to these performances. Birds and bees could do them, and a high proportion of young males could learn to do them, but nobody understood how they could.[15]

Even in his early research in the army, a successful theory of vision would have to include successful performance and holistic action. This emphasis would continue throughout his career.

Following from his work for the army, Gibson's research would often return to the problem of *visual kinesthesis,* or how vision is involved with our sense of moving through an environment. This particular problem was an essential part of his program. How can we describe the physical world and our perception of it (and in it) in ways that could account for complex behavior grounded in locomotion and action? From the beginning, Gibson's investigation of visual kinesthesis involved a description of the phenomenon of cinematic kinesthesis. If the cinema can offer an illusion of moving through the world, then certainly, the cinema must be doing something at least partially consistent with what happens visually when we move through the world. It makes an appearance as early as 1947 in his foundational description of the cinema in *Motion Picture Testing*:

> The obvious characteristic which may be possessed by the stimulus material of a motion picture test is movement. It is important to note that two different and distinct kinds of movement-perception may be induced on the screen,

movement of *objects* and movement of the *observer himself.* Particularly in the latter case, the motion picture yields an enhanced perception of the three-dimensional quality of the space portrayed on the screen.[16]

In an early article dedicated to the problem of visual kinesthesis, "Visual Perception of Objective Motion and Subjective Movement,"[17] Gibson writes:

> The analysis of motion perspective for a large portion of the visual field, also mentioned earlier, suggests that the impression of *forward* movement of the observer can be produced optically without any contribution from the vestibular or the muscle sense. . . . The closest approximation to it is an informal study based on a motion picture of the landing field ahead of an airplane during a glide. Observers reported an experience of locomotion along a glide path toward a visible spot on the ground. This perception was clearly, however, an "as if" kind of experience, pictorial rather than natural. . . . It is said that the panoramic motion picture (especially the "Cinerama") induces even more compelling experiences of locomotion, such as a ride in a rollercoaster.[18]

While Gibson never described the cinematic illusion of bodily movement in a more sustained manner, the reciprocal importance of cinematic and visual kinesthesis is clear already from Gibson's work in the 1940s. From the perspective of the historical development of the ecological approach, the interrelation of visual and cinematic kinesthesis formed an important aspect of his criticisms of traditional theories of perception. Cinematic kinesthesis may well have been a factor in his formulation of the ecological approach. While much in his thinking would change in his development of the ecological approach in the 1960s and 1970s, what stayed constant in his thinking was an emphasis on the indissociability of perception with action and a thoroughgoing affirmation that perception is wholly commensurate (and not merely adequate) to the world and to our action in the world. He developed an analytical frame that never failed to construe perception as durational, insolubly linked to terms like *locomotion* and *action,* eventually culminating in his formulation of the ecological approach to perception.

The Ecological Approach to Perception

The ecological approach to perception builds on a foundational definition of perception as an ongoing adaptive relation between an organism and an environment arising as a result of evolution. Perception is something that organisms evolve as a way of responding to the potentials for acting or being-

acted-upon in their environment. In Gibson's formulation perception is a property of an ecosystem and not of an organism—hence the term *ecological*. In a phenomenological idiom, we would say that perception does not take place in me but in the world (and I am part of the world).[19]

A few things follow from this. From an evolutionary perspective, perception cannot mean the perception of what philosophy and psychology have called *primary qualities*—location, extension, shape, etc. Rather, organisms' perceptual capacities are tuned to the relevant aspects of their environment and potentials for acting. Gibson calls these *affordances*.[20] We have evolved a perception that perceives that this solid, stable, even ground affords waking on, the edge of that cliff affords falling off, that apple affords both eating and throwing, that chair affords sitting on, that doorway affords walking through. It is one of the hallmarks of the ecological approach to say that perception is fundamentally perception of affordances and not of qualities.[21] Crucially, such affordances are not *in* the environment any more than they are *in* the organism. It is neither in my head nor in the chair that I can sit down on it.[22]

Because perception is always taken with reference to an organism, it does not resemble a transparent and total opening onto the world. It is constrained, finite, local, and enmeshed in the actual, ongoing lives of organisms (including humans). Gibson says variously that we are *attuned* to our environment or that we *resonate* with it. Gibson's overarching goal was to put perception back into the flux of actual life, enmeshed in duration. We constantly scan our environment with our eyes and our head. We move about. We explore. Perception is *ongoing*.[23] The skeptical ideal of an instantaneous, total, transparent knowledge of the world is an invention against which actual perception will always fall short.[24]

Gibson instead teaches us that an adequate theory of vision ought not deal in terms of retinal images, sense data, stimuli, or nerve impulses—the objects of traditional perceptual psychologists. Visual perception itself does not start with a fundamentally ambivalent retinal image and seek from there to construct a world or a representation of the world or our phenomenal experience of the world. (In any event, retinal images are fundamentally ambiguous only if considered instantaneously, severed from the ongoing flux of actual perceptual life.) And so the study of perception must not start with retinal images or sense data or other phenomenally unavailable analytical units. Instead, we ought to study *the world,* how it structures the information in it, and what the information in the world *specifies.* If our perception is a resonance with the world, then our analytic frame must start with our encounter with the world.

For Gibson perception is fundamentally attuned to *variation* in the world. He writes, "The perceptual system simply extracts invariants from the flowing [optic] array; it *resonates* to the invariant structure or is *attuned* to it."[25] This is why perception's ongoing nature is so important: invariants can emerge only from variation, what he calls optical flow. Our visual system is in constant movement. We move our bodies, our heads, our eyes, and even parts of our eyes nearly constantly. Because of this movement (conscious and unconscious: our eyes make nearly constant subconscious eye movements, *saccades*), the optic arrays that our eyes receive constantly change, even when the environment is still.[26] And usually, the environment is anything but. Variant and invariant structures are picked up both in these optic arrays themselves and (more important) by a differential operation across a changing optic array. As we explore, as the environment changes, as the optic array changes, we gather information about the environment.[27] These changes specify either variant or invariant properties of the environment: the ground beneath me, the walls around me, the light from that lamp; or the bird flying overhead, the waves breaking on the beach, my own changing position in the environment.

In an ecologically oriented study of perception in the cinema, James Cutting catalogs nine sources of "visual" information from which we perceive space and our position in it.[28] These sources specify (among other things) the spatial variants and invariants of our environments, including our position in and movement through them. They are as follows:

1. *Occlusion* is perhaps the most intuitive of these sources of information: parts of the environment occlude one another. Gibson puts great emphasis on occlusion; he dedicates a chapter to it in *The Ecological Approach*.[29] Features in the environment occlude one another, and this gives valuable spatial information about the layout of the environment. Occlusion follows rules, the most important of which is *reversibility*.[30] It is a transformation in time, and it can be undone by the proper reverse movement. As I move, some features of the environment become hidden behind others; as I move back to my point of departure, they reappear. Moreover, the occluding edge is not only a property of objects in the environment but also a property of the edges of our visual field, which are also reversible. Gibson suggests that occlusion and its reversibility are actually crucial aspects of the intersubjective nature of the world.[31]

2. *Height in the visual field* replaces the traditional notion of angular sizes of features of objects in the retinal image. Rather, it is a measure of an object's position and height relative to the horizon, actual or implied.

3. & 4. *Relative size* and *relative density* are both taken with respect to other features in the environment, instead of the horizon. Relative density is similar to relative size but is related to the surface texture of a feature rather than its contour.

5. *Aerial perspective* refers to the way parts of the environment that are farther away are hazier because of the thickness of the atmosphere. (Da Vinci is typically held up as a master of aerial perspective.)

6. *Accommodation* refers to the muscular adjustments of the lens in the eye in order to shift the depth of focus.

7. *Convergence* refers to differences in the angle of each of the eyes. Because the eyes are separated by a small distance, to focus on a single point in (three-dimensional) space, the two eyes must point in slightly different directions. The difference in directions varies in inverse relation to the distance of the object: the closer the object, the greater this difference, the greater the angle of convergence. To look at something very close to my face, I have to cross my eyes significantly; to look at something in the middle distance, I cross my eyes significantly less (though they are still crossed). This information is specified by the orbital muscles around the eyes, indicating their orientation with respect to the head.

8. *Binocular disparity* indicates the difference in visual information the two eyes receive. This comprises two different aspects of these differences: the duplication, with slight differences (e.g., of angle), of a portion of the environment around the focal point; and the peripheral portions of the visual field that appear only in one eye or the other.

9. *Motion perspective* comprises the geometrical and physical rules of transformation of the environment as I move through it. This includes both the rules of parallax motion as well as the subtle rotation of objects relative to the observer as she moves past them. This is a separate category in part because it describes a complex of interrelated transformations of the visual field, which are not limited to any one of these other sources of information but rather cut across all of them.

While some of these seem to be in the body (lens accommodation) and some seem to be in the world (occlusion), each of them furnishes information about the world *from here,* where I am. Their information is essentially and fundamentally relational, local, and perspectival: in other words, proprioceptive. In addition to Cutting's list, several sources of perceptual information, traditionally considered proprioceptive—i.e., specific to the body's position in space—are also crucial to cinematic perception, especially postural

and vestibular information.[32] As Gibson puts it, "One sees the environment not with the eyes, but with the eyes-in-the-head-on-the-body-resting-on-the-ground. . . . The perceptual capacities of the organism do not lie in discrete anatomical parts of the body but lie in systems with nested functions."[33] Furthermore, "perception and proprioception are not alternatives or opposing tendencies of experience but complementary experiences."[34] Cinematic kinesthesis is essentially both a perceptual and a proprioceptive phenomenon. And indeed, the palpable feeling of movement occurs not somehow in the eyes (which would be quite strange) but rather in the body.

The ecological approach emphasizes that perception is embodied. It does not limit its view of vision, as traditional accounts of perception do, to the eyes and the brain. Nowhere do retinal images, sense data, or perspectival views of objects occur here. Three important points of convergence with phenomenology follow from this. First, the ecological approach does not rely on conceptual entities or explanatory terms that are constitutively unavailable to experience, introspection, or phenomenal description. While some of these concepts may be counterintuitive, all of them can be attended to in perceptual experience. The descriptive vocabulary of the ecological approach is basically amenable to use in phenomenological description. Second, vision is not in the eyes, nor can it be usefully considered a separate sense modality, one of the traditional five senses.[35] It is embodied, involving the body in manifold ways. Third, sources of visual information are all *relational* terms. In Barbaras's words, "The subject relates itself to the world."[36] In the context of the ecological approach, these relations may be between parts of the optic array (i.e., relations between parts of the environment) or between myself and the world. Perceptual furnishes information about my situation in and relations to the world.

For Gibson perception is relational, durational, differential, and redundant. We have seen how it is relational, relational, and differential. Its redundant nature stems from his doctrine of *covariation*. The world, our bodies, and the relations between the two ordinarily structure information so that, as information about the world through one source changes, the information furnished by another source changes as well. As I approach that fire, not only does the flame grow larger in my field of vision, but the heat I feel on my skin intensifies, as do the smell of the wood smoke and the sound of the flame. This holds even within vision. As I bring an object closer to see it better—the page of a book, the screen of a cell phone, or a needle to thread—not only does it increase in relative size and density, but the lenses in my eyes shift to keep it in focus, my eyes cross subtly to keep it centered in each eye, the

occluding edge of my nose becomes more pronounced at the inside corner of each eye, and so on. These *covariations* are regular and can be described as following certain rules, which are described by *ecological physics.*[37] When transformations in the environment (or on a cinema screen) conform to this physics, they can be said to be *ecologically valid.* Perhaps most important, however, as variation requires duration, covariation can occur only in time.

Returning to cinematic kinesthesis, we must hold fast to the insight that in ordinary perception these sources of information are consonant and redundant. Our perceptual resonance with the world involves the mutual reinforcement of such resonance across multiple sources of information. *This is not the case in the cinema.* In fact, it is *never* the case in the cinema. The cinema ruptures, suspends, transforms, disorders—it modulates—the covariance of sources of perceptual information. The perceptual modulation of the cinema is a matter of its control over these sources of information, in time, *and their degree of covariance.* The cinema modulates our ongoing percept esonance with the world.

An Ecological Description of the Cinema and Its Kinesthesis

As a way of characterizing this modulation, I want to offer a description of the cinema in Gibson's idiom. The value of this description, as well as the ecological approach, lies in how it complements the more humanistic phenomenological project of description. It is technical or formal where phenomenology is literary or evocative. And importantly, it meets (with a few shifts in accent and emphasis) the requirements of an approach to the cinema concerned not with representation but with appearance and with the embodied perceptual encounter with the cinema.

Let's start with the obvious. The most basic feature of the cinema is a screen, a bounded rectangle. On this screen is projected an image. We can call this, following Gibson, the *cinematic array,* cognate to the optic array. The screen is a relatively constant distance from a viewer in his or her seat. The screen is surrounded by a darkened and mostly invariant room, usually kept as featureless as possible (with the exception of the red glow of those annoying exit signs). The cinematic array typically (but not always) changes over time, offering ongoing, covariant visual information to its viewers.[38] This covariance, however, is limited, constrained, or suspended. In the case of the photographic, representational cinema, this optical array presents changes that conform, roughly speaking, to the world (although the focal length of a lens can distort such ecological validity by changing the relations between depth

and height and width; such distortion is at work in combined dolly/zoom effects, e.g., in Hitchcock's *Vertigo*). And yet however ecologically valid a film may be, the sources of information that covary in the cinematic array can be *only* those available to the camera.[39] These are relations that are in the environment in relation to the camera as a (fixed or moving) point in the world, but not those relations that span the body's posture in the environment. Only certain sources of perceptual information can covary in the cinematic array; others simply cannot. The cinematic array offers less information and less information redundancy than ordinary perception does.

The sources of information the cinema can modulate are occlusion, height in the visual field, relative size, relative density, aerial perspective, and motion perspective. The cinema can also offer a sort of approximation of accommodation in various manipulations of focus (e.g., focus pulls). For the most part, features in the cinematic array occlude one another following ecologically valid rules of occlusion, including, most important, the occlusion at the edge of the cinematic frame. Parts of the environment follow the rules of changing height with respect to each other and to the camera. Echoing Sobchack, in a rough-and-ready approximation we can say that in the cinema I see just what the camera sees, from where it sees, according to how it sees. And for the most part what I see and what the camera sees are similar not just in substance but in form. Nevertheless, this information does not, *can never*, covary with certain other sources of information (more on this in a moment). My basic contention here is that the sense of illusoriness—that is, the locus of illusion in the cinema—lies in *departures* from the rules of ecological validity. In other words, illusion indexes any departure from the regular covariation of information in ordinary perception, in ordinary environments. Illusion is endemic to the cinema, but this illusion is not an ontological deficiency.

Let me elaborate (and please bear with the jargon for a moment). Because the screen is at constant and relatively significant distance from the viewer, accommodation, convergence, and binocular disparity do not covary with the movement of objects. Because of this, I always have a sense of my distance from the cinematic array, even as I may also have a paradoxical sense of proximity to the object. An illuminating exception here is 3D film. It has seen a recent renaissance, stemming from the same general trend toward ever more explicit, intense, overwhelming, and ostentatious perceptual manipulation in the contemporary mainstream cinema. In this case, through a variety of technical means, binocular disparity is reintroduced as a source of spatializing information. Each eye receives slightly different images from the screen, and these slight differences are (meant to be) consonant with other sources

of information on the screen (occlusion, height in the visual field, and so on). However, neither accommodation nor convergence are affected: I do not need to shift the lenses in my eyes nor cross my eyes to keep an object fixated and in focus. The odd and insubstantial feeling of many 3D films can be attributed to the absence of covariation of accommodation and convergence with the cinematic manipulation of binocular disparity. It is, of course, more complicated than that. In films like *Avatar* or *Gravity,* where 3D techniques are used primarily to create depth behind the proscenium, the illusory depth is reasonably transparent. The flimsiness of 3D objects is rather more apparent with films that project elements into the space of the cinema (a routine attractional gimmick in most 3D filmmaking before the recent cycle of middlebrow 3D films). This is because, as an object gets closer to you, the covariations between binocular disparity, accommodation, and convergence actually increase. As objects get closer to you, their illusoriness increases, taking on a weirdly flimsy aspect.

Returning to the Stargate sequence, we can now say that throughout the sequence the cinema is *specifying movement.* In fact, it includes three different ways of specifying movement (or, more precisely, quasi movement) through an environment. First, the slit-scan sequences offer movement toward a flat, featureless horizon over a landscape devoid of topographical variation (Plates 1 and 2). We might call this the degree zero of cinematic kinesthesis. The most important factor here is motion perspective, which Gibson suggests could also be called flow perspective.[40] Recall that motion perspective is the set of rules that describes transformations in the optic array specifying my movement through an environment. In fact, it is a special set of covariations across multiple sources of information, including but not limited to the following: occlusion, particularly in the case of parallax motion; relative angular change of the flowing optic array (i.e., different rates of flow in different parts of the visual field); the slight counterrotation of features in the environment as the aspects that face me change; and basic feature constancy in terms of relative size, relative density, and height in the visual field. Motion perspective also involves the arrival of features over a horizon.

In the case of the slit-scan portion of the Stargate sequence, the cinematic array specifies movement through an environment, but only through certain sets of covariation. It provides centrifugal outflow of the array from a focus of expansion on the horizon, the focus of which specifies the direction of our movement.[41] This outflow is slowest in the direction of our travel and increases toward the edges of our screen. This flow is given to us almost entirely in the texture of variously colored lights unfolding toward us. These

lights specify the invariant features of a landscape—variously colored but otherwise featureless planes above and below—unfolding toward us. These invariants are specified by a gradient of relative density that covaries with differentials in flow velocities, dictated by ecologically valid motion perspective. In addition, a horizon appears, as a zero line, the vanishing limit, of outflow.[42] This outflow increases in speed toward the edges of the screen. It is greatest where it stops at the edges of the screen.

The other configurations of cinematic kinesthesis in the Stargate sequence work differently. They provide, suspend, and modulate the covariations of ecologically valid motion perspective differently. The third sort of movement, helicopter shots through landscapes with color and luminescence values altered, nevertheless proves more compelling and less insubstantial (Plate 4). As opposed to the featureless planes of the slit-scan shots, these landscapes have more familiar environmental features. Movement here is not quite so absolutized or abstracted; it feels like movement through a world. The covariation within motion perspective here is more substantial—that is, more redundant. This increased covariation stems entirely from the features in the environment. Mountains and rocks rotate subtly to reveal their occluded aspects. Their heights in the visual field stay constant even as their relative size and density do not. Thus populated by environmental features, the cinematic array carries within it more redundant, covarying information specifying movement through an environment.

The weird, uncanny nature of quasi movement in the second sequence stems from an exaggerated rather than attenuated rupturing of ecologically valid covariation (Plate 3). It violates the rules of flow perspective while maintaining some of its features. The most important violation lies in its disordering of differential angular velocity. The cinematic array still expands radially around a focal point, specifying a point toward which I feel like I am traveling. Like ordinary movement, this expansion accelerates as it moves away from this focal point. It then slows, however, after only a few degrees. During ordinary movement, the angular velocity of expansion from the focal point increases until 90 degrees from the direction of travel (that is, at three and nine o'clock) and then decreases until it reaches the focal point at 180 degrees, which I am traveling away from. If I am facing the direction in which I am traveling, the angular velocity of features of the environment is greatest in my peripheral vision. In the psychedelic second sequence in the Stargate, the paradoxical cobelonging of flatness and depth stems from this aberrant flow, having its experiential correlate in a frankly weird experience of moving-

Plate 1. Douglass Trumbull's slit-scan machine in the Stargate sequence of *2001: A Space Odyssey* (directed by Stanley Kubrick, 1968).

Plate 2. Another example of Trumbull's slit-scan machine at work in *2001*.

Plate 3. Space goes weird in the second, "psychedelic" section of the Stargate sequence in *2001*.

Plate 4. Flyover shots of a recolorized landscape in the third section of the Stargate sequence in *2001*.

Plate 5. Movement is specified by nothing more than streaks of light in *Koyaanisqatsi: Life Out of Balance* (directed by Godfrey Reggio, 1983).

Plate 6. Another example of abstract movement in *Koyaanisqatsi*.

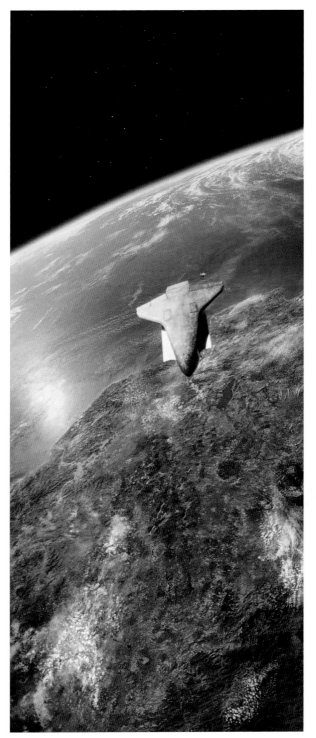

Plate 7. The space shuttle moves into view ambiguously high above Earth in the opening shot of *Gravity* (directed by Alfonso Cuarón, 2013).

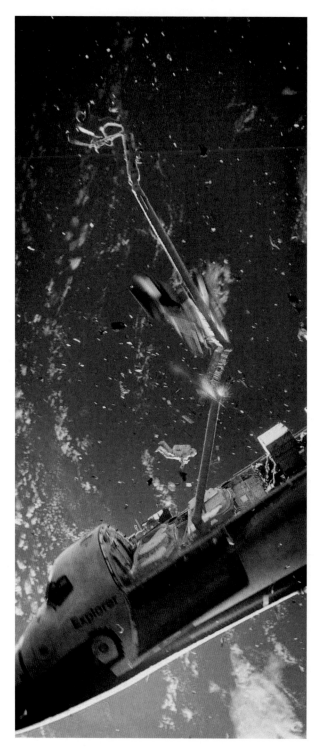

Plate 8. At the end of *Gravity*'s first shot, Ryan Stone (Sandra Bullock) rotates, still attached to the arm of a crane, with Earth as the frame of reference.

while-not-moving or of simultaneously moving quickly and slowly. It seems more apt to describe this as a weird quality of space rather than of my movement through it: space becomes uneven, elastic, thick, viscous.

In all cases, one of the most significant aspects of motion perspective is progressive occlusion at the edges of the visual field—the point at which features move from "in front of me" to "behind me." In cinematic kinesthesis we have progressive occlusion at the edges of the *screen*. The edges of the screen behave in complex ways. On the one hand, with respect to the outflow of the cinematic array, they will seem to be a constant occluding edge, which is a kind of analogy for the sweeping of the periphery of my visual field as I move. The radial outflow in the optic array and the occluding edges of my visual field with respect to the environment are the most important covarying sources of information about locomotion.[43] Because the edges of the screen are not identical with the occluding edges of my visual field, however, they are not integrated quite into my proprioception.[44] I do not mistake those edges for the edge of my visual field, even in the darkness of the cinema. Instead, the situation is closer to that of looking out the front window of a moving vehicle.[45] And yet I do not come to believe the cinema is a room moving through space—and this is not only because I remember walking into the cinema.

Quite simply, this is because a screen does not behave like a window. What I see is a surface not a depth, and in a number of ways, it behaves like a surface. It ruptures covariations that obtain in the case of ordinary perception. It violates ecological validity, but these violations are for their part mostly regular and rule following. Occlusion at the edge of a screen specifies, well, occlusion at the edge of a screen. I never mistake the screen for a window. This is why: In the case of a window, accommodation, binocular disparity, and convergence all covary with all other sources of information. In the case of the screen, they all specify objects a constant distance from the viewer. More important, the occluding edges function differently. The (even relatively insignificant) movements of my head and my eyes with respect to the screen do not cause corresponding parallax movements in the image. I see no deletion or accretion at the edges as I move (as I would see at the edge of a window). Similarly, I see no parallax variations of features within the image. Crucially, the differences here are postural as well as visual. The thickness of the body, the involvement of the whole body in vision, these refer to the postural—proprioceptive—constituents of vision: convergence, lens accommodation, and so on. Perhaps more important, visual kinesthesis typically involves covariation with more embodied proprioceptive information, including postural and vestibular information. The

cinema involves, even elaborates, this thickness of the body by modulating—disordering, suspending, rupturing—these perceptual covariations.

My body is attuned to the world. In Gibson's scheme this attunement involves not just perceptual information but the rich covariation across sources. This attunement takes place not through a number of discrete sense modalities, which must somehow be integrated by an achievement of the mind or the brain. Rather, it occurs in overlapping perceptual systems whose functioning involves and is diffused throughout the whole body. Vision does not arise out of the retinal image and complex interpretive procedures; it is not limited to one-fifth of our openness to the world. Rather, it involves multimodal, complex, and regular covariations of perceptual information. In fact, the cinema and our experience of it can serve to teach us this lesson. In heightening the "visual" part of vision, by suspending and modulating the covariation of postural information, cinematic appearance is manifestly illusory. Crucially, this palpable illusoriness does not require anything like a cognitive achievement. *It is within vision itself,* on condition that we understand vision as a manifold and reciprocal openness of body and world.

The Perceptual Faith

In chapter 2, I argue that it is a mistake to conceive of illusion as a variety of ontological or epistemological deficiency, a gap between perception and the thing itself, an index of the inadequacy of perception to the world, or an eidetic abyss between image and object. In this chapter I argue that the manifest illusoriness of the cinema image and, especially, of cinematic kinesthesis is a result of the cinema's modulation of the covariation of perceptual information—a difference and not a deficiency.

So far we can say three things about cinematic illusions like cinematic kinesthesis. First, illusion is endemic to the cinema, and it is necessarily embodied. Cinematic kinesthesis is a phenomenon that is crucially in vision, but vision is not only in the eyes, involving as it does postural elements. The experience of cinematic illusion is visual, but it is also visceral. Second, this perceptual modulation is ongoing, durational. As a modulation of the covariation of perceptual information, it is necessarily a modulation of my perceptual resonance. Third, even as I find my perception disordered by the cinema, I remain open to a world onscreen, my experience qualified by a palpably illusory sensation. In cinematic kinesthesis illusion is within perception; it is in duration; and it is a palpable qualification of perceptual experience.

This is at some distance from traditional accounts of illusion as systemati-

cally nonveridical percepts. As Shaw and Turvey argue in their case for the eco-logical approach, this mistakes the nature of perception. Perception cannot be said to be veridical or nonveridical, true or false. True and false are appropri-ate only for propositional statements. Instead, they claim that perception *exists* and that it is "necessarily true by force of existence rather than possibly true by force of argument."[46] On some level their claim is easily grasped: we're in the wrong language game if we say that a perception is true or false. (Judgments or statements about perceptions can be true or false, but that is not the same thing.) Significantly, Turvey and Shaw's claim is consonant with Merleau-Ponty's position: "This formula, 'It is true,' does not correspond to what is given to me in perception. Perception does not give me truths like geometry but presences."[47] Once you remove truth and falsehood from the equation, you lose your basis for distinguishing between illusion and . . . what? (Perceptual psychology would say veridical perception.) Do we oppose illusion to reality? To nonillusory percepts? Illusions exist, but it is unclear what sort of existence this is. Sometimes, as in cinematic kinesthesis, they feel different. Sometimes, as in the famous Müller-Lyer illusion, they do not.[48]

Gibson holds that illusion occurs when the information in the world is ambiguous, insufficient, or contradictory. In the cinema it is necessarily so, in the form of modulations of covariation. In other cases this ambiguity or insuf-ficiency takes different forms. (One of his most forceful arguments is that per-ceptual psychology's experiments are illusory because they provide ambigu-ous, insufficient, or contradictory perceptual information to their subjects.) But if the cinema is illusory, it is not because what we see is false. Rather, it is because we find ourselves in a situation where we are compelled, even cap-tivated, by the cinema's aberrant information. In cinematic kinesthesis two conditions of our perception are exacerbated. The first I have emphasized at length: perception is always embodied. Second, perception also always car-ries with it a *perceptual faith*.

This perceptual faith is at the heart of Merleau-Ponty's project in *The Visi-ble and the Invisible*. He glosses this faith as an "initial openness upon the world."[49] The first sentence of *The Visible and the Invisible* reads: "We see the things themselves, the world is what we see." We know this "the moment we open our eyes." "But," Merleau-Ponty writes, "what is strange about this faith is that if we seek to articulate it into theses or statements, if we ask our-selves what is this *we*, what *seeing* is, and what *thing* or *world* is, we enter into a labyrinth of difficulties and contradictions" (3). Faith is, in short, the condition of, even the name for, my inherence in this world. It is not a thesis or a proposition. It is neither true nor false. It is more closely related to the

sense of being faithful to somebody or doing something in good faith than it is to theological faith, belief in God, or a religious leap of faith. It would be more correct to say of perception that it operates in a space of faith, with all its attendant mystery and obscurity, rather than in a logical space of the truth or falsity of propositional statements. The mistake of skepticism is that it confuses the one with the other. And yet faith is also that which is vulnerable to skepticism. Skepticism is the impulse or the demand to articulate it in theses or statements.

The perceptual faith is also *embodied,* because perception is embodied. "It is the perceptual life of my body that here sustains and guarantees the perceptual explicitation, and far from it itself being a cognition of intra-mundane or inter-objective relations between my body and the exterior things, it is presupposed in every notion of an object, and it is this life that accomplishes the primary openness to the world" (37). This faith, then, not only is the accomplishment of a body but emerges prior to any object. Before I can intend an object, I inhere in the world, and am open to it. This implies a domain of experiences around the edges of objects, so to speak, of this primary inherence, of this perceptual faith. It is this domain I am striving to make visible. And yet these sorts of experiences are less cognitive or intellectual achievements than they are aesthetic. Merleau-Ponty speaks instead of "a strict ideality in experiences that are experiences of the flesh." He continues:

> The moments of the sonata, the fragments of the luminous field, adhere to one another with *a cohesion without a concept,* which is of the same type as the cohesion of the parts of my body, or the cohesion of my body with the world. Is my body a thing, is it an idea? It is neither, being the measurant of the things. We will therefore have to recognize an ideality that is not alien to the flesh, that gives it its axes, its depth, its dimensions.[50]

This cohesion without a concept is another name for my perceptual faith; this is why it cannot be elucidated in theses and is essentially aesthetic in nature. My basic contention is that in the illusion of bodily movement, in cinematic kinesthesis, I have a single experience that has, so to speak, two sides, recto and verso: the nontransparency of my embodied, perceptual opening onto *the* world and my nontransparent cohesion with *a* world onscreen that is nevertheless not *the* world. This double cohesion is immediately unitary—it is, in a word, simple. It is an experience of illusion and of faith whose doubled unity is an instance of the chiastic, reversible, and intertwined existence that is the hallmark of Merleau-Ponty's flesh.

In characterizing this perceptual faith, Merleau-Ponty stresses the expe-

rience of disillusionment. The experience of *dis-illusionment* does not teach that every perception might possibly be false and that therefore we must be more cautious in our perceptual or empirical judgments (paraphrasing Cavell).[51] Rather, Merleau-Ponty stresses that the recognition of an illusion is always also an affirmation of the perceptual faith. Far from being disturbed by illusions, the perceptual faith is bound up with the experience of illusion:

> When an illusion dissipates, when an appearance suddenly breaks up, it is always for the profit of a new appearance which takes up again for its own account the ontological function of the first. . . . The breakup and the destruction of the first appearance do not authorize me to define henceforth the "real" as a simple probable, since *they*[52] *are only another name for the new apparition*, which must therefore figure in our analysis of the *dis-illusion*. The dis-illusion is the loss of one evidence only because it is the acquisition of another evidence. (40)

He continues, "If subsequently it [a new evidence] breaks up in its turn, it will do so only under the pressure of a new 'reality'" (40). As Merleau-Ponty has it, in the turn from illusion to disillusion an appearance is retroactively understood to be an illusion. But in one and the same movement, a new appearance gains the force of reality. We do not do away with illusions by banishing them to the void; we are compelled to replace them with a new, positive perception. Recall that according to Gibson's scheme we dispel illusions when we gather enough information to resolve ambiguities, insufficiencies, or contradictions in perceptual information. Illusions call out for *more* contact with the world. This is why illusions cannot rupture the perceptual faith. Rather, *they entail it.* They demonstrate rather than destroy what Merleau-Ponty calls our belongingness in the world.

Merleau-Ponty returns to this structure of illusion and disillusion repeatedly in *The Visible and the Invisible,* and I cannot unfold all the nuance of his account here. Broadly, however, we can say that his description of disillusion emphasizes perception's fundamental openness and its constitutive indeterminacy. He writes, "Each perception is mutable and only probable—it is, if one likes, only an *opinion*; but what is not opinion, what each perception, even if false, verifies, is the belongingness of each experience to the same world, their equal power to manifest it, as *possibilities of the same world*" (41). He continues,

> And this is why the very fragility of a perception, attested by its breakup and by the substitution of another perception, far from authorizing us to efface the index of "reality" from them all, obliges us to concede it to all of them, to

recognize all of them to be variants of the same world, and finally to consider them not as all false but as "all true," not as repeated failures in the determination of the world but as progressive approximations. . . . [Illusions] never revert to nothingness or to subjectivity as if they had never appeared, but are rather, as Husserl puts it well, "crossed out" or "cancelled" by the "new" reality. (41–42)

Perception not only is the name for our embodied, ongoing openness to the world, but also brings with it a faith in the openness of the world and *its* incompletion.[53] For both Barbaras and Gibson, perception of the world is always perception of potential, and as such perception is always a perception of such incompletion. Disillusion, however, goes beyond this. As an adjustment of my attunement to the world, it stands at once as a demonstration that my resonance is constitutively subject to ambiguities; that it is ongoing, durational; that it does not cease until our death. Our belongingness to the world is both incomplete and incorrigible.

Cinematic kinesthesis, however, does not share this structure. The palpably illusory illusion of bodily movement is not disillusionment. It is not a turning or a movement. It carries a sense of its illusoriness with it. It is not sequential or retroactive. It is a duration saturated with illusion. It carries with it a much stronger bond to the ongoingness of perception. Even inside illusion, I am bound for and to the world, thrown open to it. Our perceptual faith rises up in ongoing illusion. And here, we must return to the doubled unity of the experience. As with all illusion, I experience the openness of my perception, its indeterminacy, its incompleteness. In the cinema, however, I am not only bound to a perceptual faith in *the* world but also find myself bearing faith to that region of the world in front of me, the screen. I discover a capacity for— and a captivity to—faith in *a* world onscreen.

In cinematic kinesthesis the illusion is manifest in the unfolding of a world onscreen, with its own incompletion and openness. I have already emphasized the occluding edges of the screen, but the other central feature of cinematic kinesthesis is its horizon. Gibson's emphasis on occluding edges and their reversibility followed from his observation that occlusion itself specifies hiddenness in the world and the partiality of perception-from-here. The horizon plays a similar role. Czech phenomenologist Jan Patočka (himself a significant influence on Barbaras) gives the horizon a force equivalent to Gibson's occlusion: "In the concept of horizon we have to do with a special phenomenon which, when we seek to describe it, leads to strange or downright contradictory tensions, for instance the contradictory turn that the horizon contains the presence of what strictly speaking is not present, what does

not present itself to us fully—a presence of the absent."[54] This presence of the absent is the incompletion of the world made manifest. The horizon is not a thing we might intend but rather belongs to appearance itself: "The horizon belongs to all manifestation, everything manifests itself within the same horizon. Yet a horizon does not manifest itself in the same sense as the givens we encounter within a horizon."[55] In its manifestation of a horizon, the cinema is able to offer an appearance of a world that is, in a deep but not absolute way, similar to the world in its incompleteness.

This similarity is formal and lies primarily in the cinema's ability to follow or approximate ecologically valid rules for occlusion and a horizon. But the concept of *form* here is not mere or dry form. Form, when it comes to perception, is also immediately embodied significance. Formal similarity unfolds into phenomenological significance and perceptual richness. It makes incompleteness manifest, specifying both presence and absence. But what is put forth in its absence on the cinema screen is not the absent, ontically degraded object of photographic representation. Nor is it the absence of the true intentional object-in-itself behind its adumbrations. Rather, this absence is the index of the incompletion and indetermination of a world.

The ability of the cinema to command our faith in a world does not arise from a structure of intentionality. Perceptual faith is not a constituent of intentionality but its ground. And anyway, one cannot intend the world or the appearance of a world. A world is not an object; it cannot be adumbrated. Intentionality passes over the world and its manifestation in favor of an object. Thus the worldliness of the cinema really does not lie at the end point of an ostensive function. *The cinema does not give us a world because it represents a world but because it makes the invisible appear.*

In a passage indebted to Patočka, Barbaras writes, "The concept of *horizon* names this singular appearance, this givenness of the constitutive unpresentable nature of the manifestation inasmuch as it is the comanifestation of a world."[56] In other words, the faith in a world that the cinema commands depends on constituents of appearance that do not emerge with intentionality. This faith and this world do not stem from the likeness (photographic or otherwise) of objects onscreen to objects in the world.[57] This faith and this world do not stem from an indexical bond with an intended profilmic object. This faith and this world arise with digital video, with blatantly counterfactual special effects, digitally rendered cinema, and animation. They arise even in a great many abstract films. In short, this faith is not a belief that what we see in front of us is really real or at some point in time must actually have existed

or anything of the sort. And this world is not false, a mere illusion, but rather *appears* onscreen. It is distinct from the ordinary world, but it is not deficient.

The Appearance of the Cinematic Image

In an (in)famous passage in "The Ontology of the Photographic Image," André Bazin writes, "A very faithful drawing may actually tell us more about the model but despite the promptings of our critical intelligence it will never have the irrational power of the photograph to bear away our faith."[58] I want to put a twist on this: the cinema has, despite the promptings of our critical intelligence, the irrational power to bear our faith. In the cinema we bear faith to a world unfolding before us, onscreen—not, as it were, as an exact cognate of Bazin's beloved realist cinema, which places its faith in reality.[59] At issue here is not the cinema's resemblance to the world nor even its ontologically weird recording and preservation of the world. Rather, we are beginning to see a cinema that does not take up as its vocation (as in Bazin's Italian neo-realism) the revelation of reality or self-effacement before reality. Neverthe-less, this is a cinema that "brings the spectator into a relation with the image closer to that which he enjoys with reality" (35). For Bazin the most important aspects of this relation are uncertainty and ambiguity. A cinema that offers ambiguity and uncertainty is a cinema that offers a world onscreen with all its indeterminacy, incompleteness, and opacity. In short, it is a cinema of per-ceptual faith.

Ecological phenomenology discloses a cinema of perceptual faith, but one not founded in representation. It discloses a cinema that is far from Baudry's disembodied camera offering the false promise of an ontologically ampli-fied, total opening to the world. But it is not, in fact, so very far from Michel-son's *2001*, in which "form and surface command the most immediate and complex intensity of physical response."[60] Indeed, since ecological phenom-enology grasps the cinema as *appearance* and develops a formal language to describe this appearance, it attends to nothing but *form* and *surface*—and their ability to command such intensity and illusion and faith. The perceptual manipulations of *2001* take place on the level of form and surface, not some-how behind them. The cinema's capacity to command our faith in a world unfolding before is, in some important sense, at the surface.

We have too long worried the questions of representation, interpretation, or depth, bound to the cinema's manifest capacities of photographic repre-sentation. We have remained too long in the natural attitude, fascinated by the ostensive function of the cinema image. We have not yet ceased to be dis-

tracted by the ostentatious object. We have not yet ceased to orient ourselves by the compass of a skepticism and a modernism that proclaim the insufficiency of our perception and the deficiency of the image—and then measure the worth of our art by our inability to account for it.

To be sure, the cinema does represent. (I worry that perhaps I seem to be denying this self-evidence at moments here.) But it does not *only* represent. (And it does not represent only by means of photography.) In every case, cinematic representation starts from an encounter between a body in the world and an appearance in the world, onscreen. I have been striving to describe this encounter, this body, and this appearance before it passes into objectivity by turning to phenomenology and to the ecological approach. Nevertheless, however precise this description may be, we will never be able to fully elucidate this encounter. It will never become totally clear, completely transparent, as skepticism would demand. The great value of modernism, the aesthetic declension of skepticism, is that it makes a virtue of this nontransparency. But our inability to provide a total accounting of an encounter (with the cinema, with the world) is not a failing. It is the condition of such an encounter, the condition of our perception, of our cinema, of our bodies, and of the world. In the cinema we encounter our faith.

On the other hand, of course, in the cinema we also encounter our bodies.

4 PROPRIOCEPTION, THE *ÉCART*

Koyaanisqatsi

In the climactic moments of Godfrey Reggio's 1983 experimental documentary *Koyaanisqatsi: Life out of Balance,* the film gives its viewers an intense, nearly nauseating experience of rushing headlong into the depth of the screen. Like *2001'*s Stargate sequence, this cinematic kinesthesis is specified by little more than streaks of colored light (Plates 5 and 6). These shots of movement through abstract spaces are, in fact, time-lapse shots of driving through a city at night and are certainly recognizable as such (Figure 14). Nevertheless, the illusory feeling of movement that abides here (and, indeed, that some viewers cannot abide) persists as a single giddy Gestalt across multiple shots; this Gestalt of movement acquires a certain independence from the spaces through which the movement passes. This composite or mosaic space hangs together as a seemingly unified but abstract space by virtue of the continuous illusion of bodily movement.

In this perceptually intense Gestalt of movement through a unitary, composite, and abstract space, we find interleaved a number of different problems. This illusory movement forms in the encounter between my embodied perception and the cinema, in complementary acts of perceptual modulation and perceptual attunement. This movement is the phenomenal aspect of the perceptual resonance between myself and the cinema. On the one hand, an editing strategy of rapid match-on-action montage, the "special effect" of time-lapse photography, and the cinema's possibility of specifying kinesthesis work together to modulate my perception in such a way that I am saturated by this effect—perhaps even to the point of motion sickness. The cinema's perceptual modulation is the dominant interest of these sequences. They solicit and rely upon the perceiving body to complete their effects; the unification of space occurs neither in the film nor in my body but in their encounter, in their

Figure 14. Driving at night in *Koyaanisqatsi* (directed by Godfrey Reggio, 1983), moments before the climax's total abstraction (see Plates 5 and 6).

coupling. Like Duchamp's *Anémic Cinéma,* the film is *completed by* and thus depends upon the embodied perceptual capacities of its viewers to resonate with the machinery of the cinema.

And like *2001, Koyaanisqatsi* does this largely by thematizing or roughening its viewer's perceptual resonance with the world through the illusion of bodily movement. It does so by emphasizing its viewers' perceptual procedures for relating themselves to onscreen space—proprioception—as the primary site and object of its aesthetics. My central claim in this chapter is that, as *Koyaanisqatsi* takes up its viewers' fundamental proprioceptive resonance with the world, in so doing it must also modulate their resonance *with themselves.* This is because, as we have already seen and as Gibson elaborates, proprioception is not merely the process of coordinating self with the world but necessarily includes perception's aspect of self-sensitivity. As a way of relating myself to the world, perception must of necessity include a form of reflexivity. Proprioception names the reflexive perceptual specification of myself as a bounded subject in the world, a thick *here* endowed with affordances. In short, *Koyaanisqatsi*'s proprioceptive vocation consists in modulating not only our resonance with the world but also our sensitivity to ourselves. This chapter explains how *Koyaanisqatsi* does this, how we might describe it in detail, and what it means to a theory of the cinema. In this, I continue my project from chapter 3 of articulating an ecological phenomenology: Merleau-Ponty and Gibson remain my major points of reference.

That said, in the previous chapter the issue is what *the cinema* does or can do to evoke the illusion of bodily movement, to modulate our embodied perception. And if the cinema's perceptual modulation is matched by the viewer's perceptual attunement, my interest in this chapter is precisely the latter half of this formula: perceptual *attunement*. My figure for this at the end of the preceding chapter is perceptual faith. But this faith is not our activity; it founds such activity but is not identical to it. Rather, by emphasizing proprioception in this chapter, I am focusing on the activity of the viewer.

To elaborate these concepts of proprioception and proprioceptive cinema, I first offer a brief overview of *Koyaanisqatsi*'s aesthetic projects, especially its interest in photography and its proximity to modernism. Then, I work at length through the three exemplary aspects of *Koyaanisqatsi*'s illusion of bodily movement: movement through environments, the confusion of objective motion with subjective movement, and an abstract, composite space formed through the illusion of bodily movement. Throughout, these discussions of the film organize an elaboration of the concept of proprioception: what it has meant and what it comes to mean when theorized (and transformed) by Gibson's ecological approach. In particular, I articulate Gibson's theory of proprioception with Merleau-Ponty's phenomenology, focusing on his late doctrine of the *écart*.

The fundamental issue in this chapter is how we might characterize the proprioceptive bond between my body and the world and the cinema's capacity to modulate it. And so I work through a problem that has thus far been latent: in encountering a cinematic world before me onscreen, I cannot but encounter my own body; it is through the cinema's modulation of my perception and proprioception that I find my body and my embodiment thematized. There is no embodiment without worldliness, as there is no worldliness without an embodied encounter. The cinema in its voluptuous aspect cannot but be a provocation of the body, and the voluptuously illusory cinematic space of *Koyaanisqatsi* entails a thematization *at once* of *both* body *and* world, of their insuperable bond, and of their insuperable separation. In *Koyaanisqatsi,* but also in *2001* and *Gravity* and so on, the cinema's perceptual modulation makes emphatic a world unfolding before me, and the fact that I am bound to and bounded in the world becomes the central interest of a proprioceptive cinema. This, then, is the cinema in its proprioceptive vocation: the cinema that modulates—and even, as in *Koyaanisqatsi*'s political aspirations, instantiates new modalities of—this primordial fact of the intertwining of body and world.

Two Modes of Reflexivity

As a documentary, however experimental it may be, *Koyaanisqatsi* not only was produced by photographic techniques but relies on their particular vocation of recording the world. It matters a great deal to the film that its images be photographic recordings of *the* world. Schematically, if the film's evident political project is to alienate us from our habitual or ordinary ways of encountering the world, it relies on the fact that we take its images to be images *of* the world. It places its faith in a photographic ontology of the cinema, under whose aegis we take as irreducibly given the strong form of the deictic or indexical vocation of cinematic images. It places a modernist faith in sensory alienation, in the conversion of perception into *apperception*. It enjoins us to *see how we see the world,* to make it open for negotiation, to condense it as an aesthetic experience, and to render it an object of politics. It does so in a doubling or reflexive move: in Michelson's words, "One becomes conscious of the modes of consciousness."[1]

This political project of modernist alienation unfolds over the course of a highly unusual documentary form. *Koyaanisqatsi* is nonnarrative, unfolding in movements like a symphony. It has no dialogue, nor any diegetic sound at all. It is a cinematographic tour-de-force. Ron Fricke, Reggio's cinematographer, is a master of time-lapse photography. Each frame is nearly overcomposed, so meticulous is its pictorial construction. Philip Glass's score is characteristically repetitive, lulling viewers into a hypnogogic, meditative, or receptive state. If such a film had a genre, it would include Dziga Vertov's *Man with a Movie Camera.* (And for both films the moniker "city symphony" is not wrong, but it is inadequate.) Its political project is coupled with an unusual degree of sophistication and expertise in its aesthetic execution. Unlike much art house cinema and experimental documentary, however, *Koyaanisqatsi* is bombastic. It is beautiful and manipulative. The scale and intensity of perceptual modulation and manipulation match anything in contemporary action blockbusters. Everything about *Koyaanisqatsi* is extravagant, even exorbitant: its images, its politics, its music, its montage.

Reggio has said that the film is meant to communicate "an experience rather than an idea, or information, or a story about a knowable or fictional subject."[2] This experience is one of alienation from the contemporary world, achieved by means of a sensual, voluptuous modernism. Mitchell Morris offers a good description of this experience:

> The audience is presented with a resonant sequence of images that succeed one
> another at widely (and wildly) varying rates of change, shot through with visual

and kinesthetic rhymes and recollections, geometrical alliterations, assonances of color, texture, and density, in complex juxtaposition with features of the score; but most of the standard features of ordinary film are absent. . . . Without characters and perceivable dialogue, the film is also without a plot other than that which might be discerned in the movement between the larger sections of the film—a trajectory from the "natural world" to the "world of technology" and (briefly) back again.[3]

As Mitchell points out, the film's political aspirations are manifest in inarticulate aesthetic experience rather than in the discursive talking-head tactics typical of many forms of political documentary.[4] At the foundation of its politics, *Koyaanisqatsi* stages an encounter with the ways in which we encounter the world, placing its faith in sensory alienation. Its political project is itself this very alienation. Like Michelson's *2001*, this alienation comes from saturation by the sensory intensity of the film. And as with *2001*, this sensory intensity arises from its perceptual modulation, from its illusion of bodily movement.

Koyaanisqatsi is not exactly a film *about* movement, but whatever it's about emerges through movement. From its early majestic helicopter shots of the desolate open spaces of the American Southwest to the frenetic time-lapse sequences of freeway traffic in Los Angeles, the film could be read seriously as almost wholly a study in movement: its acceleration, prolongation, and elaboration and the ways such altered movement reopens our possibilities for perceiving the world. Glass's score, with its relentless arpeggiation and its repeated harmonic structures, can also be understood as a musical conjugation of this elaboration and exploration of movement.[5] The thesis of the film is that the cinematic alteration of motion (of objects) or movement (of the camera) engenders a different way of perceiving the world, opening the world differently to perception. It modulates, makes palpable, and renders available for negotiation our ongoing perceptual attunement to and resonance with the world. *Koyaanisqatsi* works this out in a number of ways, perhaps most obviously in its extensive use of time-lapse and slow-motion cinematography. My focus here, however, lies in its exploration of cinematic kinesthesis. To be sure, these two effects are often coupled, as in its climactic moments of driving at night. Throughout its length, however, *Koyaanisqatsi* is uncommonly, even overwhelmingly, kinesthetic, and I cannot exhaust it here.

Meanwhile, *Koyaanisqatsi's* elaboration of cinematic kinesthesis shows that photographic representation cannot be the whole story here, even when

it's part of the story. Often, its onscreen space is composite and abstract in nature, movement attaining priority over space. In these moments the presumed indexical bond of the film, its ostensive *of*-ness, is not ruptured but rather attenuated to the point of indifference. At least sometimes, cinematic images acquire their force in a modality not governed by a strong ontology of photographic representation, even when photographic representation is nevertheless both present and necessary. Put otherwise, in these sequences cinematic space is emphatically not coincident with profilmic space. This cinematic space is not represented—nor indexed by photography, nor even figured—but forms itself in the embodied encounter between viewer and image.[6]

As *Koyaanisqatsi* elaborates its perceptual modulation in relation to and against its photographic representation, it makes a particularly interesting case study in the ways in which the cinema can give us a world in its techniques for enjoining, soliciting, or demanding faithfulness to a world unfolding before us onscreen. *Koyaanisqatsi* simultaneously gives us illusion and a world, but the world it gives us is not the evanescent quasi space of *Anémic Cinéma* nor the anemic world of the Stargate. Rather, it gives us *a* world with enough perceptual thickness that we take it to be *the* world, even as it is the world transformed. The sense of worldliness in *Koyaanisqatsi* arises not only as a result of its photographic reproduction of the world—at least not in the typical (ontological) sense of that term.[7] Whatever the importance of photography to *Koyaanisqatsi,* the world unfolding before us onscreen is bound up with our illusory movement *through* this world and thus also with the voluptuous, illusory quality of cinematic kinesthesis.

Koyaanisqatsi deploys tactics that set its vocation of perceptual modulation in tension with its photographic representation. This heightened tension occurs precisely by forcing these two vocations to coincide, without becoming reducible to each other. That is, while the film deals in both at the same time, it also discloses that these two vocations of the cinema were never in principle identical to begin with. At stake here is my perceptual attunement to the world and the cinema's technological modulation of this attunement. Even in the presence of photography's (putative) indexical bond between image and world, what is also always at issue in the cinema is the coupling and resonance between myself and the technics of the cinema. Because *Koyaanisqatsi* wants to make our ways of encountering the world an object of aesthetics and politics, it must thematize the ways in which we encounter—and attune ourselves to—the world in perception.

Implication and Immersion

Koyaanisqatsi's cinematic kinesthesis begins almost with the opening of the film. After an overture consisting of two very long takes, of Hopi cave paintings and of a rocket launch, the film's first segment consists almost entirely of moving shots of landscapes from the American Southwest, including Monument Valley, famous from countless Hollywood Westerns. The very first of these shots establishes a motif for the rest of the film, fading from white into a very lengthy helicopter shot of the Needles in Canyonlands National Park in Utah.[8] Here, as in much of the rest of the film, the aesthetic value stems from landscape. Unlike much landscape art, however, *Koyaanisqatsi* deploys and thematizes movement through its environments.[9]

In these first long takes, the crawl of a helicopter high over the desert and its slow, quiet flight foreground the inadequacy of a single image, of a punctual perspectival view, to the presentation of the world.[10] They lack the frenetic pace of the film's later time-lapse shots of the city, but the illusion is unavoidable. Meditative yet somehow also giddy, these shots open the landscape to view, folding and unfolding it, intimating in every instance that there is more to see. They affirm the inadequacy of a single view, but not by denigrating it. Each frame would be a gorgeous photograph by itself, with plenty to disclose on its own. Neither does it posit, in place of finite, partial, and perspectival embodied perception, a total God's-eye view that would know the world totally, at once, and in itself.[11] Instead, the film insists on the exploration of an environment, on the openness and porousness of this environment, and of the indissoluble bond between perception and movement.

Presenting the world by moving through it, these shots emphasize the unseen aspects of the environment by moving toward a horizon or moving the edges of the frame. In Merleau-Ponty's idiom in *The Visible and the Invisible*, we could say they render visible the invisibility of the invisible: they demonstrate the importance and irreducibility of the view-from-here, the limitedness and finitude and indeterminacy of my perception and of the world, the possibilities of exploration and discovery. I cannot see everything, because the camera cannot, either. But these are not shortcomings. In these shots *Koyaanisqatsi* heightens and draws out visibility, but it does not only show me what is visible. As in Merleau-Ponty's account of Cézanne's painting, here space

is no longer . . . a network of relations between objects such as would be seen by a witness to my vision or by a geometer looking over it and reconstructing it form the outside. It is, rather, a space reckoned from me starting as the zero

point or degree zero of spatiality. I do not see it according to its exterior enve-
lope; I live in it from the inside; I am immersed in it. After all, the world is all
around me, not in front of me.[12]

I find myself similarly immersed in *Koyaanisqatsi*'s early landscapes (and
indeed, nearly for the duration of the film). The desolate spaces of Monu-
ment Valley dilate and contract before me. In high-angle helicopter shots of
open spaces, the landscape appears or disappears slowly over a distant hori-
zon. New features of the landscape are revealed and become occluded at the
edges of the screen.

In a very literal sense, *Koyaanisqatsi*'s movement through environments
really does emphasize unseen or invisible aspects of those environments. As
I seem to move, as the camera moves, things proceed or recede over the hori-
zon. Objects turn their unseen aspects to face me as I move, hiding what was
previously visible. The edges of the screen occlude objects as the edges of a
window would (well, more or less). The presence of the invisible here is com-
plicated—or, rather, completed—by the fact that, carried along by the illusion
of movement, involved in the world onscreen, gliding over the film's early
empty, depopulated landscapes, my spatial immersion is at once both unde-
niable and equivocal. I find two spaces layered onto one another, dissolved
into one another, or intertwined together. I am immersed in the world of the
film, even as the room that is the cinema itself surrounds me.

As Merleau-Ponty points out, I am always immersed in space; it is not just
in front of me. What, then, to make of the fact that, immersed in the world of
the film, the world I am immersed in is not the world that surrounds me but
is *in front of me, and only in front of me*?[13] Even as it is only in front of me,
the cinema screen *implicates* a surround, an environment, a *world*. Implicat-
ing the far side of objects, offscreen space, a landscape that extends beyond
the horizon, and the whole surround of its immersive space, *Koyaanisqatsi*
makes palpable what is necessarily, constitutively invisible. In the *Phenomen-
ology* Merleau-Ponty glosses the notion of *world* as follows: "An open and
indefinite multiplicity where relations are reciprocally implicated."[14] He con-
trasts the world's structure of implication to objective thought's *universe* of
determination. The cinema's presentation of the invisible, with its implicative
structure, grounds its ability to give us a world.

My use of *implication* to describe both world and cinema here is not mere
wordplay. The surround of an environment is implicated, but it is neither
present nor absent. As I argue in chapter 3, the cinema thematizes the body
by suspending the postural covariants of vision. They become palpable not in

their absence but rather in the modified presence of implication. This structure of implication is similar to Vivian Sobchack's claim for the catachrestic structure of cinematic perception in her account of the cinesthetic subject. It is not that the cinema evokes taste or scent or touch by highlighting their mere *absence*, in favor of vision. Rather, while "I cannot literally touch, smell, or taste the particular figure on the screen," my body's involvement in the cinematic image compels me to speak "as if" I could.[15] The sensual qualities of an image onscreen—Sobchack's example is the tactile quality of the piano keys in Jane Campion's *The Piano*—are not absent, but neither are they present: they are implicated. I can speak of them neither literally (as I could if they were present) nor metaphorically (if they were absent): I am compelled to speak of them catachrestically.

So, too, the spatial immersion of the cinema is implicated, catachrestic. This is another way of indicating its quality of illusion, that it does not have the solidity of veridical or ordinary perception.[16] I am in the cinematic space of the film *and* in the cinematic space of the theater. But in this structure of implication, cinematic space is no different from that of the world. The world is articulated by implicative relations, and Merleau-Ponty would later simply call this relational infrastructure *the invisible*. In exacerbating the visible, the cinema simultaneously exacerbates the invisible: implicative relations of neither presence nor absence—in their indeterminacy, their porousness, and their partiality.

The cinema, like Cézanne's painting, also exacerbates what Merleau-Ponty calls "the enigma of the visible," which in "Eye and Mind" is identical with the problem of depth: "The enigma consists in the fact that I see things, each one in its place, precisely because they eclipse one another, and that they are rivals before my sight precisely because each one is in its own place. . . . If [depth] were a dimension, it would be the *first* one. . . . Depth thus understood is, rather, the experience of the reversibility of dimensions, of a global 'locality.'"[17] The enigma of the visible is the inexorable disclosure of the invisible in the visible: the far side of objects, whatever is beyond the horizon, the dilation of the world as I move through it. What assures this disclosure and the reversibility of dimensions is *movement*, exploration. Despite what Merleau-Ponty says in the *Phenomenology*—"the screen has no horizons"—in cinematic kinesthesis the screen intensifies the horizon and the arrival of features over it.[18] I move through the world; the world dilates and discloses itself as I move; and in this, such reversibility is always implicated. The world and my presence in it are constitutively implicative. As it immerses us in its world, giving rise to the palpable illusion of movement through that world, *Koyaanisqatsi* exacerbates this.

In front of *Koyaanisqatsi,* caught up in cinematic kinesthesis, I discover the mutual implication of my body and the world. This is one conjugation of Merleau-Ponty's remark that "the body is our general medium for having a world."[19] I discover the world only *through* my body, as a medium. Conversely, I encounter my body only through my encounters with the world, through its mediation of the world. And here, what ensures this mutual implication is precisely my movement through a world. Cinematic kinesthesis implicates not only my body but the reversibility of world and body, so the problem is not only the mediation of the world but also my body's fundamental separation from and continuity with the world. *Koyaanisqatsi* thematizes this mutual implication and reversibility in its cinematic kinesthesis and thus thematizes my body in its insuperable, nontransparent relations to the world as it encounters, continually attunes to, and resonates with the world. The name for this capacity of the body is, as we have already seen, *proprioception.*

Proprioceptive Cinema, or Incorrigible Indistinction

At the end of *Koyaanisqatsi*'s first segment of empty landscapes, there is a short sequence of shots that offer static camera setups but nevertheless engender a giddy, anxious feeling of movement. These show the time-lapse, sped-up movement of clouds across the sky or the movement of their shadows across the terrestrial environment. This motion is *in* or *of* the environment. Instead of an unequivocal illusion of bodily movement, we feel something like its shadow, something more insubstantial. A few moments later, the opening shot of the second movement of the film heightens this feeling. Sheets of clouds move across one another during a time-lapse sunrise, but the camera seems inverted, upside down. In place of the slow, meditative gliding and the heightened orientedness of the earlier helicopter shots, the effect here is disorienting—we don't even know which way is up.

In the disorientation of these shots, I delight, once again, in my perceptual attunement with the world—continual, ongoing. But here, in the temporary disruption of my orientedness, I come up against the fact that it is also unending, incorrigible, beyond my willing. The early Merleau-Ponty of the *Phenomenology* would call this the *ek-static* structure of perception: the antepredicative, impersonal fact that our perception begins and ends in the world.[20] Later, in *The Visible and the Invisible,* he calls this our perceptual faith.[21] As I point out in chapter 3, for the late Merleau-Ponty, illusion, instead of engendering paranoid skepticism, actually confirms our faith in the world. Illusions

always dissolve in favor of another (only presumptively veridical) percept.[22] What follows illusion is reality, or faith in it, not a void. Cinematic kinesthesis is a durable, durational illusion; caught up in its flux, I discover an ongoing faith rather than a retroactive one. Even as I know I am in illusion, I am faced with and take pleasure in the incorrigibility of my perception.

In these sequences *Koyaanisqatsi* renders motion in the environment indistinguishable from subjective movement, at least momentarily. The feeling is at once a kind of confusion and an ambivalence. Neither environmental motion nor subjective movement seems wholly secure, but instead, a feeling of pregnant irresolution abides. I cannot tell whether it is me or the world that is moving. This irresolution carries with it a palpably illusory quality, light-headed and vertiginous, intimately related to (but not identical to) that of cinematic kinesthesis in general. This is because cinematic kinesthesis is itself a form of confusion between objective motion and subjective movement. One way to describe the cinema is as a technology that produces objective motion (or its illusion) on the screen in front of me. Cinematic kinesthesis would then be, definitionally, a confusion between the objective motion onscreen and my own subjective movement.

Distinguishing objective motion from subjective movement as a perceptual problem falls squarely under the domain of proprioception, even in traditional accounts of perception. Everyone agrees that proprioception is the process by which I orient myself in relation to the world. That said, different ways of understanding perception construe the problems of proprioception, of relatedness and separateness, quite differently. In a passage I gloss in the introduction, Drew Leder summarizes traditional accounts of proprioception:

> According to a scheme employed in physiology, the body's sensory powers can be divided into three categories. *Interoception* refers to all the sensations of the viscera, that is, the internal organs of the body. It is usually distinguished from *exteroception,* our five senses open to the external world, and *proprioception,* our sense of balance, position, and muscular tension, provided by receptors in muscles, joints, tendons, and the inner ear.[23]

Proprioception names the awareness of the position and orientation of the body in space, as distinguished from perception of the exterior environment. According to this formula, because proprioception names one form of the body's sensitivity to itself—to posture, comportment, and movement—proprioceptive information must be internal, furnished by specific sense receptors that are not exteroceptive. In Leder's account, as in most traditional

accounts of perception, because proprioception names one form of the body's sensitivity to itself, proprioception must somehow occur within the body ("in the muscles, joints, tendons, and the inner ear").[24]

Gibson, perhaps not surprisingly, flatly rejects this. Already in the 1940s, his account of visual kinesthesis—the visual specification of subjective movement—hints at a criticism of this account of proprioception. Visual kinesthesis simply means *visual proprioception*; proprioception therefore does not form entirely within the body. He would go on to critique this internalist position pointedly in both *The Senses Considered as Perceptual Systems* (1966) and *The Ecological Approach* (1979). At first blush his account of proprioception resembles the classical account in his schematic formula "Perception has to do with the environment; proprioception with the body."[25] But it simply does not follow that proprioception thus somehow occurs in specific senses within the body. He writes, "Proprioception can be understood as egoreception, as sensitivity to the self, *not as one special channel of sensations or as several of them.*"[26] On Gibson's account, proprioception is not only the result of internal senses but rather a "general function of the overall perceptual system, cutting across the classical senses," not a special sense or the integration of several special senses.[27]

All perception includes a component of proprioception; proprioception arises from perception in general. If perception names my ongoing attunement to the environment and its affordances (the potentials for the conjugation of my body with an environment), then *all* perception must intertwine a proprioceptive pole of self-perception and an exteroceptive pole of environmental perception.[28] They are not different in kind. Rather, "information about the self is multiple. . . . All kinds are picked up concurrently."[29] For Gibson proprioception means "general self-sensitivity, that is, the fact that an animal stimulates itself in many different ways by nearly all of its activities, from the lowest to the highest, including the activities of looking, listening, touching, smelling, and tasting."[30] With respect to the visual system, "the optical information to specify the self, including the head, body, arms, and hands, *accompanies* the optical information to specify the environment. The two sources of information coexist." He continues, "The dualism of observer and environment is unnecessary. The information for the perception of 'here' is of the same kind as the information for the perception of 'there.'" His final formulation is as follows: "The supposedly separate realms of the subjective and the objective are only poles of attention."[31]

As "subjective" as it may be—and like all perception in Gibson's account—proprioception consists in the regular covariation of sources of information;

these just specify (at least in part) how my body occupies space. This subjective information is not different in kind from other perceptual information. Before his radical critique of traditional theories of proprioception in *The Ecological Approach*, in *The Senses Considered as Perceptual Systems* Gibson lists the most important sources of proprioceptive information; he speaks of a proprioceptive *system* spanning several different sources of information. These are muscular (stretch receptors in skeletal muscles), articular (receptors in joints), vestibular (balance), cutaneous (touch), auditory, and visual.[32] For example, a movement of my arm provokes the covariation of muscular, articular, cutaneous, and visual information about myself, all covarying to specify the same movement.

As we have seen, he would go on to reject even this account and hold that *all* perception has a proprioceptive aspect. This ensures he does not claim some special, subjective process of proprioceptive integration or synthesis. Rather, proprioception involves, as does all perception, the covariation of sources of information. In this case what is specified is self: the position of the body, a thick *here*, a set of possibilities for action from here. This *here*, then, is importantly *neither objective nor subjective*; it is *neither in the organism nor in the environment*. It is rather a constituent of the ongoing perceptual resonance between an organism and an environment, emerging from their relation in duration. The proprioceptive boundary between self and world is an ongoing phenomenon, arising from the flux of my perceptual resonance with the world. As Gibson has it, proprioception is an "experience cognate with perception" that always "*accompanies* perception."[33] There is no perception that is not also proprioception.

It does not, however, follow that proprioception is always thematic, as it is in these shots of clouds in *Koyaanisqatsi*. Typically, the ordinary coordination of myself and the world poses no problem, disappearing thematically to support my ability to carry out projects in the world.[34] *Koyaanisqatsi* makes it thematic in these shots by introducing a disorienting indistinction between the world's motion and my own movement. It emerges from ambiguous visual information. It pulls my attention to the proprioceptive aspect of my perception by attenuating or ambiguating the very information that would specify myself and my relations to the environment.[35] My inability, even momentarily, to tell whether it is my (subjective) movement or (objective) motion in the world leads to a feeling of a paradoxically embodied unraveling of my boundedness. I experience an attenuation of my coincidence with myself and an indecision about the relation or relatedness between my body and the world. Proprioception becomes thematic in the moment when I do *not* know

how to coordinate my body with the environment, arising from my efforts at a resolution of this indistinction. My proprioception becomes active or exploratory (a contradictory idea without Gibson's transformation of the term), in which I work to arrive at an unequivocal orientation.[36] Proprioception tends toward stability, density, and orientation. Becoming unbounded, I find I am compelled to seek out and reinforce the boundedness of my body. I must maintain a gap between myself and the world.

In a different context, Sobchack has highlighted the cinema's ability to unbound my body and offer up a confusion between *here* and the *there,* the body and the screen, inside and outside. For her the cinematic unbounding or indistinction is a manifestation of Merleau-Ponty's famous late doctrine of the flesh and its reversibility, or its *chiastic* structure. This reversibility goes beyond the reversibility of occlusion in Gibson's ecological approach and beyond Merleau-Ponty's problem of depth as the reversibility of dimensions. As Sobchack voices it, "Experiencing a movie, not ever merely 'seeing' it, my lived body enacts this reversibility in perception and subverts the very notion of *onscreen* and *offscreen* as mutually exclusive sites or subject positions."[37] Especially in sequences such as those of unresolved orientation in *Koyaanisqatsi,* indeed, the cinema can not only confuse us but also, in so doing, enact in an aesthetic modality the more radical reversibility of the flesh, the fundamental solidarity I have with the world. (You might say its confusion is literally a *con-fusion* of body and world into flesh.) It temporarily unbounds me from the *here* of my body, offering up a chance to experience the continuity my flesh has with the flesh of the world. While suggestive, this is incomplete.

Merleau-Ponty's concept of flesh is famously obscure. It is neither *my* flesh nor the flesh of bodies more generally: "The flesh is not matter, is not mind, is not substance. To designate it, we should need the old term 'element,' in the sense it was used to speak of water, air, earth and fire, that is, in the sense of a *general thing* . . . a sort of incarnate principle that brings a style of being wherever there is a fragment of being."[38] Several pages later, he glosses flesh "as the concrete emblem of a general manner of being."[39] The concept of flesh names the fundamental continuity and solidarity (but not identity) of myself and the world. That is, flesh also names the possibility of reversal, indistinction, or confusion between my body and the world. Or better, it names that which grounds any such possibility.

Merleau-Ponty continues, however, by noting that this reversibility is only "always imminent and never realized in fact."[40] We do not ever completely confuse ourselves with the world (or, if we do, one name for it would be *psychosis*). As Mark Hansen points out, this reversibility must happen across a

gap. This gap is the *écart* or *dehiscence* of the flesh. It is my insuperable separation from the world, my boundedness. As opaque as the doctrine of the flesh may be, the *écart* may be its most obscure concept. It designates the fact that while I am constantly in contact with the world, I do not dissolve into it. Hansen links the *écart* to proprioception and to the body's ongoing generation of a body schema. For the *écart* is not (as it might seem to a dualist, Cartesian or otherwise) the unbridgeable abyss between subject and object, the mystery of how sensations can leap from one substance to another, from matter to spirit or soul or mind, from objectivity to subjectivity. Rather, as Hansen points out, the body schema, as what lies on this side of the *écart*, nevertheless precedes the constitution of the world as objects or myself as a subject. He writes that the body schema "encompasses an 'originary,' preobjective process of world constitution that, by giving priority to the internal perspective of the organism, paradoxically includes what is outside its body proper, what lies in the interactional domain of embodied enaction."[41] Here, Hansen is pointing out that my ability to have and to act in a world arises, paradoxically, out of a separation from the world *while I nevertheless remain in contact with the world* across that separation.

The body schema includes the world within it while it also projects itself into the world. It is itself a model of my possible (or potential or virtual) action in the world. It is not merely a map or representation of my current posture but includes the manifold of my potential interactions with my environment. This notion of body schema aligns with Gibson's doctrine of affordances, in which an organism directly perceives the possibilities in the environment for acting or being acted upon. Borrowing from José Gil, Hansen writes, "Gil's term, 'abstract posture,' perfectly captures the productive plasticity of the body schema in Merleau-Ponty's analysis because, in both cases, a fundamental dedifferentiation of the boundary separating the body from space, a double invagination of the inside and outside, is at issue."[42] At the heart of all three theories—Hansen's body schema, Merleau-Ponty's flesh, and Gibson's proprioception—lies the difficult philosophical problem of how to account for the phenomenal fact of my boundedness, my sense of inside and outside, the separation between myself and the world, without reintroducing a flawed (i.e., skeptical) subjectivism or dualism into the picture.

Let us return to the concrete sensory quality of these moments of proprioceptive indistinction in *Koyaanisqatsi*. In them, I am not dissolved completely. They are temporary, if durational, and the unbounding is not complete. The either/or ambivalence of this unbounding and its tendency toward resolution both indicate an unavoidable tendency toward resolution of myself

into boundedness. *Koyaanisqatsi* does not *enact* Merleau-Ponty's reversibility (it can never be accomplished, in fact). Rather, the film offers it to us in a partial, aesthetic modality.[43] My disorientation here, insofar as it tends toward resolution, aims ultimately at my returning to a more bounded, oriented style of perceptual attunement, one that maintains my separation from the world.

To be sure, these moments are not *Koyaanisqatsi*'s dominant mode of modulating my perception, and I do not want to put too much pressure on these several shots. In fact, most of the time the film's use of cinematic kinesthesis results in a heightening of my orientedness, not its suspension. Nevertheless, these sorts of shots and their particular modulation of our spatializing processes dramatize something endemic to *Koyaanisqatsi*—and to cinematic kinesthesis more broadly and, indeed, to the cinematic manifestation of a world. That is, the cinema modulates not only my *perception* but my *proprioception*. It does not work on my vision as a discrete, separable sense (since vision isn't that). It modulates my sense of space and thus also modulates my sense of myself, my ongoing processes of drawing a boundary between myself and the world. Furthermore, in rendering proprioception thematic, the cinema thematizes not merely my processes of spatial attunement but also, crucially, my self-sensitivity, my sense of my self as a self, the feeling I have of being a sensitive *here*. In its illusory manifestation of a world, *Koyaanisqatsi* effects an attenuation or a becoming-porous of the distinction between myself and the world and, in so doing, heightens at once my self-sensitivity and my sensitivity to the world.

Abstract Space and Absolute Movement

The most obvious and most important instances of cinematic kinesthesis in *Koyaanisqatsi* come in the climactic moments of the film (Plates 5 and 6, Figure 14). They are of a scale and an intensity not seen elsewhere in the film. As in *2001*'s Stargate sequence, their movement is into the depth of the screen.[44] The visual illusion here is embodied as visceral impact. The headlong rush into the rapidly dilating world onscreen engenders sensations that do not merely reproduce the feeling of moving in general (walking, driving, riding a roller coaster) but form under the sternum, at the base of the throat. As richly embodied as it may be, as voluptuous as my proprioceptive processes may become, the sensation here is nevertheless somehow insubstantial, slippery, ethereal: a certain lightness of or in my body. At once out of control (I am moved without my willing or intending; I am manipulated) and intimate to an astonishing degree (it is my sense of my self and my boundedness the film

is modulating), this feeling is localizable neither in my body nor in the world but is immediately and unreflectively felt as an *encounter* between my body and the cinema. And at its most kinesthetic, *Koyaanisqatsi's* illusion of bodily movement borders on (or crosses over into) the unpleasure or aversiveness of motion sickness.

Like its exploration of cinematic kinesthesis in general, *Koyaanisqatsi* offers a development, elaboration, and variation of this particular configuration of the illusion, hurtling directly into the depth of the screen. It develops this over several different axes. These include (but are not limited to) camera angle, acceleration, and abstraction. Each of these reveals something about how cinematic kinesthesis works. The majority of *Koyaanisqatsi's* movement maintains a straight, level camera angle, keeping a horizon in view, but several shots offer extreme low- or high-angle shots. For example, in an early extended shot of fields of flowers, the high angle omits the horizon and frames the landscape in such a way that features appear at the sweeping top *edge of the screen* (Figure 15).

Replacing the distant horizon with its open space with an edge of the screen, these shots carry a particular claustrophobic, disorienting quality. Low-angle shots, on the contrary, replace the horizon with a view of open sky, and features arrive over the sweeping bottom edge of the screen—as in shots moving through urban canyons, gazing up at the top of skyscrapers (Figure 16). These offer a certain lightness, even as we cannot see where we might be going. Both extreme low angles and extreme high angles nevertheless

Figure 15. A high-angle fly-over shot of fields specifies movement by the sweeping top edge of the frame, without a horizon, in *Koyaanisqatsi.*

Figure 16. A low-angle shot in *Koyaanisqatsi*, gazing up at skyscrapers, also specifying movement without a horizon.

articulate with their occluding edges the implicative relation of a world; while a horizon *also* does this, and in a more emphatic way, it is not necessary. Moreover, according to the ecological approach, we should say that these different camera angles specify movement either with your head hanging, looking at the ground, or with your head back, staring up into the sky. The different qualities of these shots arise from my embodied comprehension of such correspondences. The meaning of these shots is immediately embodied, formed in my body.

More important but no less embodied is any acceleration in the movement. This includes both what we ordinarily think of as acceleration (starting or stopping) and whether the movement is straight ahead into the depth of the screen or includes curves. In fact, curves have a special significance in this context (Figure 17). Curving or turning, like all bodily acceleration (as well as the pull of gravity), is specified by the vestibular system in the inner ear as well as postural information related to the inertia of my moving body. As I have argued, cinematic kinesthesis suspends and thus catachrestically implicates the postural covariants of vision, including (and especially) vestibular information about acceleration. Paradoxically, cinematic curves thus lead to a more illusory but also more richly embodied response. In many of *Koyaanisqatsi*'s time-lapse POV shots of driving, the hurry-up fast-forward movement follows the curves of the road and the lane changes of the car. These induce an intensified feeling of illusoriness, not least because of an increased sense of moving without my willing, of another intentionality causing my

Figure 17. The illusion of bodily movement is most intense in moments of acceleration, as when we travel around curves in *Koyaanisqatsi.*

movement.[45] The increased "velocity" of the car imparted by the time-lapse photography corresponds to an increased "acceleration" in the turns, exacerbating the divergence between vestibular and visual information.

Crucially, the movement finds itself reiterated in bodily responses that are not merely felt. My response does not consist only in a sensation provoked by the moving image. Rather, my responses are expressed in and by my body. Hurtling around the curves of a freeway in Los Angeles, changing lanes at breakneck speed, I find myself, if not actually moving with or against the image, at least tensing my muscles to counter the movement, as if I had to keep upright while riding as a passenger in this improbably fast car. In response to this intensification of visual kinesthesis, I find the musculature of my core, my arms, even my feet on the ground engaged as though to stabilize myself. In these shots the cinematic modulation of my proprioception leads not just to an illusory "in here" experience but also, inexorably, to bodily engagement. It heightens my sense of my posture, including my sense of contact with my seat. As *Koyaanisqatsi* intensifies my involvement with onscreen space it paradoxically intensifies my awareness of my literal contact with the cinema considered as an architectural arrangement.

In these moments *Koyaanisqatsi*'s proprioceptive modulation entails a modulation and destabilization of a more embodied postural equilibrium. Crucially, in such proprioceptive modulation, both my perception and posture are implicated—indeed, indissolubly bound together—in a complex process of maintaining a dynamic equilibrium in my changing situation in an

environment. My relation to the world not only involves my ongoing perceptual resonance with the world but implicates the ongoing coordination of my corporeal schema with the world, which in turn includes my actual bodily posture, comportment, and movement. The world, my abstract posture, and my actual posture are all intertwined in and by my ongoing embodied resonance with and presence to the world. The cinema, in its visual modulation of my proprioception, thus also modulates my total spatial equilibrium.

This embodied spatial equilibrium is what Merleau-Ponty calls "bodily spatiality" in the *Phenomenology*: "Bodily spatiality is the deployment of the body's bodily being, the manner in which it comes into being as a body."[46] It should come as no surprise that *Koyaanisqatsi*'s modulation of proprioception is manifest as a thematization of the body. Bodily spatiality, in its dynamic equilibrium, in its ongoing interactions with the world, is not only *in the body* but *in the body in its interactions with the world*. My bodily spatiality always points, as it were, in two directions: toward the world and toward myself. Hansen's (somewhat unfortunate) term for this is "double invagination."[47] Body and world are coimplicated, and *Koyaanisqatsi* dramatizes this. My resonance with the cinema spans, in one and the same movement, in their indissoluble intertwining, my ongoing attunement to the world *and* my ongoing attunement to myself.

In this light, one final aspect of *Koyaanisqatsi*'s cinematic kinesthesis is especially significant, which the film manifests at the apogee of its elaboration: the degree of abstraction of the space through which I am moving. In the opening paragraphs of this chapter, I describe the composite, unitary, but abstract space of the climactic moments of the film. That said, the film continually deploys cinematic kinesthesis across multiple shots. The film's earliest instance of the composite, edited cinematic kinesthesis at issue here comes at the end of the second movement of the film and comprises four long takes of helicopter shots over abandoned landscapes: clouds and mountains, mountains and lake, fields of cultivated flowers (Figure 15), and Lake Mead. These four shots together take two minutes; the longest is nearly a minute. A single feeling of nearly unbroken movement persists across these four shots (in classic match-on-action montage), all while this single movement is through four distinct, fully realized spaces or environments.

Over its course, *Koyaanisqatsi* plays on this figure in a number of different ways. In one of the few moments of humor in the film, the headlong rush into the depth of the screen starts with time-lapse driving on the highway and cuts to a low-angle shot of buildings on city streets, to widgets on an assembly line, to the elevator at a mall, and then to Twinkies (!) on their assembly

Figure 18. Godfrey Reggio's alienated whimsy.

line (Figure 18). What these sorts of cuts demonstrate (beyond Reggio's sense of alienated whimsy) is that the cinema's illusion of movement through an environment carries a relative independence from that environment. Now, this independence is *relative*; at issue is always movement *through* an environment. In these segments and throughout much of the film, however, the movement attains priority over the particularities of the environment.

Koyaanisqatsi takes this to its logical (or aesthetic) conclusion in the segments in which movement attains total priority over space. In these, the illusion of bodily movement asymptotically approaches something like absolute movement. At the climax of the film, a montage of time-lapse shots of driving at night gives the Gestalt of a single passage of hyperkinetic movement that can become so intense as to be nauseating. This movement is relentlessly composite; the montage here is extremely rapid, splicing together a number of indistinguishable spaces. The spaces are already rendered abstract by the blurring caused by the long exposure times of each of the individual frames of the time-lapse photography. Even then, it becomes impossible to distinguish the cuts articulating different spaces from the interruptions of this movement caused by stoplights.

The single movement across these shots is articulated not only by the match-on-action montage across different spaces (which is to say, changes in space) but also by changes in the movement itself. Nevertheless, it remains an articulated movement through abstract space. This should come as no surprise, since the specific features of the environments we move through cease to be important. Rather, the movement itself is absolutized. Headlights, brake

lights, streetlights become streaks of light across the screen. What begins as a relatively recognizable scene of driving at night, with individual cars on the road, eventually becomes nothing more definite than a headlong rush into streaking light. Even as Kubrick's movement is much more magisterial than Reggio and Fricke's, the similarities between these sequences of *Koyaanisqatsi* and those of *2001*'s Stargate sequence are striking: movement through an environment is specified by nothing more than streaks of colored light.

The unity of this abstract, mosaic space is generated by movement.[48] As I argue in chapter 3, movement through an environment discloses faith in a world unfolding before us onscreen, even if this world does not resemble the phenomenal or ordinary world. But here, *Koyaanisqatsi*'s unitary movement through a single abstract space puts a further twist on the matter. We can also say the cinematic modulation of proprioception itself implies a world. Proprioception always presupposes, implies, bears faith to a world characterized by the implicative structure of worldly space. The unitary, abstract, and synthetic space of the film's climactic moments forms in my body, in the illusory movement through that space. The feeling of illusory, embodied movement loses none of its intensity or richness even as this space loses its definite character (it no longer makes any sense to ask *where* this movement moves through, unlike earlier shots of Lake Mead or the Golden Gate Bridge). The feeling of movement persists as a voluptuous quality in the body, even as the space though which I move itself becomes abstract, light, ethereal. Meanwhile, movement here never loses the character of movement *through*. In fact, it is in these sequences that *Koyaanisqatsi* presents the illusion of bodily movement in its greatest vertiginous intensity. My postural, muscular engagement begins to take the form of my hands clutching my armrests, my jaw clenching, holding on for dear life. The pressure behind my sternum rises to the base of my throat or sinks to the pit of my stomach. Space becomes unmoored from location, but it nevertheless remains space. I am immersed in it, perhaps more than ever before. Movement becomes overwhelming, intense, practically unbearable.

In these climactic moments, *Koyaanisqatsi* discloses one of the most important aspects of the cinema's proprioceptive aesthetics: the possibility of forming worlds onscreen that while abstract still bear our faith. In these climatic moments, I find myself attuned to a world constituted by and in mosaic, abstract space, unmoored from location, articulated by the continual illusion of movement. This aesthetic effect is continuous in Reggio's strange, not-quite-documentaristic aspiration to impart not information but a feeling (or a structure of feeling), slackening as it does the bond cinematic images typi-

cally have with their referents.[49] The world onscreen becomes abstract, and while it conforms to the structure of the ordinary perceptual world, it does not resemble it. This world is neither populated by objects nor bound by specific locations.

As illusion is not opposed to reality, this world is, however, emphatically not *unreal*: it is both illusory and abstract, but it is not fictional, and it really is made up of photographic images. It is articulated only by my ongoing attunement to the cinema's technical modulation of my proprioception and a concomitant structure of implication, made palpable by my ongoing sensation of movement through a nonindexical and nonrepresentational—that is, illusory—onscreen space. *Koyaanisqatsi*, like *2001*, gives rise to abstract worlds that are structured by implication, including both the visible and the invisible. However unlike the ordinary world its world may be, *Koyaanisqatsi* discloses how, at the heart of its proprioceptive aesthetics, the cinema might manifest a voluptuously abstract world onscreen to which I bear a small, embodied faith.

5 THE BODY, UNBOUNDED

Gravity

About two-thirds of the way through Alfonso Cuarón's *Gravity* (2013), we find ourselves in a Soyuz escape capsule with Dr. Ryan Stone (Sandra Bullock). Although the film is known for its stunning long takes—especially the first, astonishing thirteen-minute take I describe in the Introduction[1]—we arrive in the capsule's cockpit through a hard cut after she has escaped a fire in the International Space Station. She is upside down (Figure 19, see also Figure 20). What's amazing about this shot, some forty-five minutes into the film, is that while she is upside down, this is a wholly unremarkable thing—not only unremarkable but hardly noticeable. (Only on my third viewing was I able to notice.) Over the course of the previous forty-five minutes, the film has so radically reoriented our perceptual coordinates that the screen directions of up and down no longer hold any weight.

A great many critics have, of course, pointed out that *Gravity* produces a feeling of profound disorientation. Cuarón and his cinematographer, Emmanuel Lubezki, explicitly understood that in microgravity, although space may be the same in some objective, Cartesian or Newtonian, sense, our ordinary capacities to orient our bodies in space go awry. One interviewer asked Cuarón, "With the camera and characters in constant motion and changing perspective, how did you figure up from down?" He responded:

> There is no point of departure because there is no up or down; nobody is sitting in a chair to orient your eye. It took the animators three months to learn how to think this way. They have been taught to draw based on horizon and weight, and here we stripped them of both. They'd show me some amazing visuals, but then I'd point out the problem, which was, they had their character standing on an apple box. Nobody can do that in space. So we sent animators to school to find out about how things behave in zero-g, with zero resistance. Eventually

Figure 19. Ryan Stone (Sandra Bullock) appears upside down in a Soyuz capsule in *Gravity.*

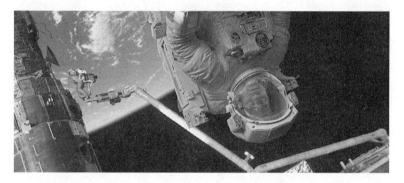

Figure 20. Matt Kowalski (George Clooney) upside down in the middle of *Gravity*'s first, extremely long take.

it became second nature, but you could tell right away which guys were new, because their stuff was oriented up and down, and they were the ones who wanted to quit.[2]

Putting it a bit more concisely, Andrew O'Hehir writes, "Up, down, right and left no longer have meaning for these two human beings lost at the outer edge of Earth orbit. (Those with motion-sickness issues may need to take appropriate medication.)"[3]

Now, one reviewer calls *Gravity* a lesson in Newtonian mechanics—and indeed, the idealized frictionless universe of high school physics class is on display.[4] Bodies in motion stay in motion, terrifyingly and forever (Figure 2). But it seems to me that *Gravity* is rather more directly a demonstration of the incredible plasticity of the human capacity for orientation and orientedness. It may have taken the animators months at school to learn how to ani-

mate microgravity, but in my seat in the theater, after forty-five minutes I have already learned how to be indifferent to—indeed, not even to notice—the fact that Stone is upside down on the screen. And of course, the meaning of "upside down" has gone weird, here; we should say only that her screen direction is inverted, and even that seems infelicitous. *Gravity* does not do without a horizon, quite, as in low Earth orbit the globe is still massive enough to act as a horizon. But the horizon has ceased to do its job: it no longer indexes *the horizontal.* And without weight, without gravity, I no longer have any possibility for the vertical. In place of linear or planar space, organized by the dimensions of height and width, axes of horizontal and vertical, *Gravity* gives me space organized instead in polar coordinates, where what matters is only rotation and depth.[5]

Kristin Thompson has pointed out that in this *Gravity* has an antecedent in Michael Snow's *La région centrale* (1971).[6] Snow's film uses a multiply articulated programmable arm mount to swing a camera filming a remote mountaintop landscape in complex and nonrepeating rotating patterns. Cuarón's film uses even more complex programmable arms innovated by San Francisco–based company Bot & Dolly.[7] Both films use rotational figures to dissolve the horizontal and vertical axes that organize our ordinary perception and most of our cinema. *La région centrale* dissolves these axes, but does so in a manner (consonant with much of Snow's career) that is in some sense inhuman; Snow seems more interested in exploring the possibilities of the machines themselves (film camera, robotic arm) than the possibilities of the proprioceptive body. *Gravity* and *La région centrale* both unmoor our proprioception from its ordinary weightiness through a rotating camera. Where Snow's film attenuates the human element, however, resolutely refusing to attune its mechanical perception to the perceptual capacities of the human body, *Gravity* teaches its viewers a new way of inhabiting space.

A more obvious (or at least mainstream) antecedent for this lies, of course, in *2001*'s rotational figures, in both the journey to the moon sequence and in the rotating artificial-gravity ring in the *Discovery One.* However, *2001* introduces these figures in order to emphasize the effort required to assert vertical and horizontal axes in the absence of gravity. In *2001,* in all its glorious late midcentury futurism, we see Velcro shoes and rotating habitat rings. In *Gravity*'s contemporary present, however, we instead see the tiny, fragile human body struggling—and finally, succeeding—as a platform for action in the impossible vacuum of space and the equally impossible microgravity of low Earth orbit. *Gravity*'s proprioceptive and aesthetic work lies in no small part in this frankly pedagogical vocation, in its lessons in new, unworldly proprioceptive modalities.

Emphasizing different aspects of the film, a number of critics, including O'Hehir, have likened *Gravity* to a video game, remarking upon the film's extremely strong focalization through a single character, its repeating action mechanics, its motifs related to maneuvering in space, and the limitedness of its dialogue.[8] What strikes me, however, is the way the crescendoing, episodic nature of the narrative, with temporal ellipses in between episodes, corresponds substantially to the ways games are often organized into levels. In particular, the opening sequences of the film operate a great deal like the initial learning level (or levels) of video games, teaching the player the basic spatial and action mechanics. Similarly, *Gravity*'s proprioceptive aesthetic effects work through a similar pedagogical function, teaching its viewers a new weightless and rotational proprioceptive modality in which screen directions are loosed from correspondence to the conditions of ordinary perception. Thus an upside-down Sandra Bullock becomes totally unremarkable.

By varying the fundamental conditions of the appearance of the world— indeed, by dissolving height and weight, horizontal and vertical—*Gravity* offers an exploration of the manifestation of a world onscreen that is literally and perhaps uniquely *unworldly.* In so doing, it draws together six fundamental aspects of the cinema's proprioceptive aesthetics, which will serve as a generalizing catalog of its fundamental problems: the adherence of body and world; an aesthetics of bodily bounding and unbounding; pleasure, often in the form of masochism, as an irreducible form of self-relation; the confusion of perception and affect; a dynamic of attunement, resonance, and modulation; and an investment in the cinema as an exhibition technology. The first five of these have as their center of gravity the body of the viewer, and these are my focus in this chapter. As is the case throughout this book, while I try to emphasize the overlapping and complementary nature of encounter between the viewer's body and the technics of the cinema, I emphasize each in turn— even as I stress the reliance of each on the other. With *Gravity* I turn toward the way proprioceptive aesthetics is an aesthetics of embodiment.

And so I address each of these six central problems of proprioceptive aesthetics in turn, using *Gravity* as my exemplar. In this I want to stress that *Gravity* extends the line of cinematic proprioceptive aesthetics that runs through *Anémic Cinéma, 2001,* and *Koyaanisqatsi.* In many ways, but especially in its virtuosic immersiveness, *Gravity* elaborates, even reinvents, the proprioceptive vocation of cinematic technology, a vocation that has organized much cinema since the earliest films, along with other, pre- and paracinematic exhibition technologies.[9] It also stands as the most successful—although certainly not the only—example of Hollywood's recent obsession with proprioceptive

aesthetics. Which is to say, *Gravity* is exemplary for me along two axes: a historical one in which the film is the most recent entry in a long line of proprioceptive aesthetics that has attended the cinema since its inception, extending even before its invention; and a contemporary one in which the film works out the aesthetic problems that are particularly pressing in much contemporary cinema. That said, in order to develop a schematic and even programmatic approach to proprioceptive aesthetics, my treatment of *Gravity* is telegraphic, sketching only the most important aesthetic topoi for understanding proprioceptive aesthetics.

Aesthetics, or Proprioception

Before doing so, however, I would like to address proprioceptive *aesthetics* schematically, offering a brief, high-altitude theorization of the transformations proprioceptive aesthetics entails in how we understand aesthetic encounters—a generalization that is in some sense at the heart of this book. To wit, I would like to specify what aesthetics means when finally loosed from the burden of modernism.

Recall from chapter 4 that proprioception is the aspect of perception that specifies self rather than (but in relation to) the world. According to Gibson, proprioception inheres in all perception: each perceptual relation points at once to the body (self) and to the world. Proprioception is the process, diffused throughout perceptual life, by which I arrive at myself as a bounded self, in a particular place in the world, with a particular set of capacities, projects, concerns, possibilities, and threats. Proprioception names the ongoing perceptual attunement I have with myself, by means of which I arrive at a sense of myself as a thick, bounded, sensible, and finite *here* in the world. In a rough-and-ready definition, we might simply say that proprioceptive aesthetics is the domain or aspect of artwork that roughens, draws out, thematizes this fact: cinema (or other art) that engages proprioception as a set of processes.

Aesthetics and proprioception have, however, a much more intimately complex relation than that formula may suggest. Steven Shaviro argues that the problem of aesthetics—at least in its guise as the Kantian reflective judgment of beauty—is precisely the problem of how something "out there" might produce an effect (intensity, feeling, emotion: affect) "in here." Aesthetics in this form names the problem of how, ineluctably, an object or event outside my body and its boundaries can nevertheless make the quantum leap across this boundary—the *écart,* specified by proprioception—and affect me. Put otherwise, aesthetics is a problem of *receptivity* and its modalities. He writes,

"Rather than being cognitive, sensibility has to do with 'the appearance of something,' and *the way we are affected by that something.*"[10] Reading A. N. Whitehead reading Kant, Shaviro argues that the primary problem of philosophy is neither cognition nor reflection—how we might *know* the world—but rather feeling, affect, *aesthetics*: how we resonate with and are attuned to the world and what is in it.[11]

As Deleuze has it, "Aesthetics suffers from a wrenching duality. On the one hand, it designates the theory of sensibility as the form of possible experience; on the other hand, it designates the theory of art as the reflection of real experience."[12] Shaviro argues that these two meanings are united in the fact that beauty and sensibility are both modalities of attunement to the world. They come into contact with one another in the philosophical problem of such attunement, which Shaviro calls alternately *affection* (in a tradition that reaches back past Deleuze to Henri Bergson and then to Baruch Spinoza) and *prehension* (following Whitehead). At the level of philosophy, this seems not only sound but convincing and productive. However, proprioceptive aesthetics accomplishes a different kind of unity, an aesthetic rather than philosophical unity, one that unites beauty and perception not by philosophical elaboration but by rendering them indistinguishable.

To put this another way, Shaviro's claim is that aesthetics qua aesthetics names the existential fact that I am separate from but ineluctably resonate with the world. Indeed. And yet as an existential (or ontological) claim, however philosophically rigorous, it seems unhelpfully general in addressing a particular set of aesthetic problems. My claim, by contrast, is that in proprioceptive aesthetics the aesthetic problems of the work of art coincide with those of my attunement to the world. In the cinema's proprioceptive aesthetics, my intimately embodied attunement to the world becomes thematic in the cinematic manifestation of a world onscreen. The cinema is surely not the only technology that creates the impression of a world unfolding before us. But by virtue of its particular way of intertwining perceptual modulation and the project of manifesting a world onscreen, the cinema's proprioceptive aesthetics is animated by the Deleuzian tension that Shaviro elucidates. In proprioceptive aesthetics this wrenching duality dissolves in favor of an immensely productive ambiguity—whose solvent is precisely the cinema's capacity for and vocation of perceptual modulation.

That said, I want to acknowledge that *proprioceptive aesthetics* is actually an imperfect name (beyond its overly technical mouthfeel and its polysyllabic obscurity), but it's the best I can do. Let me explain.

As I write in the introduction, proprioceptive aesthetics means three over-

lapping things at once: (1) a set of possibilities in the cinema as a technical system; (2) a set of films that are especially proprioceptive in their aesthetic aims and effects; and (3) a broader field of aesthetic practices and aesthetic media, not at all limited to the cinema, wherein the body's adherence to and inherence in a world are the focus of aesthetic elaboration. So far, so good. What's imperfect about it, though, lies in that what I am trying to indicate with *proprioception* isn't actually quite captured by the term, yet nothing I know comes closer. I use it not only in Gibson's sense to name perceptual self-attunement but also to name the reflexive turn within perceptual and sensory life, the feeling of feeling, the aspect of my experience that grasps that it is *mine* with a special texture, force, and salience. This is an ancient problem, of course, and so it goes under a great many names. Following Shaviro, we might call it *aesthetics,* full stop. Vivian Sobchack calls it by a newer name, *coenaesthesia,* but it has a number of more contemporary nominations.[13] In his work on new media technology, Mark Hansen calls it simply *affect,* inheriting that term, like Shaviro, from the philosophical tradition of Deleuze and Bergson and Spinoza.[14] (While I think this is probably right, it feels incomplete; although I must admit I never feel far from problems of affect theory, even as I use a different vocabulary.)[15] Brian Massumi calls it *sensation.*[16] Merleau-Ponty's name for it, as we have seen, is the *écart.* In an earlier version of this work, I called it *pleasure.*

I offer this list not to name check famous philosophers and theorists nor to suggest the inadequacy of others' accounts of it in order to bolster mine. If anything, I want to highlight the incompleteness of my account. Rather, I want to insist upon *proprioception* and *proprioceptive aesthetics* as terms to describe a structure of feeling, a horizon of experience, or a set of intensities that are simply existential and therefore extremely difficult to describe adequately. Or rather, I think that describing this complex adequately of necessity entails acknowledging the partiality of any description, the impossibility of total elucidation, since we are in the realm of wonder and of mystery. It is important not to dissolve this mystery with the universal solvent skepticism nor to bleed it dry of its mystery by means of a scientific explanation of its origins nor to chastise, as one of my students once did, an acknowledgment of the mystery of the world and my inherence in it as "namby-pamby, quasi-mystical mumbo jumbo."[17] Phenomenology has long spoken of this mystery—it has many figures for it—and has long held that wonder is the only appropriate posture when faced with it.[18] This is the posture Merleau-Ponty offers us when he speaks of the perceptual faith—the unending, incontrovertible fact that I am in and thrown open to an inexhaustible world.

This may seem too much high-altitude conceptual hand waving. So let me offer a brief archaeology of the term *proprioception* and its aesthetic inheritance. In *The Inner Touch,* Daniel Heller-Roazen reminds us that the problem of self-sensation or self-sensitivity has an ancient name, which we find in Aristotle: *aisthēsis.* Heller-Roazen glosses *aisthēsis* in this way: "It is the sense of sensing, the mere feeling that something at all is felt."[19] *Aisthēsis* has two meanings. On the one hand, each individual sense (vision, olfaction, audition, etc., what today we would call a sense modality) is its own *aisthēsis.* On the other hand, there is the *koinē aisthēsis,* the "common sense," a sixth sense or an inner touch that forms the ground for drawing together the other five senses into an integrated perception of the world, because on their own they would never be enough to describe the sensory richness of our experience of the world (35–38). Whereas each of the five has its own sense of sensing, this inner touch carries a general sensual richness: the feeling of existence itself.

Tracing the history of *aisthēsis* up to (and beyond) the foundation of modern psychology, Heller-Roazen writes, "The *koinē aisthēsis* of the ancient philosophers thus appears as the coenaesthesia of the modern physicians; the 'common sensation' emerges as a 'common feeling'; and the 'inner touch, by which we perceive ourselves,' finds itself redefined as a faculty of 'touch' (*Getast*) that apprehends the vital force of the sensing body" (241). And thus we find, at the heart of modern perceptual psychology and its concept of coenaesthesia, the constellation of precisely the same problems. A nineteenth-century neologism groups together, once again, the two poles of what turn out to be the same philosophical problem: at once a common sense at the foundation of the five senses, providing adequate grounds for their integration, inside the organism, into a representation or experience of the phenomenal world; and, at the same time, the means by which living beings arrive at a reflexive sensation of self, a feeling of existence, the inner touch. Heller-Roazen writes, "All of perception and but one of its elements, the fundamental organ of sensation and yet still a sensory power of its own: the paradoxical status of the nineteenth-century common feeling once more recalls the ancient common sense, which consistently resisted being represented either as the entire aesthetic power or as one of its many parts" (250). Coenaesthesia and its way of condensing and updating the paradoxes of *aisthēsis* did not of course disappear at the turn of the twentieth century.

In fact, Sobchack uses coenaesthesia, alongside its more familiar cousin synaesthesia, as one of two theoretical foundations of her cinesthetic subject. *Synaesthesia* names an instance of literal confusion between the typically or normatively discrete sense modalities.[20] *Coenaesthesia* for her refers

to the condition of possibility for such confusion across modalities, the original commonality and indifferentiation of sense modalities—and, of course, at the same time, the sensation of sensation. In Sobchack's account, "Coenaesthesia names the potential and perception of one's whole sensorial being" (68). Moreover, it "refers to a certain prelogical and nonhierarchical unity of the sensorium that exists as the carnal foundation for the later hierarchical arrangement of the senses achieved through cultural immersion and practice" (69). The cinesthetic subject, as I take it, is her attempt to theorize how the cinema is able to effect a dedifferentiation of sense modalities, to make us taste, smell, touch *only by seeing*.[21] In Sobchack's account it is the cinema's capacity to hook into coenaesthesia's dedifferentiation of the senses that allows for a sensual or aesthetic situation in which I "reflexively turn toward my own carnal, sensual, and sensible being to touch myself touching, smell myself smelling, taste myself tasting, and in sum, sense my own sensuality" (77). We might note that in this context, the cinema's power to attenuate the differences between discrete sense modalities—its evocation or invocation of coenaesthesia—nevertheless ends in the five discrete senses. To sense my own sensuality, I touch myself touching, I smell myself smelling, and so on.

And so it cannot come as a surprise to discover that Sir Charles Scott Sherrington, at the turn of the twentieth century, gave a new name to coenaesthesia ("our secret sense, our sixth sense"): *proprioception*.[22] And it should come as no further surprise that James Gibson thus credits Sherrington with "great insight" "when he distinguished between proprioception and exteroception."[23] Although he gives proprioception a sense radically different from Sherrington's, Gibson shares Sherrington's goal of naming, in an idiom of perceptual psychology, this same feeling of existence that Aristotle names the common sense. Keeping with Gibson's account, Heller-Roazen points out that this *koinē aisthēsis,* this coenaesthesia, this proprioception, is precisely a *general* sense, which means that "there is a perception that cannot be referred to any single object; there is a sensation that, while felt, cannot be defined as the representation of one part or one set of parts and that cannot, perhaps, be defined as the representation of 'one' living being at all."[24] Now, this sensation cannot be referred to any single object, but it might be taken to refer either to a body or to a world. In fact, as we see in Gibson as well as in Merleau-Ponty, it refers to both, in their mutual coimplication.

In Gibson's hands, however, proprioception neatly inverts the priority of the terms in the traditional accounts of *aisthēsis* as self-sensation. Here, it is not that we have a special, subjective inner faculty that perceives that we perceive. Rather, my sense of myself as a sensing self *emerges from* my perceptual

relation with the world. *Proprioception arises as a result of an ongoing process and is itself an ongoing process.* There is no "proprioceptive system"; rather, "the continuous act of perceiving involves the coperceiving of the self."[25] And of course, vice versa. Sources of information that specify self and world *coexist*: "The one could not exist without the other. When a man sees the world, he sees his nose at the same time; or rather, the world and his nose are both specified." In short, "self-perception and environment perception go together."[26] The thickness of my phenomenal world and of my self-sensitivity is not a result of an internal accomplishment on my part; it is rather *a condition of the world and my inherence in it.*

As for the cinema, this means that at least in its proprioceptive vocation, the cinema modulates the proprioceptive boundary between myself and the world. As it modulates my ongoing resonance with the world, the cinema also inevitably modulates my self-sensitivity. And in fact, this much should seem familiar by now. But here a more important and more difficult consequence arises. The reflexivity of sense is not the relation of myself to my senses but rather is endemic to sensory and perceptual life, distributed and diffused throughout my perceptual resonance with the world. Self-sensation is not an activity of a subject but rather the process by which a subject can come into being in relation to the world. The cinema's modulation of my perception entails the modulation of my proprioception, which then itself names a modulation of me as a subject—that is, as a knot of relations with the world.[27]

With all of this, I am insisting that proprioceptive aesthetics is not only a set of films or an aesthetic program (or heritage) in which particular films take up its viewers' proprioception as an aesthetic resource. Of course, it is this. But I am also trying to establish a sense in which the term *proprioceptive* doesn't merely name a region of aesthetics, a territory whose contours and shapes are already known in advance. Each term conditions the other: *proprioceptive* necessarily transforms what we can mean by *aesthetics.* Proprioceptive aesthetics exacerbates the sense in which aesthetics refers in some way to the modalities of receptivity or attunement. An aesthetics grounded in proprioception as the body's fundamental modality of attuning itself to the world not only thematizes, roughens, draws out, or elaborates the fact of such attunement but makes such attunement the central category of its art. Which is to say, as an aesthetic regime, like any other aesthetic regime, it has its characteristic mode of receptivity. Given that it thematizes its mode, however, proprioceptive aesthetics is *about* this mode—that is, about aesthetics as a form of receptivity, in a particular and a particularly elaborated way.

Gravity's Proprioceptive Aesthetics

Gravity is not just any example of proprioceptive cinema. It captured the popular imagination in remarkable ways, immediately becoming the apotheosis of our contemporary, highly technologized cinema. Cuarón became Hollywood's "thinking" director, while Lubezki has become perhaps the best-known cinematographer in Hollywood. *Gravity* not only garnered an Oscar nomination for best picture but won for best director, cinematographer, editing, visual effects, sound editing, sound mixing, and original score. It's a big-budget film that, despite its obvious commercial ambitions, also had substantial aesthetic ones: it's "blockbuster modernism," "the world's biggest avant-garde movie," or "two characters lost in an experimental film."[28]

By most accounts it succeeded in both ambitions. While I disagree with Hoberman's assessment of modernism (for what I take are obvious reasons at this point but which I specify later), his contradictory locution gets at something important. The contradiction lies in the fact that while *Gravity* is an aesthetically ambitious and compelling film, it nevertheless manages to maintain a populist appeal. As a film primarily within the idiom of proprioceptive aesthetics, *Gravity* is somehow aesthetically respectable while not requiring critical work to grasp. Its aesthetic logic does not require elucidation or criticism in order to work; it is not stupid, perhaps, but it is somehow mute.

And yet I offer here an elaboration of this aesthetic logic in order to give an account of proprioceptive aesthetics as a cluster of related aesthetic problems. My goal in doing so is not, in fact, to make *Gravity* speak in an idiom more closely associated with modernism. Rather, in using it as an exemplar for proprioceptive aesthetics in general, I hope to show it is aesthetically important despite its muteness, its insignificance. This aesthetic importance is manifest at the moment of a shifting investment in cinemas as technologies for the perceptual modulation of viewers' bodies (and the concomitant shift in the cinema's investment in technology). Which is to say, the importance of proprioceptive aesthetics lies as much in the ways it indexes these shifting investments as it calls for the development of a critical idiom that does not mistrust perception, does not require cognition or intellection or criticism for aesthetic importance—which is to say, a critical idiom that might acknowledge its position as peripheral to the aesthetic vocation of the cinema.

Adherence of Body and World

Proprioceptive aesthetics tends to insist upon the manifestation of a world onscreen as one pole of the resonance between cinema and viewer. Often,

this world onscreen is different in some important way from the ordinary world (beyond the irreducible fact of being onscreen, which is difference enough). Sometimes, this difference is subtle; sometimes, it is radical. Tending toward the radical, *Gravity* opens with an image of Earth from orbit: a partial view of the familiar massive glowing blue orb against the stark blackness of stars. We hear the familiar, tinny voices of mission control and astronauts. Hearing this, we begin the search for the space shuttle and our space walkers. After a moment of scanning the frame, we find them—very small and very white against the very big and very black emptiness of space. Slowly, they get bigger: they're getting closer (Plate 7).

But already, this movement is disorienting, utterly unfamiliar: there's nothing onscreen to indicate whether it's our movement or theirs that's causing the approach. There's nothing else close enough by to give parallax motion, nothing to occlude nor to be occluded, no textured surface to move against, no counterrotating features of an environment, nothing to specify any displacement at human scales. The planetary and cosmic backdrop are just too vast. The relative rotation of Earth below specifies one kind of movement: we are in orbit, after all. Meanwhile, the stars are a static backdrop, far too far away to offer a frame of reference for movements at scales and speeds meaningful to my tiny size and earthly perception. Even *Gravity*'s opening moments are complex and complexly disorienting. In fact, we already see the three frames of reference that organize the film, which will continuously and vertiginously shift between them: the material in orbit, the rotating Earth below, and the fixed frame of the stars. The film, in fact, continually works these frames of reference against each other.

Koyaanisqatsi delivers several moments with ambivalent perceptual information, confusing subjective movement and objective motion. *Gravity*, by contrast, offers relentlessly consistent information. Its confusion stems instead from insufficient information. The shuttle's increasing relative size is, in fact, exactly correct ("realistic"—the entire film is exactingly verisimilar), yet when it comes to the spatial dynamics in orbit, it *feels* somehow wrong. Our perceptual resonance is tuned to an earthly plane, and space really is, in some important way, *unworldly*. This is not only about movement but about space as well. For example, in a vacuum there is no air and therefore no aerial perspective to specify distance; the film dispenses with it.[29] Space dissolves ordinary perceptual covariations, and so does the film. Throughout, the film maintains this unworldly aspect. It teaches us how to perceive according to its alien logic, to adhere to its laws.

Once the camera is close enough to the shuttle and astronauts and Hub-

ble telescope (or vice versa), these become the frame of reference for what are now clearly camera movements. The opening, largely linear approach becomes relentlessly rotational. To stay close enough to the shuttle, the camera starts moving in sweeping curves, rotating along all multiple axes and dimensions as it moves in complex figures around the space walkers. This shift is marked by establishing the shuttle and telescope as the frame of reference, in place of the blue orb of Earth. As the camera movement shifts, its palpable quality shifts as well, away from the slightly wrong and weird unworldly approach at film's opening toward something rather more out of control, unnerving in a more visceral and slightly nauseated way. Especially in the IMAX 3D that is the native home of *Gravity*, this movement around and through the rigging of the shuttle offers, in the technical sense of the word, nearly constant acceleration—and thus nearly constant proprioceptive stimulation. Although different from the initial approach, this floating, frictionless, rotational movement also gives us a sense of something *wrong*. This time, the movement feels untethered, light-headed, too slick. There's too much movement: I'm out of control. I find it panic inducing, thrilling, even nauseating. The only bearable posture is one of submission.

These two movements, both of them unfamiliar, weird, and unworldly, demonstrate that even under novel conditions, ones that don't obtain except under the most extraordinary of circumstances, as a viewer I am nevertheless immersed in a world onscreen, however unfamiliar, weird, or unworldly it may be. My perceiving body adheres to the perceived world onscreen, even as the conditions of that world are transformed, in this case profoundly. I find that I am ineluctably oriented in and oriented toward, destined for, even this, a world without surfaces, without friction or air resistance, without gravity, whose spatial coordinates therefore no longer include up and down—or better, as the film's opening text tells us, a nonworld where life is impossible. I experience this adherence as involuntary, ineluctable, thrilling. Merleau-Ponty's term for this dimension of experience is my "inherence in the world," but in this context, in a cinema, bearing faith to a world unfolding before me onscreen, I want to call this the *adherence of body and world.*

As a viewer in the cinema, as a viewer of *Gravity*, I do not *inhere* in its world so much as *adhere* to it. I find that for as long as I am in the cinema, I am bound to and for the world onscreen, although I am not *in* this world. I must follow its logic of appearance. I may destroy this adherence by walking out of the theater, but only by doing so. (Although, if I leave to go get popcorn or to go to the bathroom, I may only attenuate it temporarily. Meanwhile, if I close my eyes, the world continues to unfold even as I do not see it

and will be there when I open them—exactly as the ordinary world.) This follows Merleau-Ponty's perceptual faith and depends upon it. This adherence, instead of describing a fundamental disposition, describes an unavoidable dimension of my resonance with the cinema. Nevertheless, we might say that as I bear faith to a world unfolding before me onscreen, I am its *adherent*. Proprioceptive aesthetics exacerbates, as *Gravity* does, this adherence as a primary aesthetic effect.

A Logic of Bounding and Unbounding

To say that proprioceptive cinema thematizes my adherence to a world unfolding before me onscreen does not describe this adherence particularly. *Gravity* adheres us to an unworldly world whose alien logic of manifestation thematizes such adherence. I do not merely find myself adhering to the world unfolding before me onscreen; I find that I must take up a position in it. More than that, adhering to a world onscreen, I coperceive myself and the world. That is, this relation of adherence not only encompasses my perception of the world but also includes my perception of myself, my proprioception.

Proprioception groups together those perceptual processes by which I arrive at my sense of myself as a bounded and thick *here* in the world. It refers to the aspects of my ongoing perceptual resonance with the world that specify self. To the extent that *Gravity* shifts the conditions of appearance of the world, the film engenders a process of proprioceptive disorientation and reorientation whereby my ordinary procedures of arriving at a sense of myself have themselves gone weird. *Gravity* takes to its logical conclusion the cinematic disordering and reordering of perception. It ruptures, in unusually flagrant ways, that most important of perceptual and proprioceptive covariations: the one between my vestibular sense and my vision. Of course, it disorders visual covariations as well, not least by simply offering a situation in which such information, despite its virtuosic realism, is absent. A rupture or divergence between these covariations occurs most palpably in the cinema when the camera accelerates in some way, specifying a change of direction or speed. And indeed, circular and rotational figures of camera movement abound in *Gravity*. But perhaps most important, the absence of onscreen weight and the dissolution of any vertical or horizontal axes engender a more constant, if subtle, rupture between my vision and my vestibular sense.

As my body in the theater is pulled upon by the earth, I am oriented by vertical and horizontal axes not merely by habit but by the actual, ongoing fact of gravity's vertical pull. This pull is specified not only by my vestibular sense of

balance but also by the tactile contact between my body and the clothes that rest upon it and the seat that supports it, as well as internally in my body's tensioned posture. As with cinematic kinesthesis in general, *Gravity* ruptures the covariations that ordinarily obtain between more "embodied" aspects of proprioception and those that are more distant, less embodied, more "visual." By introducing contradictory, or just aberrant, information into my proprioceptive processes, it roughens these processes, draws them out, draws them to my attention, makes them thematic. My proprioceptive attunement with myself ordinarily passes beneath conscious awareness, but *Gravity* forces me to work to resolve contradictions or ruptures or insufficiencies in perceptual information. But the awareness of proprioception *Gravity* brings does not take the form of a cognitive apprehension of embodied, lower-level perceptual processes. Rather, proprioception becomes thematic by means of embodied affect. I don't *think* my disorientation—whether it is voluptuously pleasurable, or nauseating and panicked, or both—I *feel* it.

Gravity effects a proprioceptive disordering whose affects are at once panic, thrill, disorientation, nausea, submission. In this proprioceptive disordering, the film puts into question, even into crisis, my ordinary ways of orienting myself in the world. As the film disorders the perceptual processes by which I arrive at a sense of myself as a bounded body, it effects an unraveling or unbounding of my ordinary self-possession. In so doing, it exacerbates my procedures for maintaining perceptual boundedness. It draws out the *écart*. As with the pleasurable proprioceptive unbounding of childhood dizziness after a game of Ring around the Rosie, the thrilling disorientation isn't so much a loss of boundedness as a temporary moment of irresolution in my boundedness, an unbounding that is not total but partial, not punctual but ongoing.

Masochism, Pleasure, and Self-Relation

Such unbounding has long been a central category of film theory, particularly in descriptions of cinematic pleasure. Christian Metz's famous account of spectatorship in *The Imaginary Signifier* includes a description of cinematic pleasure as perceptual intensification coupled with a form of becoming-unbounded. Pleasure inheres in the cinema's status as a "more perceptual" art form. It regresses the spectator to the "all-perceiving" instance of the infant and thus to the originary dedifferentiation of subject and world before the mirror stage.[30] For Metz as it is for Laura Mulvey—indeed, according to the Lacanian logic of film theory's psychoanalytical period—this unbounding is

pleasurable because it addresses our desire to overcome our separation from the world: it offers an approximation of *jouissance*.[31] But because *jouissance* is terrifying, the cinema cannot proffer it directly (even in this aesthetically and technically mediated form). This primary unbounding thus carries with it a compensatory identification both with the technics of the cinema and with protagonists within the film's diegesis.[32]

In his earlier work, Shaviro critiques this Lacan-inspired account of cinematic pleasure, arguing that cinematic pleasure is instead a form of masochistic pleasure taken in a shattering of the ego. Shaviro's spectator remains all-perceiving, "within the orbit of the senses."[33] For him the perceptual intensification of the cinema radically overwhelms the spectator, offering masochistic pleasure in "the violent stimulation of the body and the loss of ego boundaries" (56). In contrast to psychoanalytical film theory's emphasis on compensatory mechanisms, Shaviro follows Leo Bersani's account of infantile sexuality, in which all "sexuality, at least in the mode in which it is constituted, may be a tautology for masochism," in which we take pleasure in the body and its agitations: "that which is intolerable to the structured self."[34] In both accounts an unraveling or breaking of the boundaries of the spectator is the fundamental condition of cinematic pleasure. Whether it be masochistic shattering or self-loss accompanied by compensatory identification, cinematic pleasure has long lay in the cinema's attenuation or rupture of our boundedness. Cinematic pleasure has, in other words, long been proprioceptive pleasure.

And so when in *Gravity*'s opening camera movements I feel the dizzying, thrilling panic of movement beyond my control and according to an alien logic and my subsequent release into submission, this is in some sense a straightforward, if particular, instance of cinematic pleasure. Depending on your theoretical investment (or, for that matter, your aesthetic investments and spectatorial dispositions), you may care more or less about the narrative's relationship to this embodied proprioceptive pleasure, with its potential for a compensatory identification with Stone (buoyed further by Sandra Bullock's profoundly unthreatening star persona). Or such unbounding may be grasped directly as the film's primary and virtuosic achievement, the story fading into the background, the alibi for a more experimental form of filmmaking. The affects that attend proprioceptive unbounding—dizziness, thrill, nausea, submission—are the embodied index of viewers' intensified process of asserting proprioceptive boundaries. That is, they are the modes in which the cinema's proprioceptive modulation are manifest in experience.

That said, I do not wish to suggest that the cinema's proprioceptive plea-

sures are necessarily masochistic, although they may be. Rather, I want to draw a lesson from Shaviro's and Bersani's accounts of masochism: *pleasure is not the opposite of pain*. Instead, in Arnold Davidson's words, "pleasure is, as it were, exhausted by its surface; it can be intensified, increased, its qualities modified, but it does not have the psychological depth of desire. It is, so to speak, related to itself and not to something else that it expresses, either truly or falsely."[35] Pleasure in this context is the aspect of a perceptual relation that aims at the relation itself and is immanent in that relation. It is a form of sensory reflexivity that does not give rise to discourse. When I experience a tightening in my chest, a small lump in my throat, an involuntarily intensifying grip on my armrests and a tensing of my core muscles, a dizzying and thrilling, if slightly panicked, disorientation, these are not my pleasure. My pleasure instead consists in a relation to these responses and their affects.

All of this is to say, proprioceptive pleasure is a paradoxically open form of autoeroticism in which my resonance with the world becomes the occasion for my delight. Perhaps it is not surprising that autoeroticism should be the relevant figure here: Merleau-Ponty's *écart* is not only the seeing-seen but the touching-touched, and Gibson's proprioception is self-stimulation. In any event, this pleasure has a special relationship to its status as proprioceptive pleasure. My pleasure lies in the attenuation of my boundedness—that is, an intensification of my attunement to the world. I take pleasure not only in the world as such but in my body's responsiveness to it. It is precisely aesthetic pleasure in Shaviro's terms from *Without Criteria*—pleasure in my receptivity to the world, to the insuperable fact that I am in the world and responsive to it. And in this, it is not only aesthetic but also specifically *affective*.

Proprioception, Perception, and Affect

Gravity's relationship to typical Hollywood film is unusual, not least because its narrative is minimal compared with those of other high-concept studio product. I've remarked on its similarity to games, but another aspect is particularly salient in regard to its proprioceptive vocation: its affective force. *Gravity* is an unusually anxious film; it offers an anxiety that is masochistically pleasurable. Ordinarily, I think, our tendency would be to explain this with recourse to a theory of identification: the anxiety or dread we feel takes root, in the first instance, in an identificatory relationship to Stone and is recuperated by that identification and the narrative closure of her ultimate survival. The interest we have in her success or failure lies in the way Bullock's character and performance consolidate what Metz teaches us to call a

secondary cinematic identification.[36] And to be sure, this is an element of how the film works.

That said, my extremely anxious experience of the film is not recuperated by her survival but rather coupled with a resolute indifference to the characters and their fates, along with annoyance at both the writing and the plotting of the film. I wasn't the only one to note *Gravity*'s minimalist narrative.[37] Moreover, my anxious response to the film persisted upon repeat viewings, even after I knew Stone survived. While part of this is easily explained by my own (habitual or constitutional) aesthetic attunement to the nonnarrative aspects of films, no small part of this anxiety lies in the film's proprioceptive unmooring. It induces anxiety in its viewers through its dissolution of horizontal and vertical axes of perception, as well as the way it displays the human body striving and only barely succeeding to get purchase in the frictionless, weightless vacuum of space, where life is impossible.

Like all films that dramatize a character's capacity (or incapacity) for embodied enaction—what elsewhere I call dramas of self-adjustment— *Gravity* must present its world according to the canons of the perception and ability—that is, the proprioception—of its protagonist.[38] Proprioceptive cinema that focalizes its perceptual effects through a character laminates a mimetic and affective resonance with a character onscreen to the proprioceptive modulation of the viewer's body that thematizes the manifestation of a world onscreen. To be sure, while this mimetic and affective resonance with bodies onscreen anchors and indeed can compensate for the proprioceptive unbounding of such films, this resonance often lies to the side of narrative, even in emphatically narrative films.[39] In *Gravity* my anxiety is focalized through Stone, generated in no small part by her flailing, her out-of-control rotation along three axes, her breathing, her voice, her terror. It is organized less by anticipation of a narrative outcome than by the proprioceptive and affective modulations of the film. To say this a bit differently, the narrative is only one small aspect of a complex and integral modulation of the viewer's affects in which the most important constituents are a proprioceptive attunement to the cinema, a mimetic attunement with Stone, and the more abstract musical attunement to Steven Price's masterly score.

And yet proprioceptive unbounding has a deeper relation to affective intensification than that. Take *Koyaanisqatsi*. The film's proprioceptive modulation is affectively intense. My body responds with the same tension of my core muscles, the same tightening in my throat, and a rather similarly bowel-loosening headlong flight through the world onscreen, a palpable pleasure in

my body's ongoing attunement to the technics of the cinema and the world onscreen. Music is similarly important as a channel of affective attunement. And yet no protagonist anchors such a relation. Proprioceptive modulation is affectively intense even in the absence of a protagonist to serve as a mimetic anchor in the world onscreen.

The reason for this is that proprioception itself is almost already affect. Recall that for Gibson *proprioception* is the name for perceptual self-stimulation, or *resonance with oneself.* French philosopher Gilbert Simondon defines *affectivity* as "the resonance of a being with respect to itself."[40] That is, affectivity is *internal resonance.* In Simondon's scheme—important for later philosophers of affect such as Gilles Deleuze and Brian Massumi—affectivity names the capacity of an organism to be affected by what lies outside it as well as *by itself.* In *Without Criteria* Shaviro calls this *receptivity,* but affectivity, like perception, is not only a question of the receptive resonance of an organism with its environment or a subject with its world but also an *internal* resonance, resonance with itself. This is not to say that perception, or even proprioception, is identical with affect or affectivity. Rather, it is to name proprioception as the site at which they intersect, or become indistinguishable. In a formula: *proprioception is the affective dimension of perception and the perceptual dimension of affectivity.*

For the proprioceptive aesthetics of films like *Gravity,* proprioception and affect are made to coincide, both thematized as attunement to the world onscreen as well as the technics of the cinema. As they invest proprioception aesthetically, such films take up as their aesthetic object not only my perception but something more intimate: my internal resonance, my self-sensitivity. Proprioceptive cinema works not only on my attunement to the world but on its correlate: my attunement to myself. In proprioceptive cinema's pleasurable unbounding, my resonance with the cinema points in two directions at once, playing both sides of my attenuated boundedness.

Attunement, resonance, and modulation.

I have been describing our encounter with the cinema in terms of overlapping acts of (cinematic) modulation and (bodily) attunement, giving rise to *resonance* as my central figure for our encounters with the cinema. In fact, this differs from the adherence of body and world I have described: they play out as different moments of a single process. Schematically, we can say that my body adheres to a world unfolding before me onscreen, and this adhesion arises as

a result of my ongoing resonance with the cinema. Put otherwise, adherence is my relation to the world onscreen; resonance is my relation to the cinema as a technical arrangement.

Proprioceptive aesthetics emphasizes overlapping acts of modulation and attunement as part of an ongoing resonance between cinema and viewer. In this, it draws together aspects of the cinematic encounter usually thought of as contradictory or in tension: immersion in (read: adherence to) a world onscreen, on the one hand, and an awareness or investment in the cinematic encounter itself, my bodily presence in a cinema, on the other.

Partly, I want to suggest this is a false opposition. Such an argument would be far beyond the scope of what I can do here (or what I am really qualified to do), in part because it has so many different figures in so many different domains of thought. Michael Fried names these poles *theatricality* and *absorption*.[41] Tom Gunning outlines the cinemas of attractions and narrative integration.[42] We can even see two variants of this in Mulvey's "Visual Pleasure and Narrative Cinema": in the opposition between fetishistic scopophilia and narcissistic identification and in her political goal of analyzing beauty to destroy pleasure in favor of "passionate detachment."[43] Of course, much film theory, especially in its moment of political modernism and inherited from a broader modernist orientation, has mistrusted the immersive term, what it has sometimes called the diegetic effect, and preferred some form of reflexive alienation to the deceptive "illusory" immersion in a fictional or constructed world.[44]

At least from the perspective of proprioceptive cinema, however, these aren't opposing terms at all. They are, rather, bound tightly together as moments in an ongoing process. As a viewer in front of *Gravity* (or *2001* or *Koyaanisqatsi* or, really, any film whose aesthetics are substantially proprioceptive), in a single, simple aesthetic moment, I find myself at once adhering to the world onscreen *and* resonating with the technics of the cinema. While the former depends in some sense upon the latter, my adherence to the world onscreen does not supersede or sublate or otherwise overcome my ongoing perceptual and proprioceptive resonance with the cinema. Indeed, if anything, the common critical sense that there's something emphatically *cinematic* about *Gravity* or other recent big-budget, effects-heavy filmmaking—*Avatar* is the only other example that made as much noise, but it's far from the only one—indexes the ways in which these films' virtuosically immersive world making are also, at the same time, equally virtuosic feats of embodied and embodying cinematic modulation.

From a theoretical standpoint, this is because *I do not lose myself in a world onscreen.* Rather, I *find* myself in one. Or more correctly, *I arrive at a*

sense of myself in the cinema in collaboration with the world onscreen. To "find myself" in the cinema is to arrive at a sense of myself caught up in an ongoing perceptual resonance with the cinema and an ongoing adherence to a world onscreen. Because a single process of resonance gives rise to the manifestation of a world onscreen to which I adhere and my sense of myself as a bounded or unbounded body adhering to that world, there is no opposition or even tension between an investment in the world onscreen and an investment in my resonance with the cinema.

This is why, in proprioceptive aesthetics, aesthetics appears primarily in its sense of the mystery of my receptivity to the world. Proprioceptive cinema restages, in its aesthetic and technical process, the unaccountable and inevitable and mysterious fact that I am bound to and bound for a world, that I resonate with that world, that I am thrown open to that world. In proprioceptive aesthetics this fact is not elucidated or rendered the object of critical or philosophical reflection. It does not need to be converted into something of value by a process of criticism or philosophy but appears as immanent self-relation and affective intensification.

Technics and Aesthetics

I am now in a position to offer an elaboration I call for in the first chapter: *proprioceptive aesthetics is the alternative to modernist aesthetics.* Proprioceptive aesthetics stages, in its mute wonder at my resonance with the world, a relation to both technics and aesthetics profoundly different from the modernism with which it is so easily confused. Aesthetics takes on a different meaning in proprioceptive aesthetics. Its modes of aesthetic apprehension are decisively different from modernism's. They do not require Cavell's critical effort to become communicable nor Michelson's "critical athleticism" to elaborate them—and not because proprioceptive aesthetic experience is easily communicated.[45] Indeed, it is not (as I have discovered again and again writing this book). Rather, as we have seen, it does not share the same anxious compulsion to be communicated. Unlike the aesthetic judgments of beauty or, indeed, cuteness it so closely resembles, not least in the ways they thematize attunement to the world, proprioceptive aesthetics postulates neither universal assent nor even generalizable validity—and hence is not vulnerable to skepticism. This is because the mode in which proprioceptive aesthetics thematizes my attunement to and inherence in the world, the affects to which it gives rise, do not lead to an aesthetic encounter that is *extraordinary* in the same way modernist aesthetic experience is.

Gravity thematizes adherence to a world onscreen, attunement to it, by deforming and even destroying the ordinary conditions of the appearance of the world—gravity, friction, horizontal and vertical—thus thematizing the otherwise unremarkable processes of proprioception. What's important here—and what marks its departure from extraordinariness in the modernist mold—is that in such an encounter thematization is not the result of an act of phenomenology or aesthetic criticism or other intellection or cognition. Rather, it is grasped *within perception, as proprioception.* The *New Yorker*'s Richard Brody makes this drolly obvious, complaining that "it's hard to recall a movie that's as viscerally thrilling and as deadly boring as 'Gravity,' a colossal and impressive exertion of brain power aimed at overriding—at obviating—the use of brain power."[46] *Gravity* neither calls for nor rewards critical elaboration as it is usually understood. Instead of calling for cognition (or even, following Ngai, what we might call *interest*), *Gravity* offers the modulation of perception and indeed of proprioception as sufficiently interesting in itself.[47] Furthermore, as we have seen, proprioception *itself* names the reflexive turn within perception. So *Gravity*, like other proprioceptive cinema, makes my perceptual attunement to the world reflexively thematic *within* perception, without the threat of skepticism, without criticism or philosophy, without the risk of missing the world as it is in itself, without pernicious or deceptive illusion. In proprioceptive aesthetics perception rises up, with all its partiality and finitude, as the fundamental way we have of resonating with the world.

In the cinematic encounter, then, proprioception arises as the modality of attunement—not only to the world onscreen but also to the cinema itself. And so proprioceptive aesthetics marks a second important departure from modernist aesthetics: its relation to technics. What marks the difference between the cinema's onscreen world and the ordinary world lies in the illusion that attends cinematic perception. That is, it stems from the cinema's technical modulation of perception. Unlike modernist aesthetics, which relates technology in the first instance to an indefinable medium specificity or an ever elusive ontology—most often but not only understood as the procedures for recording or producing cinematic images—in proprioceptive aesthetics the cinema's most important technical dimension is its capacity for perceptual modulation.

And so it can come as no surprise that one of the particularities of critical discussion of *Gravity* lies in the return, again and again, to the question of exhibition technology. Evidently, the ideal setting for *Gravity* is IMAX 3D. This is not to say that technologies of production aren't important to how critics speak of the film or how we might understand it. *Gravity* involved more

technical innovation than any film in recent memory, except perhaps *Avatar*, and such innovation was well remarked. Unlike *Avatar*, however, whose immersiveness lies in part in an ostentatious mise-en-scène that foregrounds the technical innovation as internal to the film's aesthetic, *Gravity*'s technical innovation tends toward the invisible, the relentlessly verisimilar, the almost documentary. It is not surprising such aspiration should lead it straight to IMAX, so often associated with the middlebrow edification of nature documentaries, as its home. As Hoberman has it, "To watch *Gravity* on the huge IMAX screen is to appreciate the power of illusion—what André Bazin described as 'total cinema.'"[48] This total cinema, of course, relies on the massive, integrated technical regime that Cuarón and Lubezki have largely innovated themselves. This cinema is, of course, largely digital: *Gravity* was shot largely in digital video, relied heavily on digital compositing and 3D conversion, and, not least important, required the innovation of digitally programmable robotic arms and LED light boxes. In fact, it is far from Bazin's idealized total cinema as the re-creation of the world in its own image, an ideal that has oriented much of the technological investment in photochemical cinema. The totality of the cinema here lies not in the documentary recording of the world nor in its re-creation but rather in the cinema's capacity—especially in its apotheosis of IMAX 3D—to immerse its viewers in a world. The total cinema is a *proprioceptive* cinema.

While a shift from production to exhibition technologies is indeed a hallmark of the cinema's proprioceptive aesthetics, to put it this way is to emphasize only a shift in which technologies seem important. Once, this might have seemed crucial on its own, as critics and theorists worried immensely about a cinema newly saturated by digital technology. The cinema's photographic technology seemed to be the most important technological fact about the cinema and was under erasure in a moment of profound technological shift. This no longer seems quite so pressing, as the cinema's saturation by digital technology is a done deal, a rather mundane observation by now. And yet a deeper shift is at stake here in the departure from modernist aesthetics. More important is *how* proprioceptive aesthetics invests the technology of the cinema, what the stake of that investment is.

6 AESTHETICS BEYOND THE PHENOMENAL
The Flicker

Tony Conrad's *The Flicker* is a fiendishly difficult film to write about, more so than the other films in this book, more than most. There are the usual, what we might call *ekphrastic*, reasons for this: presenting an aesthetic experience of a visual and temporal object as data for critical and theoretical operations is (if you're doing it right) always difficult. *The Flicker*, however, is almost uniquely ambivalent. It operates at thresholds of determination, undermining our capacities to describe its effects and putting our categories for such description under torsion. And yet *The Flicker*'s difficulty is also what makes it exemplary. It constellates a large number of distinct but related and mutually inflecting ambivalences: between inside and outside; between my body and the world; between what's onscreen and what's offscreen; between active and passive; between adherence to a world and inherence in the world; between perception and affection; and between modernist medium specificity and proprioceptive aesthetics. (These are the ones that occupy me here, but there are others that are significant and related but that I must leave to the side: for example, between real and hallucinatory; between motion and stillness; between sense modalities; between structure and process.)

Despite its singularity, *The Flicker* is, in important ways, quite similar to *Anémic Cinéma*: abstract, flagrantly illusory, and easily confused with a modernism to which it is proximate but from which it is nevertheless decisively distinct. By the same token, this closing chapter turns through many of the same themes as chapter 1, returning to the problem of aesthetic experience and its significance. My way of proceeding is to trace the contours of this constellation of ambivalences and then to mine them for the lessons they hold for proprioceptive aesthetics and its investment in the cinema as technics. I pursue two major claims in this chapter. First, as an exemplar of proprioceptive

aesthetics, *The Flicker's* structural or structuring ambivalence is, if not quite an embodiment of, at least deeply related to the chiastic structure of the flesh that Merleau-Ponty articulates in *The Visible and the Invisible.* Second, inflected by Merleau-Ponty's late ontology as well as Renaud Barbaras's phenomenology of appearance (elaborated in chapter 2), Walter Benjamin's radical reformulation of aesthetics shows how *The Flicker* leads to an aesthetics beyond the category of experience: an aesthetics beyond the phenomenal. This aesthetics beyond the phenomenal is the property of neither a body nor a subject but rather emerges with the body's encounter with technics. In *The Flicker's* aesthetics beyond the phenomenal, aesthetics ceases to be the domain of an embodied subject or even a body in its resonance with the world but is distributed across the viewer's organic body and the cinema's inorganic technics in the resonant thickness of their encounter.

To start, however, we need some facts about the film. Conrad made *The Flicker* in 1965. It consists of black and white (or rather, clear) frames arranged in various strobing patterns. It is a half-hour long. Its soundtrack is a kind of aural equivalent, in which frequencies resonate and interfere with one another, complementing and counterpointing the image. In this, it very closely resembles Peter Kubelka's 1960 *Arnulf Rainer,* also a flicker film consisting of black and clear frames, matched by a sort of aural equivalent. At this level of high-altitude formal description, the only real difference is runtime: *Arnulf Rainer* is seven minutes long; *The Flicker,* thirty. This similarity belies what is perhaps the only important difference: *Arnulf Rainer* is merely assaultive. The experience of *Arnulf Rainer* is that of a barrage, mercifully brief, whose perceptual intensity is matched by a single-minded focus on disclosing the material facts of the cinema. *Arnulf Rainer* is as aesthetically simple as its form: it is modernist cinema through and through.

The Flicker, by contrast, is subtle and complex. It eases you in, softening you up before it lays into you. Its extremely carefully calibrated stroboscopic patterns give rise to bizarre and unpredictable perceptual effects, including afterimages and phantom colors. It routinely makes viewers hallucinate, although it does not do so without fail. I have seen it several times, and no viewing has been similar, let alone identical. This runs from my first viewing, almost accidental, in which I enjoyed it just fine and saw some purple and green but didn't think too much of it, to a viewing in an avant-garde cinema course I taught, in which I had an ecstatic, frankly psychedelic, almost out-of-body experience with extremely vivid—but, weirdly, still purple and green—hallucinations. (This was, as you might imagine, a little awkward in a room

full of undergraduates.) Even when I have seen it in back-to-back screenings, even on the same day, the experience has been remarkably different.

This is part of what makes the film so difficult to write about: I can (and will) report my own experiences, the experiences of students in my classes, the experiences of the various audiences whom I have subjected to the film, and the experiences others have documented. But unlike representational or even most abstract cinema, its form so radically underdetermines its effects that all of what I say about them in particular is both provisional and partial and frequently merely autobiographical. No two viewings of the film are the same. And while that fact may be nominally (and sophistically or sophomorically) true of any film, it is central to how *The Flicker* works. Any description of an individual encounter with the film simply cannot have the authoritative generality that criticism—or phenomenology, for that matter—typically arrogates to itself. I return to this impossibility of criticism when I discuss its relation to modernism. It has decisive implications for what we can make of experience here.

Not only because of the impossibility of rigorous generalization, my goal here is not to explain *The Flicker*. As in the other chapters, I am not attempting to explain how the film works but rather to leverage what it does in an argument about the cinema, its proprioceptive aesthetics, and the importance of grasping the cinema as technics. In fact, I want to do as little explaining of *The Flicker* as possible, since Branden Joseph has done so in an extraordinary manner in his book on Tony Conrad, *Beyond the Dream Syndicate*.[1] So here, I want to emphatically acknowledge that in my theoretical treatment of *The Flicker*, I'm relying heavily on Joseph's masterly art-historical account as a springboard for my own, decidedly different, phenomenological and media-theoretical agenda.

Pursuing this agenda, I move through three major phases. First, I turn through each of the ambivalences I have listed, developing them as heuristic devices to describe the work the film does. In particular, in this part I use the way *The Flicker* stages a confrontation between modernism and proprioceptive aesthetics to articulate how the film offers a way to understand the cinema as technics. Next, I turn to the problem of what I call an aesthetics beyond experience, putting Benjamin's famous diagnosis of a radical crisis of experience up against the ecological-phenomenological approach I work out over the course of this book. Finally, I argue that since aesthetics is no longer grounded in a subject's experience, it takes place in the encounter between the organic body of the viewer and the inorganic technics of the cinema.

Six Ambivalences

Watching *The Flicker,* I may experience colors (green, purple) or see catherine wheels or buckyballs or complex spiraling figures or demonic faces. Or, as reported by several subjects in a psychology experiment at NYU in the late 1960s who submitted to private screenings of the film and filled out questionnaires after, I may see "various types of insects (fly, roach, beetle), a large eye that rolled its pupil, and even 'a lady and boy in garb of old frontier, standing by a stream, apart from a wagon train.'"[2] In all of these situations, the question of *where* these images occur is not merely ambivalent: the distinction between inside and outside is disordered to the point of undecidability. It is not, as in cases of psychotic or even drug-induced hallucination, really *in my head,* since what I see is, in some inscrutable way, caused by the film.[3] But it's also not *in the film* either, since what's in the film is actually and really *only* strobing. In this, however, it is like any perceptual illusion in the cinema: it is only in the cinematic encounter, in the ongoing modulation of my body by the technics of the cinema, that the percept at hand arises.

Which is to say, what we see when we watch *The Flicker* is not simply onscreen. At a first level, the film makes it impossible to arrive at a determination of whether what I see is in my head or in the film. Furthermore, its strobing is not confined to the screen. Reflected off the screen, it fills the whole space: the walls and the ceiling strobe, too. I may look away from the screen, but I am still subject to the technical manipulation of the film. If the projection is bright enough, I close my eyes, and *still* I see the flicker. Furthermore, flicker effects through closed eyes are often even more intense.[4] Unless I leave the room, I cannot escape it: the strobing continues. *The Flicker* is, no matter how much it *uses* the screen as a reflective surface, not bound to it in any ordinarily cinematic way. It suffuses the space; it gets in its viewers.

A third ambivalence, then, also related to these first two, is between passivity and activity. As Conrad himself explains:

> My idea was that basically this would just knock people's socks off, and I wanted them to understand that they were being run by the power of this film. That it was not coming from them even though the experience of the film happened inside of their body and not really in space. . . . I wanted to really give people a chance to pretend that they were in control of the situation, but then to make it very painfully and slowly clear—as though you're slicing them very slowly—that it's the film that is in control of what's going on.[5]

I must admit I do not entirely understand what he means by "pretending to be in control of the situation," since my own experiences of the film have run from hypnogogic relaxation to ecstatic submission. One of my students, however, reported that he would give himself over to the film until he got to the point where he was worried he "wouldn't come back" and would somehow pull himself together, resist the flicker. Meanwhile, I think in those moments (or, rather, in similar moments, at a threshold of *ekstasis*), I experienced the obverse feeling, that I wished the film would *really* let go, really give it to me. Either way, in Joseph's words, "Plugged into the black-and-white patterns as though wired to the flow of alternating current, viewers seem on the verge of dissolving into a circuit with the technology, although perhaps also being aware of their position on this edge."[6] Whatever mode this awareness may take—cognitive, perceptual, proprioceptive, affective—it comes only after the viewer becomes part of the cinema's technical system.

However insistent or totalizing this technical system may be, whatever it is I may or may not see during a screening of *The Flicker,* the effects of the film arise only from the addition or contribution of my body—radically private, singular, unlike the contribution of any other body. Even as it is undecidable whether what I see in *The Flicker* is out there or in here, it is nevertheless the case that what I see in it is, in some unusually emphatic sense, not at all the same as anything anybody else sees in it. Of course, active and passive (like their cognates, voluntary and involuntary) do not divide the world entire,[7] but here, it seems their failure to capture the facts of the case, instead of indicating that their use may be an abuse of the words, is rather precisely the condition the film wishes to exacerbate. Actively passive or passively active, what seems really at issue is an activity in excess of or to the side of, beyond or below, my willing. A privacy and, even, a freedom not sovereign in nature take root in the singularity of being *this* body—even as the film is insistent, even dictatorial, in its control.[8]

What seems to be a straightforwardly perceptual process, the subjecting of a body to various strobing patterns, ends in a complex affective response—submission, ecstasy, aversion, nausea.[9] As with *Gravity, The Flicker*'s effects lie at the point of total ambivalence between perception and affection. In this, it is just proprioceptive cinema. It is, however, not proprioceptive cinema in quite the same way as *Gravity* or *2001.* It is perhaps proprioceptive more in the mode of *Anémic Cinéma.* It does not thematize our proprioception by offering a world onscreen to which we find ourselves adhering. Rather, it moves off the screen. In so doing, it roughens our relation to *the* world, the world around us,

what I hesitate a bit to call the ordinary world, the world *not* onscreen—the world, full stop. In other words, it renders ambivalent the cinematic adhesion to a world onscreen and my ordinary (or existential) inherence in the world. As with other examples of proprioceptive cinema, it effects this disordering of my proprioception by rupturing ordinary covariations: I see something, a flickering, insubstantial purple-green spiral, but it does not displace in my visual field the way it ought when I move my head, and its various parts slither in ways that subtly or flatly violate the rules of occlusion. It is neither in me nor in the world—and I do not know where or indeed how to draw a boundary between my body and the world. These ruptures, of course, carry with them the palpable feeling of illusion. My hallucinations are insubstantial, obviously aberrant, voluptuously or terrifyingly *wrong*. What I see in *The Flicker*'s hallucinatory intensity is the contribution of *my* body: it belongs to my body; it *is*, in some sense, my body. Thus it belongs to proprioception's reflexive turn in perception.

Which is also to say, *The Flicker* affects the body in such a way that it rises up in excess not only of my will but also of my ego. As Jean-Luc Nancy and Philippe Lacoue-Labarthe have it in their brief programmatic essay "The Unconscious Is Destructured Like an Affect," "The affect is the unconscious *as* consciousness"—and moreover, the affect names "the affection of an inside by an outside, therefore the division of the two *and* their reciprocal penetration. Ambivalence is thus the affect itself."[10] To put it another way, *The Flicker* configures perception such that it becomes affection, directly so, with all its ambivalence, and more emphatically than *Gravity*. This stems in part from its removal of an object: perception here is not anything like the intentional perception of an object, as there is no object. Nothing approaches the solidity of a determinate object, even if I find myself intending a purple-green rotating buckyball or a menagerie of insects or a scene from the Oregon Trail. Here again, we see the ambivalence of inside and outside, in here and out there. Perception becomes a process of pure resonance or attunement, and no object serves as the prop or occasion for such attunement. The quality of my affect may be masochistic or ecstatic or terrifying, but what is not in question in the form of my response is that *The Flicker* works at the point where perception and affection are precisely indistinguishable.

The Ends of Modernism

It may be obvious to point out that these ambivalences—inside and outside, body and world, active and passive, onscreen and offscreen, adhesion and

inherence, perception and affection—arise in Conrad's film through means both aesthetic and technical. It is, after all, a film. And yet describing *The Flicker* in this way allows us to see that these ambivalences are not *coincidentally* technical but rather have the technical nature of the cinema at their very core. *The Flicker* acts as a demonstration of the fact that I am susceptible to modulation by technics in a profound way. Something as existentially primary as my inherence in the world and as intimate as my capacity to draw a boundary between myself and the world can be technically modulated by the cinema. To the extent *The Flicker* dispenses with the typical conditions of the cinema (characters and narrative; a world onscreen; photographic, animatic, or other images onscreen; a process bounded by the screen) the film lays bare the fact that the technological arrangement of the *cinema* (a darkened room, a screen, a projector, a sound system, etc.) lies at the heart of the cinema's proprioceptive aesthetics.

In fact, *The Flicker* doesn't work without a cinema. At a first, obvious level, it requires a darkened room, a screen, and so on. But beyond that, because it is tuned precisely to the frame rate of synch-sound cinema, it also requires a 16 mm projector. Like *Gravity, The Flicker* invests in the cinema as a technology for exhibition, and like *Anémic Cinéma,* it configures the cinema as an optical device. The film—and, I am arguing, proprioceptive aesthetics more generally—turn on an aesthetic investment in the cinema as a technological arrangement in ways for which film theory has no easy figures. It relies on neither modernist medium specificity nor alienating apparatus. Rather, insofar as proprioceptive aesthetics modulates the *écart,* the cinema appears as a technics of the flesh.[11]

With all its ambivalence, it is perhaps not surprising that *The Flicker* can be easily confused for modernism, with its insistence on medium specificity as an ontological problem. And indeed, it does not seem to be much of a stretch to consider *The Flicker* a modernist piece of cinema, if by that you mean it makes visible, even unavoidable, the material and technological specificity of the cinema. P. Adams Sitney uses *The Flicker* as one of the purest examples of "structural film,"[12] and Conrad himself accepts as valid that the audience might "ask questions about the very functioning of cinema, through the demystification of the apparatus of projection."[13] That said, *The Flicker*'s relation to modernism hinges less on how it makes cinematic technology available or unavoidable than on its modalities of reflexivity. Speaking of *2001,* Michelson's writes that modernist film "heightens our perception of being physical to the level of apperception: one becomes conscious of the modes of consciousness."[14] Modernist apperception is not, like proprioception, a

reflexive turn in perception but rather a cognitive grasping of perception, the elaboration of its logic, the subjection of perceptual life to intellectual elucidation: an act of phenomenology rather than a texture of experience. As Sitney has it, part of what drives structural film is the "apperceptive acknowledgement of the cinematic materials and circumstances," and Malcolm Le Grice has written that *The Flicker* engenders "awareness of gradually changing modes of perception."[15]

While I'm certain moments of apperceptive acknowledgment and awareness do occur (as I have had them myself), they aren't at the core of *The Flicker* (as they are of *Arnulf Rainer*). Put otherwise, if things are going as they should (in striking parallel to *Anémic Cinéma* and its stereokinetic effect), while watching *The Flicker* you will be too caught up in buckyballs and catherine wheels and scenes from the Oregon Trail to wonder very much about the material basis, medium specificity, or ontology of the cinema. And if you're given over to excessive wonder, I expect you'll find wonder at how strobing patterns can give rise to hallucination—and precisely not about the cinema qua cinema.

Indeed, as Joseph documents, *The Flicker* arose for Conrad as part of a more general investigation into techniques of perceptual stimulation and modification, including the use of strobe lights, cathode-ray tubes, and auditory phenomena. In this line of his work, Conrad's interest lay in the technical modulation of perception, proprioception, states of consciousness, and modalities of experience, over and above the media in which he was working and their various specificities. After all, flicker phenomena are not essentially or even characteristically cinematic. In fact, *The Flicker* is nothing if not wildly atypical, even among experimental films. *Arnulf Rainer,* as an explicitly and undeniably modernist flicker film, has patterns determined by a kind of mathematical formalism. *The Flicker,* by contrast, with its much more ambivalent relation to modernism, tunes its flickering to the bodies of its viewers. (This rhymes with the difference I note in chapter 5 between *La région centrale* and *Gravity.*) Conrad is careful to ease his audience in, designing patterns that will elicit hallucinatory or hypnogogic responses. In other words, what marks Conrad's film is his careful attention to and modulation of the perceiving and proprioceptive body.

As I have been insisting, proprioception, as a mode of perceptual reflexivity, is precisely not apperception's a posteriori act of cognition or intellection. Its reflexivity takes place in the moment and is durational. It is endemic to perceptual life. And this may be the most difficult and subtle point I want to make: when you give yourself over to *The Flicker,* it is emphatically not so you can be an intellectual about it later (or during)—doing so precisely misses the

point (and your viewing experience will end up being boring or unpleasant). Instead, you must maintain a kind of relaxed and actively receptive perceptual posture, not unlike the comportment required for *Anémic Cinéma* and its stereokinetic effect. The reflexive thematization of the body and its perceptual openness to the world is in this case not in the first or even second instance intellectual or cognitive. It is affect, not intellect, that we might confuse with perception here. Proprioceptive aesthetics not only takes up the body as its *manipulandum* but also places its faith in the perceiving body as a sensate and sensitive object.

It is sensate and sensitive but also reflexive and sufficient—and perhaps inarticulate, but not needing cognition to tame it or convert it into something of value. (This is what I mean by "placing its faith.") The exorbitance of the body is called upon, elaborated, drawn out. That said, the proximity of proprioceptive aesthetics and modernism, the fact they might be confused here, is also telling. In both we encounter the limits, or limitedness, of our perception. Modernism demands that we cognize those limits and communicate something of them. Proprioceptive aesthetics makes us *feel* them.[16] But I find something dissatisfying in this formulation: it may only be because there really is a world of difference between thinking and feeling. But it has less to do with the difference between thinking and feeling and more to do with the kind of limit or boundary at issue. In the paradoxical separation/contact across the boundary or perhaps in its exacerbation/violation, *The Flicker* brings us up to a limit arising from an encounter, as a process, in duration— not absolute but local, even singular, in its contour and its texture.

Aesthetics without Experience

What lies on either side of the limits of perception (the visible, the invisible); the scope or generality or singularity of this boundary; and whether it is felt or thought—to name these I would like to abuse a seductive if problematic phrase from Jacques Rancière: "the distribution of the sensible." I want to continue this abuse by suggesting this distribution is at the heart of Walter Benjamin's politics of aesthetics, or politicizing of art.[17] Alongside Benjamin (fittingly, with all its ambivalence), *The Flicker* thematizes not merely the limits of perception and experience—that is, the distribution of the sensible—but also the means and the media of these limits and this distribution.

A brief tour through Benjamin's Artwork essay (and related writing) will sharpen and clarify what I mean when I speak of an aesthetics *beyond* the phenomenal, as well as its stakes.[18] I hesitate to follow such a well-trodden

path; I worry its familiarity is a blockage to thought. And yet with all its familiarity, Benjamin's thought remains complex and deep, and its historical and historicist articulation refracts our contemporary problems in unexpected ways. In any case, my treatment of these problems and of Benjamin are meant to be provocative and suggestive—a sketch of new problems for theoretical thinking about cinema and media, about aesthetics and technics, about perception and proprioception—and not an attempt at their resolution. My central interest is in Benjamin's fundamental insight that our capacity for experience is not merely conditioned by but saturated by our contemporary technology and technical regime. If we acknowledge the fundamental technicity of experience, then what of a phenomenology of the media? What role does experience have in the expanded sense of aesthetics in play here? How does experience figure in proprioceptive aesthetics as an aesthetic regime? And what importance does the cinema hold in this conceptual terrain and in our current moment?

In a schematic simplification of Benjamin's Artwork essay, we might say that the cinema's importance to a politics of aesthetics lies in its technical and aesthetic potential for a *redistribution* of the sensible. In its "social function . . . to establish equilibrium between human beings and the apparatus,"[19] the cinema is most decisive in two aspects: on the one hand, its dilation in the world of a "a vast and unsuspected field of action," a *Spielraum,* or room-for-play, which Benjamin aligns with the optical unconscious (117); and, on the other, a complementary training in the "apperceptions and reactions" necessary to cope with this apparatus (108).[20] The first of these is particularly intertwined with film's photographic basis, although for Benjamin (unlike, say, for Bazin) this dilation of the world is closely aligned with and ultimately necessary because of the vast increase in our capacity for technological action and exploitation of nature, unmatched by our capacity for perception, reflection, or control.[21] This is perhaps the aspect of Benjamin's writings on media that is most explicitly in need of revision; photographic media (whether chemical or digital) simply do not have the same force or importance they once had, even as our technological capacities have both increased and transformed. And since one of my aspirations is a theory of the cinema relatively indifferent to photographic procedures, unsurprisingly I wish to suspend his reliance on photography as the basis for a theory of the cinema.

Instead, I want to pursue the way Benjamin articulates the cinema's conditions of reception and its reorganization of experience. Cinema's importance in this aspect is again twofold. First, the cinema provides figures for a less damaged incorporation of technology. In the 1933 essay "Experience and

Poverty," Benjamin figures Mickey Mouse's various adventures as an embodiment of a different, less damaged, playful, magical, and even miraculous relation with technology.[22] In the Artwork essay, meanwhile (at least in the second version), it is the film actor who embodies a way of preserving one's humanity in the face of the apparatus, operating as he does with his whole person but without the benefit of his aura (111–12). In place of the damaged relations between humanity and technology Benjamin diagnoses in the Artwork essay and elsewhere,[23] both Mickey Mouse and the film actor point in the direction of a less pathological relation to technology in which it is no longer massively threatening, deadening to experience, leading to fascism or the love of total war. For Mickey and the actor, technology ceases to be an alien and alienating *apparatus* but is rather incorporated as *technics* in the sense Stiegler gives to it, an extension and an exteriorization of living activity.

In Mickey Mouse and the film actor, the cinema's negotiation of the relations between bodies and technology must pass through a *figure,* a point of identification, a mimetic anchor. By contrast and like proprioceptive cinema in general, *The Flicker* takes up this relation between the human body and technology directly, although it does so without representation or figuration. In another parallel with *Anémic Cinéma,* its intensities, its perceptual effects, its proprioceptive modulations take place without an object or a world. *The Flicker,* in its proprioceptive aesthetics, directly engages the cinema as a site for the modulation and aesthetic elaboration of the fundamental technicity of the correlation between body and world.

And so the second of Benjamin's articulations is most salient here: his notoriously problematic notion of reception in distraction (119–20). Benjamin's valorization of this reception in distraction is a displacement of the old and by-then corrupt canons of "beautiful semblance" championed by nineteenth-century bourgeois aesthetics. Modern technology has long since liquidated this aesthetics of interiority and contemplation, much as it has liquidated the deep experience Benjamin elsewhere names *Erfahrung.*[24] By contrast, as Benjamin means it here, an aesthetics of distraction is repetitive or reproducible, embodied and sensuous, collective rather than individuating, and does not rise to the level of aesthetic experience. It is somehow minor even when it is also intense. As he has it, "For the tasks which face the human apparatus of perception at historical turning points cannot be performed solely by optical means—that is, by way of contemplation. They are mastered gradually—taking their cue from tactile reception—through habit" (120; emphasis removed). In place of cognition, reflection, interiority, and critical thought, Benjamin valorizes distraction, affect, surface, and habit.[25]

In Benjamin's terms a politics of aesthetics entails a transformation in both aesthetics and politics. Aesthetics, as we know well by now, is not merely the philosophy or theory of art or beauty, nor even a theory of perception, but rather comes to coincide with the very distribution of the sensible.[26]

Meanwhile, politics ceases to be cognitive, contemplative, reflective, or intellectual; for Benjamin you simply cannot think your way out of fascism. And as for our situation today, reflective cognition seems even more impotent (even if you don't start from the insipid and asinine state of what goes under the name "politics" in popular discourse). Perhaps this is what drives the contemporary interest in affect in much humanities scholarship. The terrain of politics lies below or to the side of what can be grasped as experience. In the work of a great many recent theorists, this leads to an articulation of politics in terms of *affect*.[27] While this body of work has been incredibly productive (and influential for me), I want to pursue a different consequence, with a media-theoretical valence. The terrain of politics shifts to the technical infrastructure of that experience.[28] This, simply put, is media theory's version of the politics of aesthetics.

I must say that I am not ready, in this age of the profusion of screens, to embrace reception in distraction as holding a radical (or even positive) possibility for political or aesthetic regime change. Our well-documented battles with technically organized distraction too pointedly indicate its regressive actuality (and I myself am not exempt from such battles). So if the prescription here may be worrying or insufficient—hooray for distraction!—the diagnosis seems to be right. I want to stress that what Benjamin is offering and what is so rarely grasped in his thought is his insistence that *a radical revaluation of experience is necessary—and has been for quite some time.*[29] In fact, he points out that this revaluation is a done deal at the level of how we live in technological modernity: he claims in at least two essays that "experience has fallen in value."[30] This recognition has been operative at the level of aesthetic production for quite some time, but it is a recognition that critical thinking has a great deal of difficulty grasping. Interiority is difficult to liquidate in reflection.

One indication of this difficulty is the continued attachment to modernist aesthetics in much of film theory. In modernist aesthetics experience is deep and unaccountable: the inability of language to capture the intensity, quality, and contours of one's experience of a work of art is the index of its significance. In its continued attachment to experience and to the conceptual and reflexive elucidation of this experience, this modernist structure of aesthetic

experience is an atavistic recapitulation of the romantic, bourgeois structure of aesthetic experience that has been rendered obsolete, even decadent, by technologized, capitalistic modernity.[31] And so one common response to this complex in contemporary thinking has been a Deleuze-inspired valuation of what we might call the opposite of interiority, the valuation of affects, intensities, asubjective and asignifying flows.[32] This, it strikes me, is too much a reversal, a too-neat inversion, one that tracks the reversal of the film-theoretical fate of cinematic pleasure (from Mulvey's compensatory sadism to Shaviro's shattering masochism). It reproduces the logic of the capitalistic organization of modernity (and, if you wish, postmodernity), which liquidated the subject in the first place, commodifying and exploiting the affects that shatter it.[33] Valorizing the shattered subject is a species of Stockholm syndrome.

In this context, then, I want to stage my claim that *The Flicker* orchestrates an aesthetic encounter at the limits of experience—organized neither by experience nor by its shattering or dissolution. *The Flicker* does not somehow prevent or block experience. Rather, whatever experience its viewers may have or undergo, this experience does not have the force, weight, or density required for aesthetic significance under modernism. Aesthetics, here, happens elsewhere: in an encounter, in my body's coupling with and modulation by the perceptual technics of the cinema. If experience is something a subject has or undergoes, *The Flicker*, predictably, is much more ambivalent on this account. The ambivalence between inside and outside thus gains a deeper, stranger salience. It is not that experience, in whatever form it may arise, has become impossible. Rather, when I cannot tell the difference between inside and outside, such experience will seem beside the point.

An aesthetics without experience may well seem to pose a problem to phenomenology, whose method has been largely understood as grounded in lived experience.[34] Barbaras teaches us, however, that this very grounding is itself skeptical. Indeed, following a certain path in Husserl, one made available by Merleau-Ponty, he shows how the phenomenology of appearance, as explained in chapter 2, forms a crucial alternative to a phenomenology of *experience*. Recall that Barbaras's critique of Husserl passes through a discussion of Husserl's doctrine of perception by adumbrations. Oriented by a skeptical metaphysics that takes the determinate object as its model of being, Husserl understands adumbrations as merely adequate when compared to the object they index. Barbaras argues instead that adumbrations "reveal an original mode of being, one more profound than the crude distinction between positive being and negative nothingness, a being-at-a-distance."[35]

For Barbaras the phenomenological *epochē,* in suspending intentionality, must also suspend the *object* and its ostentatious ontology: the thesis of the pure positivity of being.

Barbaras's *epochē* thus discloses an original mode of being: appearance. Appearance carries within it an openness, a constitutive indeterminacy, partiality, porousness that skepticism mistrusts. For Barbaras skepticism's mistake lies in "the determination of [the] world as an object. The naïveté does not reside in thinking that there is a world there, but rather admitting that it is governed by a principle of absolute determinability and that it can therefore be attained as it is *in itself*" (56–57). Barbaras, here, is having some very subtle fun. It is precisely the skeptic who presumes the world is governed by a total determinability and thus can be rendered absolutely explicit. The skeptic is, finally, the naïf.

A phenomenology of appearance thus affirms the partiality, ambiguity, and ambivalence of the world—and therefore also of experience. Barbaras writes, "The partiality of givenness is its very condition" (36). But the partiality and openness of givenness is a characteristic not only of perception but of *all* givenness in the world; it is the condition of the world. And we are, as it turns out, part of the world. We are given to ourselves only partially, ambiguously, ambivalently. Husserl inherits from Descartes an assumption of a certain irreducible self-presence, which Baudry refers to as "the apodicity of the ego."[36] As Husserl puts it in the *Ideas I,* "A mental process or feeling is not adumbrated."[37] Barbaras, however, reads Husserl against himself, upsetting the assumption of subjective self-presence that underwrites the structure of Husserl's phenomenology, and metaphysics, and skepticism: "One must say that lived experience *is given by adumbrations* just as the thing is" (67).

Of course, at this late date we ought to be comfortable with the dissolution of the subject's pure self-presence. The nontransparency of the subject has been a theme of psychoanalysis—and of perceptual psychology and neuroscience—for at least a century. But Barbaras is working toward a phenomenology not founded on the immediacy of lived experience. In this phenomenology of appearance, "the appearance of the subject . . . to itself is subject to the general conditions of appearance, to the givenness of a world; the manifestation of my own existence, my consciousness, has as its basis and condition the originary manifestation of the world" (67). Lived experience can no longer serve to ground phenomenology, but that is simply because it is, like all appearance in the world—illusory, hallucinatory, or otherwise—partial, porous, provisional. It may seem a small shift from experience to appearance, but it has decisive consequences and for two reasons.

First, appearance simply cannot bear the burden of the things we expect of experience, not least communicability and significance. Second, where experience belongs inextricably to a subject, appearance first and foremost arises relationally, in an encounter.

Aesthetics and Technics

In this light I want to return to the odd and desultory particularity that descriptions of *The Flicker* usually take. Descriptions of the phenomena that arise during viewings of the film do not carry the postulation of universal assent that inhere in Kantian judgments of beauty, nor do they carry the burden of the elucidation of the ineffable that attends the work of Cavellian criticism in modernist aesthetics. While modernism does frequently affirm sensuous intensity, it does so by capturing this intensity in Michelson's "critical athleticism," recuperating it by a procedure of intellectual reflection into apperception.[38] Only certain kinds of experience, with a particular texture, a certain specific density, will bear this burden, and *The Flicker*'s phenomena, with their desultory singularity, simply do not. Put otherwise, like proprioceptive aesthetics, modernism does indeed affirm the partiality of experience, its nontransparency to itself. Nevertheless, modernism can do so only when such partiality appears in a specific way. In modernism this partiality is a burden; it must be overcome. I must account the unaccountable, redeploying the skeptical demand that I give an (impossible) account of myself as the hallmark of aesthetic significance.

In proprioceptive aesthetics, however, this partiality looks like a mere fact of life, and self-possession seems not only impossible but an extravagant and rather noisy affair. Even, as with *The Flicker*, when proprioceptive becoming-unbounded is both intense and incommunicable, it does not accrue significance of the quantity or quality that attends modernist aesthetics as ineffable experience. In this, I think, lies its promise—and not as in Joseph's reading, in which the singularity of *The Flicker*'s phenomena leads to a politics of a minor sovereignty: a radical but small freedom attending my existence as *this* singular body. That feels to me like a relic of the freedom that attends, indeed structures, Kantian judgments of beauty—and certainly not in the sense that *The Flicker*'s de-experientialized aesthetic encounter holds out the key to a redistribution of the sensible. I do not think such films or such encounters can sufficiently orient a politics of aesthetics. Instead, in a more Benjaminian vein, the promise of proprioceptive cinema lies in how it might lead the way to a different disposition or comportment in relation to technics, in which such

technics are precisely *not* alienating or destructive or threatening, even when they operate at speeds or scales not available to perception or experience. In this disposition we find ourselves at home in an openness and partiality that are not just grounded by the fact of being *this* body but by an openness and a partiality that are always also articulated technically.

At home in technics, resonating (or even hallucinating) with *The Flicker*, we can perhaps see more clearly that when such a proprioceptive aesthetic encounter occurs, it does not take place as a definite aesthetic experience *within* a bounded subject. *The Flicker* makes available an aesthetics without experience, but this does not only mean that what takes place in the aesthetic encounter forms below or to the side of my cognition, intellection, or awareness. What takes place in the aesthetic encounter is also distributed across my body and the cinema as a technological arrangement. Aesthetics in this sense is the property of a technical system, one that includes *both* my perceiving and proprioceptive body, open to technical modulation, *and* the cinema, which is open to its viewers, who, as it were, complete the circuit.

To be sure, this may seem at once both a banal claim (aesthetics requires something outside the subject) and an obscure one (aesthetics is the property of a technical system, not of an experiencing subject). I suspect only the second needs clarifying. Proprioceptive aesthetics makes the two senses of aesthetics—our apprehension of beauty and our modes of receptivity—coincide, and it does so by means of our involvement in and encounter with a technical system. Which is also to say, it realizes this coincidence of the two senses of aesthetics through a specifically technical solution: the technical modulation of proprioception, the technical modulation, that is, of our modes of receptivity. In much the same way that our sense of aesthetics must be transformed by its proprioceptive manifestation, so too must we shift our sense of what technology can be in the cinema in this, the scene of its technical aesthetics. It is, finally, to this transformed sense of the cinema's technicity that I now turn.

CONCLUSION

THE TECHNICITY OF THE CINEMA

Apparatuses and Technics

To conclude, I would like once again to consider the apparatus. What we have come to know as apparatus theory is, at its heart, a way of arguing that the cinema's importance as a technological system is not confined to its inorganic technical matter but includes the viewer, which it calls the spectator or the subject, in its operation. The problem—and it is a very productive problem, indeed—lies in how it construes relations between humans and what it calls the apparatus.

A broader view of the concept of the apparatus is useful. Baudry's use of the term has largely determined its reception in film theory, but it is Michel Foucault's use of the term that is typically translated as "apparatus"— *dispositif*—that has had better purchase in the broader humanities.[1] *Dispositif* is sometimes translated as "apparatus," but it can also be translated variously as "technology," "device," "mechanism," or even "deployment."[2] Despite the difficulties in translation, Giorgio Agamben has given a very clear account of what is at stake in the concept of *dispositif,* which obtains in Baudry and is explicitly drawn from Foucault's use. Agamben's sense of the apparatus is sweeping: "I wish to propose to you nothing less than a general and massive partitioning of beings into two large groups or classes: on the one hand, living beings (or substances), and on the other, apparatuses in which living beings are incessantly captured."[3]

In this scheme we have, on the one hand, an "ontology of creatures," living beings with the weight of being, and, on the other, a vast array of apparatuses that perform work but do not attain the dignity of being. He outlines these in an astonishing parataxis, worth quoting at length:

> I shall call an apparatus literally anything that has in some way the capacity to capture, orient, determine, intercept, model, control, or secure the gestures,

behaviors, opinions, or discourses of living beings. Not only, therefore, prisons, madhouses, the panopticon, schools, confessions, factories, disciplines, juridical measures, and so forth (whose connection with power is in a certain sense evident), but also the pen, writing, literature, philosophy, agriculture, cigarettes, navigation, computers, cellular telephones and—why not—language itself, which is perhaps the most ancient of apparatuses—one in which thousands and thousands of years ago a primate inadvertently let himself be captured, probably without realizing the consequences he was about to face. (14)

These two categories, then, form the foundation for what amounts to a general theory of subjectivity. Agamben writes, "We have then two great classes: living beings (or substances) and apparatuses. And between these two, as a third class, subjects" (14). In Agamben's formula the human subject arises from the interaction between a living creature and a set of apparatuses whose function is ancient, even primordial. While this, the modern, capitalist, epoch has been marked by a "massive accumulation and proliferation of apparatuses," we must also acknowledge that "ever since *Homo sapiens* first appeared, there have been apparatuses" (15). If this feels familiar, it is because it borrows a very familiar figure of thought, indeed: life is the thesis, apparatus the antithesis, and human subjectivity their dialectical synthesis.

Agamben's dialectical scheme is remarkable in its resonances with the account of technicity we find in Mark Hansen's media theory, drawing as he does on Bernard Stiegler. There are marked differences, however, that might be glossed (approximately) by saying that where Agamben's scheme is dialectical, Stiegler's is deconstructive. For Agamben the subject is marked by an ambiguous relation both to its own life and to the apparatuses that capture, discipline, and orient this life.[4] From the perspective of life or the apparatus, however, the apparatus is, in fact, massively alien to life. It befalls life from the outside. The tension between these is the ground from which subjectivity arises. Meanwhile, the film-theoretical articulation of apparatus theory outlines a very similar model. In Baudry's model, which Metz borrows, the cinematic apparatus dominates and captures the creaturely life of its viewers, and the spectator position as a structure of subjectivity arises from the encounter between the two, as the resolution of this tension—a resolution whose necessity is imposed upon the viewer in his passivity. This opposition of life and the apparatus hypostasizes a notion of life: "The term 'apparatus' designates that in which, and through which, one realizes a pure activity of governance devoid of any foundation in being" (11).[5] For Agamben life is the ontological substance on which apparatuses operate and that apparatuses pervert.

And yet in the body of thinking I draw upon—in the phenomenology of Merleau-Ponty and Barbaras and in the media theory of Stiegler and Hansen—life is not and cannot be self-identical, whole, ontologically solid.[6] We cannot accept an ontology in which life is the sole possessor of being or in which experience, because it is lived, can be the ground of an ontology. Because life is not this ontological ground, technology cannot in this way be implacably opposed to, utterly external to, such life as apparatus. More to the point, a different conception of the cinema, not as apparatus but as *technics,* is necessary.

Recall that for Stiegler technics—that is, inorganic technical systems—do not form a domain over and against life but are rather a continuation of and supplement to life. Literally, it is life, exteriorized, life made manifest outside a living body. In fact and in pointed opposition to Agamben, his account of technics precludes any possibility of articulating an ontological divide between living, organic matter and inert, technical matter. This is a classic deconstructive figure: we discover not only that life requires a category of technics to count as life but that life (at least human life) is itself *essentially* technical. Life is no longer contained only in living organisms. It takes place in technical objects, which are fully involved with the project of living.[7] For Stiegler, drawing on French anthropologist André Leroi-Gourhan, technics and the human are fundamentally coconstitutive: no humanity without technics, no technics without humanity.[8]

In much the same spirit as Stiegler, Hansen argues against the theory of prosthetic technicity manifest in Merleau-Ponty's example of the blind man's cane. On this account, "technics befall the human from the outside and function merely to extend the scope of its proper embodiment."[9] In Merleau-Ponty's example, the blind man's body literally in-corporates his cane, transforming his world (in the emphatic sense).[10] The flaw in this argument, according to Hansen, is its sequential character: first the body and only then technics. Developing Merleau-Ponty's later philosophy, Hansen argues that "the *écart* names the *condition* for a prosthetic extension of the already individuated human being."[11] The *écart* is technical *prior to any technical extension*: it is the condition of such extension. This notion of the *écart* founds Hansen's concept of the fundamental *technicity of the flesh*. Technics are not merely a resource for an individual that could get along on its own, so to speak. Rather, technics are required in order to become an individual in the first place. They are essential to what, drawing on Simondon, Hansen refers to as *individuation*.[12] Like the rest of the *écart*, its technical dimension is existential, necessary, constitutive, fundamental—but also unaccountable: we cannot appropriate it; it

is beyond and outside ourselves. For Hansen our life is not only made up of the biological stuff of our bodies or the psychic stuff of our inner lives, but also necessarily includes technics. Our flesh is not only susceptible to technically facilitated individuation but requires it and is founded upon it.[13]

Recall that Gibson's proprioception is the ongoing process by which I draw a boundary between myself and the world. Proprioception is, in a strong sense, *perceptual individuation*: my ongoing process of separating myself from the world as an individual. Following Hansen, I want to suggest that proprioception is itself an essentially technical process. The cinema's vocation of proprioceptive modulation demonstrates that proprioception is, at the very least, *open* to technics, susceptible to technical modulation. As an illustration of how proprioception itself can be understood to be fundamentally technical, consider Lacan's mirror stage, in which we arrive at a sense of our body as an "orthopedic totality" only by virtue of seeing it reflected in a mirror.[14] As Hansen points out, this scheme makes my perceptual and even existential self-possession dependent on a primordial, presubjective encounter with technics.[15] To be sure, I mean this to be suggestive and illustrative rather than conclusive. Nevertheless, even though it is overlooked, Lacan's famous mirror stage is a story about how our very boundedness, our perceptual self-possession—that is, our proprioception—can come into being only by means of an originary collaboration with technics. With respect to the cinema, we can say that our proprioceptive modulation by the cinema is also a modulation of our affectivity, our internal resonance, our ongoing individuation. Our proprioception is a matter of technics.

Proprioceptive aesthetics is not merely an aesthetics founded on the technical modulation of proprioception. This technical encounter engenders a *reflexive* relation to such technical modulation in the form of affectivity. In the cinema's proprioceptive aesthetics, I encounter my susceptibility to technical modulation. This encounter is also a concrete instance of the ongoing modulation of my reflexive and proprioceptive self-relation by the technics of the cinema. In this encounter I also encounter my adherence to or inherence in a world as a matter of my encounter with technics. Because they are intertwined, my sense of self and the world with which I resonate are both implicated in a technical system of which I am an integral part. For Merleau-Ponty the incorporation of technics transforms our openness to the world, adds new dimensions to it, opens the world differently, and transforms my resonance with it. The section of the *Phenomenology* containing the analysis of the blind man's cane emphasizes the correlation of body and world: "perceptual habit as the acquisition of a world."[16] All of this is to say, the cinema is a place where

we encounter—perceptually and proprioceptively and so also reflexively and affectively—technics in the mode Stiegler describes, to which Hansen gives the felicitous name: the cinema appears as *a technics of the flesh.*

This technics of the flesh has a counterpart in our positive capacity to lend ourselves to this technics, to allow ourselves to be, as Joseph describes it with respect to *The Flicker*—but which could just as well describe *Anémic Cinéma* or *2001* or *Koyaanisqatsi* or *Gravity*—"dissolv[ed] into a circuit with the technology."[17] With recourse to a different concept of Agamben's, I want to name this capacity *technical genius.* We encounter our technical genius in the pleasurable or at least affectively reflexive encounter with the cinema's modulation of our perception and proprioception. In a brief eponymous essay, Agamben gives the name *genius* to the general sense in which we reflexively encounter our existential self-differing. Originally and mythically, "*Genius* was the name used for the god who becomes each man's guardian at the moment of birth."[18] Our genius, then, is rather the impersonal element that accompanies us throughout our lives. For Agamben "everything in us that is impersonal is genial" (12). Encountering genius, then, means encountering the impersonal within us, the difference from myself that I always embody but can neither appropriate nor account for. Genius names the fact "that man is not only an ego and an individual consciousness, but rather that from birth to death he is accompanied by an impersonal, preindividual element" (11). Now, genius is a *general* name for this fact because it is not limited to a particular scene of encounter, to a particular ontological, psychological, phenomenological, or affective register. Genius accompanies the fact of embodied human life, and "it is Genius that we obscurely sense in the intimacy of our physiological life, in which that is most one's own is also strange and impersonal, and in which what is nearest somehow remains distant and escapes mastery. . . . Living with Genius means, in this sense, living in the intimacy of a strange being, remaining constantly in relation to a zone of nonconsciousness" (12).

This zone of nonconsciousness is not, however, a psychoanalytic unconscious: "This zone of nonconsciousness is not repression; it does not shift or displace an experience from consciousness to the unconscious, where this experience would be sedimented as a troubling past, waiting to resurface in symptoms and neuroses" (12). Genius, then, is not an unconscious that is repressed, nor is it somehow an inner core of ourselves. It is instead akin to Merleau-Ponty's reformulation of the unconscious in his working notes to *The Visible and the Invisible*—thus it accompanies his elaboration of the *écart*: "This unconscious is to be sought not at the bottom of ourselves, behind the back of our 'consciousness,' but in front of us, as articulations of our field.

It is 'unconscious' by the fact that it is not an *object*, but it is that through which objects are possible."[19] Agamben's notion of genius, when aligned with Merleau-Ponty, offers a name for the existential fact that we exceed ourselves in ways that we can neither control nor account for but are ongoing, ordinary, unremarkable, and personal. As with proprioceptive aesthetics, genius is not (or not necessarily) grandiose or sublime. Nor for that matter is it beautiful—at least not in Kant's sense. It is not Lacan's *jouissance*, nor is it modernist aesthetic significance.

Genius is mysterious, but in a small way. In a passage that resonates with Shaviro's cinematic pleasure and the masochism of Bersani's infantile sexuality, Agamben writes: "This intimacy with a zone of nonconsciousness is an everyday mystical practice, in which the ego, in a sort of special, joyous esoterism, looks on with a smile at its own undoing and, whether it's a matter of digesting food or illuminating the mind, testifies incredulously to its own incessant dissolution and disappearance. *Genius* is our life insofar as it does not belong to us" (12–13). Crucially, the ego is not shattered in this encounter, but only "the ego's pretension to be sufficient unto itself" (12). An ego encountering its genius takes a small pleasure in its insufficiency to its life. In genius I encounter, with a smile, the fact that I exceed myself, that I can become disorganized, that I can become otherwise than I am.

The concept, then, of a *technical* genius does not indicate its colloquial meaning of an amazing inventiveness or facility when it comes to technology. Rather, it names the fact that this genial nonconsciousness carries with it a specifically technical dimension: my life insofar as it belongs to technics. Hansen's technics of the flesh is matched by our technical genius, our intimacy with technics. The cinema's proprioceptive modulation is a concrete instance of this technical intimacy: it modulates our very sense of self. Our encounter with the cinema as technics is not just an encounter with a technical system in some sense already there, out there, ready to take us up as an object, raw material, or its manipulandum. Rather, our encounter with the cinema is simultaneously an encounter with a technics of the flesh and with our own technical genius.

My claim, then, is that what we encounter in proprioceptive aesthetics is our technical genius, the impersonal, general condition of technical life. To affirm this technical genius is to affirm that this zone of nonconscious noncoincidence is not only a vital fact, a psychic fact, or an existential fact but also a *technical* fact: we can get on in the world only by way of ongoing collaboration with technics. This is not merely a general and impersonal fact about my existence—although it surely is that, as I experience when I

become unmoored when I lose a cell phone or my computer crashes (or even in voluntary separations from contemporary technics, as when I go camping). But also, in the durational moment of my proprioceptive modulation in the cinema, in the flux of my voluptuous attunement to a world unfolding before me onscreen, the duration of my perceptive and proprioceptive modulation by the cinema is *a concrete instance of a technical modulation of my ongoing individuation.* Proprioceptive aesthetics is a name for the everyday mysticism and joyous esoterism with which we encounter our technical genius.

Technical Genius and Technical Aisthēsis

Now, I invoke Agamben's genius, with its joyous esoterism and everyday mysticism, in much the same spirit as I earlier invoked Merleau-Ponty's perceptual faith. Merleau-Ponty's fleshly faith names the fact that we are insuperably, ineluctably open to the world in all its obscurity, partiality, and finitude—and that this very openness itself is subject to the same obscurity, partiality, and finitude. This minor faith is vulnerable to a skepticism that only always comes after it, a skepticism at the core of the modernist aesthetics that have animated and oriented so much of our cinema and our film theory, including even our need to give an account of cinematic ontology. In much the same way, the mysticism of technical genius is a mysticism of a minor but very important sort. It names the acknowledgment and the affirmation of my obscurity to myself, of the unaccountable fact of my existence that earlier I called, variously, *proprioception, aesthetics,* or *aisthēsis.*

I want to emphasize two points here. First, technical genius is not a *personal* genius. It *is* intimate—proprioception is a form of self-relation—but it is *impersonal.* (At best, we might say that it is impersonally personal.) Genius's impersonality expresses its force as an existential fact. Its small mysticism is at once an affirmation of the reciprocal fact of my own obscurity to myself and the world's obscurity to me. Furthermore, to the extent that this genius is technical, it is also an affirmation of the obscurity of the impersonal technicity of my flesh. But this is not an exceptional fact; it is both intimate and everyday. Wittgenstein teaches that "the mystical is not how the world is, but rather that it is."[20] What is exceptional—or rather, what makes our encounter with it an encounter at all, an event, no matter how minor (and the scale runs from ecstatic shattering to looking on with a smile)—is the mode of its thematization, in its proprioceptive (perceptual and affective) reflexivity that does not rely on cognition, intellection, or criticism.

This reflexivity is extremely difficult to figure—as, I am sure, has been clear

over the course of this book. At issue in both modernist and proprioceptive aesthetics is a structure of reflexivity, a certain way of encountering something unaccountable in ourselves. The difference between them lies in the modalities of this reflexivity and the modes of encounter with the unaccountable. Modernist aesthetic experience is, literally, extra-ordinary. It is a dramatic departure from the ordinary. It entails burdens: it must be shared, elaborated in criticism, grasped by the intellect. Its stage is the interior of the aesthetic subject. Proprioceptive aesthetics, with its perceptual faith and technical genius, in its joyous but small mysticism, is a dedramatized aesthetics.[21] Its modes of reflexivity are perceptual and affective, not easily communicated but also not demanding communication. Its stage is the body, not the subject: it takes place below and to the side of interiority, experience, or subjectivity.

That is to say, in the cinema's proprioceptive aesthetics, we encounter a number of impersonal, unaccountable facts about ourselves: the existential impersonality of perceptual life that Merleau-Ponty describes in the *Phenomenology,* the susceptibility of that perception to technical modulation, the porousness of my body and my embodiment to influences from the environment, the astonishing intensity and intimacy of the cinematic modulation of my very sensitivity to myself. But these do not arise, as it were, because I am able to grasp such impersonal facts in acts of cognition—for example, in the rigorous asceticism of phenomenology's *epochē*. Which is also partly to say, these are not yet experienced in proprioceptive aesthetics as existential or aesthetic *facts,* but rather in the mode of what we might call aesthetic *facticity.* What brings us up short when we encounter technical genius is the ease and the intimacy of our own technical alterity to ourselves.

Allow me a moment of caution: as aesthetics is not wholly on my side as a human subject, the technical dimension of the cinematic encounter is not wholly on the side of the technological system of the cinema. It is, rather, distributed across my body and the technology. The danger here is a description of the cinema as an aesthetic *apparatus*: a machine that takes my body as its manipulandum, producing a series of aesthetic effects in the organic, perceiving matter of my body, with the voluptuous *aisthēsis* of sensory life, an autoerotic or aesthetic reflexivity turned in on itself. In this description any genius I encounter is made up wholly of *my life.* Even if I look on with a smile as I come undone, here I am (or my genius is) a living creature captured in an apparatus.

There is a danger precisely because this scheme does seem to capture something about how the cinema operates (most especially spectatorial passivity). In this model the cinematic apparatus operates upon my body as raw

material in order to produce the perceptual intensities of aesthetic experience. It is the obverse of Merleau-Ponty's prosthetic model of technology; instead of befalling the human and extending the body, it objectifies the human and works upon it. In this sense it closely resembles the vision of the cinematic apparatus and its pleasures Shaviro imagines in *The Cinematic Body.* And yet this conception does not at all contradict my insistence that the cinema is a technology for perceptual modulation.

If we are to understand the cinema as truly a *technics* of perception, in the sense Stiegler and Hansen give it, we must understand it not as aesthetic apparatus but as an *aisthetic technics.* Perception is not, as Hansen argues, something distinct from technics but is itself technical. Likewise, technics is not, as Stiegler has it, opposed to living activity but is itself an inorganic embodiment of life. In the scene of the cinema, we can say that as perception is itself a name for an ongoing resonance between a body and its world, between an organism and an environment, *this perceptual resonance includes technical resonance.* In the cinema this means that perception is not merely an object of manipulation but names an ongoing resonance, *itself technical in nature,* between my body and the cinema. Cinematic perception is not *my* perception, belonging to me, nor does it belong to the cinema, somehow a result of its manipulation of my body. Rather, it arises in an ongoing encounter. *Cinematic perception is in the cinema* just as ordinary perception is in the world.

In fact, this is something of an intuitive result when we consider the sorts of perceptual effects I discuss in this work, but it requires understanding the cinema to include the viewer's embodied perception and not merely the equipment or the technology of the cinema. The easiest examples are *Anémic Cinéma* and *The Flicker,* whose effects are not any more in the films than they are in the perceiving bodies of their viewers. The cinema does not merely act upon but *includes* the embodied perception of its viewers, and viewers' perception incorporates the cinema.[22] Neither apparatus nor prosthesis, the cinema as *technics* requires an understanding of living activity and of technical equipment not as opposing forces nor as continuous or undivided but as open, complementary, and intertwined, requiring and completing each other.

As a technics of *aisthēsis,* the cinema is not merely a technics of perception in general. It does not only extend perception. In important ways, it is not like a telescope, microscope, or x-ray. As an aisthetic technics, the cinema modulates and involves the body's proprioceptive self-sensitivity and affective reflexivity. In the cinema's proprioceptive aesthetics, we find a specifically technical *aisthēsis,* a reflexive relation endemic to its perceptual resonance. This reflexivity, my sense that something is sensed in an essentially

technical manner, this feeling is not properly mine and does not occur inside me any more than my perception does. As Hansen teaches us, the *écart* is essentially technical; the self-differing and reflexivity of *aisthēsis* must similarly be understood as technical and not merely coincidentally so. At the existential level of generality Shaviro offers in *Without Criteria,* this is why the "wrenching duality" Deleuze diagnoses at the heart of aesthetics is not coincidental to but embedded in the very logic of aesthetics as a theory of sensibility, as *aisthēsis.* To the extent that the *écart* is technical, my self-sensitivity (the sensation of sensation, Heller-Roazen's inner touch) *is itself always technical.* That is, the specific technics—call them *aesthetic* technics—involved in the technical expertise of art, of the cinema, of music, of painting, etc., are a particular instance of a generalized technical *aisthēsis.*

And yet technical *aisthēsis* also names something else, more subtle. It is not just the result of an encounter with aisthetic technics that aim at, modulate or manipulate, or thematize the reflexive doubling of perception, the sensual experience of sensing. It is not merely *any* reflexive perception achieved in an aesthetic encounter. Rather, given the open, manipulable, modulatable, self-differing nature of perception, it also names a reflexivity and a sensuousness specific to perceptual resonance accomplished in collaboration with technics. That is, technical *aisthēsis* is the reflexive aspect of a perceptual resonance *distributed across perceiving bodies and perceptual technics.* Concretely, in the cinema, at a first and most obvious level, the very palpability of the difference between ordinary perception and cinematic illusion would fall under the domain of a technical *aisthēsis:* the voluptuousness of proprioception; the delight of the illusory intensity of stereokinetic effects, cinematic kinesthesis, or *The Flicker*'s hallucinations; in short, the *excess* or *exorbitance* of a technically modulated perceptual resonance.

The cinema's ability to manifest a world unfolding before me is inseparable from its ability to modulate my sense of myself. My faith toward the world unfolding before me and the mysticism of the cinematic encounter with my technical genius are not identical, but they are inseparable. In this proprioceptive encounter, I find the obscurity of my perceptual life and its proprioceptive sense of self intertwined with its unerring, adherent faith in the world. *Aisthēsis* in the cinema, the reflexive pleasure of its perceptual modulation, inheres in and arises from the cinematic manifestation of a world. The *aisthēsis* of the cinema, what makes it the aisthetic technics par excellence, is that in its palpable illusion it thematizes a series of interlocking complementarities, at different scales: of my body and the world; of the openness of my perception and its susceptibility to technical modulation; of the *écart* and the

technicity of my flesh; of proprioceptive coordination with the world and an equally proprioceptive self-sensitivity; of perceptual faith and genial mysticism; of the worldliness the cinema manifests and the intensification of my self-sensitivity in cinematic pleasure.

To affirm the cinema is an aisthetic technics is to affirm that it is not merely a technology for perceptual *manipulation* (and even less a technology for representation). The cinema does not (merely) take up my embodied perception as an object. It remains largely indifferent to traditional questions of a modernist cinematic ontology. It does not find particular significance in my inability to be articulate about myself, even as it stages an encounter with my obscurity and the obscurity of the world. Rather, in a cinema of technical *aisthēsis,* we discover a radically different sense of aesthetics in which reflexivity is not the burden of the inarticulable but takes the form of a perceptually and proprioceptively simple pleasure, affect, or intensity. In *Anémic Cinéma,* in *2001,* in *Koyaanisqatsi,* in *Gravity,* and in *The Flicker,* we discover that the cinema is, and has always been, the scene of an embodied, technical, perceptual resonance. In short, in the cinema of technical *aisthēsis,* in its manifestation of a world, we learn a way at once astonishing and familiar, impersonal and intimate, of being at home in the world—and in the partiality and obscurity of our presence to it.

ACKNOWLEDGMENTS

When I was eight years old or thereabouts, my father took me to Disneyland. I was your garden-variety painfully introverted science fiction nerd, and I made sure we went straight for Tomorrowland. I fell helplessly in love with the new *Star Wars*-themed motion simulator Star Tours. Mispiloted away from a routine transport flight by a hapless, incompetent, cheesy-comedian robot and accompanied by a screaming R2D2, my father and I and a few dozen other "passengers" hurtled past spaceships, through a comet, into battle, and, finally, through the canyons on the Death Star just behind Luke Skywalker as he landed the crucial shot, blowing up the Death Star and securing for the Rebels a decisive victory against the Empire. By the time we left the park, I had made my poor father ride the damn thing at least four times. It may have been more. This experience was, rather embarrassingly, formative. It is only a slight exaggeration to say it is the personal origin for the work I present here.

This book is dedicated to my parents: to my father and my mother. I thank them for their enormous patience and generosity, whether it takes the form of riding Star Tours over and over *and over* again with me or the various sorts of support they unhesitatingly, eagerly bestowed upon me over the years it took me to write this book and the dissertation that is its origin. I love you, Mom and Dad. Thank you.

Of course, this book has depended on the patience and generosity of a great many people. In particular, my beloved partner, Jason Burton, and beloved friend Theo Kuhnlohe have given me the emotional, logistical, and moral support I needed, mostly without asking—and without asking for anything in return. In more intellectual terms (but by no means exclusively so), it would not have been possible for me to complete this book without the steadfast friendship (and implied audience) of Jim Hodge and Damon Young. I cherish your passion, your brilliance, and your commitment to new thinking.

I remain profoundly indebted to my dissertation advisor at the University of Chicago, Tom Gunning, for his ongoing enthusiasm for this project and for his invaluable guidance and mentorship along the way. I am indebted as well to the members of my dissertation committee, Lauren Berlant, James Lastra, and the late Miriam Bratu Hansen, who all helped me discover and develop the thought I present here. This book would simply not exist without their rigor and encouragement. My colleague Steven Shaviro has been an invaluable guide, mentor, and friend to me, and I thank him for being an effective cheerleader both for me as a young scholar and for this book.

I thank those who have shared valuable advice, guidance, comments, conversation, and other forms of solidarity—mentorship, logistical support, a kind word, a well-timed suggestion, a much-needed drink—along the way: Ellen Barton, Kris Cohen, Nilo Couret, Jonathan Flatley, Doron Galili, Mark Hansen, renée hoogland, Patrick Jagoda, Andrew Johnston, Caroline Jones, Ian Jones, Ian Kennedy, Arthur Marotti, Rob Mitchell, Daniel Morgan, Christina Petersen, Inga Pollman, Ryan Powell, Elizabeth Reich, John David Rhodes, Jordan Schonig, Jon Foley Sherman, Kyle Stine, Julie Turnock, Johannes von Moltke, and Jennifer Wild.

For their editorial work on the manuscript, I thank Doug Armato and Danielle Kasprzak at the University of Minnesota Press, as well as Kate Mondloch and the two anonymous readers. Finally, I offer thanks to the audiences who gave valuable feedback and insight to presentations of the ideas in this book, including the Mass Culture and New Media Workshops at the University of Chicago; the Franke Institute for the Humanities Affiliated Fellows at the University of Chicago; the Chicago Film Seminar; the Humanities Center Brown Bag Colloquium at Wayne State University; the Proseminar in Environmental Cinema at the University of Iowa; the Media and Experience Symposium at the University of Michigan; and the Sawyer Seminar on Phenomenology, Mind, and Media at Duke University.

I received funding to support work on this book from the following sources: a University of Chicago–Mellon Foundation Dissertation Year Fellowship; a University Research Grant and a Research Enhancement Program in the Arts and Humanities Grant from Wayne State University.

NOTES

Introduction

1 Kristin Thompson, "*Gravity*, Part 1: Two Characters Adrift in an Experimental Film," *Observations on Film Art*, November 7, 2013, http://www.davidbordwell.net/blog/.

2 Effectively, this means any space film organized neither by alien encounters nor by space battles—e.g., *Moon* (Duncan Jones, 2009) and *Sunshine* (Danny Boyle, 2007). This is especially true for *Gravity*'s contemporary other, Christopher Nolan's ponderous *Interstellar* (2014), which is much closer to *2001* and which suffers substantially more from the comparison.

3 I am borrowing the astonishing phrase "tiny, fragile human body" from Walter Benjamin, "Experience and Poverty," in *Walter Benjamin: Selected Writings*, vol. 2, ed. Michael W. Jennings, Howard Eiland, and Gary Smith (Cambridge, Mass.: Bellknap Press of Harvard University Press, 1996–2003), 731–36, 732. It also appears in "The Storyteller," in *Selected Writings*, vol. 3, 143–66, 144. Subsequent references will indicate volume and page number.

4 In fact, it is now very difficult indeed to properly experience *2001*, as the Cinerama screens on which its 70 mm images were projected are rare, having mostly been demolished. I was able to see a 70 mm projection at the Toronto International Film Festival's Bell Lightbox theater, and the traditional widescreen exhibition format was impressive enough.

5 For more on the history of this sort of camera movement, see Sara Ross, "Invitation to the Voyage: The Flight Sequence in Contemporary 3D Cinema," *Film History* 24, no. 2 (2012): 210–20.

6 As will become clear, I do not use *stupid* in a derogatory manner. In fact, I have argued that *Jackass* and other contemporary media are "critically stupid," in Scott C. Richmond, "'Dude, That's Just *Wrong*': Mimesis, Identification, *Jackass*," *World Picture* 6 (2011).

7 Christian Metz, *The Imaginary Signifier: Psychoanalysis and the Cinema*, trans. Ben Brewster et al. (Bloomington: Indiana University Press, 1982), 43.

8 I borrow *roughen* from Russian formalism. See Viktor Shklovsky, "Art as Technique," in *Russian Formalist Criticism: Four Essays* (Lincoln: University of Nebraska Press, 1965), 3–24. On its elaboration with respect to film study, see Kristin Thompson, *Breaking the*

Glass Armor: Neoformalist Film Analysis (Princeton, N.J.: Princeton University Press, 1988).

9 This account is drawn largely from Drew Leder's admirable study of embodied perception, *The Absent Body* (Chicago: University of Chicago Press, 1990), 39.

10 Daniel Heller-Roazen shows this across the opening chapters of *The Inner Touch: Archaeology of a Sensation* (New York: Zone Books, 2007).

11 I write much more about this in other chapters, but Gibson's most pointed work on proprioception comes in James J. Gibson, "The Uses of Proprioception and the Detection of Propriospecific Information," in *Reasons for Realism: Selected Essays of James J. Gibson,* ed. Edward Reed and Rebecca Jones (Hillsdale, N.J.: Lawrence Erlbaum Associates, 1982), 164–70.

12 Steven Shaviro, *Without Criteria: Kant, Whitehead, Deleuze, and Aesthetics* (Cambridge, Mass.: MIT Press, 2009), 5, 66, and passim.

13 J. Hoberman, "Drowning in the Digital Abyss," *New York Review of Books,* October 11, 2013, http://www.nybooks.com/blogs/nyrblog/.

14 Annette Michelson, "Bodies in Space: Film as Carnal Knowledge," *Artforum* 7, no. 6 (1969): 54–63, 59. Subsequent references are cited parenthetically in the text.

15 Here, by "strictest" I mean to indicate Husserl's formulation of the *epochē* in the *Ideas* and elsewhere in his early work. I return to this similarity between Michelson's modernism and Husserl's *epochē* in chapter 2.

16 To be sure, there are important differences among these thinkers, but it is the similarities between them that matter for my account here. In particular, I am arguing (with some degree of ambivalence) against the version of modernism largely shared between Fried and Cavell. Robert Jackson refers to them as "compadres" in "The Anxiousness of Objects and Artworks 2: (Iso)Morphism, Anti-literalism, and Presentness," *Speculations* 5 (2014): 311–58, 312. More to the point, Pamela Lee documents the mutual importance of Cavell and Fried and their importance to a larger project of thinking modernism in *Chronophobia: On Time in the Art of the 1960s* (Cambridge, Mass.: MIT Press, 2004), 36–81. Finally, for Cavell's influence on Fried, see James Meyer, "The Writing of 'Art and Objecthood,'" in *Refracting Vision: A Critical Anthology on the Writings of Michael Fried,* ed. Jill Beaulieu, Mary Roberts, and Toni Ross (Seattle: University of Washington Press, 2000).

17 By this I mean a body of work we might shorthand as "the new realism." Here, I'm thinking especially of D. N. Rodowick, *The Virtual Life of Film* (Cambridge, Mass.: Harvard University Press, 2007). Under this heading, we might also place Garrett Stewart, *Framed Time: Toward a Postfilmic Cinema* (Chicago: University of Chicago Press, 2007); Dudley Andrew, *What Cinema Is!* (Malden, Mass.: Wiley-Blackwell, 2010); Markos Hadjioannou, *From Light to Byte: Toward an Ethics of Digital Cinema* (Minneapolis: University of Minnesota Press, 2012); and even (with substantially different commitments) Steven Shaviro, *Post Cinematic Affect* (London: Zero Books, 2010).

18 Maurice Merleau-Ponty, *The Visible and the Invisible,* ed. Claude Lefort, trans. Alphonso Lingis (Evanston, Ill.: Northwestern University Press, 1968), 3.

19 Scott Bukatman, "The Artificial Infinite: On Special Effects and the Sublime," in *Matters of Gravity: Special Effects and Supermen in the 20th Century* (Durham, N.C.: Duke University Press, 2003), 81–110.

20 Martin Heidegger, *The Fundamental Concepts of Metaphysics: World, Finitude, Solitude,* trans. William McNeill and Nicholas Walker (Bloomington: Indiana University Press, 1995). Heidegger's use of the German *Stimmung* is often translated as "mood" but is more accurately and technically rendered as "attunement." For more on *Stimmung* in contemporary affect theory, see Jonathan Flatley, *Affective Mapping: Melancholia and the Politics of Modernism* (Cambridge, Mass.: Harvard University Press, 2008); and "How a Revolutionary Counter-Mood Is Made," *New Literary History* 43, no. 3 (2012): 503–25.

21 Vivian Sobchack, *The Address of the Eye: A Phenomenology of Film Experience* (Princeton, N.J.: Princeton Univeristy Press, 1992), esp. chap. 3, 164–249.

22 Damon R. Young has offered an important and related critique of Sobchack's intersubjective model of the cinematic encounter in psychoanalytic terms in Damon R. Young, "The Vicarious Look, or Andy Warhol's Apparatus Theory," *Film Criticism* 39, no. 2 (2015): 23–50, 32.

23 Jordan Schonig, "Seeing Aspects of the Moving Camera: On the Limits of Phenomenological Film Theory" (paper presented at the Society for Phenomenology and Media, San Diego, Calif., March 27, 2015). For more on how the analogy between the cinematic image and ordinary perception breaks down, see Ryan Pierson, "Whole-Screen Metamorphosis and the Imagined Camera (Notes on Perspectival Movement in Animation)," *Animation: An Interdisciplinary Journal* 10, no. 1 (2015): 6–21, esp. 8–11.

24 Jennifer M. Barker, *The Tactile Eye: Touch and the Cinematic Experience* (Berkeley: University of California Press, 2009).

25 Vivian Sobchack, "What My Fingers Knew: The Cinesthetic Subject, or Vision in the Flesh," in *Carnal Thoughts: Embodiment and Moving Image Culture* (Berkeley: University of California Press, 2004), 53–84; Laura Marks, *The Skin of the Film: Intercultural Cinema, Embodiment, and the Senses* (Durham, N.C.: Duke University Press, 2000); *Touch: Sensuous Theory and Multisensory Media* (Minneapolis: University of Minnesota Press, 2002); Elena del Rio, "The Body as Foundation of the Screen: Allegories of Technology in Atom Egoyan's *Speaking Parts,*" *Camera Obscura* 13, no. 2 (1996): 92–115. See also Susan Buck-Morss, "The Cinema Screen as Prosthesis of Perception: A Historical Account," in *The Senses Still: Perception and Memory as Material Culture in Modernity,* ed. C. Nadia Seremetakis (Chicago: University of Chicago Press, 1996).

26 Renaud Barbaras, *Desire and Distance: Introduction to a Phenomenology of Perception,* trans. Paul B. Milan (Stanford, Calif.: Stanford University Press, 2002).

27 Bernard Stiegler, *Technics and Time,* vol. 1, *The Fault of Epimetheus,* trans. Richard Beardsworth and George Collins (Stanford, Calif.: Stanford University Press, 1998), 17.

28 Ibid.

29 Mark B. N. Hansen, *Bodies in Code: Interfaces with Digital Media* (New York: Routledge, 2006).

30 Mark B. N. Hansen, "Media Theory," *Theory, Culture, and Society* 23, nos. 2–3 (2006): 297–306.

31 The *locus classicus* is of course "apparatus theory," which I discuss at length at various points in the book. See, of course, Jean-Louis Baudry, "Ideological Effects of the Basic Cinematographic Apparatus," in *Narrative, Apparatus, Ideology,* ed. Philip Rosen (New

York: Columbia University Press, 1986), 286–98; and "The Apparatus: Metapsychological Approaches to the Impression of Reality in the Cinema," in *Narrative, Apparatus, Ideology*, 300–18.

32 Gabriele Pedullà, *In Broad Daylight: Movies and Spectators after the Cinema,* trans. Patricia Gaborik (New York: Verso, 2012).

33 This is a well-known story. A recent telling of it, explicitly in relation to the cinema's adoption of digital technologies, is Ariel Rogers, *Cinematic Appeals: The Experience of New Movie Technologies* (New York: Columbia University Press, 2013).

34 Of course, I mean Tom Gunning's famous formulation of the cinema of attractions. For more on the cinema of attractions, including a folio of the original essays from the 1980s, see Wanda Strauven, ed., *The Cinema of Attractions Reloaded* (Amsterdam: Amsterdam University Press, 2006).

35 Mark B. N. Hansen, "Technical Repetition and Digital Art, or Why the 'Digital' in Digital Cinema Is Not the 'Digital' in Digital Technics," in *Technology and Desire: The Transgressive Art of Moving Images,* ed. Rania Gafaar and Martin Schultz (Chicago: Intellect, 2014), 77–102, 95–96.

36 This media-theoretical figure mirrors the rise of the recent philosophical movement of speculative realism, with its critique of correlationist thought. For a good (if a bit tendentious) summary of positions, see Steven Shaviro, *The Universe of Things: On Speculative Realism* (Minneapolis: University of Minnesota Press, 2014). For my rejoinder to this line of thinking, see Scott C. Richmond, "Thought, Untethered," *Postmodern Culture* 21, no. 1 (2010); and "Speculative Realism Is Speculative Aesthetics," *Configurations* 23, no. 3 (2015): 399–403.

37 The term *perceptual technics* appears in a related but very different sense in Jonathan Sterne, *MP3: The Meaning of a Format* (Durham, N.C.: Duke University Press, 2012), chap. 2. Sterne's gloss on the term is "the specific economization of definition through the study of perception in the pursuit of surplus value" (53)—in other words, the discarding of inaudible information in the MP3 compression algorithm. Meanwhile, cinema's vocation of recording the world has often been determining in its reception in (new) media theory. Hansen shifts the discussion in the right direction, but as I hope to show, he does not go far enough. More common is Lev Manovich's pithy definition: "cinema, art of the index." Lev Manovich, "What Is Digital Cinema?," in *The Digital Dialectic: New Essays on New Media,* ed. Peter Lunenfeld (Cambridge, Mass.: MIT Press, 1999), 172–96. See also *The Language of New Media* (Cambridge, Mass.: MIT Press, 2002).

38 Hodge writes about this in an exciting book manuscript in progress, "Animate Opacity: Digital Media and the Aesthetics of History." He has presented these ideas in encapsulated form in "Encountering Opacity" (paper presented at the Annual Meeting of the Society for Literature, Science, and the Arts, October 2014, Dallas, Tex.). His examples are often exemplary studies of new media scholarship that nevertheless depend on a faith that such explication will *do* something. For example, see Alexander R. Galloway, *Protocol: How Control Exists after Decentralization* (Cambridge, Mass.: MIT Press, 2006); Matthew G. Kirschenbaum, *Mechanisms: New Media and the Forensic Imagination* (Cambridge, Mass.: MIT Press, 2012).

39 Stiegler, *Technics and Time,* 21.

1. The Unfinished Business of Modernism

1 Jennifer Gough-Cooper and Jacques Caumont, *Ephemerides on and about Marcel Duchamp and Rrose Sélavy, 1887–1968,* ed. Pontus Hulten (Cambridge, Mass.: MIT Press, 1993), entry of 1921.7.28.

2 Toby Mussman, *"Anemic Cinema," Art and Artists* 4, no. 1 (1966): 48–51, 49.

3 Ibid., 49–50.

4 For a thoroughly annotated translation of the word spirals, see Katrina Martin, "Marcel Duchamp's *Anémic Cinéma," Studio International,* no. 189 (1975): 53–60. For an extended discussion of them, see P. Adams Sitney, "Image and Title in Avant-Garde Cinema," *October* 11 (1979): 97–112.

5 Mario Zanforlin, "The Height of a Stereokinetic Cone: A Quantitative Determination of a 3-D Effect from 2-D Moving Patterns without a 'Rigidity Assumption,'" *Psychological Research* 50 (1988): 162–72.

6 Noël Carroll, "The Essence of Cinema?," *Philosophical Studies* 89 (1998): 323–30, 324.

7 Carroll invokes these films to criticize Gregory Currie's spurious definition of a film as "1) a moving 2) pictorial 3) representation" (324). Carroll's essay is a review of Gregory Currie, *Image and Mind: Film, Philosophy and Cognitive Science* (Cambridge: Cambridge University Press, 1995).

8 Rosalind Krauss, "'*Moteur!*'" in *Formless: A User's Guide,* ed. Yve-Alain Bois and Rosalind Krauss (Cambridge, Mass.: Zone Books, 1997), 133–37, 134.

9 Which is to say, with the urge to disclose and aestheticize its functioning rather than its ontology, it is closer to what Neil Harris calls "the operational aesthetic" than it is to modernist aesthetics. Neil Harris, *Humbug: The Art of P. T. Barnum* (Chicago: University of Chicago Press, 1973), 59–90.

10 Apparently, Duchamp experimented with the cinema in other ways, as well. This work is also lost. See Jennifer Wild, "L'Hélice (Délice d'): Anémic Cinéma dans le champ de l'avant-garde," in *La Fiction éclatée,* ed. Jean-Pierre Bertin-Maghit and Geneviève Sellier (2007), 231–40; and *The Parisian Avant-Garde in the Age of Cinema, 1900–1923* (Berkeley: University of California Press, 2015), 102–34.

11 Marcel Duchamp, *Salt Seller* (New York: Oxford University Press, 1973), 185.

12 This is documented in a number of places, including in Rosalind Krauss, *The Optical Unconscious* (Cambridge, Mass.: MIT Press, 1998); and Alice Goldfarb Marquis, *Éros, c'est la vie: A Biography* (Troy, N.Y.: Whitston Publishing, 1981); as well as directly in Duchamp, *Salt Seller,* 189.

13 Marquis, *Éros, c'est la vie,* 255.

14 The stereokinetic effect was first described in the scientific literature in 1924 by Italian psychologist C. L. Musatti (Zanforlin, "Height of a Stereokinetic Cone"). I deal with the philosophy and perception of cinematic illusion at much greater length in the following two chapters.

15 On Duchamp's theories of vision or of the cinema, see Rosalind Krauss, "Where's Poppa?," in *The Definitively Unfinished Marcel Duchamp,* ed. Thierry de Duve (Cambridge, Mass.: MIT Press, 1991), 433–62; Erkki Huhtamo, "Mr. Duchamp's Playtoy, or Reflections on Marcel Duchamp's Relationship to Optical Science" (paper presented

at Excavating the Future, Prague, December 2001); and Wild, "L'Hélice (Délice d')" and *The Parisian Avant-Garde.*

16 P. Adams Sitney, *Modernist Montage: The Obscurity of Vision in Cinema and Literature* (New York: Columbia University Press, 1990), 20–21.

17 Krauss, "'*Moteur!*'" 134.

18 Ibid.

19 Michelson, "'Anemic Cinema': Reflections on an Emblematic Work," *Artforum* 12 (1973): 64–69, 64.

20 Ibid., 67.

21 On the avant-gardists turn to cinema and the perhaps not shocking (but still surprising) diversity of their engagement with the cinema, see especially Levi, *Cinema by Other Means* (New York: Oxford University Press, 2012); and Wild, *The Parisian Avant-Garde.*

22 I thank Jennifer Wild for suggesting this line of thinking to me.

23 Laura Mulvey, "Visual Pleasure and Narrative Cinema," in *Narrative, Apparatus, Ideology,* 198–209, 209.

24 Rey Chow, "When Reflexivity Becomes Porn," in *Entanglements, or Transmedial Thinking about Capture* (Durham, N.C.: Duke University Press, 2012), 13–30, 22. Subsequent references will be cited parenthetically in the text.

25 Lee, *Chronophobia,* 45.

26 I address the relationship between aesthetics, modernism, and the ordinary in different, but deeply related, terms in Scott C. Richmond, "Vulgar Boredom, or What Andy Warhol Can Teach Us about *Candy Crush,*" *Journal of Visual Culture* 14, no. 1 (2015): 21–39.

27 I feel obliged to add that I first wrote that *Anémic Cinéma* is cute long before I read Ngai's work on the topic. I still mean cute in the way I originally meant it.

28 Sianne Ngai, *Our Aesthetic Categories: Zany, Cute, Interesting* (Cambridge, Mass.: Harvard University Press, 2012), 38. Subsequent references will be cited parenthetically in the text.

29 In this, Ngai's account is significantly consonant with Rosalind Galt's in *Pretty: Film and the Decorative Image* (New York: Columbia University Press, 2011). That said, where Ngai works with categories that often seem not to be aesthetic at all, showing how cute, interesting, and zany share the canonical structure of aesthetic judgments, Galt's category of the pretty is often instead an index of excess, of too great an aestheticism. As she shows, a judgment of being "pretty" is almost always a judgment of being "too pretty"— along with a mistrust of knowingness, of too much self-consciousness.

30 While I emphasize Ngai's engagement with Cavell as a philosopher of aesthetics, she draws not only from Cavell (and, through him J. L. Austin) but also from Adorno (filtered through Frederic Jameson). To be sure, the Marxian and ordinary language philosophies of aesthetics differ in important ways, but Ngai's subtle and sophisticated account works across both, disclosing not only important areas of overlap but the profound consonance between otherwise disparate midcentury bodies of thought about aesthetics. Which is to say, I take Ngai's account as part of my warrant to treat Cavell's philosophical aesthetics as generalizable to modernism more broadly.

31 Stanley Cavell, *Philosophy the Day after Tomorrow* (Cambridge, Mass.: The Bellknap Press of Harvard University Press, 2005), 9. Quoted in Ngai, *Our Aesthetic Categories,* 39.

32 Cavell, *Philosophy the Day after Tomorrow,* 12.

33 Here, among others, I am thinking about Kathleen Stewart, *Ordinary Affects* (Durham, N.C.: Duke University Press, 2007); and Lauren Berlant, *Cruel Optimism* (Durham, N.C.: Duke University Press, 2011).

34 Cavell, *Philosophy the Day after Tomorrow,* 9. In this passage, Cavell is discussing his earlier essay "Aesthetic Problems of Modern Philosophy," in *Must We Mean What We Say?* (Cambridge: Cambridge University Press, 2002), 73–96. This essay belongs to a cycle of work on modernism from the 1970s including its companion in *Must We Mean What We Say?,* "Music Discomposed," the rejoinder to the latter essay, "A Matter of Meaning It," as well as his book on film, *The World Viewed: Reflections on the Ontology of Film,* enlarged ed. (Cambridge, Mass.: Harvard University Press, 1979). In what follows, I treat Cavell's account of modernist aesthetics synthetically, treating these three texts as a single, comprehensive account of modernism and turning occasionally to his retrospective account of this work in *Philosophy the Day after Tomorrow.*

35 Another bit of philosophy Cavell inherits from Austin and is relying on here is the performativity of knowledge: knowledge is not, as an analytical philosopher might have it, "justified true belief" or some other internal state. Instead, according to Austin, when I say, "I know x," I am telling you that I stake both my reputation and our relationship that you can and ought to behave as though x were true. Austin develops this point in "Other Minds," in *Philosophical Papers,* ed. J. O. Urmson and G. J. Warnock (New York: Oxford University Press, 1979), 76–116.

36 Immanuel Kant, *Critique of the Power of Judgment,* trans. Paul Guyer and Eric Matthews (New York: Cambridge University Press, 2000), 99–101. I learned to use the term "incorrigibility" in this sense from J. L. Austin, *Sense and Sensibilia* (Oxford: Oxford University Press, 1962). Cavell calls this Kant's "universal voice," in "Aesthetic Problems," 94–96.

37 Cavell's deep engagement with skepticism spans his career and is part of his Wittgensteinian inheritance. Perhaps his most pointed statement of the problem comes in "What Is the Scandal of Skepticism?," in *Philosophy the Day after Tomorrow,* 132–54.

38 Cavell, *The World Viewed,* 72.

39 Immanuel Kant, *Critique of the Power of Judgment,* trans. Paul Guyer and Eric Matthews (New York: Cambridge University Press, 2000), §9, 102–3.

40 Michelson, "Bodies in Space," 59.

41 The figure of "the standing threat of skepticism" comes from Cavell, "What Is the Scandal of Skepticism?"

42 Cavell, *The World Viewed,* 14.

43 Rodowick, *The Virtual Life of Film,* 9.

44 For versions of each of these claims, respectively, see Tom Gunning, "Moving Away from the Index: Cinema and the Impression of Reality," *differences* 18, no. 1 (2007): 28–52; and Mark B. N. Hansen, "Technical Repetition and Digital Art."

45 Cavell, *The World Viewed,* 14. We find a crucial complement to Cavell's way of construing ontology as an aesthetic problem in Thierry de Duve, *Kant after Duchamp* (Cambridge, Mass.: MIT Press, 1998).

46 Cavell, "Music Discomposed," 193.

47 Cavell, *The World Viewed*, 14, 15. Subsequent references will be cited parenthetically in the text.

48 André Bazin, "The Ontology of the Photographic Image," in *What Is Cinema?* (Berkeley: University of California Press, 2005), 9–16, 15 (translation modified).

49 A concern with cinematic ontology has been common among scholars beyond the new realists, even when not structured by a difference between photochemical and digital cinema. See, for example, Mary Ann Doane, *The Emergence of Cinematic Time: Modernity, Contingency, the Archive* (Cambridge, Mass.: Harvard University Press, 2002); Tom Gunning, "Moving Away from the Index"; and Justin Remes, *Motion(less) Pictures: The Cinema of Stasis* (New York: Columbia University Press, 2015).

50 Rodowick, *The Virtual Life of Film*, 96.

51 Levi, *Cinema by Other Means*, xiii.

52 To be sure, cinematic ontology has never been quite so technologically determinist that it is simply reducible to photochemical cinema. Rodowick's position is a telling example. In a book that is maximally dedicated to understanding a photochemical ontology, he argues that, unlike other artistic media, cinema has no positivist ontology. Rodowick, *The Virtual Life of Film*, 23–24.

53 Stephen Mulhall, *Stanley Cavell: Philosophy's Recounting of the Ordinary* (Oxford: Clarendon Press, 1994), 104.

54 This account of skepticism, in perceptual psychology called *empiricism* (among other things), is something I work out at much greater length in the next two chapters in relation to Kubrick's *2001*. Cavell gives a related account of the "traditional epistemologist's" account of perception in *The Claim of Reason: Wittgenstein, Skepticism, Morality, and Tragedy* (New York: Oxford University Press, 1979), 199–204. For Cavell the denial of embodiment and finiteness looks like a denial of the perspectival nature of, the *location* and *mobility* of, a perceiving body: "This suggests what philosophers call 'the senses' are themselves conceived in terms of this idea of a geometrically fixed position, disconnected from the fact of their possession and use by a creature who must act" (202). Here Cavell draws together the perceptual and ethical aspects of skepticism. Most important for my purposes here is Cavell's linking of perception with action in—*and movement through*—a world, a figure that runs through a host of nondualist (and antiskeptical) philosophers: Henri Bergson, Martin Heidegger, Maurice Merleau-Ponty, to name only the most famous examples.

55 If it is indeed a question of finding a way of being at home, then this has resonances with Cavell's account of Wittgensteinian philosophical-investigation-as-therapy, which he figures as bringing words *home* (*Must We Mean What We Say?*, 43). The difference here might be that, where in Wittgenstein and Cavell words appear lost, or departed, or so to speak prodigal, here what we discover is that we are at home, that we never left. If what we must *rediscover* after skepticism and in modernism is the ordinary, then we discover here that we never departed from it.

56 Krauss, *The Optical Unconscious*, 137.

2. Beyond the Infinite, at Home in Finitude

1 For example, see the variety of essays collected in Robert Kolker, ed., *Stanley Kubrick's 2001: New Essays* (New York: Oxford University Press, 2006).

2 Michelson, "Bodies in Space," 58. Subsequent references are cited parenthetically in the text.

3 See, for example, Edmund Husserl, *Ideas Pertaining to a Pure Phenomenology and to a Phenomenological Philosophy*, first book, *General Introduction to a Pure Phenomenology* (The Hague: Martinus Ninjhoff, 1982), §§27–32. The *epochē* is the basic technique of phenomenological analysis: the suspension or bracketing of the thesis of the existence of the world. That is, phenomenology should proceed as if indifferent to whether or not the world exists. This suspension is meant to ensure subsequent analyses of phenomena are invulnerable to skeptical doubt. The *epochē* is Husserl's fundamental innovation in his attempt to overcome Cartesian skepticism. For a very good summary of the *epochē*, see Dermot Moran, *Introduction to Phenomenology* (New York: Routledge, 2000), chap. 4, esp. 146–52. I return to the *epochē* below.

4 On the aesthetic significance of Trumbull's work, see Bukatman, "The Artificial Infinite" and "Zooming Out: The End of Offscreen Space," in *The New American Cinema*, ed. Jon Lewis (Durham, N.C.: Duke University Press, 1998), 249–72. For a more thoroughly historicized consideration of his place in the history of effects-based filmmaking, see Julie Turnock, *Plastic Reality: Special Effects, Technology, and the Emergence of 1970s Blockbuster Aesthetics* (New York: Columbia University Press, 2015).

5 Richard Rickitt, *Special Effects: History and Technique*, 2nd ed. (New York: Billboard Books, 2007), 178. See also Douglas Trumbull, "The Slit Scan Process as Used in *2001: A Space Odyssey*," *American Cinematographer* (1969). I thank Julie Turnock for pointing me to this reference.

6 "Future Selves" is the title of this chapter on the DVD.

7 "After staring at a waterfall for a couple of minutes, objects seem to be shifting upwards. This was followed up by Lucretius, Purkinje and Addams who coined the term 'waterfall illusion.'" Michael Bach and Charlotte Poloschek, "Optical Illusions," *ACNR* 6, no. 2 (2006): 20–21, 20.

8 Bukatman, "The Artificial Infinite," 97 (emphasis in original). At the risk of seeming needlessly pedantic, the character/astronaut in question is actually named Dave Bowman; his colleague, killed by HAL, is Frank Poole.

9 Although, interestingly, in much contemporary cinema such movement is frequently broken up by such reaction shots. For more on the relationship between cinematic identification and the illusion of bodily movement, see Scott C. Richmond, "The Exorbitant Lightness of Bodies, or How to Look at Superheroes: Ilinx, Identification, and *Spider-Man*," *Discourse* 34, no. 1 (2012): 113–44.

10 Bukatman, "The Artificial Infinite," 90.

11 Ibid., 90–91.

12 Michelson, "Bodies in Space," 59.

13 Richard Gregory, "What Are Illusions?," *Perception* 25 (1996): 503–4.

14 Richard Allen, "Representation, Illusion, and the Cinema," *Cinema Journal* 32, no. 2 (1993): 21–48, 21.

15 It also entails a particular dedication to modernist aesthetics: "Though reference to illusionism is more a trope of the seventies than of the eighties, where the notion of transparency often replaces it, the idea of illusionism is still worth discussing not only because it continues to crop up but because its use indicates the degree to which contemporary film theory is motivated, often implicitly, by a commitment to modernist aesthetics." Noël Carroll, *Mystifying Movies: Fads and Fallacies in Contemporary Film Theory* (New York: Columbia University Press, 1988), 91.

16 "Contemporary film theorists have made careers out of underestimating the basic intelligence and reality-testing abilities of the average film viewer and have no trouble treating previous audiences with similar disdain." Tom Gunning, "An Aesthetic of Astonishment: Early Film and the (In)Credulous Spectator," *Art and Text* 34 (1989): 31–43, 32.

17 Carroll, *Mystifying Movies,* 93.

18 Allen, "Representation, Illusion, and the Cinema," 40.

19 On the diegetic effect, start with Noël Burch, "Narrative/Diegesis—Thresholds, Limits," *Screen* 23, no. 2 (1982): 16–33.

20 Christiane Voss, "Film Experience and the Formation of Illusion: The Spectator as 'Surrogate Body' for the Cinema," *Cinema Journal* 50, no. 4 (2011): 136–50. Subsequent references are cited parenthetically in the text. In this, Voss is in agreement with Gertrud Koch, whose account of illusion is substantially similar. Gertrud Koch, "Carnivore or Chameleon: The Fate of Cinema Studies," *Critical Inquiry* 35 (2009): 918–28.

21 Christian Metz, *Film Language: A Semiotics of the Cinema,* trans. Michael Taylor (Chicago: University of Chicago Press, 1991), 8.

22 Metz, *Film Language,* 9. Here, I would like to anticipate a result that emerges in my discussion of Barbaras. In Metz we already see an attenuation, if not an outright erasure, of the opposition between appearance and reality when it comes.

23 The account Metz gives here resonates quite strikingly with Gilles Deleuze's concept of the movement-image, which he develops in the opening chapters of *Cinema 1: The Movement Image,* trans. Hugh Tomlinson and Barbara Habberjam (Minneapolis: University of Minnesota Press, 1986). In the cinema we do not see an image *of* movement; the movement is not re-presented. Rather, the cinema manifests movement. Nevertheless, what I am attempting to describe here is emphatically *not* Deleuze's movement-image. As Mark Hansen points out, the trajectory of Deleuze's *Cinema* books is a progressive disembodiment. Mark Hansen, *New Philosophy for New Media* (Cambridge, Mass.: MIT Press, 2004), 8. The concept of the movement-image (at least in the way Deleuze develops it) entails a certain rejection of the phenomenological aspect of the cinema. As we will see, Deleuze sides with Bergson over Husserl, leading him to deprecate the encounter with the cinema. I argue we will in fact have to reject Husserl's doctrine of intentionality—the *of*-ness of perception. But I arrive at this result only by scrutinizing the structure of phenomenal, embodied perception. Phenomenology can and must get along without Husserl's doctrine of intentionality. But it seems to me that if the object of investigation is the *illusion of bodily movement,* the viewer's feeling of moving through

onscreen space, then casting this in terms of Deleuze's movement-image places two of these terms under erasure: *illusion* and *body*.

24 Edmund Husserl, *Cartesian Meditations: An Introduction to Phenomenology*, trans. Dorion Cairns (Boston: Kluwer Academic Publishers, 1999). In fact, the similarity of the cinematic recording of the world to perception has been noted by two phenomenologists of the cinema: in Sobchack's *The Address of the Eye* and in Allan Casebier, *Film and Phenomenology: Toward a Realist Theory of Cinematic Representation* (New York: Cambridge University Press, 1991). Casebier's work is much more in keeping with the Husserlian thrust of these several paragraphs; Sobchack's work is much more indebted to Merleau-Ponty's revision of Husserl, with its emphasis on embodiment. My own approach to the phenomenology of perception and illusion is largely drawn from Merleau-Ponty's late work, but under the influence of Renaud Barbaras. His basic point is that Merleau-Ponty's philosophy never ceased to be in conversation with Husserl and that Merleau-Ponty's unfinished *The Visible and the Invisible* is an attempt to complete Husserl's own unfinished philosophical project. See Renaud Barbaras, *The Being of the Phenomenon: Merleau-Ponty's Ontology*, trans. Ted Toadvine and Leonard Lawlor (Bloomington: Indiana University Press, 2004). Barbaras's *Desire and Distance*, which I discuss at length, is his attempt to draw both of these projects out to at least a provisional conclusion. The question, at least if we follow Barbaras on this point, is not really one of Merleau-Ponty versus Husserl but rather one of which Husserl you are working with. Dan Zahavi especially shows Husserl's profound continuity with later phenomenologists, especially Merleau-Ponty. Dan Zahavi, *Husserl's Phenomenology* (Stanford, Calif.: Stanford University Press, 2003), esp. chap. 3.

25 Baudry, "Ideological Effects," 290. Subsequent references are cited parenthetically in the text.

26 Baudry attaches a footnote to this sentence, a reference to Jean Mitry's *Ésthétique et psychologie du cinéma*, but he might just have well cited Dziga Vertov, *Kino-Eye: The Writings of Dziga Vertov*, ed. Annette Michelson, trans. Kevin O'Brien (Berkeley: University of California Press, 1984). This trope, that the cinema frees vision from its attachment to a physical and, therefore, situated, limited, and finite body, has a long history in theorizing about film. Some, like Vertov, make claims for a kind of cinematic *reembodiment* of vision, the construction of a new cinematic body. Others make claims for a *disembodiment*. Either way, disembodiment is itself a modality of embodiment.

27 Although movement is not a *necessary* condition of the cinema, as Justin Remes points out in *Motion(less) Pictures*.

28 Husserl's doctrine of intentionality is complex and shifting over the course of his thought. In particular, since intentionality names the relation between consciousness and its objects, the nature of such intentionality is one of the most difficult (and most productive) problems of the phenomenological project. For a great overview of intentionality in general, Husserl's interpretation of it, and its importance to his phenomenology, see Zahavi, *Husserl's Phenomenology*, chap. 1, esp. 13–22.

29 Sobchack, *Address of the Eye*, 217–18. Subsequent references are cited parenthetically in the text. Sobchack explicates this structure with particular clarity around the camera's

movement through the world in "Toward Inhabited Space: The Semiotic Structure of Camera Movement in the Cinema," *Semiotica* (1982): 317–35.

30 Barbaras's reading of Husserl in *Desire and Distance* is largely consonant with Zahavi's in *Husserl's Phenomenology*. That said, Barbaras offers his critique in terms of a latent tension in Husserl's thought, whereas Zahavi construes the "two Husserls" problem rather as one of interpretation: a caricature of Husserl offered by later critics (not least Heidegger and Derrida) versus the real Husserl, available to us now that we have access to his unpublished manuscripts. Mostly because Barbaras construes the problem as a matter of the phenomenology of perception rather than the correct interpretation of Husserl, I use him as my guide here.

31 This can be found in, say, D. N. Rodowick's claim that neither Stan Brakhage's *Mothlight* nor Peter Kubelka's *Arnulf Rainer* are films in *The Virtual Life of Film*, 59, or in Dudley Andrew's "concentric circle" model of the ontology of cinema in *What Cinema Is!*

32 Sobchack, "What My Fingers Knew," 61–64.

33 Eugenie Brinkema, *The Forms of the Affects* (Durham, N.C.: Duke University Press, 2014).

34 Barbaras, *Desire and Distance*, 36. Subsequent references are cited in the text.

35 Husserl, *Ideas I*, 92–93; Barbaras, *Desire and Distance*, 17 and passim.

36 Maurice Merleau-Ponty, *Phenomenology of Perception*, trans. Donald A. Landes (New York: Routledge, 2013), 74.

37 Roland Barthes, *Camera Lucida: Reflections on Photography*, trans. Richard Howard (New York: Hill and Wang, 1981), 6, 5.

38 To be sure, *apparatus* in English actually translates two French words in Baudry: *appareil* and *dispositif*. The essay of Baudry's at issue in this chapter, "Ideological Effects," employs the former.

39 Metz, *The Imaginary Signifier*, 46–47. Here, I present in highly redacted form an argument I make at greater length in Richmond, "The Exorbitant Lightness of Bodies." See also essays from a recent issue of *Film Criticism* on the concept of cinematic identification, Elizabeth Reich and Scott C. Richmond, "Introduction: Cinematic Identifications," Damon R. Young, "The Vicarious Look: Andy Warhol's Apparatus Theory," and James J. Hodge, "Gifts of Ubiquity," *Film Criticism* 39 no. 2 (Winter 2015): 3–78.

40 Stiegler, *Technics and Time*, vol. 1, 17.

41 Marshall McLuhan, *Understanding Media: The Extensions of Man* (Cambridge, Mass.: MIT Press, 1994). I am not, of course, the first to point this out. See Hansen, "Media Theory," 299.

42 "Organized inorganic beings" is Stiegler's phrase. *Technics and Time*, vol. 1, 17.

43 McLuhan, *Understanding Media*, 46.

44 Bernard Stiegler, "The Time of Cinema: On the 'New World' and 'Cultural Exception,'" *Tekhnema* 4 (1998): 62–114; *Technics and Time*, vol. 3, *Cinematic Time and the Question of Malaise*, trans. Stephen Barker (Stanford, Calif.: Stanford University Press, 2011).

45 Amy Villarejo, *Ethereal Queer: Television, Historicity, Desire* (Durham, N.C.: Duke University Press, 2014); Mark B. N. Hansen, "Technics beyond the Temporal Object," *New Formations* 77 (2012): 44–62.

46 Villarejo, *Ethereal Queer*, 73.

47 Ibid.

3. Ecological Phenomenology

1 Here, I am thinking especially of the work of Jane Bennet and Timothy Morton. For a start, see Jane Bennett, *Vibrant Matter: A Political Ecology of Things* (Durham, N.C.: Duke University Press, 2010); and Timothy Morton, *The Ecological Thought* (Cambridge, Mass.: Harvard University Press, 2010). Ecocriticism has a longer history, more prominent in literary studies, and already has several anthologies, the most recent of which is Ken Hiltner, ed., *Ecocriticism: The Essential Reader* (New York: Routledge, 2014).

2 It may then be more useful to think about his position as *evolutionary* rather than *ecological*. That, however, suggests a different rather more misleading affinity with evolutionary psychology. Gibson himself was contemptuous of evolutionary psychology. I find it to be a problematic endeavor at best. On this, see the classic S. J. Gould and R. C. Lewontin, "The Spandrels of San Marco: A Critique of the Adaptationist Programme," *Proceedings of the Royal Society of London, Series B: Biological Sciences* 205, no. 1161 (1979): 581–98.

3 Jakob von Uexküll, *A Foray into the Worlds of Animals and Humans, with a Theory of Meaning*, trans. Joseph D. O'Neil (Minneapolis: University of Minnesota Press, 2010). For a philosophical discussion of Uexküll, see Giorgio Agamben, *The Open: Man and Animal*, trans. Kevin Attell (Stanford, Calif.: Stanford University Press, 2003). On Uexküll's relationship to the cinema, see Inga Pollmann, "Invisible Worlds, Visible: Uexküll's *Umwelt*, Film, and Film Theory," *Critical Inquiry* 39, no. 4 (2013): 777–816.

4 James J. Gibson, *The Ecological Approach to Visual Perception* (Boston: Houghton Mifflin, 1979). For an easily accessible introduction to the ecological approach, see the chapter on Gibson and the ecological approach in Ian E. Gordon, *Theories of Visual Perception* (New York: Psychology Press, 2004), 143–82.

5 John Sanders has investigated this similarity most fully. See especially John T. Sanders, "Merleau-Ponty, Gibson, and the Materiality of Meaning," *Man and World* 26 (1993): 287–302; "Affordances: An Ecological Approach to First Philosophy," in *Perspectives on Embodiment: The Intersections of Nature and Culture*, ed. Gail Weiss and Honi Fern Haber (New York: Routledge, 1999), 121–42. See also Philip A. Glotzbach and Harry Heft, "Ecological and Phenomenological Contributions to the Psychology of Perception," *Noûs* 16, no. 1 (1982): 108–21.

6 Sanders, "Merleau-Ponty, Gibson, and the Materiality of Meaning," 298n8. The volume in question is Maurice Merleau-Ponty, *Structure of Behavior*, trans. Alden L. Fisher (Boston: Beacon Press, 1963). For more on Gibson's intellectual history and relation to philosophy (including phenomenology), see Harry Heft, *Ecological Psychology in Context: James Gibson, Roger Barker, and the Legacy of William James's Radical Empiricism* (Mahwah, N.J.: Lawrence Erlbaum Associates, 2001).

7 James M. Edie, "William James and Phenomenology," *Review of Metaphysics* 23, no. 3 (1970): 481–526.

8 See James J. Gibson, "James J. Gibson," in *A History of Psychology in Autobiography*, ed. Edwin G. Boring and Gardner Lindzey (East Norwalk, Conn.: Appleton-Century-Crofts, 1967), 127–43; and Heft, *Ecological Psychology in Context*.

9 Hugo Münsterberg, *Hugo Münsterberg on Film: The Photoplay—A Psychological Study and Other Writings*, ed. Allan Langdale (New York: Routledge, 2002).

10 The ecological approach has, of course, entered into film studies in the work of Joseph and Barbara Anderson, most significantly in Joseph Anderson, *The Reality of Illusion: An Ecological Approach to Cognitive Film Theory* (Carbondale, Ill.: Southern Illinois University Press, 1996). My take on Gibson is substantially different from theirs, on nearly every point. Their engagement with Gibson lies squarely in the cognitivist agenda, and their take on the ecological approach places it in alignment with the mainstream of cognitive science and perceptual psychology. As will become clear at length, my interest in Gibson lies rather in his sustained critique of traditional theories of perception, including cognitivist approaches. I will take this opportunity to note that the ecological approach is extremely capacious in terms of its scope of application, which sometimes leads to strange bedfellows among those who see themselves working in this idiom. While the Andersons perform with aplomb the mid-1990s cognitivist polemics against the excesses of "contemporary theory," only a few years later, Eric Clarke can, without embarrassment, borrow the concept of *spectator position* from film theory as a central conceptual tool in his ecological account of musical listening in *Ways of Listening: An Ecological Approach to the Perception of Musical Meaning* (Oxford: Oxford University Press, 2005).

11 M. T. Turvey and Robert Shaw, "The Primacy of Perceiving: An Ecological Reformulation of Perception for Understanding Memory," in *Perspectives on Memory Research: Essays in Honor of Uppsala University's 500th Anniversary* (Hillsdale, N.J.: Lawrence Erlbaum Associates, 1979), 167–222. My account of the ecological tradition's critique of traditional theories of perception is largely indebted to Turvey and Shaw's, although it borrows from other sources, most significantly Gibson, *The Ecological Approach*; and Heft, *Ecological Psychology in Context*.

12 Which is also to say, the ecological approach is not uncontroversial. For the contentious debates around the ecological approach within perceptual psychology, see Simon Ullman, "Against Direct Perception," *Behavioral and Brain Sciences* 3 (1980): 373–415, including (and especially) the responses published after Ullman's main article.

13 Gregory, "What Are Illusions?"

14 James J. Gibson, ed., *Motion Picture Testing and Research* (Washington, D.C.: U.S. Army Air Forces Aviation Psychology Program Research Reports, 1947). His interest in the cinema persisted: he dedicates a chapter to the cinema, "Motion Pictures and Visual Awareness," in *The Ecological Approach,* 292–302.

15 Gibson, "James J. Gibson," 135–36. Robert McLeod, a colleague of Gibson's at Cornell, summed up this research delightfully: "During World War II, Jimmy took a reprieve from the Smith College girls and served in the U.S. Air Force. He demonstrated quite satisfactorily that pilots can see, and the better they see the better pilots they are. This was an important discovery." Robert B. McLeod, "A Tribute to J. J. Gibson," in *Perception: Essays in Honor of James J. Gibson,* ed. Robert B. McLeod and Jr. Herbert L. Pick (Cornell University Press, 1974), 11–13, 11.

16 Gibson, *Motion Picture Testing,* 10; see also *The Ecological Approach,* 184–85.

17 The title of this article indicates a convention I have arrived at myself, independently of Gibson, but which I have employed throughout this book (unless I am following another author's usage locally, e.g., Metz): "The word *motion* will always be used to refer

to change in position of an object, and the word *movement* will always refer to change in position of the observer's body in whole or part, that is, a response. Both may be visually perceived." Gibson, "The Visual Perception of Objective Motion and Subjective Movement," *Psychological Review* 101, no. 2 (1994): 318–23, 319.

18 Gibson, "The Visual Perception of Objective Motion," 321. This article originally appeared in 1954. The 1994 date is a republication of the article for a special issue of *Psychological Review*. The original citation is James J. Gibson, "The Visual Perception of Objective Motion and Subjective Movement," *Psychological Review* 61, no. 5 (1954): 304–14.

19 It bears remembering that I am not just in but *of* the world—that is, perception is the relation of one part of the world to another. This is what is fundamentally at stake in Merleau-Ponty's late doctrine of the flesh, of the chiasm, and of intertwining. See Merleau-Ponty, "The Intertwining—The Chiasm," in *The Visible and the Invisible,* 130–55. I address this in the following section and return to these problems and to *The Visible and the Invisible* in considerable detail in chapter 4.

20 Sanders has radicalized this notion of affordances by considering them to be "ontic primitives," the foundation of all that there is in the world, the foundation of the worldliness of the world itself. See John T. Sanders, "An Ontology of Affordances," *Ecological Psychology* 9, no. 1 (1997): 97–112; and "Affordances: An Ecological Approach to First Philosophy." He does this in relation to Merleau-Ponty's late ontology in *The Visible and the Invisible,* the same work that drives most of Barbaras's account of Husserl in *Desire and Distance.* While not in exact agreement, Barbaras's account of desire accounts for at least half of Gibson's notion of affordances as potential relations between organism and environment. Nevertheless, since Gibson was not a philosopher, affordances do not in fact play the role of ontic primitives in his writing; there is simply no question of ontic primitives. Another major term that could conceivably be elevated to that stature would be *variation* and its important cognates here, *covariation* and *invariant,* which I consider at length.

21 It also gives the ecological approach its sometimes circular character. The terms *organism, environment,* and *affordance* are all fundamentally relational; they have no meaning outside a frame of reference that involves all three. This frame of reference is the ecosystem, which corresponds approximately to the phenomenologists' concept of *world.* A technical formulation of this is the following: an environment is an organism-indexed structure of affordances; affordances are organism-indexed properties of an environment; and organisms are environment-indexed structures of affordances.

22 Here, we may draw another remarkable alignment between ecological psychology and Maurice Merleau-Ponty's phenomenology of perception. Perception does not say *there-is,* it says *I-can.* In Merleau-Ponty this position is inherited from Henri Bergson: "The body functions as a kind of filter that selects, from among the universe of images circulating around it and according to its own embodied capacities, precisely those that are relevant to it." Hansen, *New Philosophy for New Media,* 3. See also Merleau-Ponty, *Phenomenology of Perception*; and *The Primacy of Perception,* ed. James M. Edie (Evanston, Ill.: Northwestern University Press, 1964); and Henri Bergson, *Matter and Memory,* trans. Nancy Margaret Paul and W. Scott Palmer (New York: Zone Books, 1991). Barbaras details Merleau-Ponty's Bergsonian inheritance in *The Being of the Phenomenon.*

23 One of Gibson's major criticisms of traditional perceptual psychology is that in order to simplify its units of analysis, it reduces perception to a minimum: *stimuli*. Bite boards fix bodies and head. Tachistoscopes reduce perception to an instant. He claims that this distorts perception beyond recognition and that such procedures produce illusions because of their reduction of perceptual information. Ames rooms are a great example of this. The rooms are constructed using forced perspective, showing one person to be a giant and another a midget. The illusion occurs only from one particular point. Given the chance to explore the room or move about, people immediately unmask the illusion. Gibson, *The Ecological Approach,* 166.

24 Recall that Cavell makes this point, too. Concerned as always with the problem of skepticism, he criticizes "traditional epistemologist's" account of perception in *The Claim of Reason,* 199–204. For Cavell this looks like the denial of embodiment and finiteness, a denial of the perspectival nature of, the *location* and *mobility* of a perceiving body: "This suggests what philosophers call 'the senses' are themselves conceived in terms of this idea of a geometrically fixed position, disconnected from the fact of their possession and use by a creature who must act" (202). Cavell here draws together the perceptual and ethical aspects of skepticism.

25 Gibson, *The Ecological Approach,* 249.

26 In fact, constant stimulation of sense receptors in the body eventually leads to an anesthetic effect. Experiments that have contrived to hold the retinal image constant reveal that subjects eventually become blind to that image, regaining sight only when this artificial image is removed and optical flow resumes: "A truly persisting stimulus on the retina or skin specifies only that the observer does not or cannot move his eye or limb, and the sense perception soon fades out by sensory adaptation. The persistence of an object is specified by invariants of structure, not by the persistence of stimulation." Gibson, *The Ecological Approach,* 248, see also chap. 4. This has a very uncomfortable relevance to more nefarious techniques of perceptual manipulation. Normal, healthy humans become psychotic after only forty-eight hours of sensory deprivation (sometimes less). Some effects of such deprivation are permanent. This, of course, was demonstrated by the U.S. Army and Central Intelligence Agency in the course of MK-ULTRA, the Cold War–era research program on what we now know as "enhanced interrogation techniques." This sort of research followed upon the ineffectual (and strangely quaint) notion that dosing Soviet spies with LSD might help with interrogations. In the course of this research, the CIA also experimented with flicker effects—to which we will return in chapter 6 with Tony Conrad. As it turns out, sensory manipulation is far more effective at breaking prisoners than just about anything else, including drugging them or more familiar application-of-pain torture techniques. Alfred W. McCoy, *A Question of Torture: CIA Interrogation from the Cold War to the War on Terror* (New York: Henry Holt, 2006).

27 Gibson's fascination with optical flow and locomotion was long-standing. His second book, *The Perception of the Visual World* (Boston: Houghton Mifflin, 1950), introduces a rigorous notion of optical flow. This resulted from Gibson's studies of locomotion and visual kinesthesis starting in the 1930s. See also "James J. Gibson," and "Objective Motion and Subjective Movement." For his most developed theories of optical flow, see

"Looking with the Head and the Eyes" and "Locomotion and Manipulation," in *The Ecological Approach*, 203–37.

28 James E. Cutting, "Perceiving Scenes in Film and the World," in *Moving Image Theory: Ecological Considerations*, ed. Joseph Anderson and Barbara Anderson (Carbondale, Ill.: Southern Illinois University Press, 2005), 9–27, 10–16. He outlines these sources and their relevance to the cinema. As might be expected, these are not identical with the account Gibson gives more than twenty-five years earlier in *The Ecological Approach*. They are compatible, however, and rather more consistent with the current state of research.

29 Gibson, "The Discovery of the Occluding Edge and Its Implications for Perception," in *The Ecological Approach*, 189–202.

30 I submit there is an interesting, potentially very fruitful, coincidence between Merleau-Ponty and Gibson: an emphasis on *reversibility* in perception. See especially Merleau-Ponty, "The Intertwining—The Chiasm." Reversibility is, for both philosopher and psychologist, crucial to the sense of the worldliness of the world and its intersubjective availability, even though I am always limited to the situated *here-where-I-am* of my body. It bears further note that in offering rigorously nondualistic and nondialectical accounts of perception, both Merleau-Ponty and Gibson introduce a reversibility as figure of duality-in-unity.

31 Gibson, *The Ecological Approach*, 200.

32 Cutting already sneaks these in through the back door, so to speak, since accommodation and convergence as sources of information arise from the posture of the muscles in and around the eye. The vestibular sense arises from the inner ear, responding to gravity and inertial changes, and gives information consonant with both visual information and information about the posture of the body (which, if you wanted to attribute to the perceptual-psychological notion of sense modalities, would arise from receptors in the muscles and joints, as well as touch).

33 Gibson, *The Ecological Approach*, 205.

34 Ibid., 201.

35 In any event, even if one were to articulate this in terms of sense modalities, one would have to take account of the fact that there are ten, not five, sense modalities, with separate sense receptors: "(1) touch and pressure, (2) kinesthetic [or postural; this is given by stretch receptors in the muscles], (3) the vestibular system [that is, the sense of balance arising from the inner ear], (4) temperature, (5) pain, (6) smell, (7) taste, (8) vision, (9) audition, and (10) the common chemical sense [in certain mucous membranes, it responds by irritation to certain strong chemicals—cutting into an onion, or tear gas]." Maureen Connolly and Tom Craig, "Stressed Embodiment: Doing Phenomenology in the Wild," *Human Studies* 25 (2002): 451–62.

36 Barbaras, *Desire and Distance*, 71.

37 My emphasis on covariation is an extrapolation from Gibson's work in *The Ecological Approach* and *Reasons for Realism*. *Covariation* belongs to a set of terms that cluster around his central concept of *variation*. He places much more emphasis on variants and invariants of perception, especially in *The Ecological Approach* (see, e.g., Appendix 2), and tends to attach to objects in the world. The term *covariant* appears much less

frequently in Gibson's work and tends to attach instead to questions of proprioception (see, e.g., *Reasons for Realism,* 16, 58, and 189).

38 There are, of course, exceptions; even *2001* offers an overture in which the screen is kept black and the music encoded on the filmstrip can only be said to be part of the film. Derek Jarman's *Blue* (1993) would be another notable exception. Both of these exceptions raise the question of sound, which I fail to deal with at all in this chapter. Diegetic sound provides important sources of information that are redundant to and covary with the image onscreen—although this is only approximate. See Rick Altman, "The Material Heterogeneity of Recorded Sound," in *Sound Theory/Sound Practice,* ed. Rick Altman (New York: Routledge, 1992), 15–31. Of course, the cinema offers the possibility of suspending or rupturing this covariation. While diegetic sound (especially with the loud, multichannel sound systems characteristic of today's multiplexes) can certainly provide information that covaries with the cinematic array during—and can therefore be a constituent of, cinematic kinesthesis—it is plainly not necessary for the illusion. Meanwhile, my examples of cinematic kinesthesis in this chapter and the next (*2001* and *Koyaanisqatsi*) both have very important musical soundtracks and no covarying auditory information. These do not reinforce in any straightforward way the illusion of bodily movement. They do, however, add significantly to the overall aesthetic and sensory impact of these sequences. Beyond acknowledging that sound can be a relevant source of information for cinematic kinesthesis, I am also acknowledging (emphatically) that the overall effect of the sequences is not exhausted by the description I offer here. Thanks go to Ian Kennedy for informing my thinking, however limited it may still be, about sound.

39 This opens up a different way of considering Sobchack's concept of *film's body.* A film or video camera cannot pick up information from all the sources of information available to human bodies and sometimes picks up this information in subtly different ways. This mismatch in visual information and its covariance is then the source of what she refers to as the "echo focus" of the cinema's "machinic" body. See Sobchack, *The Address of the Eye,* 164–259.

40 Gibson, *The Ecological Approach,* 227.

41 Ibid., 121–26.

42 A horizon is not an occluding edge for anything other than celestial objects. Instead, it has its own rules of reversible transformation, which we can call disappearing into or arriving from the distance. Gibson, *The Ecological Approach,* 162–64.

43 Gibson, *The Ecological Approach,* 206–9.

44 To get very subtle with how the cinematic array does not coincide with the optic array, we might note that binocular disparity specifies locomotion quite significantly. In ordinary straight-line forward-facing locomotion, those parts of the individual eyes' optic arrays that do not overlap, at the peripheral edges, have the greatest angular velocities of flow and the greatest difference between local angular velocities of optic flow. In short, movement through the world is often most strongly specified in peripheral vision. In the cinema my peripheral vision does not receive information specifying movement through an environment; rather, it picks up my stasis in the cinema. This holds true, however, only when my head and eyes are pointed in the direction of move-

ment. This cuts to just how complex these transformations are and how difficult it is to sort out visual kinesthesis and proprioception in general. For an overview of these complexities and how traditional theories of perception cannot account for it, see "Objective Motion and Subjective Movement."

45 This might explain the ease, the obviousness, and the literalness of the form of the earliest examples of cinematic kinesthesis; so-called phantom rides are largely documents of vehicular travel.

46 Turvey and Shaw, "Primacy of Perceiving," 182n2.

47 Maurice Merleau-Ponty, "The Primacy of Perception and Its Philosophical Consequences," in *The Primacy of Perception* (Northwestern University Press, 1964), 12–42, 14. Strangely, Turvey and Shaw do not mention Merleau-Ponty's essay "The Primacy of Perception" in their "The Primacy of Perceiving." Again, the ecological approach and phenomenology converge.

48 The Müller-Lyer illusion is the oft-cited misperception of two identical lines as having different lengths when one has inward-pointing arrowheads and the other has outward-pointing ones. This distinction between palpable and impalpable illusions is related to but does not cleave neatly along the lines of perceptual psychology's cognitively impenetrable (compelling, cannot be dissolved by an effort of conscious will) versus cognitively penetrable illusions (those we can snap ourselves out of, e.g., Magic Eye dot-stereograms). See Gregory, "What Are Illusions?"

49 Merleau-Ponty, *The Visible and the Invisible*, 28. Subsequent references are cited parenthetically in the text.

50 Merleau-Ponty, *The Visible and the Invisible*, 152 (emphasis added). Here Merleau-Ponty is evoking Kant's claim that aesthetic judgments are made without a concept, which is important for philosophies, like Merleau-Ponty's, that make aesthetics a central category. On Merleau-Ponty's engagement with aesthetics, see Galen A. Johnson, *The Retrieval of the Beautiful: Thinking through Merleau-Ponty's Aesthetics* (Evanston, Ill.: Northwestern University Press, 2010). For more on Kant's aesthetics as an ontological category, see (of course) Immanuel Kant, *Critique of the Power of Judgment*; but also Shaviro, *Without Criteria*.

51 Cavell, *Philosophy the Day after Tomorrow*, 139.

52 That is, "the breakup and destruction": "L'éclatement et la destruction de la première apparence ne m'autorisent pas à définir désormais le 'réel' comme simple probable; puisqu'*ils ne sont qu'un autre nom de la nouvelle apparition*." Maurice Merleau-Ponty, *Le visible et l'invisible* (Paris: Gallimard, 1964), 62.

53 It might be tempting, but it would be a mistake, to hear in Merleau-Ponty's locution "progressive approximations" the flawed doctrine of adumbration by adequate givenness. Merleau-Ponty writes in a particularly difficult working note for his unfinished *The Visible and Invisible*, of November 1959: "The visible, which is always 'further on,' is *presented* as such. It is the *Urpräsentation* of the *Nichturpräsentierbar—To see* is precisely, in spite of the infinite analysis always possible, and although no *Etwas* ever remains *in our hands*, to have an *Etwas* . . . the visible ceases to be an inaccessible if I conceive it, not according to the proximal thought, but as an encompassing, lateral investment, *flesh*." *The Visible and the Invisible*, 217. I take the visible's status as *always further on* to

be the same thing as our seeing by *progressive approximations.* That is, vision itself indexes its constitutive partiality, especially in disillusionment. Ultimately, I see the structure of disillusionment Merleau-Ponty outlines as compatible with Barbaras's account *Desire and Distance,* which is an attempt to finish the project of *The Visible and the Invisible.*

54 Jan Patočka, *Body, Community, Language, World,* trans. James Dodd (Chicago: Open Court, 1998), 39.

55 Patočka, *Body, Community, Language, World, 39.* Patočka (or his translator) has given such phenomena the frankly adorable name *demi-phenomenon.*

56 Barbaras, *Desire and Distance, 77.*

57 This, then, is not the "perceptual realism" of Stephen Prince, "True Lies: Perceptual Realism, Digital Images, and Film Theory," *Film Quarterly* 49, no. 3 (1996): 27–37. For more on Prince's perceptual realism in the context of ecological phenomenology, see my "On Learning to Fly at the Movies: *Avatar* and *How to Train Your Dragon,*" *Journal of Narrative Theory* 46 no. 2 (Summer 2016): 254–83.

58 André Bazin, *What Is Cinema?,* 14. Subsequent references are cited parenthetically in the text. Now, I should acknowledge this is a misleading translation, but there is sometimes wisdom in misleading translations. Here, Gray's translation renders the French *croyance* as "faith" when in fact "belief" would be the correct choice. Across the whole of *What Is Cinema?* Gray mistakenly renders *croire* and its derivatives as locutions employing "faith." *Croire* shares an almost identical grammar with the English "to believe," whereas the English "faith" has its equivalent in the French *foi* (which similarly share almost identical grammars). This has the effect of making Bazin seem more theological in his thrust, more Catholic, somehow, than he actually is. In any event, the original French reads, "Le dessin le plus fidèle peut nous donner plus de renseignements sur le modèle, il ne possédra jamais, en dépit de notre esprit critique, le pouvoir irrationnel de la photographie qui emporte notre croyance." André Bazin, *Qu'est-ce que le cinéma?,* édition définitive (Paris: Éditions du Cerf, 1975), 14. A more correct translation of the phrase in question is "the irrational power of the photograph to bear our belief."

59 Continuing my cranky translation pedantry in footnotes, what Gray renders as "puts its faith in reality" is "croit à la réalité"—whose correct translation would be "believes in reality." Bazin, *Qu'est-ce que le cinéma?,* 14.

60 Michelson, "Bodies in Space," 56.

4. Proprioception, the *Écart*

1 Michelson, "Bodies in Space," 59.

2 Cited in and transcribed in Mitchell Morris, "Sight, Sound, and the Temporality of Myth Making in *Koyaanisqatsi,*" in *Beyond the Soundtrack: Representing Music in Cinema,* ed. Daniel Goldmark, Lawrence Kramer, and Richard D. Leppert (Berkeley: University of California Press, 2007), 120–35, 121.

3 Morris, "Sight, Sound, and the Temporality of Myth Making," 121. He goes on to note the absence of characters, dialogue, and diegetic sound—all crucial to his interest in developing the importance of Glass's remarkable soundtrack.

4 Of course, not even close to all documentary relies on discursive strategies. Indeed,

Koyaanisqatsi belongs somewhat uneasily alongside the films Jane M. Gaines discusses in "Political Mimesis," in *Collecting Visible Evidence*, ed. Jane M. Gaines and Michael Renov (Minneapolis: University of Minnesota Press, 1999), 84–102.

5 For more on the soundtrack, see, of course, Morris, "Sight, Sound, and the Temporality of Mythmaking."

6 You could make this claim for the composite space of classical Hollywood editing or other forms of "psychological realism." And indeed, this problem of cinematic space and its articulation by editing in other styles and periods is well worth exploring along the lines I develop here. A good start (despite the emphasis on narrative) might be found in the accounts of narrative, space, and editing in David Bordwell, *Narration in the Fiction Film* (Madison: University of Wisconsin Press, 1985); and *The Way Hollywood Tells It: Story and Style in Modern Movies* (Berkeley: University of California Press, 2006). Especially interesting in this respect is his concept of "intensified continuity."

7 Of course, *Koyaanisqatsi* was made using photographic procedures, and so obviously, this sense of worldliness *is* a result of these procedures. The density of the illusion in *Koyaanisqatsi* is a result of the robust covariance of sources of information about the world that itself is a result of its photographic procedures—but that is not in any sense ineluctably bound to an ontology of these procedures. An alternative line of inquiry might take up the relation of photographic procedures for making cinematic images and the adherence of those images to the canons of ecological validity. Nevertheless, because the postural covariants of visual perception are always suspended in the cinema, no matter how much fidelity to the world you manifest in your cinematography, it will *always* be illusory. That is, after all, precisely my point.

8 These opening shots are not exclusively in the American Southwest. One appears to be of Waimea Canyon, on Kauai in Hawai'i. A "crowdsourcing" website exists to establish the many locations of shots in *Koyaanisqatsi*, http://www.spiritofbaraka.com/koyaanisqatsi.

9 Here, I mean to acknowledge but suspend the art-historical perspective. *Koyaanisqatsi* participates in the famous and long tradition of the American landscape in the visual arts, which includes the Hudson School, Ansel Adams, Georgia O'Keefe, and myriad others. This bears on my argument primarily in *Koyaanisqatsi*'s proximity to (if not quite participation in) the sublime (whatever you take that term to mean). This cuts to important questions about aesthetic scale, or intensity, in *Koyaanisqatsi*, which I address later. It is not, however, my interest here to get mired in attendant theorizations of (and debates around) the sublime and their applicability (or not) to the film. In any event, the film's interest in environments lies primarily with the urban environments of late modernity rather than the empty, "natural" landscapes of the American Southwest.

10 In fact, movement and exploration are decisively, even constitutively, linked in *all* of the antiskeptical philosophies I have been deploying. Barbaras links his critique of Husserl's phenomenology of perception to an organism's capacity for movement in an environment, thus linking perception with exploration. See Renaud Barbaras, *Desire and Distance*, 81–107. Of course, this is a major theme in Gibson's work, not least *The Ecological Approach*. It is a common trope in much theorizing about perception, especially in phenomenological idioms. See also Patočka, *Body, Community, Language,*

World, 143–62; and, of course, the famous chapter "The Spatiality of One's Own Body and Motricity," in Merleau-Ponty, *Phenomenology of Perception,* 100–48. We even find it in Stanley Cavell, *The Claim of Reason,* 202.

11 Even if, as we have seen, perception always transcends itself toward objective perception as its "natural continuation." Merleau-Ponty, *Phenomenology of Perception,* 74.

12 "Eye and Mind," in *The Primacy of Perception,* 159–90, 178.

13 This is complicated by the existence of surround-sound technologies. *Koyaanisqatsi,* however, shows us that other ways of inducing cinematic immersion are not required for an immersive dynamic.

14 Merleau-Ponty, *Phenomenology of Perception,* 73.

15 Vivian Sobchack, "What My Fingers Knew," 76.

16 We might say that *faith* is a name for our compulsion to take the *as if* as adequate. We might then also say that skepticism names a desire for the (de)nominative powers of language to be literal rather than catachrestic.

17 Merleau-Ponty, "Eye and Mind," 180.

18 Merleau-Ponty, *Phenomenology of Perception,* 70.

19 Merleau-Ponty, *Phenomenology of Perception,* 147. This translation is modified using Colin Smith's earlier translation of this sentence in *Phenomenology of Perception,* trans. Colin Smith (New York: Routledge Classics, 2002), 169. The French word in question is *moyen.* Maurice Merleau-Ponty, *Phénoménologie de la perception* (Paris: Gallimard, 1945), 182. Landes renders this as "means"; Smith uses "medium." I prefer the second not because it is more correct (both are) but because it resonates with my media-theoretical approach.

20 For example, in *Phenomenology of Perception,* 81 and 498–99.

21 There is some disagreement as to the substantive differences between the early Merleau-Ponty of the *Phenomenology* and the late Merleau-Ponty of *The Visible and the Invisible.* Renaud Barbaras holds there is significant development and a strong difference; Mark Hansen, however, affirms the continuity. I have found it useful to take a synthetic view of his work, but that has meant reading the *Phenomenology* through *The Visible and the Invisible* rather than on its own terms. See Barbaras, *The Being of the Phenomenon;* and Hansen, *Bodies in Code,* 42ff.

22 Merleau-Ponty, *The Visible and the Invisible,* 41–42.

23 Drew Leder, *The Absent Body,* 39.

24 Proprioception, on this account, would then be in close proximity to affect. See, for example, Brian Massumi, *Parables for the Virtual: Movement, Affect, Sensation* (Durham, N.C.: Duke University Press, 2002), 60–62. Although not quite affect, I discuss proprioception as a dimension of affectivity in chapter 5.

25 Gibson, *The Senses Considered as Perceptual Systems* (Boston: Houghton Mifflin, 1966), 44.

26 Gibson, *The Ecological Approach,* 115 (my emphasis).

27 Gibson, "The Uses of Proprioception," 166.

28 For more on Gibson's doctrine of affordances, see especially *The Ecological Approach,* chap. 8; and "Notes on Affordances."

29 Gibson, *The Ecological Approach,* 115.

30 Gibson, "Uses of Proprioception," 165.

31 Gibson, *The Ecological Approach*, 116.

32 Gibson, *The Senses as Perceptual Systems*, 36–37.

33 James J. Gibson, "A Theory of Direct Visual Perception," in *Perception*, ed. Robert Schwartz (Malden, Mass.: Blackwell, 2004), 158–71, 159.

34 I mean to evoke Leder's account of *disappearance* here in *The Absent Body*, chaps. 1 and 2, esp. 25–27 and 42.

35 In this, it is very similar to a classic of psychological literature, the train effect. You are sitting at a train in a station. The train next to you starts to move. Or have you started moving? This feeling of irresolution is a heightening of proprioception induced by visual information alone.

36 Gibson, "Uses of Proprioception," 168–69.

37 Sobchack, "What My Fingers Knew," 66–67.

38 Merleau-Ponty, *The Visible and the Invisible*, 139.

39 Ibid., 147.

40 Ibid.

41 Hansen, *Bodies in Code*, 39. He is explicitly speaking a language deeply indebted to second-order systems theory and its concept of *autopoiesis*, which I cannot do justice to here. For more on second-order systems theory, see Bruce Clarke and Mark B. N. Hansen, eds., *Emergence and Embodiment: New Essays on Second-Order Systems Theory* (Durham, N.C.: Duke University Press, 2009), especially their introduction. Gibson himself made reference to cybernetics in discussing proprioception, e.g., Gibson, "Uses of Proprioception," 169. In fact, while Gibson himself emphasized the concept of perceptual systems (most prominently in *The Senses Considered as Perceptual Systems*), he was explicitly critical of cybernetics and systems theory in its midcentury incarnations (most specifically, he disagreed pointedly with Claude Shannon's characterizations of the nature of information). However, the rise of neocybernetics, or second-order systems theory, and its reinvention of systems thinking have seemed to make the ecological approach and the major formulations of systems theory broadly compatible. I offer a lengthy discussion of second-order systems theory in relation to phenomenology, as well as to Gilbert Simondon's philosophy of individuation, in an earlier version of this work, Scott C. Richmond, "Resonant Perception: Cinema, Phenomenology, and the Illusion of Bodily Movement" (PhD diss., University of Chicago, 2010), 220–41.

42 Hansen, *Bodies in Code*, 43. On abstract posture, see José Gil, *Metamorphoses of the Body* (Minneapolis: University of Minnesota Press, 1998), 135–37.

43 In a different idiom, you could say that *Koyaanisqatsi* does not shatter us in these moments and that it does not fully participate in Steven Shaviro's cinematic conjugation of Leo Bersani's masochism. I return to this idiom and to the relation between the unbounded body and cinematic pleasure briefly in chapter 5. See Leo Bersani, "Sexuality and Esthetics," in *The Freudian Body: Psychoanalysis and Art* (New York: Columbia University Press, 1986), 29–50; "Is the Rectum a Grave?," *October* 43 (1987): 197–222; and Steven Shaviro, *The Cinematic Body* (Minneapolis: University of Minnesota Press, 1993).

44 It is worth dwelling for a moment on the paradoxical locution "the depth of the screen"—the depth of a two-dimensional surface. That is, the cinematic space at issue

here involves the decidedly weird transformation of a surface into a depth by means of certain rule-following changes of patterns of projected light. (These rules, as we have seen, conform to certain canons of ecological validity.) Maintaining a sense of this weirdness—and a sense of wonder at it—is necessary for grasping what is important about cinematic kinesthesis.

45 On camera movement specifying an intentionality substantially different from my own, see especially Sobchack, "Toward Inhabited Space."

46 Merleau-Ponty, *Phenomenology of Perception,* 150 (translation modified).

47 Hansen, *Bodies in Code,* 43.

48 This way of putting things bears a strong resemblance to Bergson's theses on movement, at least glossed in the first chapter of Deleuze, *Cinema 1.* At issue here, however, is not the ontological priority of movement over space nor the nondecomposability of movement—and thus (once again) not the movement-image, at least not in any straightforward sense.

49 In an early version of this passage, I wrote "indexical bond," but as it turns out, the dissolution here is not one of indexicality but rather of iconicity: these images no longer *resemble* the physical causes of their images. What is dissolved or slackened here is instead the photographic or cinematographic intertwining of indexicality and iconicity. On the dissolution of such intertwining, see Richmond, "On Learning to Fly at the Movies."

5. The Body, Unbounded

1 Although, of course, it's not "really" a long take in the same way as Cuarón's other famous long take in *Children of Men* (2006). *Gravity's* long takes are all digitally composited (as are nearly all its shots).

2 ICG Staff, "Exposure: Alfonso Cuarón," *ICG,* October 4, 2013, http://www.icgmagazine .com/.

3 Andrew O'Hehir, "'Gravity': Bullock and Clooney, Lost in Space," *Salon,* October 3, 2013, http://www.salon.com/.

4 Christopher Orr, "The Spectacular Simplicity of *Gravity,*" *Atlantic,* October 4, 2013, http://www.theatlantic.com/.

5 Compare with Merleau-Ponty's claim that if there were a first dimension, it would be depth, in "Eye and Mind," 180.

6 Kristin Thompson, "*Gravity,* Part 1: Two Characters Adrift in an Experimental Film," David Bordwell's Website on Cinema, November 7, 2013, www.davidbordwell.net.

7 For a demonstration of the Bot & Dolly technology that Cuarón used to make *Gravity,* see the impressive short film *Box* (Bot & Dolly, 2013), http://www.botndolly.com/ box.

8 O'Hehir, "'Gravity': Bullock and Clooney, Lost in Space"; Chris Plante, "'Gravity' Borrows Its Best Bits from Video Games," *Polygon,* June 17, 2014, 2013, http://www.polygon .com/; and Andrew Duffy, "Why 'Gravity' is Actually the Best Video Game Movie in Years," Examiner.com, October 16, 2013, http://www.examiner.com/.

9 For more on the proprioceptive vocation of paracinematic technologies, see Alison Griffiths, *Shivers down Your Spine: Cinema, Museums, and the Immersive View* (New

York: Columbia University Press, 2008); and Kate Mondloch, *Screens: Viewing Media Installation Art* (Minneapolis: University of Minnesota Press, 2010).

10 Shaviro, *Without Criteria,* 54.

11 To be sure, it's a question not only of how *we* resonate with the world but of how everything in the world resonates with everything else in the world (i.e., Whitehead's prehension). While *Without Criteria* was written before the recent explosion of interest in speculative realism, Shaviro's position in *Without Criteria* anticipates his positions in speculative realist debates, which he continues in *The Universe of Things.* I am explicitly attempting to rescue for phenomenology a sense of what it might be like for us to be in an aesthetic field that is not limited to humanity—while acknowledging that our experience of it is ineluctably bound to our conditions of embodiment and its finitude: that is, the conditions of appearance of the world. Meanwhile, it bears mention that beyond the context organized by speculative realism, Brian Massumi has recently offered a Whiteheadian account of aesthetics that emphasizes creativity rather than receptivity in *Semblance and Event: Activist Philosophy and the Occurent Arts* (Cambridge, Mass.: MIT Press, 2011).

12 Gilles Deleuze, *The Logic of Sense,* trans. Mark Lester (New York: Columbia University Press, 1990), 260.

13 Sobchack, "What My Fingers Knew."

14 This is true especially of Hansen's work around 2004—for example, *New Philosophy for New Media* and "The Time of Affect, or Bearing Witness to Life," *Critical Inquiry* 30, no. 3 (2004): 584–626. His more recent work, like Shaviro's, turns to Whitehead's idiom. See, for example, "Ubiquitous Sensibility," in *Communication Matters: Materialist Approaches to Media, Mobility and Networks,* ed. Jeremy Packer and Stephen B. Crofts Wiley (New York: Routledge, 2012), 53–65.

15 Of course, there is a whole complex and sometimes contradictory body of work that sometimes goes under the name "affect theory" that collapses, in various ways and to various aims, the distance between affect and aesthetics. Two lines of thinking are particularly important for my purposes here. First is the nonrepresentational sense of affect and aesthetics, which we can find in Nigel Thrift, *Non-representational Theory: Space, Politics, Affect* (New York: Routledge, 2008). Second is the sense that even as proprioceptive aesthetics is existentially palpable and salient, it is small, not dramatic, not significant. Here, I am thinking of Lauren Berlant's method of dedramatization in *Cruel Optimism* and, with Lee Edelman, in *Sex, or the Unbearable* (Durham, N.C.: Duke University Press, 2014).

16 Massumi, *Parables for the Virtual.*

17 Indeed, this is a direct quote from a graduate student of mine with Marxist inclinations, in a discussion several years ago, of Merleau-Ponty's "Eye and Mind."

18 Merleau-Ponty was, of course, the frankest and most eloquent of phenomenologists on mystery and wonder. See the preface to Maurice Merleau-Ponty, *Phenomenology of Perception,* esp. lxxvii; "Eye and Mind"; and *The Visible and the Invisible,* especially the working notes. Of course, Martin Heidegger offers a number of figures for it, perhaps most famously *Gelassenheit,* in Martin Heidegger, *Country Path Conversations,* trans. Bret W. Davis (Bloomington: Indiana University Press, 2010), although figures for mystery and

wonder appear in a great many places in his work. On aesthetics and mystery, see his "The Question concerning Technology," in *The Question concerning Technology and Other Essays* (New York: Harper & Row, 1977), 3–35; and "The Origin of the Work of Art," in *Poetry, Language, Thought* (New York: Harper Perennial Classics, 2001), 15–86. Emmanuel Levinas gives this mystery and wonder its theological dimension in *Totality and Infinity,* trans. Alphonso Lingis (Norwell, Mass.: Kluwer, 1991). However this wonder has been conjugated by phenomenological philosophers, in theological or atheistic tones, it has attended phenomenology in its earliest and most basic formulations of its philosophical operations, including in Husserl, who calls for what his student Eugen Fink glosses as "astonishment over the mystery of the being of the world itself," in Eugen Fink, "The Phenomenological Philosophy of Edmund Husserl and Contemporary Criticism," in *The Phenomenology of Husserl: Selected Critical Readings,* ed. R. O. Elveton (Chicago: Quadrangle Books, 1970), 73–147, 109; cited in Merleau-Ponty, *Phenomenology of Perception,* 494n30.

19 Heller-Roazen, *The Inner Touch,* 34. Subsequent references are cited parenthetically in the text.

20 A woman "experiences her husband's voice and laughter not metaphorically but literally as 'a wonderful golden brown, with a flavor of crisp, buttery toast.'" Sobchack, "What My Fingers Knew," 67–68. Subsequent references are cited parenthetically in the text.

21 Here, another parallel arises, which, if beside the point, is both suggestive and interesting in its own right. As we have seen, Sobchack claims this dedifferentiation consigns our speech to catachresis. Meanwhile, Heller-Roazen suggests that when we are in the domain of *aisthēsis* and coenaesthesia, we are also in the domain of catachresis: "It is as if the common power resisted being given a single title, as if its every appellation were, in the end, a kind of catachresis, an improper name for a power that could not be lent a single term and easily represented as one among others in the animal soul." Heller-Roazen, *Inner Touch,* 38.

22 Heller-Roazen, *Inner Touch,* 249.

23 Gibson, "The Uses of Proprioception," 165. For Sherrington's accounts of proprioception and its distinction from exteroception and interoception, see Sir Charles Scott Sherrington, *The Integrative Action of the Nervous System* (New Haven, Conn.: Yale University Press, 1906), esp. 316–19; and "On the Proprio-ceptive System, Especially in Its Reflex Aspect," *Brain* 29, no. 4 (1907): 467–82.

24 Heller-Roazen, *Inner Touch,* 251.

25 Gibson, *The Ecological Approach,* 240.

26 Ibid., 116.

27 I borrow the term "knot of relations" from Merleau-Ponty, who himself borrows from Antoine de Saint-Exupéry. Merleau-Ponty, *Phenomenology of Perception,* lxxxv, 483, and 97n50.

28 Hoberman, "Drowning in the Digital Abyss"; Scott Foundas, "Why 'Gravity' Could Be the World's Biggest Avant-Garde Movie," *Variety,* October 7, 2013, http://variety.com/; and Thompson, "*Gravity,* Part 1."

29 Kevin H. Martin, "Star Fall," *ICG,* October 4, 2013, http://www.icgmagazine.com/.

30 Metz, *Imaginary Signifier,* 45–46.

31 Mulvey, "Visual Pleasure and Narrative Cinema."

32 For more on this and on Metz's scheme of cinematic identification, see Richmond, "The Exorbitant Lightness of Bodies."

33 Shaviro, *The Cinematic Body*, 32.

34 Bersani, "Is the Rectum a Grave?," 217; "Sexuality and Esthetics," 38. Bersani's account relies heavily on the account of infantile sexuality, anaclisis (or propping; in German, *Anlehnung*), and the origin of the drive in Jean Laplanche, *Life and Death in Psychoanalysis*, trans. Jeffrey Mehlman (Baltimore, Md.: Johns Hopkins University Press, 1976).

35 Arnold I. Davidson, "Foucault, Psychoanalysis, and Pleasure," in *Homosexuality and Psychoanalysis*, ed. Tim Dean and Christopher Lane (Chicago: University of Chicago Press, 2001), 43–50, 46.

36 Metz, *Imaginary Signifier*, 55–56.

37 Richard Brody dislikes the narrative quite intensely. Richard Brody, "Generic 'Gravity,'" *New Yorker*, October 4, 2013, http://www.newyorker.com/. Meanwhile, both Hoberman and Foundas see the minimal narrative as an enabling condition of the film's success. Hoberman, "Drowning in the Digital Abyss"; and Foundas, "Why 'Gravity' Could Be the World's Biggest Avant-Garde Movie."

38 Richmond, "Exorbitant Lightness of Bodies," 114–15.

39 For more on mimetic resonance in the cinema, see Richmond, "Dude, That's Just Wrong."

40 Gilbert Simondon, "The Position of the Problem of Ontogenesis," *Parrhesia*, no. 7 (2009): 4–16, 9 (translation modified).

41 Michael Fried, *Absorption and Theatricality: Painting and Beholder in the Age of Diderot* (Berkeley: University of California Press, 1980).

42 Tom Gunning, "An Aesthetic of Astonishment," and "Narrative Discourse and the Narrator System," in *Film Theory and Criticism*, 6th ed., ed. Leo Braudy and Marshall Cohen (New York: Oxford University Press, 2004), 470–81.

43 Mulvey, "Visual Pleasure and Narrative Cinema," 209.

44 See Chow, "When Reflexivity Becomes Porn."

45 Michelson, "Bodies in Space," 59.

46 Brody, "Generic 'Gravity.'"

47 Ngai, *Our Aesthetic Categories*, chap. 2, "Merely Interesting."

48 Hoberman, "Drowning in the Digital Abyss."

6. Aesthetics beyond the Phenomenal

1 Branden Joseph, *Beyond the Dream Syndicate: Tony Conrad and the Arts After Cage* (New York: Zone Books, 2008).

2 Ibid., 341.

3 To be sure, these other sorts of hallucinations carry their own ambivalences and perplexities. Nevertheless, with both drugs and psychosis, the cause of the hallucinations is literally inside the body and the brain.

4 In fact, in psychology and neurology experiments in which subjects are subjected to strobing or flickering, it seems the hallucinatory percepts (or quasi percepts) arise more vigorously with the eyes closed. W. Grey Walter, *The Living Brain* (Middlesex: Penguin, 1961), 96–98.

5 Quoted in Joseph, *Beyond the Dream Syndicate,* 299.

6 Ibid., 299–300.

7 Cavell, *Must We Mean What We Say?,* 9.

8 Joseph deals with a particular kind of experience at length in *Beyond the Dream Syndicate,* not only with respect to Conrad's film but also in different chapters, including, particularly, his treatment of John Cage. Joseph's take on this, however, emphasizes the political rather than the embodied nature of this freedom. Here, we must also hear something of Kant's insistence that aesthetic judgments must, definitionally, be made in freedom. See Kant, *Critique of the Power of Judgment,* 162–66. See also Cavell, *Must We Mean What We Say?,* 94, 208.

9 It may also lead, however, to a total loss of affect: an epileptic seizure that may cause convulsions or the loss of consciousness. While the possibility of seizures seems both fascinating and relevant to the theoretical and philosophical agenda of the limits of experience, it seems a rather dangerous line of inquiry to pursue: exposing epileptics to *The Flicker* is a terrible idea.

10 Philippe Lacoue-Labarthe and Jean-Luc Nancy, "The Unconscious Is Destructured Like an Affect (Part I of 'The Jewish People Do Not Dream')," *Stanford Literature Review* 6, no. 2 (1989): 191–209, 198.

11 I am borrowing this phrase "technics of the flesh" from Mark B. N. Hansen, *Bodies in Code.*

12 P. Adams Sitney, "Structural Film," in *Visionary Film: The American Avant-Garde, 1943–2000* (New York: Oxford University Press, 2002), 347–70.

13 Quoted in Joseph, *Beyond the Dream Syndicate,* 300.

14 Michelson, "Bodies in Space," 59.

15 Sitney, "Structural Film," 359; and Malcolm LeGrice, *Abstract Film and Beyond* (Cambridge, Mass.: MIT Press, 1977), 106.

16 I learned to say it in this way from a response Steven Shaviro gave to an earlier version of this work at the Society for Literature, Science, and the Arts (Kitchener, Ontario, October 2011).

17 I really am abusing this term. I am doing so for reasons of economy and to acknowledge Rancière's influence on this line of argument. He deploys both terms in sophisticated ways, especially *distribution* (which translates the French *partage* in problematic or at least limited ways). Meanwhile, Rancière develops this term in relation to Benjamin's work, especially the Artwork essay, but in an ambivalent way, drawing from but criticizing what he takes Benjamin's program to be. (He does not get it quite right.) Jacques Rancière, *The Politics of Aesthetics: The Distribution of the Sensible,* trans. Gabriel Rockhill (New York: Continuum, 2004), 13; see also "Contemporary Art and the Politics of Aesthetics," in *Communities of Sense: Rethinking Aesthetics and Politics,* ed. Beth Hinderliter, et al. (Durham, N.C.: Duke University Press, 2009), 31–50.

18 My thinking here is guided in particular by two readings of Benjamin's writing on media, which differ considerably from one another. On the one hand is Mark B. N. Hansen, "On Some Motifs in Benjamin," in *Embodying Technesis: Technology beyond Writing* (Ann Arbor: University of Michigan Press, 2000), 231–63. On the other is a cycle of writings by Miriam Bratu Hansen, most pointedly in "Room-for-Play: Benjamin's Gamble

with the Cinema," *October* 109 (2004): 3–49; and *Cinema and Experience: Siegfried Kracauer, Walter Benjamin, and Theodor W. Adorno* (Berkeley: University of California Press, 2011).

19 Walter Benjamin, "The Work of Art in the Age of Its Technological Reproducibility (Second Version)," in *Selected Writings*, vol. 3, 101–33, 117 (emphasis in original has been removed). Further references to the Artwork essay are cited in the text.

20 On *Spielraum*, see especially Hansen, "Room-for-Play."

21 Of course, Benjamin first names the "optical unconscious" in relation to photography, rather than cinema, five years before the Artwork essay in "Little History of Photography," in *Selected Writings*, vol. 2, 507–530.

22 Benjamin, *Selected Writings*, vol. 2, 734–35. See also Miriam Bratu Hansen, "Of Mice and Ducks: Benjamin and Adorno on Disney," *South Atlantic Quarterly* 92, no. 1 (1993): 27–61.

23 In "Experience and Poverty," to be sure, but most significantly in "On Some Motifs in Baudelaire," in *Selected Writings*, vol. 4, 313–55, which I address below.

24 In what follows, I do not draw out the distinction Benjamin makes, in "On Some Motifs in Baudelaire," between *Erfahrung* and *Erlebnis*, or between deep, interiorizing experience and the superficial experience to which industrialized modernity gives rise. I have two reasons for this. First, it would descend into distracting and maddening philology in proximity to phenomenology, with the centrality of its category of "lived experience," which translates Husserl's use of *Erlebnis*. Benjamin and Husserl emphatically do *not* mean the same thing by this word. Although tracking the noncoincidence of their respective uses of the term would likely be enlightening, I am neither qualified to perform nor interested in such an accounting here. For the beginnings of this accounting, see Hansen, "On Some Motifs in Benjamin," 237–43. Second and more to the point, my argument is that we need to move away from an aesthetics organized by a concept of experience—either *Erlebnis* or *Erfahrung*. And so while they are distinct categories, I am trying to articulate a position in which this is a distinction without an effective difference.

25 Here, a reference to Merleau-Ponty's famous example of the blind man's cane in *Phenomenology of Perception* (153–54) would not go amiss: as a literal incorporation of technics arising from *habit*, the blind man need no longer interpret what he feels with the cane—that is he no longer *experiences* it.

26 Benjamin merely hints at this in the Artwork essay. *Selected Writings*, vol. 3, 120. On this expanded sense of aesthetics in the Artwork essay, see especially Susan Buck-Morss, "Aesthetics and Anaesthetics: Walter Benjamin's Artwork Essay Reconsidered," *October* 62 (1992): 3–41.

27 This is a vast literature. It includes many thinkers I have already cited here—Lauren Berlant, Mark Hansen, Brian Massumi, Steven Shaviro, and Nigel Thrift. For a start, see Melissa Gregg and Gregory J. Seigworth, eds., *The Affect Theory Reader* (Durham, N.C.: Duke University Press, 2010). See also Sara Ahmed, *The Cultural Politics of Emotion* (New York: Routledge, 2004); Stewart, *Ordinary Affects*; and Davide Panagia, *The Political Life of Sensation* (Durham, N.C.: Duke University Press, 2009).

28 Of course, the opposition between affect theory and media theory isn't particularly hard and fast. I am taking my cues here from Hansen, "Media Theory."

29 Mark Hansen begins the work of this revaluation in "On Some Motifs in Benjamin." He of-
 fers a useful reconsideration of his work there in "Technics beyond the Temporal Object."

30 Like the phrase I borrow in the introduction and chapter 5, "the tiny fragile human
 body," Benjamin repeats this sentence verbatim in "Experience and Poverty," *Selected
 Writings,* vol. 2, 731; and "The Storyteller," *Selected Writings,* vol. 3, 143, although it car-
 ries very different valences in each piece.

31 I want to reiterate I am using *modernist* in a relatively restricted sense, whose center
 of gravity is "high" modernism and whose mythical central figure is Clement Green-
 berg. I am not claiming everything that might be usefully considered some variant of
 modernism shares this aesthetic structure. In this context, particularly relevant is the
 concept of "vernacular modernism," in Miriam Bratu Hansen, "The Mass Production of
 the Senses: Classical Cinema as Vernacular Modernism," *Modernism/Modernity* 6, no. 2
 (1999): 59–77. Vernacular modernism has a different structure from the high modern-
 ist project, and Hansen draws a picture of a variant of cinematic modernism precisely
 not organized by high modernism's canons of aesthetic significance. Nevertheless, what
 makes vernacular modernism modernist is its aesthetic structure, in which the condi-
 tions of experience can be grasped reflectively, even in mass culture.

32 Here, I am thinking not only of Brian Massumi, as well as Mark Hansen in several of his
 moods, but also of Nick Davis, *The Desiring-Image: Gilles Deleuze and Contemporary
 Queer Cinema* (New York: Oxford University Press, 2013).

33 I learned this way of thinking about the Deleuzean take on film and media theory from
 Steven Shaviro, *Post Cinematic Affect.*

34 Once again, I want to signal I am well aware of difficulties—of translation, of philology—
 that attend a discussion of experience in English in proximity to German philosophy.
 Phenomenology's lived experience is *Erlebnis,* not *Erfahrung,* but my argument is we
 must move way from both of these terms, which the English *experience* draws together.
 Meanwhile, for a complementary account of how Husserl founds his phenomenology
 on lived experience, see Zahavi, *Husserl's Phenomenology,* chap. 1, esp. 22–27.

35 Barbaras, *Desire and Distance,* 58. Subsequent references are cited parenthetically in
 the text.

36 Baudry, "Ideological Effects," 292.

37 Husserl, *Ideas I,* 96.

38 Michelson, "Bodies in Space," 59.

Conclusion

1 As I briefly mentioned earlier, in the titles of the two essays for which Baudry is known,
 "Ideological Effects of the Basic Cinematic Apparatus" and "The Apparatus: Metapsy-
 chological Approaches to the Impression of Reality in the Cinema," "apparatus" ac-
 tually translates two different French words: *appareil* in the former, *dispositif* in the
 latter. *Dispositif* has been the more important French word for discussions of appa-
 ratus theory, for reasons I note. For a schematic gloss of the terms *apparatus* and *dis-
 positif,* see Frank Kessler, "Notes on Dispositif," http://www.let.uu.nl/~Frank.Kessler/
 personal/Dispositif%20Notes11-2007.pdf. For a deeper examination of the term as it

works in contemporary thinking on life, especially Agamben, see Timothy C. Campbell, *Improper Life: Technology and Biopolitics from Heidegger to Agamben* (Minneapolis: University of Minnesota Press, 2011), esp. (but not only) chap. 2. So far as I can tell, Foucault never made any reference to Baudry's use of the term.

2 As it is in Foucault's *History of Sexuality*. The title of part 4, "The Deployment of Sexuality," translates "Le dispositif de la sexualité." Michel Foucault, *L'histoire de la sexualité*, tome 1, *La volonté de savoir* (Paris: Gallimard, 1976); *The History of Sexuality*, vol. 1, *The Will to Knowledge*, trans. Robert Hurley (New York: Vintage, 1990). Recent English usage has most often been to leave it in French and italicize it.

3 Giorgio Agamben, *What Is an Apparatus? And Other Essays*, trans. David Kishik and Stefan Pedatella (Stanford, Calif.: Stanford University Press, 2009), 13. Subsequent references are cited parenthetically in the text. For translational clarity, it is worth noting the Italian word in question is *dispositivo*.

4 Indeed, the relation of the human to the creaturely life that subtends it has been the subject of one of Agamben's more remarkable books, *The Open*.

5 However, this suggests that Agamben's "Foucauldian" notion of an apparatus may be insufficiently Foucauldian. The last part of the first volume of Foucault's *History of Sexuality* runs explicitly *not* as a story of how life is, or can be, the ontological ground on which the apparatus of sexuality operates; rather, the various apparatuses of biopolitics operate in such a way as to *produce* life as their ontological ground. See Foucault, *The History of Sexuality*, 133–60.

6 Given the nature of life itself is at issue here, the bibliography is vast. I therefore keep my focus on Agamben and phenomenology (leaving to the side the philosophical articulations of life by thinkers like Roberto Esposito and Eugene Thacker, as well as the very big, very messy question of Foucauldian biopolitics). Indeed, despite the breadth of its terms, my argument here is in fact fairly restricted, warranted as it is by the importance of terms like *organism* and *flesh* to ecological phenomenology. To start, Agamben's own work does not support this thesis. Although I will not draw this out at length, the way Agamben uses the concept of life in *The Open* authorizes a notion of life as fundamentally self-differing. For a study of Agamben's concept of life in relation to media theory as well as Heidegger's phenomenological philosophy, see, once again, Campbell, *Improper Life*. Dominic Pettman integrates this thinking into a broader media-theoretical view in *Human Error: Species Being and Media Machines* (Minneapolis: University of Minnesota Press, 2011). Barbaras's recent work also fully supports this claim, developing life as fundamental and irreducible self-differing with recourse to any number of thinkers in the phenomenological tradition, including Husserl, Merleau-Ponty, and Derrida. The most compressed and pointed presentation of Barbaras's argument in English is "A Phenomenology of Life," in *The Cambridge Companion to Merleau-Ponty*, ed. Taylor Carman and Mark B. N. Hansen (Cambridge: Cambridge University Press, 2005). See also the later chapters of *Desire and Distance*. In French, see especially *Introduction à une phénoménologie de la vie* (Paris: Vrin, 2008).

7 My understanding of Stiegler owes much to James J. Hodge's generosity—that is, the conversation and work he has shared with me.

8 Stiegler pursues this argument at length in "Who? What? The Invention of the Human," chap. 3 of *Technics and Time*, vol. 1, 134–79.

9 Hansen, *Bodies in Code*, 99–100.

10 Merleau-Ponty, *Phenomenology of Perception*, 153.

11 Hansen, *Bodies in Code*, 100 (my emphasis).

12 I cannot do it justice here, but Simondon's philosophy of individuation is a crucial and tragically underappreciated moment in twentieth-century French thought. It has yet to be published in English in a sustained way. See Gilbert Simondon, *L'individu et sa genèse physico-biologique* (Paris: Presses Universitaires de France, 1964); and *L'individuation psychique et collective* (Paris: Aubier, 1989). The general introduction to both of these has been published twice in English, most recently as "The Position of the Problem of Ontogenesis"; but also as "The Genesis of the Individual," in *Incorporations*, ed. Jonathan Crary and Sanford Kwinter (New York: Zone Books, 1992), 296–319.

13 Hansen's account includes the reciprocal, but not symmetrical, coindividuation of the technical, also developed out of Simondon's philosophy of technics in *Du mode d'existence des objets techniques* (Paris: Aubier, 1989). The process of collaborative individuation does not result only in a human individuation but also in a technical one. These happen at different time scales, at different levels of generality, and by different means. Even further, this process of *transindividuation* includes the ways in which we are caught up in the social. While my phenomenological focus here is in fact on perceptual life and thus on the human, this focus takes place with the acknowledgment of a theoretical context in which the human is constitutively displaced from its central role.

14 Jacques Lacan, "The Mirror Stage as Formative of the *I* Function as Revealed in Psychoanalytic Experience," in *Écrits: The First Complete Edition in English* (New York: W. W. Norton, 2006), 75–81, 78.

15 Hansen, *Bodies in Code*, 100.

16 Merleau-Ponty, *Phenomenology of Perception*, 153.

17 Joseph, *Beyond the Dream Syndicate*, 299.

18 Giorgio Agamben, *Profanations*, trans. Jeff Fort (New York: Zone Books, 2007), 9. Subsequent references are cited in the text.

19 Merleau-Ponty, *The Visible and the Invisible*, 180.

20 Ludwig Wittgenstein, "Tractatus Logico-philosophicus," in *Major Works: Selected Philosophical Writings* (New York: Harper Perennial Modern Classics, 2009), 81 (Proposition 6.44; translation modified).

21 I learned to use the term *dedramatized* from Lauren Berlant. For a careful explanation of what she takes as the stakes of dedramatization, see her contributions to Berlant and Edelman, *Sex, or the Unbearable*, esp. chap. 1.

22 An illuminating and thorough account of this kind of reciprocal incorporation comes in Sobchack's discussion of "film's body," in *The Address of the Eye*, 164–259.

INDEX

Page numbers in italics refer to figures.

and covariation, 7, 82–83, 108–9, 125, 127, 129–30, 137, 139, 176n11, 189n20, 191–92nn37–38; rejection of traditional accounts of perception by, 75–78, 187n2, 188nn11–12, 190n23. *See also* ecological phenomenology

Gil, José, 111

Glass, Philip, 100

Gravity (Cuarón), 1–6, 121–43, 171; adherence of body and world in, 131–34; affective force of, 137–41, 150; as antiskeptical alternative to modernism, 9–13, 131; comparison to *2001* of, 3–4, 175n2; continuous camera movement in, 2–3; critical response to, 3, 124; disorienting unboundedness in, 134–35; dissolved horizontal and vertical axes in, 122–24, 134–35; embodied cinematic pleasure in, 135–37; escape capsule scene of, 121–23; honors and awards of, 131; minimalist narrative of, 138; opening shot of, 1–3, 132–33, 198n1, *Plates 7, 8*; pedagogical function of, 123–24; programmable arm-mounted cameras of, 123; proprioceptive aesthetics of, 1–6, 8, 11, 20, 124–25, 131–41; 3D effects in, 1, 3–6, 84–85, 142–43

Greenberg, Clement, 11, 204n31

Gunning, Tom, 58, 140, 178n34

Hadjioannou, Markos, 176n17

hallucination, 60, 146–52, 170. *See also* illusion

Haneke, Michael, 39

Hansen, Mark B. N., 71–72; on affect, 127, 199n14; body-schema theory of, 110–11, 116, 196n21, 197n41; on Deleuze's movement-image, 184n23; phenomenological media theory of, 17, 19, 71–72, 162–63; on technicity and individuation, 22, 162–66, 169–70, 178nn36–37, 204n29, 206n13

Hansen, Miriam Bratu, 202n18, 204n31

Harris, Neil, 179n9

Heidegger, Martin, 14, 177n20, 199n18

height in the visual field, 80, 84

Heller-Roazen, Daniel, 128–29, 200n21

History of Sexuality (Foucault), 205n5

Hoberman, J., 9, 131, 201n37

Hodge, James J., 22, 176n38

Holt, Edwin B., 75

horizon/horizontal, the, 92–93, 123, 192n42; dissolution in *Gravity* of, 122–24, 134–35; in *Koyaanisqatsi*, 103–5, 112–19, 197n44, 198nn48–49, *Plates 5, 6*

Husserl, Edmund, 19, 75; Barbaras's critique of, 66–69, 74, 76, 157–58, 189n20, 195n10; on the *epochē*, 67, 158, 176n15, 183n3; on intentionality of perception, 15, 62–64, 66–69, 184n23, 185–86nn27–30; on mystery, 199n18; on perception as adequate givenness, 68, 74, 76, 157–58; on perception by adumbration, 62–63, 65, 68–69, 76, 93, 157–58, 203n24

Ideas, I (Husserl), 158

illusion, 12–13; argument from, 76; in Baudry's apparatus theory, 60–63; cinematic forms of, 58–60; as divergence from ordinary perception, 84; in film theory, 57–60; Merleau-Ponty on, 89–92; in Sobchack's theory of cinema, 64–65

illusion of bodily movement, 2–3, 12–13, 18, 51–72; Barbaras's phenomenology of appearance and, 15–16, 19, 52–53, 63–71, 94–95, 146, 157–59, 184n23, 185–86nn26–30; cinematic array in, 83–84, 192n38, 192n42, 192n44; departure from the rules of ecological validity in, 84–88; as felt impression of reality, 57–58, 61–63, 184nn15–16; Gibson on cinematic kinesthesis and, 18, 74, 82–88, 192nn38–39, 192–93nn44–45; perceptual faith in, 74, 88–95, 99, 127, 167–68, 193n50, 193nn52–53, 194n58, 196n21, 199n18; perceptual resonance in, 14, 19–20, 73, 79–80, 97–119, 139–41; thematization of perception in, 57, 111,

141–43, 149–50, 153; versus traditional notions of cinematic illusion, 58–60. *See also* proprioceptive aesthetics; technics/technicity; *see also specific films*

Imaginary Signifier, The (Metz), 63, 135–36

IMAX, 1, 3–6, 84–85, 142–43

interoception, 7, 107

Interstellar (Nolan), 175n2

"Intertwining—The Chiasm, The" (Merleau-Ponty), 189n19, 191n30

invisible, the, 93, 103–5, 119, 153. *See also Visible and the Invisible, The*

Jackson, Robert, 176n16

James, William, 75

Jarman, Derek, 192n38

Joseph, Branden, 147, 149, 152, 159, 165, 202n8

Kant, Immanuel: on aesthetic judgment, 40–41, 43, 125, 159, 181n36, 193n50; on phenomenon versus noumenon, 67

Koch, Gertrud, 184n20

Koyaanisqatsi: Life Out of Balance (Reggio), 6, 18, 20, 97–119, 171; cinematic modulation of proprioception in, 101–2, 106–19, 132, 138–39, 195n7; climactic sequence (with missing horizon) of, 97, 112–19, 197n44, 198nn48–49, *Plates 5, 6*; cloud sequence of, 106–12, 197n35, 197n43; Glass's score for, 100, 101; moving landscape shots of, 103–6, 195nn8–10; political project of, 100–102, 194n4; time-lapse shots in, 97, *98*, 100–101, 103, 106, *Plates 5, 6*

Krauss, Rosalind, 11, 19, 29, 35–36, 47, 50

Kubelka, Peter, 146

Kubrick, Stanley, 3, 51, 54, 118. *See also 2001: A Space Odyssey*

Lacan, Jacques, 61, 135–36, 164, 166

Lacoue-Labarthe, Philippe, 150

Laplanche, Jean, 201n34

Leder, Drew, 107, 176n9

Lee, Pamela, 39, 176n16

Léger, Fernand, 35

Le Grice, Malcolm, 152

lens accommodation, 81, 84–85

Leroi-Gourhan, André, 163

Levi, Pavle, 48–49

Levinas, Emmanuel, 199n18

Ligeti, György, 54

Lindsay, Vachel, 75

Lubezki, Emmanuel, 121, 131, 143

Lux Aeterna (Ligeti), 54

Manovich, Lev, 176n37

Man with a Movie Camera (Vertov), 100

Marks, Laura U., 15, 67

masochism, 135–37

Massumi, Brian, 127, 139, 199n11

Matt Kowalski (character), *122*

McLeod, Robert, 188n15

McLuhan, Marshall, 17, 71

media theory, 17, 71. *See also* phenomenological theory

Merleau-Ponty, Maurice: doctrine of the *écart* of perceptual resonance of, 20, 99, 110–12, 127, 137, 163–66, 170; on the ek-static structure of perception, 106; on the flesh, chiasm, and intertwining, 110–11, 146, 189n19; on illusion and disillusion, 91–92; on immersion in visibility, 103–6, 196n19; intersection with Gibson of, 20, 74–75, 99, 189n20, 191n30; on perceptual faith, 12, 19, 74, 88–94, 106, 127, 167–68, 193n50, 193nn52–53, 196n21, 199n18; phenomenology of perception of, 7, 13–15, 69, 73–74, 185n24, 189n22, 193n47, 196n11, 196n21, 203n25; prosthetic model of technology of, 163–65, 169, 203n25. *See also* ecological phenomenology

Metz, Christian, 6; on cinematic apparatus, 70–71, 162, 186n39; on cinematic identification, 137–38; on cinematic motion, 61, 63, 184nn22–23; on cinematic pleasure, 135–36

Michelson, Annette: on doubled reflexivity, 100; on Duchamp's *Anémic Cinéma*, 35; on modernism, 9–11, 44, 141; on *2001*'s phenomenological esthetic, 51–52, 57, 94, 99, 151

Mitry, Jean, 185n26

modernist aesthetics, 9–13, 19, 176nn16–17; Cavell's formulation of, 35, 42–47, 49, 180n30, 182nn54–55; critical reflexivity in, 38–44, 71, 142, 156–57, 168, 181nn34–35, 204n31; discourses of cinematic ontology and skepticism in, 30–31, 36–37, 45–50, 181n41, 182n49, 182n52, 182nn54–55; Duchamp's Precision Optics and, 35–36, 180n21; of flicker films, 29, 146, 151–52; in *Koyaanisqatsi*'s sensory alienation, 100–102; photography and, 47–48; proprioceptive aesthetics as antiskeptical alternative to, 11–13, 30–31, 46, 53, 131, 141–42; technology and anxiety in, 18, 42–43, 46–47; of *2001: A Space Odyssey*, 51–52, 151

Morris, Mitchell, 100–101

Morton, Timothy, 187n1

motion perspective, 81, 84–86

Motion Picture Testing and Research (Gibson), 77–78, 188n17

Mulhall, Stephen, 49, 140

Müller-Lyer illusion, 89, 193n48

Mulvey, Laura, 38, 71, 135

Münsterberg, Hugo, 75

Musatti, C. L., 179n14

Musil, Robert, 60

Must We Mean What We Say? (Cavell), 42, 181n34

Nancy, Jean-Luc, 150

New Philosophy for New Media (Hansen), 199n14

new realism, 176n17

Ngai, Sianne, 19, 30, 38–42, 44, 142, 180nn29–30

Night of the Living Dead (Romero), 59

Nolan, Christopher, 175n2

noncorrespondence, 16–17

nonrepresentational space. *See* illusion of bodily movement

nonrepresentational theory of cinema. *See* ecological phenomenology

Nude Descending a Staircase (Duchamp), 35–36

occlusion, 80, 84, 87, 92–93

O'Hehir, Andrew, 122, 124

ontology. *See* cinematic ontology

"Ontology of the Photographic Image, The" (Bazin), 94, 194nn58–59

Open, The (Agamben), 205n4, 205n6

Our Aesthetic Categories (Ngai), 39–40

Patočka, Jan, 92–93

Pedullà, Gabriele, 21

perception, 1–6, 167–71; ecological phenomenology of, 13–19, 23, 50, 73–95; as embodied phenomenon, 4, 6, 14–16, 31–32, 89–90, 181n35; Gibson's ecological approach to, 7–8, 13–15, 19, 73–83, 176n11; Gibson's foundational definition of, 78–79, 92–93; Merleau-Ponty's phenomenology of, 13–15, 69, 73–74, 185n24; perceptual faith in, 12, 19, 74, 88–95, 99, 127, 167–68, 193n50, 193nn52–53, 194n58, 196n21, 199n18; resonance between subject and world in, 14, 19–20, 73, 79–80, 97–119, 139–41; technological modulation of, 6, 11, 13–18, 31–34, 97–99; thematization of, 57, 111, 141–43, 149–50, 153; three registers of, 7, 176n9; traditional accounts of, 75–78, 88–89, 188nn11–12, 190nn23–24

Perception of the Visual World, The (Gibson), 190n27

perceptual attunement, 14, 88, 99, 101–2, 125–26, 139–41, 177n20

perceptual illusion. *See* illusion

perceptual realism, 193n57

perceptual resonance, 14, 19–20, 73, 79–80, 97–119; Merleau-Ponty's doctrine of the *écart* of, 20, 99, 104, 110–12, 127, 137, 163–66, 170; ongoing immersive world of, 80, 103–6, 196n13; perceptual attunement and disorientation in, 14, 88, 99, 101–2, 111–19, 139–41, 177n20, 198nn48–49; as reflexive modulation, 98–99, 130, 139–41; as technics of *aisthēsis*, 167–71; technological manipulation of, 97–98, 171

perceptual technics, 176n37

phenomenological theory, 14–18, 50; Barbaras's phenomenology of appearance in, 15–16, 19, 52–53, 63–71, 146, 157–59, 184–85nn23–24, 185–86nn26–30; Baudry's phenomenology of illusion in, 61–64, 68, 185n26; on cinematic kinesthesis, 18, 74, 82–88, 192nn38–39, 192–93nn44–45; on the *epochē*, 51, 158, 176n15, 183n3; Husserl on intentionality of perception in, 15, 62, 63–64, 66–69, 184n23, 185–86nn27–30; Metz's impression of motion in, 61, 63, 184nn22–23; Sobchack's cinematic intentionality in, 64–65, 67, 70, 185n24, 185n29; Stiegler's phenomenology of technics in, 17, 19, 71–72; on suspension of representational intent, 69–70, 95. *See also* ecological phenomenology

Phenomenology of Perception (Merleau-Ponty), 75, 105–6, 164–65, 168, 196n21

photography, 46–49, 102

Piano, The (Campion), 105

Picabia, Francis, 35

Plato, 61, 67

pleasure, 135–37

postural information, 81–82, 114, 191n32

Precision Optics (Duchamp), 31–36, 47, 50, 179n10, 179n14, 180n21

prehension, 126

Prince, Stephen, 193n57

projective illusion, 59–60

proprioception, 3; as affect, 139; definition of, 6–8, 107–8, 125; Gibson's ecological approach to, 7–8, 108–9, 125, 127, 129–30, 137, 139, 176n11; as perceptual individuation, 164

proprioceptive aesthetics, 6–9, 13, 20–23, 125–30, 175n8; adherence of body and world in, 131–34; affective force of, 137–41, 150; as antiskeptical alternative to modernism, 9–12, 30–31, 46, 53, 131, 141–42, 176nn16–17; avoidance of cinematic ontology in, 45–50, 182n49, 182n52; the body as intentional object of, 16–17; contemporaneity of, 21–23, 178nn33–34; versus critical reflexivity, 38–44, 71, 142, 168, 181nn34–35; disorienting unboundedness in, 134–35; in Duchamp's Precision Optics, 31–36, 47, 50, 179n10, 179n14, 180n21; ecological phenomenology of perception in, 13–19, 23, 73–95; embodied attunement of beauty and perception in, 125–27; embodied cinematic pleasure in, 135–37; illusion of bodily movement in, 2–3, 12–13, 18, 51–72, 106–12; pedagogical intention of, 123–24; perceptual resonance of abstract space in, 14, 19–20, 73, 79–80, 97–119, 139–41; technicity and technical genius in, 16–18, 22–23, 97–99, 147–71, 177n31, 206n21; as term, 125–30; thematization of perception in, 57, 111, 141–43, 149–50, 153; three intentions of, 9; viewers' reflexive self-relation in, 10–11, 30–31, 130. *See also specific films*

Rancière, Jacques, 153, 202n17

Ray, Man, 25, 35

Readymades (Duchamp), 35–36

Reggio, Godfrey, 6, 97, 100, 117–18. *See also Koyaanisqatsi: Life Out of Balance*

région centrale, La (Snow), 1, 123

relative size and density, 81, 84

Remes, Justin, 185n27

representation, 12–13, 16–17. *See also* phenomenological theory

reproductive illusion, 59

Rodowick, D. N., 45–46, 48, 176n17, 182n52, 186n31

Romero, George, 59

Rotary Demisphere (Duchamp), 31–32

Rotary Glass Plates (Duchamp), 31–32, *33*

Rotoreliefs (Duchamp), 19, 31–32, 50

Ryan Stone (character), 136; cinematic identification with, 137–38; in escape capsule scene, 121–23; in opening shot, 1–3, *Plate 8*

Saint-Exupéry, Antoine de, 200n27

Sanders, John T., 189n20

Schonig, Jordan, 15

science fiction film, 20–21

Senses Considered as Perceptual Systems, The (Gibson), 108–9, 197n41

Sex, or the Unbearable (Berlant and Edelman), 199n15

Shannon, Claude, 197n43

Shaviro, Steven, 170, 176n17, 197n43; on cinematic pleasure, 136–37, 166; on receptivity and affect, 125–27, 137, 139, 199n11

Shaw, Robert, 76, 89

Sherrington, Charles Scott, 129

Shklovsky, Viktor, 39

Simondon, Gilbert, 139, 163, 206nn12–13

Sitney, P. Adams, 151–52

slit-scan shots, 54–55, 65–66, 85–86, *Plates 1, 2*

Snow, Michael, 1, 123

Sobchack, Vivian, 60; on cinema's representational function, 65, 67, 70; on the cinematic encounter, 14–16, 22, 84, 177n22; on cinematic intentionality and intersubjectivity, 64–65, 70, 185n24, 185n29; on the cinesthetic subject, 105, 110; on coenaesthesia and synaesthesia, 127, 128–29, 200nn20–21; on film's body, 192n39

special effects. *See* technics/technicity

Spider-Main (Raimi), 21

Spinoza, Baruch, 126–27

stereokinetic effect, 58. *See also* Precision Optics

Sterne, Jonathan, 176n37

Stewart, Garrett, 176n17

Stiegler, Bernard, 17, 19, 22, 71–72, 155, 162–65, 169

Structure of Behavior, The (Merleau-Ponty), 75

surround-sound technology, 196n13

synaesthesia, 128–29

technics/technicity, 6, 11, 13–20, 97–99, 142, 161–71, 177n31; of aesthetics beyond experience, 146–47, 153–60; Agamben's concept of genius and, 165–71; in Agamben's theory of subjectivity, 161–63, 205nn5–7; in Baudry's apparatus theory, 19, 61, 70–71, 94, 161–62, 177n31, 186nn38–39, 204n1; in Conrad's *The Flicker*, 150–53, 159–60, 165; digital forms of, 22–23, 178nn36–38; digital ontology and, 48–49; of Duchamp's Precision Optics experiments, 31–36, 179n10, 179n14, 180n21; as Foucault's *dispositif*, 161, 204n1; of *Gravity*'s IMAX 3D, 84–85, 142–43; in Hansen's media theory, 22, 162–66, 169–70, 178nn36–37, 204n29, 206n13; Stiegler's phenomenology of, 17, 19, 22, 71–72, 155, 162, 169; technical genius and, 165–71; as technics of *aisthēsis*, 167–71; of *2001: A Space Odyssey*, 19, 70–72

This Is Cinerama (film), 6

Thompson, Kristin, 1, 123

3D film, 1, 3–6, 84–85, 142–43

Thrift, Nigel, 199n15

train effect, the, 197n35

Trumbull, Douglas, 54–55, 65–66, *Plates 1–4*

Turvey, Michael, 76, 89

2001: A Space Odyssey (Kubrick), 3–6, 8, 19, 51–72, 171; as antiskeptical alternative to modernism, 9–13, 52–53; close-up

eye shot reaction in, 55, *56,* 183n8; critical comparisons to, 3–4, 175n2; future selves segment of, 55; illusion of bodily movement in, 51–57, 60, 65–66, 85–87; modernist aesthetics of, 51–52, 151; proprioceptive aesthetics of, 52–53, 70; soundtrack of, 4, 54, 192n38; space station sequence of, 4, *5,* 51–52, 123; Stargate sequence of, 12–13, 52–57, 60, 65–66, 85–87, 118, *Plates 1–4;* technical apparatus of, 4–6, 55, 70–72, 175n4

Uexküll, Jakob von, 74
"Unconscious Is Destructured Like an Affect, The" (Nancy and Lacoue-Labarthe), 150
Universe of Things, The (Shaviro), 199n11

Vertov, Dziga, 100, 185n26
vestibular information, 81–82, 114, 191n32
Villarejo, Amy, 72
Virtual Life of Film, The (Rodowick), 45–46
Visible and the Invisible, The (Merleau-Ponty), 69, 103–4, 106, 185n24, 193n53,
196n21; on chiastic structure of the flesh, 146, 189nn19–20; on perceptual faith, 89–92
visual kinesthesis, 77–78, 82, 108–9. *See also* cinematic kinesthesis; the invisible
"Visual Perception of Objective Motion and Subjective Movement" (Gibson), 78, 188–89nn17–18
"Visual Pleasure and Narrative Cinema" (Mulvey), 38, 140
Voss, Christiane, 59–60, 72, 184n20

"What My Fingers Knew" (Sobchack), 67
Whitehead, A. N., 126, 199n11, 199n14
Without Criteria (Shaviro), 137, 139, 170, 199n11
Wittgenstein, Ludwig, 167, 181n37, 182nn54–55
World Viewed, The (Cavell), 42, 47, 181n34

Young, Damon R., 177n22

Zahavi, Dan, 185n24, 186n30

SCOTT C. RICHMOND is assistant professor of cinema and digital media in the Cinema Studies Institute at the University of Toronto.